Women at Work
Ontario, 1850-1930

Women's Press Publications:
 Women Unite!
 Marxism and Feminism
 Cuban Women Now
 Never Done: Three Centuries of Women's Work in Canada
 Born a Woman: The Rita MacNeil Songbook
 Herstory 1975: A Canadian Women's Calendar

And for children:
 Fresh Fish... and Chips
 Mandy and the Flying Map
 The Travels of Ms. Beaver
 Stone Soup

© 1974 by the Canadian Women's Educational Press

Edited by Janice Acton, Penny Goldsmith and Bonnie Shepard
Drawings by Gail Geltner
Cover Design by Liz Martin
Production by the Canadian Women's Educational Press, Toronto (editing, design and layout) and Dumont Press Graphix, Kitchener (typesetting, paste-up, negatives)

Cover photograph from the Archives, Eaton's of Canada Limited
Published by the Canadian Women's Educational Press, Toronto, Ontario
Printed by the John Deyell Company, Willowdale, Ontario
Financial assistance was provided through the OFY Programme, Department of Manpower and Immigration, and from the Ontario Arts Council.

Preface

We've Only Just Begun

We began to work on this book about two years ago. We knew that our mothers and grandmothers had worked—as mothers, domestic servants, nurses, teachers, etc.—but we did not understand the nature and significance of their work. History and political economy courses in school implied that women, alongside immigrants and the working class in general, had no role in Canadian history. Our involvement in organizations addressing themselves to women's oppression made us realize the urgent need to uncover a history which would challenge the conclusions of existing texts and establish women's rightful importance in Canada's past.

The initiative came from a small group within the Canadian Women's Educational Press; we concluded that the only way to stimulate research in this area was to do it ourselves. We wanted to piece together the picture of how Canadian women's lives have been folded, packaged and stamped "female" to preserve a whole range of exploitative relationships.

"Who are we?" Daughters, wives and mothers. But these are identities imposed by others. We must determine our own, by combining the experiences of our mothers and grandmothers into an accurate history. So it is with any group or country which seeks to discard imposed definitions ("underdeveloped," "Backward," etc.) which have previously been internalized. They set about to redefine their past and with that understanding shape their future. For women this process is equally imperative.

Women, in trying to come to grips with their identity, have found that even traditional Marxist models for examining societies, however useful, have been inadequate. The realm of work that women have been traditionally assigned has been designated by advocates of the Marxist model as the private or personal sphere, which lies outside of the major battle lines of our economic system—wage labour versus capital. In delineating the areas of women's work to be researched we used the above model—in that we only considered waged work. However, from our examination of waged work, it became very clear how important this so-called private sphere—the family—was. As industrialization and the corresponding proletarianization of the work force drastically changed the relationship of the family to the economy, the traditional responsibilities of women were also greatly altered. Industry's labour needs welcomed some women into waged work, but at the same time, this work was restricted by the primary demand for women to produce and maintain a labour force.

The ideas we have developed in the following articles are not part of a completed political analysis due to the number of gaps left, the unanswered questions, and the newness of this material. We offer our hypotheses for consideration and criticism, and hope that they will be augmented by additional research in the other major areas of women's work, (clerical work, retail sales, housework, etc.) and particularly with histories of women in other parts of the country.

We are publishing this book in order to share the process of reclaiming our past with many women across Canada, who, perhaps like us, had not considered the manipulation and struggles of women who went before. By gaining a perspective on the experience of these women and by examining the structures, (social and cultural, as well as economic) which have oppressed women, we can more clearly understand our position today, and develop strategies for change.

Twenty heads are better than one — The Collective Process

None of us realized the size of the task we set ourselves two years ago. Nor did we have any idea of the invaluable experience and knowledge we would acquire during the project. We were committed to the idea of a collectively produced book as we all felt that it was very important to break down the individualized and

competitive work habits that had been drilled in by years of schooling. This was not an easy process. It was characterized by regroupings, redefinitions of our goals, re-examination of our methods and re-evaluation of our political and historical assumptions.

It would perhaps be useful for other women if we described our steps. We began by brainstorming about the important social and economic developments in Canadian history, and then selecting an appropriate time period and preliminary research topics on women. After a period of initial investigation into suggested topics, the list was redrawn and authors assigned. Other authors were drawn into the group on the basis of women's research which they had already begun. First and second drafts were prepared and submitted to the collective for criticism and suggestions. These discussions gradually became much more substantive as our knowledge of our own field increased and as we became more familiar with general historical trends. These discussion sessions were invaluable exercises in a number of skills; learning to make and take constructive criticism, improving our abilities to analyze material and to develop broad themes from specific data. The group's debate and exchange concerning events and their importance had the effect of combining several ideas and producing an interpretation or conclusion which transcended individual efforts. Often this was an exciting experience. Frustrations were also common and had much to do with the gradual realization of certain collective necessities: discipline, delegation of authority within the democratic structure, mutual support and perseverance, to name a few.

The editing of articles went through two stages. Initial editing on the content was done by a small sub-group of the collective, and the enormous job of final editing was done by members of the Women's Press working in close contact with the authors.

In conclusion, the experience of women writing their own histories is not only personally rewarding but of crucial importance to women carrying their struggle forward together. We heartily urge similar undertakings... We have only just begun.

ACKNOWLEDGMENTS

So many people helped us put this book together, it is difficult to know where to start. To Bonnie Ward who carried the thankless task of coordinating during the first difficult half of our history, we owe a great deal of gratitude. Editors Janice Acton and Bonnie Shepard with assistance from Penny Goldsmith, worked tirelessly and tactfully to help us hammer our material into shape. Other editorial assistance came from Susan Kent, Dianne Martin, Chris Anderson, Anne Wall and Jane Usukawa. Special thanks goes to Steve Izma, Sue Calhoun and Bob Mason from Dumont Press Graphix for the enormous job of typesetting, paste-up and preparation of negatives. The lead article requires special mention as it was done on the request of the collective by Leo Johnson, who was also very helpful in giving us a picture of general historical developments during our time period. Our articles borrowed from many other peoples' expertise or previous research; critical input from Charnie Guettel, Mercedes Steedman, Donna McCoombs, Cathy Pike and Laurel Ritchie; papers from Pat Alexander, Gail Dzis, Dawn Haites, Toby Vigod, Zoya Stevenson, Patty Deline and Vicki Trerise; and resource help from Greg Kealey, Russell Hann and Nancy Stunden. We are indebted to Canadian Women's Educational Press for their role in initiating, encouraging, publishing, and distributing this book. And to the many other people who supported us in our efforts—thank you.

Contents

Introduction *by Linda Kealey* 1

Articles

The Political Economy of Ontario Women in the Nineteenth Century, *by Leo Johnson* 13

The Wayward Worker: Toronto's Prostitute at the Turn of the Century, *by Lori Rotenberg* 33

Domestic Service in Canada, 1880-1920, *by Genevieve Leslie* 71

"I See and am Silent": A Short History of Nursing in Ontario, *by Judi Coburn* 127

Schoolmarms and Early Teaching in Ontario, *by Elizabeth Graham* 165

Besieged Innocence: The "Problem" and Problems of Working Women—Toronto, 1896-1914, *by Alice Klein and Wayne Roberts* 211

Women during the Great War, *by Ceta Ramkhalawansingh* 261

Women in Production: The Toronto Dressmakers' Strike of 1931, *by Catherine Macleod* 309

Women's Organization: Learning from Yesterday, *by Dorothy Kidd* 331

Research Guide *by Patricia Schulz*

How to do Research 363
Bibliography 369

Tables

Comparison of ethnic breakdown of female population of Toronto and ethnic breakdown of various samples of prostitutes, 1891 to 1911 ...37

Sample survey of previous occupations of prostitutes38

Wage and cost-of-living figures, 1889, for female workers over sixteen years of age without dependents48

Wage and cost-of-living figures, 1889, for female workers over sixteen years of age with dependents49

Convictions, fines and imprisonments of keepers, inmates and frequenters of houses of ill-fame, January 1, 1912 to June 30, 1914, listed by the Social Survey Commission67

Ethnic breakdown of female domestics in Toronto in 191168

Occupational breakdown of the female labour force in Ontario in 1914, for the six major occupations for women69

Number of women in domestic service in Canada, 1881 to 192172

Ratio of female servants to number of households in Canada, 1881 to 1921 ...75

First appearance of household goods in Eaton's catalogues, 1885 to 1920 ...78

Immigrant and Canadian-born women in domestic service in Canada, 1911 ..96

Median annual gross income of nurses in Ontario, 1929147

Cost of living, 1929 ...147

Statistical breakdown of nurses for the year 1930162

Numbers of physicians, nurses, midwives and practical nurses for the years 1851 to 1930 ..163

Hierarchy in the Toronto common school system, 1858182

Comparative salaries of beginning female teachers and other workers in Toronto, 1900192

Salaries of teachers in Toronto, 1858 to 1930194

Average rural teacher's salary in Ontario in 1870, 1901 and 1928 ..194

Growth of urban population in Canada (excluding Newfoundland), 1851 to 1961, expressed as percentages of total population ..265

Leading occupations of paid women workers, 1801, 1901,
1911, 1921 and 1961 ... 267
The Canadian population and labour force, 1881 to 1971 268
Women manual workers in munitions plants 276
Replacement of men by women in various occupations
during the war .. 277
Percentage distribution of working women by leading
occupational groups, Canada, 1901 to 1971 280
Women as percentage of all workers in major occupational
groups, Canada, 1901 to 1971 281
Nurseries in Toronto and number of child days serviced,
1892, 1893, 1902, 1909, 1912 and 1922 291
1927 Survey of the East End Day Nursery (marital status of
women served, and their reasons for using the nursery) 293
Marital status of women in the labour force, 1931 to 1971 294
Married female population by age group, 1891 to 1956 294
Enrolment of women at undergraduate and post-graduate
levels as a percentage of total enrolment, 1920-21 to 1967-68 295
Summary of trends in the percentage distribution of
working women for clerical and personal occupations,
1901, 1911, 1921, 1931 and 1961 297
Female labour force, 1911: distribution by occupation 298
Wage scale of garment workers in 1931 320
Number of workers in the garment industry in Ontario
between 1928 and 1933 (women's clothing factories
and men's clothing factories) 327
Salaries and wages paid out in the garment industry in
Ontario between 1928 and 1933 (women's clothing
factories and men's clothing factories) 328
Gross value of production in the garment industry in
Ontario between 1928 and 1933 (women's clothing
factories and men's clothing factories) 328
Capital investment in the garment industry in Ontario
between 1928 and 1933 (women's clothing
factories and men's clothing factories) 328
Average annual wages paid in the garment industry in
Canada between 1928 and 1933 (men's clothing
industry and women's clothing industry) 329

Introduction

The Women's Movement of the past ten years encouraged women to rediscover their history. This rediscovery has led to a spate of books published by and for women. Similarly, political agitation for suffrage in the first quarter of the twentieth century encouraged the publication of many studies for and about women. Activists concerned with women's rights inevitably faced, and still face, the historical questions raised by political agitation. For example, we must ask how the position of women has changed in North America with industrialization. Have women achieved greater participation in the public sphere and how has this affected their role in the home?

The earlier period of women's activism, like the World War II era, witnessed a noticeable influx of women into the work force. The higher visibility of women as workers and political beings created an interest in their working conditions both past and present. In Great Britain, Olive Schreiner, Alice Clark and Ivy Pinchbeck explored the lives of working women in the past. In the United States, Edith Abbott and Alice Henry concerned themselves with the lot of industrial workers and trade union women. Although Canada did not produce similar scholarly works, several interesting vocational manuals for women appeared which discussed employment opportunities.[1]

Recently, however, women's rekindled interest in their own history has linked up with an academic interest in a "new history," a social history which seeks both to extend the boundaries of the historical discipline and to redefine the way we look at history. Rather than concentrating on the traditional concerns of many

historians—the structure of politics and political parties—the social historian seeks to analyze the less well-known experiences of the working classes, ethnic groups and women. The social historian wants to study the popular base of politics and to trace its relationship to the structure of national political parties and movements. Furthermore, these historians are eager to investigate the conditions of everyday life in the past—the structure of the household, family relationships, sexuality, work and leisure. To do this it is not enough to approach the old sources with traditional questions and attitudes. The social historian must ask new questions of old materials and explore previously unused sources.

Disciplines outside of history can be used to ask these questions. Social psychology, anthropology, sociology and geography provide possibilities of new approaches. Geography and climate, for example, suggest to the historian the rationale behind land use and inheritance patterns which are reflected in family structure. Cultural anthropology delineates for the social historian a process of adaptation which explains the survival of pre-industrial work patterns like "Blue Monday" among cigar-makers or the survival of Africanisms among Southern blacks in the U.S.[2]* Social historians of women's work may also find these disciplines useful in discussing women's perceptions of themselves as workers. Sociologists' and psychologists' study of social roles, for example, may aid our understanding of the difficulties of organizing women into trade unions.[3]

Social history assumes an underlying emphasis on economics as well. Even non-Marxist social historians recognize the importance of economic factors on the course of history. Some Marxist historians, unfortunately, have transformed economic considerations into a vulgar economic determinism which postulates a rigid dominance/dependence relationship between economic and social factors.[4] Other Marxist social historians are attempting to look at historical problems in terms of the dynamic interplay of forces. For example, their recognition of the importance of class is combined with the realization that "class defines not a group of people in isolation but a system of relationships both vertical and horizontal."[5]

*Blue Monday or Saint's Monday was for many artisans a traditional day of recovery from the rigors of the week-end.

The new social history is particularly relevant to the study of women's work, the focus of this book. It provides an entry into the lives of women who left few records of the type traditionally studied by historians. In addition, it allows us to bring to life the stark statistical studies of women's economic role. This collection of essays deals with various forms of women's work in the period from 1850 to the Depression, when industrialization took place in Canada. The decision to study this important period of Canadian history does not signify disinterest in women's unpaid household labour. Lack of time, space and womanpower, rather than lack of interest, has limited our scope to women's work outside the home in this period. Working within a Marxist framework, the authors have attempted to demonstrate the interrelations between economic and social factors in the secondary position of the woman worker.

The Context

This collection of essays should be considered in the context of previous historical writing on women and women's work. Until recently, women's history has consisted largely of the biographies, correspondence and memoirs of well-known literary and political women, discussions of the suffrage movement and some histories of various philanthropic and reform movements. This middle- and upper-class bias reflects the nature of the sources as well as the nature of historiography. These women possessed educational advantages, however faulty, that gave them the ability to record their thoughts for posterity. This is not to deny, however, the valuable role played by such studies and sources. These works can and must be used by the social historian who is aware of the biases in the material.

In the area of working-class women's history there are far fewer sources for the historian. Some attention has been given to trade union activities and biographies of union leaders and radicals, for just as middle-class women's organizations provide clues to the conditions of the working woman, so can more traditional kinds of labour history.[6] More biographies and union histories would be useful for a study of women's work in Canada. However, in Canada even these studies have been unusual.[7] Certainly there is nothing on the level of Edith Abbott's *Women in Industry*, a detailed study of the cotton, clothing, boot and shoe, cigarmaking

and printing industries in the United States. Studies in other areas of endeavor should also be encouraged. If, as social historians, we wish to understand the entire working-class milieu—the family, cultural patterns, leisure activities, political affiliations and general world-view—we will have to go deeper into and beyond the conventional sources.

In writing this kind of history the historian has to consider carefully what sources are available and useful for the subject at hand. Part of the historian's task consists of drawing attention to relevant material, and especially to archivists and librarians. In this book, the reader will find a summary of the problems encountered in research and an extensive bibliography.

What this book is about

Each essay in this collection explores relatively new ground in the social history of Canadian working women. Certain themes and problems occur again and again as the authors grapple with their respective subjects. The authors focus on the single, waged woman worker, and much of their analysis centers on the exploitation of these women in the context of a rapidly industrializing society. As Leo Johnson notes in his economic overview of the early period of industrialization, the most important change was the creation of a large proletarian class.

This concept of proletarianization lies at the base of the theme of the woman as exploited worker. Some types of employment were, however, less affected by proletarianization than others. Prostitution, for example, existed in pre-industrial societies, as did domestic service, but the nature of the prostitute's work changed less than that of the domestic servant. By treating prostitution as a form of women's work engendered by inadequate wages for women and by society's need to preserve the nuclear family, the author has removed the prostitute from the category of the social deviant. The nature of domestic service changed more noticeably with industrialization and technological innovation. The servant's role was undermined by the development of labour-saving devices. In addition, while formerly she participated in the life of the household, she now found herself in the position of a hired hand. Working for scanty wages and room and board, the servant rapidly deserted the ranks of service for factory jobs at the end of the nineteenth century.

With the onset of industrialization, a set of new women's

"professions" emerged to fill the needs of an expanding economy. A surplus female population eagerly explored the potential of these new areas of employment. Working-class women were recruited into teaching and nursing at the end of the nineteenth century, hoping to find upward mobility in a genteel occupation. These tasks, formerly performed in the home, were transformed into "professions" which extended the domestic sphere into the public domain. Teachers and nurses, however, waged a long battle to achieve professional recognition and status, and in the process failed to discern their position as exploited workers.

Part of the exploitation of women workers stemmed from their position as a reserve labour pool. This point is emphasized in the essay on the garment workers in which the author demonstrates the expendability of women during the Depression. Similarly, during the First World War, attitudes towards women's employment changed in response to the needs of capital. However, as the author points out, the war represented an acceleration of a trend begun in the first fifteen years of the twentieth century with the rapid development of industrialization and technological innovation. As business and government bureaucracy expanded, women's work became increasingly clerical in nature.

A related theme explored by these essays consists of the attempts of women to organize at the workplace. The garment workers' unsuccessful strike of 1931, the strike at Canadian Cottons in 1929 and the strike of Bell Telephone workers in 1907 lead the authors to ask why a unified, sustained leadership failed to appear among women workers under oppressive conditions. This query draws the reader to consider a third theme running through these essays.

Oppressive conditions alone do not produce the consciousness necessary to effect change. Although women workers experienced oppressive working conditions, the pervasive influence of the domestic role prevented women from identifying themselves as working women. The expectation of marriage and motherhood delimited the female sphere and mitigated against sustained struggle. This third theme, the powerful influence of the domestic role ideology, often appears as an explanatory device in this collection. One of the essays in this collection challenges us to rethink the problem. "Besieged Innocence..." suggests that working women viewed themselves in different terms than did the middle-class reformers. Working women aspired to independence and in the

various labour struggles researched by the authors, did not accept the limited domestic role envisioned for them by middle-class reformers and philanthropists. If this contention is true, then one must ask, what *was* the working woman's view of herself and her domestic role? Furthermore, one must ask how feminist consciousness, that is, realization of the strictures of the female sex role, interacts with class consciousness?

Suggestions for further research

In his conclusion, Leo Johnson notes that his essay deals with the productive aspect of women's work. Using the categories suggested by Juliet Mitchell in *Women's Estate*, he comments that reproduction, sexuality and socialization have yet to be considered. Most of the essays in this collection also deal with the question of working conditions and to a lesser extent with the self-conceptions of working women. Many other areas of study remain for the historian of women's work.

Historically, much of women's lives have been spent in the home. Consequently, questions of domestic economy, technology and childraising practices are of particular interest to the historian of women's work. This activity, however, has not always been regarded as productive work. Furthermore, the private domestic sphere has been treated in isolation from the work world of those primarily single women who engaged in wage labour. The separation of home and work life reflects the process of industrialization in which the economic independence of the married woman was greatly reduced. In pre-industrial societies women had always worked in some fashion and their labour was crucial. With industrialization the wage earning female labour force remained primarily single until well into the twentieth century.

For the historian interested in the daily life of the unpaid household worker, the workingman's wife, the task will not be easy. Since she rarely appears in the statistics and reports of any organization, the historian has to rely on domestic manuals, the woman's page of the daily newspaper, the advertisements in magazines and newspapers, medical manuals and cookbooks in any attempt to reconstruct her pattern of life. Attention must be given to changes in household technology, architecture and housing patterns. Careful use of novels written by middle-class women on domestic life may also provide some clues. However, the historian cannot assume that the life of the unpaid household

worker reflects the life of the family as a whole. It has been suggested by an historian of the British nineteenth century labouring poor that the standard of living of the wife was considerably below the rest of the family.[8] This point would bear further study in the North American context.

Because of the important influence assigned to woman's domestic role, the social historian of woman's work has to consider more precisely how role expectations affect the woman as worker and even her choice of work. For the single woman the expectation of eventual marriage influenced the type of employment chosen. The belief that women worked for "pin money" or for fulfillment in pseudo-maternal roles led to a justification of the lower wages and limited employment opportunities to which women themselves have often been resigned. The perceived incompatibility between family life and work can be seen in the development of the women's professions in the late nineteenth century. The nurse, the teacher, the social worker and the librarian were approved social roles for predominantly single women who wanted to or had to work. Significantly, these professions provided the single female with a means of participating in an institutionalized maternal role removed from the family circle. At the same time these professions provided social mobility for working-class women.

The prevailing biological view of women also contributed to the argument against women's employment. This area is only beginning to be explored by social historians of science. Medical manuals and journals of the late nineteenth century reveal scientific support for the theory that women needed to conserve their energies for the vital tasks of reproduction. Sir William Osler, a noted Canadian physician, discussed the wide-spread phenomenon of hysteria and related this malady to heredity and education:

> At school between the ages of twelve and fifteen the most important period in her life, when the vital energies are absorbed in the rapid development of the body, she is often cramming for examinations and cooped in close school rooms for six or eight hours daily. The result too frequently is an active, bright mind in an enfeebled body, ill adapted to subserve the functions for which it was framed, easily disordered, and prone to react abnormally to the ordinary stimuli of life... [9]

A British textbook on women's diseases published in 1890 noted that amenorrhea (failure to menstruate) occurred very commonly

among shop girls and domestic servants who spent too much time indoors.[10] Women who worked or studied during the years of sexual maturation supposedly risked upsetting the reproductive function.

Thus biology lent support to sexual stereotypes. Women who worked as domestics, factory workers and nurses were often accused of immoral behaviour, thought to be the result of their working conditions and environment causing a disordered biology. In order to raise the status of their work, the new professional women attempted to disassociate themselves from the sexual stereotype of the working-class woman. In order to transform nursing from a low status occupation to a respectable one, pioneers like Florence Nightingale sought to deny the sexual identity of her nurses. She chose her trainees on the basis of moral character and instructed them that "their mission was to prove that the woman can be sunk in the nurse."[11] Yet, Nightingale envisioned herself as a spiritual mother to the British troops. A similar phenomenon arose in the development of the American social work profession under Jane Addams.[12] These active professional women created an asexual maternal role for themselves which allowed them to operate in a male world without challenging sexual stereotypes.

A further area of interest to the social historian of women's work is the question of women's culture. Were there Canadian counterparts to the *Lowell Offering*, the newspaper of the New England factory operatives? Did working-class women form self-help societies and benefit clubs? The new professional woman perhaps had more opportunity for social and cultural pursuits. What role did these women play in their churches or reform societies? How did the unpaid household worker spend her leisure time? What neighbouring patterns evolved in working-class neighbourhoods? These are only a few of the questions that could be asked.

In general we need to move beyond the documentation of oppression and focus on the response to that oppression. The historian cannot assume that prescriptive norms were translated into actual behaviour. By treating women as passive victims we presuppose that role prescription works. Rather than assuming this, we ought to examine the relationship between what is prescribed and what is actually done. This inevitably leads us back to the relationship between males and females. Much of the prescrib-

ing is done by men. We need to know, therefore, how women perceived these prescriptive norms and how they affected the female self image. Furthermore, we must ask what relationship exists between these prescriptive norms and the social order.

We have begun to reassess the historical role of women workers and in the process we have realized how much more must be known. The areas of family structure, socialization patterns, sex role norms, sexuality, and female culture remain barely explored by historians of women's work. The task that lies ahead encompasses a re-evaluation not only of our own history but of the history of the relations between the sexes.

We hope this collection of essays and the questions they pose will encourage others to pursue similar studies. In attempting such projects the would-be historian is faced with a dearth of secondary materials. The importance of primary empirical research at this early stage cannot be overstressed. For too long we have relied on generalizations about women which have been based on inadequate knowledge. Careful research into national, local and provincial archives has yet to be done across Canada on the subject of women's work.

We have learned from working on these essays the importance of utilizing local materials. The regional identities within Canada make national statements difficult to support. It is our hope that more bibliographies and local studies will emerge in different parts of the country.[13]

Footnotes

1. Edith Abbott, *Women and Industry*.
 Alice Clark, *Working Life of Women in the Seventeenth Century*.
 Alice Henry, *The Trade Union Woman*.
 Ellen Knox, *The Girl of the New Day*.
 Marjory MacMurchy, *The Canadian Girl at Work*.
 Ivy Pinchbeck, *Women Workers and the Industrial Revolution, 1750-1850*.
 Olive Schreiner, *Women and Labour*.
2. Herbert G. Gutman, "Work, Culture and Society in Industrializing America, 1815-1919," *American Historical Review*, v. 78, no. 3 (June 1973) pp. 558-559.
 Sidney Mintz, "Towards an Afro-American History," in Herbert G. Gutman and G.S. Kealey, *Many Pasts*, v. 1, Englewood Cliffs, 1973, pp. 115-130.
3. See Jill K. Conway, "Women Reformers and American Culture, 1870-1930," *Journal of Social History*, v. 5, no. 2 (Winter 1971-1972), pp. 164-176 for an application of sociological role theory to middle-class women.
4. Eric J. Hobsbawm, "Karl Marx's Contribution to Historiography," in Robin Blackburn, *Ideology in Social Science*, London, 1972, pp. 270-271.
5. Eric J. Hobsbawm, "From Social History to the History of Society," *Daedalus*, v. 100, no. 1 (Winter 1971) p. 37.
6. For a critique of trade union and labour history see Gutman, "Work, Culture and Society..."
7. See Catherine Vance, *Not by Gods but by People... The Story of Bella Hall Gauld*, for the story of a labour organizer.
8. Laura Oren, "The Welfare of Women in Labouring Families: England, 1860-1950," *Feminist Studies*, v. 1, no. 3-4 (Winter-Spring 1973).
9. William Osler, *The Principles and Practice of Medicine*, New York, 1893, p. 967.
10. Arthur H.N. Lewers, *A Practical Textbook of the Diseases of Women*, London, 1890, p. 47.
11. Cecil Woodham-Smith, *Florence Nightingale, 1820-1910*, p. 348.
12. Conway, "Women Reformers...."
13. Several bibliographies have appeared recently that will be useful to the social historian of women. See Veronica Strong-Boag. "Cousin

Cinderella" in Marylee Stephenson, *Women in Canada*. See also Russell G. Hann et. al., *Primary Sources in Canadian Working-Class History, 1860-1930*.

The woman not only lost her status as leader of the production team but was required to an ever greater degree to serve her children's material needs as well as those of her husband.

The Political Economy of Ontario Women in the Nineteenth Century

In this brief outline of the political economy of Ontario women in the nineteenth century, I will try, in a general way, to describe the major structural changes in Ontario's economy and society which affected the economic position and role of women. No attempt will be made to deal with cultural or social aspects of female society *per se*. The picture I will present is both complex and controversial: complex because of the colonial origins and rapid changes in Ontario society; and controversial because so little has been done to develop a full understanding of Canadian society during the nineteenth century. The ideas presented here were developed over the last decade as I struggled to understand the local history of Home District, as well as the development, on a national basis, of class and incomes. The ideas and arguments set forth, therefore, are still very much in a state of development.[1]

Before examining in detail the class structure of female society in Ontario, several large background generalizations must be made to clarify what follows. First, there were important changes in Canada's position as a colony during this period. During the nineteenth century, Canada moved from a position of colonialism, to semi-colonialism, to neo-colonialism: that is, from virtually complete dominance by the British Government in all spheres, to "responsible government" (i.e. autonomy in local affairs), to the post-Confederation period of general British non-interference in governmental affairs but almost total dependence on England and the United States in economic matters. These colonial relationships, although changing, continued to create an anomalous situation in Canada. Whether the class structure was one in which the

ruling class was aristocratic and bureaucratic, as in the early period, or capitalist, as in the latter half of the century, in either case the ruling classes' base lay outside Canada and depended upon its foreign ties for its position and power.

Secondly, the forms and social relations of commodity production in Ontario in the nineteenth century went through three quite distinct phases. While there is considerable coincidence in time between these changes in relations of production and those of colonial relationships, they appear to be distinct and separate events. In Ontario, economic society began at the stage of "toiler" production where virtually every member of every family laboured from sun-up to sun-down. In this stage there was little specialization, individual productivity was low, and commodity exchange was carried on primarily through debt relationships. Out of this period developed a second in which the primary form of production was that of individual producers labouring in their own shops or on their own farms. Considerable amounts of capital equipment had been accumulated, specialization was the norm, and a full-fledged monetary exchange system prevailed. Finally, after 1895, industrial capitalist production replaced the independent craft producer, and by the end of the nineteenth century Ontario's economic society looked much like it does today.

Finally, female economic and social roles were subordinated to male economic relations. The world of production was both created by and dominated by men, and changes in female roles came about as the result of changes in male roles. The class positions of women were defined by those of their husbands or fathers, and what women did, economically or socially, was shaped by the needs of the defining male relation. Although women did occasionally cross class lines, their movement invariably came about either because their husbands or father had crossed those lines, or the woman had married into a different class from that of her father. Thus while class relations among men were structured economically, class relations among women were structured socially—that is, defined not by what women did economically, but where they were placed socially. In other words, male social relations were determined by their economic relations, while female economic relations were determined by their social relations.

In summary then, in each of the stages of development in Ontario in the nineteenth century, female economic society was

defined by, dependent upon, separate from, and complementary to male economic society. With these generalizations in mind, we can now turn to a more detailed examination of the political economy of Ontario women during the nineteenth century.

Toiler Society

The development of a toiler society in Ontario came about as the result of a series of misadventures in the British Empire. When Upper Canada was acquired as a by-product of the conquest of Quebec, Britain's first response was to ignore its potential as a colony. For example, in 1774 the area was designated as an Indian reserve and buffer zone between England's white colonies and her Indian allies, and it was not until the end of the American Revolution that this attitude changed.

Because England needed land to reward the Loyalists and to create military settlements against American expansion, the British government decided to open the new area. In its original plans, the intention was to create the same sort of huge estates that had been established in Nova Scotia and Prince Edward Island. This plan collapsed, however, because the Loyalists received far more land than they could use, and because military needs demanded the attraction of a large population as quickly as possible. As a result, vast amounts of cheap or free lands were made available. As it turned out, neither potential American frontier immigrants nor British immigrants of the servant or labouring class were willing to work on the estates when it was possible to acquire land and to work for themselves. Thus by 1820, the great majority of Upper Canadian society was composed of independent small landowners living in isolated settlements.

In this toiler society, the basic economic unit was the lower-class family engaged in autonomous production. Whether on the farm or in the workshop, every member of the family, from the small child to the elderly grandparent, laboured to contribute to the family's wealth. Although the family unit exchanged a certain amount of produce and labour for such necessary goods as ironware, tin ware, books, clothing and, perhaps, a few luxuries such as tea, tobacco, fine cloth or alcohol, for the most part the family produced what it needed to consume. Without specialization, craftsmanship in toiler society was primitive and productivity was low. In spite of these difficulties, because every member of the family worked, it was possible for capital in the form of cleared

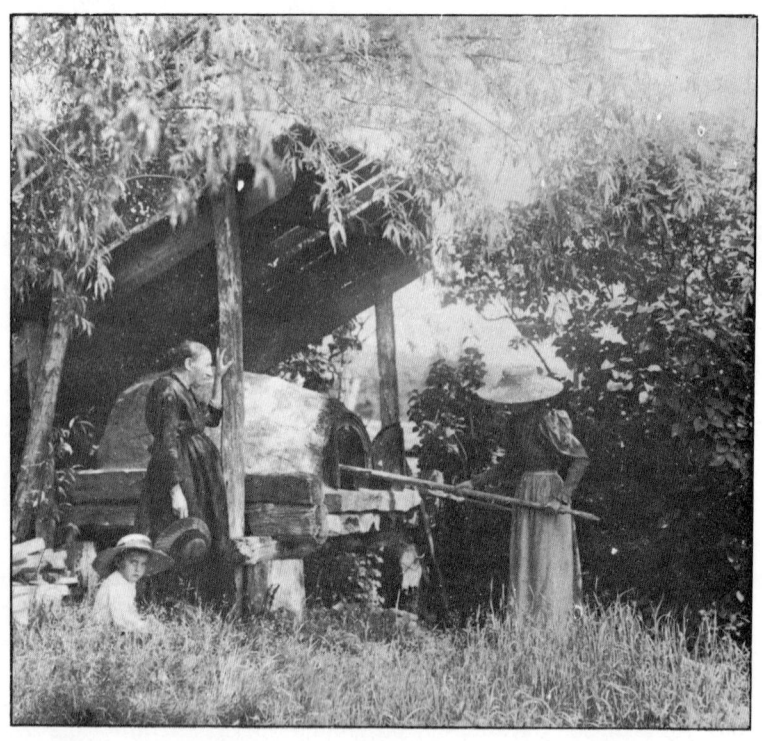

Bake Oven, Cap à l'Aigle, (P.Q.), c. 1900 (Public Archives of Canada)

land, buildings, tools and livestock to be accumulated at a fairly rapid rate.

Within the toiler economic unit, the role of the woman was crucial. Not only did she labour directly, but she produced the children whose labour was absolutely necessary to the success of the unit. Within the toiler society, there was a clear division of labour between the men, on the one hand, and the women and children on the other. While the men worked in the fields or woods, or sold their labour power off the farm, the women and children worked as a production unit in the area immediately surrounding the house, garden and outbuildings. There they looked after the livestock, tended the garden, picked and preserved fruit and vegetables, spun yarn, wove cloth, made clothing, prepared meals and did the thousand-and-one tasks which existed around the home. Although the wife-mother was clearly the leader of the mother-

child work unit, there was little, except in skill level, to distinguish the mother's tasks from those of the children of either sex. Of course, once a male child reached sufficient physical maturity to be useful as an aid to his father, he left his mother's production team and joined his father in the fields. Female children, on the other hand, remained in the home production unit until they married and left to found their own family work teams.

In the toiler society, therefore, the role of women was both integral to commodity production and central to economic organization. With so many tasks assigned to her and her mother-child production team, it is understandable that men without wives and families laboured under severe handicaps. Thus the death of the wife, when no adult unmarried female children were available to take her place, resulted not only in personal loss, but severe economic hardships as well. Men remarried quickly, not merely because of loneliness, but because of economic necessity. Similarly, adult females without husbands and families were persons without a clear-cut economic or social role. Although a few unmarried women did find employment as local teachers, the stereotyped figure of the "old maid" desperately searching for a man—any man—suggests the social pressures on these women to acquire the only acceptable status available to women in the toiler society: that of wife-mother-producer.

In contrast to the clearly defined economic role of women in the lower class, the role of women in the aristocratic and bureaucratic class—the ruling class before 1850—was more complex and subtle. The base of this elite lay not in Canada, but rather in England, where it owed its origins to hereditary ties in the British landed aristocracy. High positions in Canada, particularly in the early period, were acquired by appealing to kinship ties with well-placed relatives in England who could wield influence where it counted. Not the least of these kinship ties was that acquired when a man made a "good marriage" to the daughter of an important personage.

The origins of this system of kinship promotion, however, lay much deeper than family loyalty. The basis of the aristocracy's power lay in the possession of land, and the legal and social capacity to pass it on to future generations. Because the whole structure depended upon society's willingness to accept the legitimacy of the "rightful heir," the question of paternity was crucial. Thus while the aristocratic woman might serve her hus-

band in many ways, nothing was more important than her being a secure link between generations of inheriting males. In order to guarantee legitimacy of inheritance, absolute sexual purity was required from such women. Moreover, daughters of guaranteed purity were equally useful when alliances were being formed among members of the landowning class. Marriages were commonly arranged by parents according to their own interests, without regard for the wishes of the young daughter. Again, as with the toiler class, daughters who failed to attract eligible males quickly lost their economic and social value, and were regarded with ill-concealed contempt and hostility by both their family and society at large.

Once a female married a member of the aristocratic class, her duties were related to the social requirements of her husband: first, to produce an heir; and secondly, to enhance his social and economic position. As *chatelaine*, she was expected to oversee the economical management of household production, to manage and discipline servants, and, generally, to ensure that the household was kept in a state of readiness for her husband's social needs. As hostess she was required to be ornamental as well as charming: to attract the attention and interest of the men whom her husband wished to influence or befriend. Of course, she was required to accomplish this goal without calling into public question her state of guaranteed purity. Not surprisingly, more than one husband silently accepted the cuckold's horns in order to win some advantage; but to be found out in such a game meant social destruction, and in all probability, a duel to preserve the façade of family honour.

Finally, it was the aristocratic woman who performed the important function of managing the welfare system; that is, the private charitable and moral organizations. The maintenance of male dominance in the nineteenth century depended largely upon the perpetuation of social stereotypes among men and women. Thus men were characterized as (and boys were socialized to be) intellectual, aggressive, courageous, hardy, oriented toward physical activity, and competitive. Women were characterized as (and girls were socialized to be) emotional, passive, timid, tender, fearful of physical activity, and compliant. When a man fails, in a male-dominated competitive society, it is relatively easy to ignore the structural or class basis of his failure, and to explain it on the grounds that he was insufficiently endowed with one of the "mas-

culine" attributes. But when such a failure has dependent children and a wife, the injustice of their suffering is much more difficult to rationalize. Such cases of social ineptitude and failure were handled in nineteenth century Ontario by voluntary charitable organizations, generally managed by the wives of upper-class men.

But *why* was charity placed in the hands of these women? First, it seems likely that charity was viewed as a sign of emotionality or weakness, that is, it was based upon feminine attributes. Secondly, the basis of charitable acts in female institutions had a happy by-product. Investigation of injustices often leads to social criticism. But when such criticism is made by "emotional" females, it is easily dismissed by "rational" males. Thus, charity was used to smooth over some of the harshest results of exploitation, and by placing charity in the hands of women, man could avoid the serious questions raised by its necessity.

The social reactions of the aristocracy were the norms for the bureaucracy as well. As long as the gift of lands, offices and promotion lay in aristocratic hands, bureaucrats and officials were forced to accept their values and to ape their manners. As a result, although the bureaucracy had little material basis in landed estates or inherited offices which would require females to be sexually pure, the bureaucrats' economic dependency upon the aristocracy required them to accept the same norms of social behavior.

Integrally related to the aristocratic and bureaucratic class was the servant class. Necessary but despised, not slave but required to be always subservient, the house servants of the nineteenth century found themselves in an unenviable position. Moreover, even among servants a sex-based hierarchy existed. The male butler was the chief servant who oversaw the work of all other servants, down to that of the youngest upstairs maid. Children of the servant class became servants at an early age, and could expect to remain servants for life, rising if they were successful, to such skilled occupations as butler, cook or housekeeper. Pay, however, was extremely low, the work demanding (indeed, perfection was not too little to ask) and the hours encompassed every waking moment.

For the female servant, life was particularly difficult. Although male members of the servant class might find alternate employment as soldiers or labourers, female servants did not have similar options. If they were thrown out of work they were faced with finding another servant position or ending up on the street as a

beggar, thief or prostitute. Moreover, if nineteenth century literature is to be believed, female servants, particularly the young, vulnerable maids, were commonly forced to become the sexual plaything of the members of their employers' families. Of course, if these liaisons were discovered or the girl was made pregnant, she could expect to be fired on the spot, without recommendations, to sink to the gutter.

In Canada, the position of the female servant offered one avenue of escape not available to her British counterpart. Women were scarce on the frontier and toiler farmers were greatly in need of wives. In spite of the physical hardship imposed upon farm women in toiler society, it is clear that many women took the avenue of marriage to toiler farmers in order to escape from the servant class.

Members of the aristocratic class complained constantly about the scarcity and lack of humility among the servant class. One such complainant, a British upper-class immigrant named Susanna Moodie, put her finger on the cause:

> The unnatural restraint which society imposes upon these people at home forces them to treat their more fortunate brethren with a servile deference which is repugnant to their feelings, and is thrust upon them by the dependent circumstances in which they are placed. This homage to rank and education is not sincere. Hatred and envy lie rankling at their heart, although hidden by outward obsequiousness. Necessity compels their obedience; they fawn and cringe, and flatter the wealth on which they depend for bread. But let them once emigrate, the clog which fettered them is suddenly removed; they are free; and the dearest privilege of this freedom is to wreck upon their superiors the long-locked-up hatred of their hearts...[2]

Much of Canadian immigration policy in the nineteenth century was aimed at bringing in and maintaining a supply of servants for the upper class.

Between the aristocratic and toiler classes in Canada developed a growing stratum of merchants, mill owners, money lenders, and small capitalists of all sorts. Although few and weak at the beginning of the century, their wealth, numbers and power increased steadily as time went on. Theirs was an uneasy and precarious life. Not only were they dependent upon their economic ties with the British capitalists for their capital, but, in Canada, because the aristocracy controlled most local sources of wealth, they were also dependent upon the aristocrats' good will

and assistance. Although profits could be made, markets were insecure, capital was scarce, and transportation was difficult. Little wonder, therefore, that members of the Canadian bourgeoisie were among the leaders who demanded greater internal democracy for the colonies.

Because of the capitalists' diversity of activity and disparity in wealth, the role of its female members varied greatly according to circumstances. In general, it can be said that because that class was dependent upon the aristocracy, its social behaviour necessarily complied with aristocratic standards. Thus while the wives of capitalists were never accepted as equals by their aristocratic counterparts, nevertheless, there was little to distinguish the roles and activities of the wealthier bourgeois women from those of the aristocracy. In particular, the problems related to the transmission of wealth and property from one generation to another necessitated similar moral rules and attitudes concerning sexual behavior. Among the poorer capitalists' wives, on the other hand, the need for the women's labour and that of their children meant that there was little to distinguish their lives from those of toiler women.

There was, however, one important point of social difference between the capitalist, the aristocracy, and the toiler farmers. Because the essential economic base of each class differed, the training of the children from each class for their future roles necessarily differed as well. Thus, education became the focus of early class conflict in Ontario. The issues centred upon who was to control education, what was to be taught, who was to be taught, and who would pay for the teaching. Once the rhetoric of religion was stripped away, three essentially different class positions appeared. Among the toilers, education beyond the rudiments of reading, writing and arithmetic was considered not only wasteful of the children's time (and labour power) but carried the danger of creating "high fallutin'" ideas and discontent. Their method was to teach their children the necessary skills through actual labour on the loom or plow. In contrast, the aristocracy trained its children in both the cultural artifacts and moral attitudes which represented its claim to political leadership. Thus school subjects such as Greek and Latin, and the tenets of British aristocratic Anglicanism were carefully and thoroughly implanted. If manners did not make the man, at least they distinguished the ruling class from its inferiors. To this end, female children of the aristocracy were generally taught in their own homes by tutors and governesses,

while male children were taught either in private schools or the government-financed district grammar schools.

The capitalist class, whether rich or poor, desired a particular kind of practical education for their children. To manage a business successfully, one required skills in grammar, composition, mathematics, principles of logic and a materialistic outlook on life. Moreover, as capitalist enterprises developed, there was a growing need to have the children of the lower classes, the future clerks and managers, trained in these skills as well. Thus the bourgeoisie led the campaign to create a public, compulsory, state-financed, non-sectarian educational system in Ontario. The debate about education, therefore, became a crucial political issue in the first half of the nineteenth century.

Because a major part of the economic and social lives of women of all classes was based upon the procreation, raising and enculturation of the children, it is not surprising that they were deeply affected by the education controversy. Educational programmes that attacked or challenged their traditional goals and methods of child-rearing threatened their very social existence, and, of course, drew counter-attacks on their part. It was around the "moral" issues of education that women first assumed a prominent political voice in Upper Canada. Similarly, it was around other "moral" issues, such as juvenile delinquency, prostitution and alcoholism—all cover-issues for areas of important class conflict—that women were called upon to take active public political roles.

Independent Commodity-Producer Society

The economic and social makeup of Ontario society in the 1850-1880 period differed from that of the earlier period in several important ways. First, the triumph of the British capitalist class over the aristocracy completely changed the nature of Britain's interest in its white colonies. Because of England's need for cheap food to feed its working class, England turned to commercial alliances with central European grain growing states, and interest in Canada as a secure source of grain waned. The Corn Laws and Navigation Acts, the granting of Responsible Government and the creation of reciprocity between Canada and the United States in 1854 signalled not only the fall of the Canadian aristocratic class from power, but the emergence of a Canadian capitalist class whose interests would henceforth shape the Canadian state.

Second, and equally as important as the triumph of the Canadian capitalist class, was the accumulation by the toiler farmers of extensive capital in the form of cleared lands, buildings, livestock and machinery. This accumulation (greatly accelerated by the rise of grain prices during the Crimean and American Civil Wars) brought about fundamental changes in toiler agricultural society. As machinery and capital equipment replaced hand labour, and as transportation improved, the farmers became much more deeply involved in production for the capitalist exchange system. Fewer goods, but in larger volume, were produced on the farm, and more necessities were purchased for cash. Thus the capitalist aspect of agricultural production began to dominate the formerly survival-oriented toiler society.

Third, in the 1820s, the British government decided, as a matter of policy, to force the creation of a proletarian working class in Canada. To do so, in 1826 it ended its policy of free land grants to working-class immigrants while still encouraging their migration to Canada. Such a policy pleased the Canadian capitalists as well. They were well aware that as long as lower-class immigrants could get cheap land they would refuse to work for starvation wages. As William Allan, the Canadian banker and Legislative Councillor pointed out in 1845:

> The greatest drawback to the employment of Capital in this country...consists in the *high price of wages,* and the *extreme difficulty of procuring the labour* requisite for its profitable employment in *any* pursuit... Everything, therefore, which tends to lessen the *quantity of labour in the Market*, will tend also to *exclude capital from it*.[3]

By 1850, therefore, a growing scarcity of cheap land and a flood of immigrant Irish paupers created significant pools of proletarian labourers in cities such as Quebec, Montreal, Kingston, Toronto and Hamilton.

With the changing nature of the various classes in mid-century Ontario society, the role of women was altered as well. Most deeply affected were the lives of agricultural women. Two developments were primarily responsible for these changes: increased agricultural specialization due to the development of the cash economy, increased use of farm machinery, and the triumph of the capitalists' school programme which, through compulsory education, removed the children from the home production team. In the new cash economy more and more of the products con-

sumed in the home were purchased while fewer were manufactured. Thus, while the making of clothing and preparation and preserving of food remained as farm household tasks, the care of livestock (now a specialized field in itself), gardening and even such traditional female tasks as carding, spinning and weaving were gradually abandoned. With the removal of the children from the home during the school day, more and more of the wife-mother's time was consumed by the routine tasks of household maintenance. Thus the farm woman not only lost her status as leader of the production team, but was required in an ever-greater degree to serve her children's material needs as well as those of her husband. Rather than occupying an economic role which was clearly parallel to that of her husband, the farm woman's labour was reduced to activities more akin to those of a servant in a wealthier household. With little of lasting value to show for her work, her subservient status was greatly reinforced.

Moreover, with farm children required to attend school for much of the year, their economic value was greatly reduced. By the latter quarter of the century children were no longer regarded as producers of wealth, but as consumers. Thus the farm woman's reproductive function became similar to that of women in the other propertied classes. It was the necessity of social continuity rather than direct economic production that made her reproductive capacity a socially valuable asset.

Yet, if the farm wives had seen their individual economic status narrowed and weakened, the accumulation of capital on the farm and the creation of an urban working class raised the relative economic status of the entire agricultural class. Now, rather than resting at the bottom of productive society, they found developing below them a restless, hungry, dangerous class, to whom property rights were neither sacred nor beneficial. The agricultural class, therefore, found itself in a difficult position. Although it found that the greed and exploitiveness of the capitalist class was opposed to its interests, the tendency of leaders of working-class movements to demand the end of the system of private property rendered them even more dangerous than the capitalists. Thus when working-class women objected to their oppression and exploitation and began to organize, farm women were divided from them by their objective class interests.

In spite of the political triumph of the capitalist class in Canada, there were few fundamental changes in the roles and

duties of bourgeois women. As wealth and property accumulated in the hands of their husbands, greater emphasis came to be placed upon the necessity of its safe transmission to the inheriting male. Thus, as time passed, the lives of bourgeois women in their sexual and procreative roles became more like those of their aristocratic predecessors. The question of female purity, therefore, remained a central social issue. Similarly, the duties of ruling class women to organize charity and to lead the battles for social "morality" were assumed by the wives of the capitalist class. In contrast to the wives of the aristocracy, however, the wives of the capitalist class faced an ever more complex world. Higher levels of education and a greater degree of worldly knowledge were required for them to play their roles effectively. Moreover, the first rumblings of discontent among women against their social subordination were being heard. In general, upper-class women responded to these situations not by making greater demands for themselves, but by pushing for better education and greater equality of opportunity for their daughters. Thus it was that Egerton Ryerson ran into overwhelming opposition by the capitalist class in 1866 and 1867 when he attempted to prevent female students from attending the grammar schools.

Besides these developments in the agricultural and capitalist classes, the most important change in the mid-century period was the creation of a large class of proletarian labourers. Until about 1850, most commodity production outside agriculture had taken place in small workshops owned by independent, highly skilled master craftsmen. In a structure which had changed little since medieval times, the master hired skilled journeymen who, in turn, attached to themselves apprentices who were learning the trade. Journeymen were well paid (often on a piece work basis) and were the elite of the working class. The workshop conducted in this manner tended to linger on in Canada long after it had been wiped out in England and the United States, primarily because bad roads and expensive transportation protected it against mass-produced goods created under the labour relations of industrial capitalism.

As Canada's population grew and internal communication improved, the market available to the manufacturer expanded. By 1870 many larger establishments had appeared, a few employing as many as five hundred men. In spite of this growth, the essential productive process tended to remain in the hands of the highly skilled journeymen ("mechanics" as they were called) while the

unskilled manual labourers were employed as helpers to the journeyman-apprentice production teams, as warehousemen, or as a source of brute muscle power in menial jobs. Thus, although the small, local workshop was replaced, it was replaced by the manufactory, based on crafts production, rather than the factory, where the crafts worker was replaced by the proletarian labourer.

The division of roles within the working class was reflected not only in the arrangement of production, but in their social lives as well. The skilled "mechanics" generally received high wages and frequently owned their own homes. "Labourers" were poorly paid and usually dwelt in tenements or rented squalid cottages on or close to the manufactory grounds. Moreover, there was a good deal of rivalry and antagonism between the two groups of workmen. Capitalists constantly tried to reduce the cost of production by using semi-skilled labourers in the place of the mechanics, while skilled crafts workers organized into unions in order to defend their status and standard of living against such encroachments. Many of the early strikes were direct outgrowths of this problem.

The lives of the wives of workers reflected the same division. Because the skilled mechanics struggled constantly to retain their "respectable" position in society, and to justify their high standard of living, much of their wives' activities were aimed at ensuring that respectability. If his employer's wife, with her servants, maintained her home in spotless order, then it was necessary for the mechanic's wife to achieve similar conditions by herself. If the rich man's wife dressed herself and her children in style, then the crafts worker's wife sewed, washed and repaired in order to achieve an approximation of the same style. It mattered little that the aping of the life style of the bourgeoisie required that the mechanic's wife must constantly clean, cook, sew and maintain a rigid frugality in all things in order to maintain the family's "decent" condition. Dependency requires conformity, and the vulnerability of the position of the crafts worker meant that anything that tended to maintain his distinction from the labouring class had to be enhanced at all costs.

Although constant pressure was placed upon the wives of the poorly paid labourers to maintain the same "decent" and "respectable" life style as that of their richer contemporaries, the low wages earned by their husbands made it generally impossible to do so. Because working-class women had no more than rudimentary knowledge of birth control (and were under constant social pres-

sure to refrain from its use), labouring class families quickly grew beyond any possibility of parental support. Although the wives of urban labourers often worked as washerwomen, chars, piece workers in the sweating system (that is, goods being sent by a manufacturer to the worker's home to be done on her own time) or in other forms of menial day labour, it was never enough. Childbearing, disease, inadequate diet, backbreaking toil and unsanitary conditions quickly reduced their productivity. It is little wonder then that their children were often inadequately cared for and took to the street to work in the "street trades"—to beg or to engage in petty crime or vice. Naturally the breakdown in respectability was treated by their betters as evidence that the failure of labourers' wives to achieve a higher standard of living was due to their personal inadequacy.

In the case of both the mechanics' and the labourers' wives, their economic role was crucial to the men's ability to fulfill the demands of their employers. Men were required to work from sixty to seventy-two hours per week, and without wives to cook, sew, clean, bake and preserve, such a massive utilization of the males' energy would have been impossible. In other words, when an employer hired a man, in effect he hired two people: the man to work on the job and the man's wife to keep the workman, physically and mentally, in working order. Although single men could "make do" by living in a boarding house, they were generally less desirable as employees.

Finally, in an era when there was no medicare, workman's compensation or old age pensions, children were the only form of security available against illness, injury and old age. Parents raised children expecting to be supported by them at a later date. Without a wife and a family, a working man could look forward to poverty and loneliness in his old age. Thus, although the economic burden of a wife and family might to modern eyes appear to be an irrational acquisition for a poor labourer, it still represented to him his only hope of eventual security. The working-class woman faced a similar situation. Since so few careers were available to them, they experienced a lack of security similar to that of working-class men. Thus marriage was as necessary for women as it was for men.

Industrial Capitalist Society

In the last quarter of the nineteenth century the major changes affecting the Canadian economy were the growing economic influence of the United States, and the replacement of the manufactory by the factory system of industrial capitalism. (It was the latter change that fundamentally altered the political economy of women.) John A. Macdonald's national policy had the result of creating a protected market and attracting a large amount of foreign capital to Canada. Because the Canadian market was protected from foreign competition, it became large enough to absorb the necessary volume of goods to allow the efficient application of mass production techniques. Almost overnight an industrial revolution occurred in Canada.

The key technological innovation of industrial capitalism lay in its organization of labour: particularly in the replacement of high-cost skilled labour by low-paid unskilled labour, and the replacement of muscle power by machine power. In this process complex skills were broken down into simple repetitive tasks that could be done by the cheapest available workers. For lower-class women this transformation created two new opportunities. First, an economic career other than that of wife-mother or servant became available. Second, for the first time women (and children) became direct economic competitors (and, potentially the economic equals) of men. Up until this transformation the rationalists who had rejected the biblical basis for the social inferiority of women, had explained her subordination on the grounds of her physical weakness and childbearing role. Now it appeared that the Industrial Revolution contained within it the solution to these physical limitations. There were, however, powerful forces working in opposition to such a "liberation."

The group of male workers most directly attacked by the introduction of mass production techniques were the highly skilled crafts workers. Using the factory system, industrialists seized upon every poorly paid, disadvantaged group as a source of cheap labour. Thus Blacks, Chinese, Irish and immigrants of all sorts, women and children were all drawn into the attack upon the mechanics' standard of living and status. To their co-workers, the crafts workers raised the rallying cry of economic self-interest. To the other sectors of society their appeals were based upon religious bigotry (against the Irish and French Canadians), racism (against the Blacks and Chinese), humanitarianism (against the children)

and sexism (against women). Against the latter two groups, at least, the tactics enjoyed considerable success.

The initial reaction of the male workers to the employment of women and children had been to oppose equal wages for them. They argued that women were not by nature equal, nor did they have equal economic responsibilities. To pay women at the same rate as men, they believed, was both unjust and demeaning to working men. Naturally a number of leading women took up the fight for equal pay, and a good deal of intra-sexual warfare took place around the equal pay issue. Finally, cooler heads among the crafts workers began to prevail. Rather than opposing equal wages for women, they believed that men should make equal wages for women a key demand. Women and children, they argued, were naturally inferior workers, and to enforce lower wages for them simply had the effect of making their labour competitive to that of men. If employers were required to pay equal wages for women and children, and to provide even higher standards of factory conditions for them than for men, the results would ultimately exclude women from the labour market.

The appeal to the other classes against the employment of women was made on quite a different basis. With the emphasis throughout society on the necessity of female purity, the purity issue offered a ready-made rationalization. Female workers were pictured as being both physically weaker and morally more corruptible than their male counterparts. In particular the "mixing of the sexes" in the workplace was cited as a source of moral and spiritual breakdown among female workers. Because men in both the capitalist and agricultural classes had reason to resist the rise to equality by women, males of the working class found ready collaborators among them. The solution discovered by the capitalist employers was ingenious to say the least. Although the appeals against the employment of women failed, the separation of sexes was achieved. Within the factory and office an apartheid system was developed in which certain tasks were designated as "women's work," and paid for with low wages. As a result, both male goals were achieved. For the capitalists, women still provided a source of cheap industrial labour, while for working-class men, there was a reduction of direct job competition from cheap female labour.

In spite of their failure to win job and pay equality, henceforth women in ever increasing numbers would look for employment in

the capitalist sector. For those women who needed jobs to support themselves or their dependents, the autonomy provided by the wage system seemed to offer better conditions than the oppression and subservience of the servant's life. Moreover, industrial employers were much less likely to be concerned about "moral character" than their previous domestic employers. On the other hand, the lack of security experienced by the female wage workers provided (just as it did for males) a powerful incentive to marry and to raise large families. Thus while industrial capitalism offered a measure of choice and social freedom to working-class women's lives, it ended neither their exploitation nor their oppression.

For upper-class women, employment as wage labour did not offer an attractive alternative to upper-class social oppression by their husbands. For them, education would provide the needed escape route. Playing upon the puritanical attitudes of the times, these women were able to occupy and dominate those professions that dealt intimately with women and children. Again, such segregation meant that these occupations (such as nursing and teaching) became stereotyped as "women's work" and were lower paid than those which were occupied by their professional male counterparts.

Conclusion

In general, then, the political economy of Ontario women underwent radical changes within a relatively short time. But the changes described here are only part of the story. Because I have concentrated upon the structural changes, I have said little or nothing about other important topics.

Finally, it must be remembered that during these great economic transformations, women were not merely the passive objects of social change. Within the structural limitations of the economy and society, they struggled to create for themselves, and for those they loved, rich, meaningful and happy lives. Not infrequently, these struggles caused them to meet head-on the strongest and most entrenched biases and oppressions. Although their progress was slow and difficult, by the end of the nineteenth century, women had begun to win the first battles for recognition and to lay the groundwork for future advances. The economic structural changes described in this article, therefore, do no more than describe the arenas in which their battles were waged.

Footnotes

1. Should the reader be interested in examining the origins of what is presented here, these can be found in my *History of the County of Ontario*, Whitby, 1973; and "The Development of Class in Canada in the Twentieth Century", *Capitalism and the National Question*, edited by Gary Teeple, Toronto, 1972.
2. Susanna Moodie, *Roughing it in the Bush*, 6 rev. ed. (Toronto, 1913), p. 245.
3. Statement by W. Allan and R.A. Tucker, Upper Canada, "State Papers", vol. 24.

The Wayward Worker: Toronto's Prostitute at the Turn of the Century

Introduction

Prostitution had long been recognized as a reality in Canadian cities, but the social purity crusade of the late nineteenth and early twentieth centuries was the first really concerted effort to expose the "social evil" to the Canadian public. At that time, prostitution was considered to be one of the most serious problems besetting urban life in Canada. In 1898 C.S. Clark, a Toronto newspaperman, commented on the dimensions of the problem in his city: "Houses of ill-fame in Toronto? Certainly not. The whole city is an immense house of ill-fame..."[1]

Moral reformers and clergymen called prostitution the "*social* evil" because they viewed it as a crime against *society*, a threat to the established social order. When they used this term, they did not mean to imply that prostitution was socially caused. On the contrary, most moral reformers assumed that the roots of "the oldest profession" lay in *individual* aberration; to them, the prostitute was a deviant who was guilty of transgressing the moral code of society. Very few Torontonians at the turn of the century understood how prostitution operated as a social institution in their city.

Most writers on the subject have been so appalled by the immorality of prostitution that they have never thought of viewing the prostitute as anything other than a "fallen woman." The heavy emphasis on the "sinful" nature of the prostitute's sexual activity has obscured her role as a worker. But the prostitute is indeed a worker, a service worker who provides her body for use in the sexual act in return for a fee from her clients.[2] In selling her labour

power in a capitalist society she is subject to considerable exploitation and alienation, as are other women workers.

Prostitution in Toronto: The Physical Setting

At the turn of the century prostitution was practiced in Toronto on both a full-time and part-time basis. Part-time or "occasional" prostitutes were not solely dependent on their earnings from the sale of their bodies; prostitution was a means of supplementing their income from other sources. Some of these prostitutes had regular, that is, "legitimate," employment as factory workers, domestic servants, chorus girls and needle-workers.[3] Often their clients were employed in the same factory or shop.

Full-time prostitutes tended to seek out more permanent bases of operation than did women who "plied the trade" on a part-time basis. As a result, many full-time prostitutes worked for madames in brothels or "houses of ill-fame," as they were euphemistically called. The Social Survey Commission, established in 1913 to investigate "the problem of the white slave traffic, existing vice and social disease in the City of Toronto," discovered a number of brothels catering to a select clientele willing to pay high prices for the services provided.[4] These brothels were patronized by wealthy men, young and old, from all over Canada. The proprietress was usually a middle-aged woman who had been a prostitute herself at one time. Miss Lucy Brooking, Superintendent of the Haven and Prison Gate Mission, claimed that Toronto also contained scores of "dives" and "dens," that is, lower-class brothels, characterized by dirt, drunkenness, and rowdiness.[5] Both the more select brothels and the lower-class bawdy houses were located in the downtown area of Toronto. Street names such as Front, Richmond, Albert and Seaton appear frequently in newspaper accounts of raids on brothels.

In Toronto, houses of assignation were almost as numerous as brothels. The keepers of such houses rented out rooms for the purposes of prostitution.[6] Although houses of assignation did not offer prostitutes a permanent residence, they did provide a convenient work-place for women who picked up clients on the streets or in other public places.

The legitimate business of massage parlours, hotels, restaurants and ice-cream parlours was sometimes used as a cover for prostitution. The Social Survey Commission discovered that almost every place advertised in the Toronto newspapers as a mas-

> ### Massage Parlour Operators
>
> *"When I went into the business, I certainly thought I could do a straight massage business...I am constantly having men asking for the most filthy treatment. I have even had young boys come to me, and knowing what they wanted, I have always refused them admittance. Fully three parts of the men coming do not expect massage, but something else."*
>
> * * * * * * * * * *
>
> *"I am desirous of doing a perfectly clean and proper business, but, owing to the numerous places doing any but a clean business, will have to admit that at times I have been forced to give treatments that were not proper in order to earn a living for myself and children..."*
>
> —*quoted in the* Report of the Social Survey Commission, *pp. 17-18.*

sage parlour was, in fact, a "house of ill-fame."[7] Most of the women who ran these massage parlours were totally ignorant of the techniques of scientific massage. When interviewed, they stated that their clients demanded not only massage, but also "improper" sexual treatment. The Commission also found that a number of well-known hotels and restaurants were being used as meeting-places by prostitutes and their clients. One of the more fashionable establishments visited by the Commission investigator had, besides the public restaurant on the ground floor, a private rendez-vous area on the second floor and bedrooms on the third floor to which the prostitutes took their men.[8]

Furnished boat-houses on the Toronto lakefront were also used as sites for the sale of the sexual act.[9] These boat-houses were located near York Street and were usually rented by well-paid clerks. In addition, men purportedly rented rooms over stores in various parts of Toronto to which they brought prostitutes. Often young women themselves rented such rooms. They installed a sewing machine to make people think they were seamstresses and then took their clients there in the evenings.

Prostitutes were most visible to the public when they were hustling in the streets. Street-walking was common among those women who operated outside of the brothel situation, i.e., in houses of assignation, hotels, boat-houses and private rooms. According to C.S. Clark, the higher-class street-walkers, who were well-dressed and who presented an air of respectability, were most often found promenading on Yonge Street and Queen Street West. The lower-class street-walkers, who had no pretensions about the purpose of their strolls, frequented Richmond Street West, King Street West, Simcoe Street and Front Street West.[10] The prostitutes interviewed by the Social Survey Commission stated that they picked up clients in all kinds of public places. Hustling was an accepted practice at many restaurants, dance halls, skating rinks, parks and theatres.[11] Public recreation centres were often poorly supervised and insufficiently lit. And the ferries travelling to and from the Island also served as a convenient rendez-vous for prostitutes and men seeking their services.

Profile of the Toronto Prostitute

While it is not possible to construct a complete profile of the Toronto prostitute of this period, some information is available which helps us to understand the background of women who "plied the trade." C.S. Clark tells us that the majority of prostitutes working in Toronto at the turn of the century were between fifteen and twenty-four years old.[12] The Ontario Sessional Papers indicate that most of the women in the Industrial Refuge, a work-home for the reformation of prostitutes, were between the ages of sixteen and twenty-five.[13] Youth was a highly marketable commodity for which men would pay well. The careers of most prostitutes were of fairly short duration due to the widespread incidence of venereal disease and the extensive use of alcohol and drugs. This helps to explain why the ranks of prostitutes comprised few middle-aged and older women.

There is some statistical information regarding the ethnicity of Toronto prostitutes. The following tables show the ethnic breakdown of Toronto's female population for the years 1891, 1901 and 1911, and of selected samples of Toronto prostitutes for approximately the same years (1891, 1899 and 1913).

It can be observed from the tables (for which only limited samples are available) that for all three time periods the percentage of Toronto prostitutes born in Canada was substantially smaller

Table 1

Comparison of Ethnic Breakdown of Female Population of Toronto
and Ethnic Breakdown of Various Samples of Prostitutes

(Female)	Year	Canadian Born No.	%	British No.	%	Foreign Born Other No.	%	Total No.	%
Population of Toronto	1891[a]	49,399	66%	—	—	—	—	25,103	34%
Inmates of Industrial Refuge	1891[b]	12	20	43	72	5	8	48	80
Population of Toronto	1901[c]	62,010	74	—	—	—	—	21,224	26
Inmates of Industrial Refuge	1899[d]	15	31	31	65	2	4	33	69
Population of Toronto	1911[e]	108,783	66	41,881	26	13,358	8	55,239	34
Inmates of 3 Institutes for Delinquent Women in Toronto*	1911[f]	—	43	—	51	—	6	—	57

Sources:
a. Census of Canada, 1891, vol. 1, p. 174 and vol. 2, p. 232.
b. Annual Report on the Houses of Refuge and Orphan and Magdalen Asylums, 1891, Ontario Legislative Assembly, Sessional Papers, vol. 24, pt. 1, p. 95.
c. Census of Canada, 1901, vol. 1, pt. 14, pp. 468-9.
d. Annual Report Upon the Hospitals and Refuges of Ontario, 1899, Ontario Legislative Assembly, Sessional Papers, vol. 32, pt. 9, p. 180.
e. Census of Canada, 1911, vol. 2, pp. 402-4.
f. Report of the Social Survey Commission, p. 42.

Note: 1911 is the first Canadian census year which distinguishes between female Torontonians born in the British Isles and British possessions, and those born elsewhere outside of Canada. Prior to 1911, these two categories were combined under the headings "foreign born" or "immigrant."
*Sample size not indicated.

than the percentage of female Torontonians born here. Foreign-born women were greatly over-represented in the ranks of Toronto prostitutes. The statistics in Table 3 indicate that in 1911-1913 the percentage of British-born women in this sample of Toronto prostitutes was much higher than the percentage of British-born women in the female population of the city as a whole. It is interesting to note that only British-born women, and not other female immigrants, were strikingly over-represented among these Toronto prostitutes. This may also have been the case in earlier years, but the limitations of the existing data make it impossible to prove such a hypothesis.

Why were immigrant women such likely candidates for prostitution? The explanation for this is not entirely clear. Girls and women from the Old Country may have been less well equipped to support themselves financially than were Canadian-born women. Their material and psychological vulnerability, in combination with their unfamiliarity with the city of Toronto, made these young women particularly susceptible to overtures from madames and pimps. There is also evidence that the most common occupation followed by women before they became prostitutes was that of domestic service, and that a substantial proportion of Toronto's domestics were immigrants.[14]

There is very little data available concerning the class background of Toronto's prostitutes for the period from 1890 to 1914. C.S. Clark claimed that prostitution was most extensive among lower-class women, especially domestics and factory workers.[15] The Social Survey Commission gave the following breakdown of previous occupations in their sample of seventy-five prostitutes:[16]

Table 2

	Number	Percentage
Domestics	36	48
Factory workers	12	16
Employed in hotels or restaurants	8	11
At home	8	11
Office employees	4	5
Dressmakers, milliners or tailoresses	3	4
Sales girls	2	3
Actresses	2	3
Total	75	101

Almost half of these women (48 percent) stated that they had worked as domestic servants before their entry into prostitution. The Toronto pattern closely parallels that of New York City where an extensive study was carried out by Dr. William Sanger in 1858. He and his associates interviewed two thousand prostitutes of whom 46 percent listed their previous occupation as "domestic servant."[17] In responding to a question about her previous employment, the prostitute may have answered "domestic", when, in fact, she had previously been an unpaid worker in the home, that is, a housewife. There is no way of knowing how often the term "domestic" was used to denote the occupation of "housewife" in the interviews conducted by Dr. Sanger or the Social Survey Commission.

From Domestic Service to Prostitution

Why was there such a strong connection between domestic service and prostitution?[18] What factors encouraged domestics to take up work as prostitutes? Women working as domestics in Ontario during this period earned wages that were relatively high compared to those earned by other unskilled women workers.[19] Domestic service offered fairly steady employment as well as training and experience in housework and childcare. However, this occupation was poorly regarded by other working women. While the factory worker was forced to sell her labour power for a specified number of hours per week in order to survive, at least the remaining time was her own. The domestic, on the other hand, usually had to work very long hours with no fixed time off each week.[20] Forced to live under the same roof as her employer, she was constantly at his/her disposal. Because of this, she had very little privacy or opportunity to socialize. Thus domestic service was regarded by most working people as a degrading, and therefore, low prestige occupation.

Prostitution, by virtue of its illegality and sexual "immorality," was considered to be the least attractive type of work open to women. Since domestic service was closest to prostitution in the social scale of female occupations, it was likely that an unemployed domestic, unable to find a "situation," would move one notch down the scale by accepting work as a prostitute. Because the movement from domestic service to prostitution involved less downward mobility than a movement from factory or office work to prostitution, it occurred with greater frequency.

The nature of domestic work in private homes partially explains the entry of domestics into prostitution. When these women were fired or let go by their employer, they suffered greater insecurity than did factory or office workers in similar circumstances. They lost not only their means of earning a livelihood, but also their home and the roof over their heads. Because domestics lived at their place of employment, they were likely to have fewer social connections than other women workers. Thus the insecurity, isolation and loneliness which characterized domestic service made unemployed domestics particularly vulnerable to the recruitment efforts of madames and pimps.

Local News
Servant Girls Should Avoid It

When Mrs. Maria Clayton, who keeps a so-called registry office for servants at 32 and 34 Adelaide Street West, was charged before the County Judge yesterday with stealing a trunk from Ellen Donnelly, a woman well up in years, the plaintiff stated to the judge that she had lived with Clayton for a week, and that this "registry office for servants" was in fact a house of ill-fame. Mrs. Donnelly said she could prove this statement. A GLOBE reporter enquired of the police last night as to the place, and every constable spoken to agreed that if a respectable girl had the misfortune to go to this place to look for a situation, she would be told that there was no opening just then, but if she would stop with Mrs. Clayton for a few days a situation would no doubt be found. Before the poor girl had stopped out her few days she was generally allured from virtue by the hoodlums lurking about the premises. The place is becoming notorious, and the authorities should lose no time in suppressing it. It should be avoided by all respectable servant girls; nor should any respectable citizen be deluded in going to this place to look for a servant.

—*Toronto* Globe
June 8, 1883, pg. 6.

As mentioned earlier, many of the domestic servants working in Toronto at this time had emigrated from other countries. Some of these women (for example, those associated with private employment agencies like the Dr. Bernardo Homes) arrived in Toronto without family or close friends. They must have had even fewer social resources than other domestics to help them cope with the difficult situation created by unemployment. When an immigrant domestic lost her job, her emotional vulnerability must have increased the likelihood that she would enter prostitution.

Another explanation for the movement of domestics into prostitution was the fact that some domestics suffered sexual exploitation at the hands of their employer and/or his sons. C.S. Clark mentions several instances of this form of abuse.[21] Clark spoke with a number of adolescent boys who claimed to have had sexual relations with the domestic servants working in their homes. One boy stated that during the past five years he had slept with every domestic employed by his father. The domestic servant who lost her virginity, or worse, became pregnant, could no longer look forward to the possibility of marriage. If she bore an illegitimate child, she would lose her job and be ostracized by society at large. A woman in these circumstances would have had few qualms about selling her sexuality in order to earn a living. Thus, the low prestige rating of domestic service, the nature of the work itself, the fact that so many of the women employed in private homes were immigrants, and the possibility of sexual abuse, were all factors which encouraged unemployed domestics to work as prostitutes.

Reasons for "Plying the Trade": The Moral Reformers' Perspective

What motivated other women, that is, those who were not unemployed domestics, to earn their living through the sale of their bodies? There were many divergent opinions concerning the reasons for these women's entry into prostitution. Unfortunately, there are no accounts written by prostitutes themselves in which they discuss why they took up this kind of work. History has only left us writings which express the opinions of middle-class reformers and these must be interpreted with caution.

C.S. Clark argued that many of Toronto's prostitutes were motivated by "pure licentiousness".[22] Although not based on concrete evidence, Clark's contention was supported by William

Sanger's findings in New York City in 1858. Of Sanger's sample of two thousand women, 26 percent stated that they had entered prostitution because of "inclination" or a desire for sexual gratification."[23] But one must be wary of these findings. Sanger's interviewers may have posed their questions in such a way as to elicit reponses of this nature. And the same women who claimed to have been motivated by "inclination" also mentioned other motivating factors, for example, poverty, seduction and loss of virginity, and persuasion by friendly prostitutes. One would suspect that the middle-class reformers' emphasis on the "unnatural" sexual passions of prostitutes was more an indication of what these reformers themselves wanted to believe than a true reflection of reality.

It was generally acknowledged by public moralists and clergymen that women who had been deserted by their husbands often felt compelled to sell their sexuality to support themselves and their children. In some cases, when the "breadwinner" was incapacitated by illness or alcoholism, women turned to prostitution, with the tacit consent of their husbands. On rare occasions, a woman's husband was directly responsible for her entry into prostitution. Such was the extraordinary case of Max Berline, which was reported in the *Toronto News* on November 23, 1910. Berline married a seventeen year old girl and then turned her over to a brothel on their wedding night.[24]

The naivete and ignorance of young women newly arrived in Toronto were often blamed for the successful recruitment of such women as prostitutes. According to the National Council of Women, procurers, both male and female, frequently travelled to small towns in Ontario. Through misrepresentation and bribery, they managed to induce some unsophisticated girls to come with them to the city.[25] Procurers often made these girls a false offer of a well-paying job as a domestic servant in Toronto. Young women from rural districts were seen as particularly susceptible to procurers because of the "deadly dullness of village life."[26] In addition, misleading newspaper advertisements of employment opportunities and boarding-house accommodations sometimes led women who were unfamiliar with Toronto into brothels and prostitution.

Lucy Brooking told a rather sensational story about a young woman from rural Ontario who came to Toronto to study and found herself trapped in a brothel.[27] When this young woman

arrived in Toronto she took a room in an apparently respectable boarding-house. The first evening she was there, the landlady invited her to join the other "boarders" in the parlour. She excused herself, saying that she had unpacking to do. The next evening she was again pressured to socialize. Becoming somewhat suspicious, she retired to her room on the pretense that she had to study. Late that night the landlady entered the woman's room, explained that she was in a brothel, and told her that she was to begin work as a prostitute immediately. The young woman screamed for the police out of an open window and thus managed to leave the brothel.

Miss Brooking also described the plight of young immigrant women who arrived alone in Toronto and easily fell prey to procurers of the city's brothels. Often these women were met at the train station or down at the waterfront by someone "from home." This apparently friendly person would offer the woman assistance in finding a place to stay, while actually intending to lead her to a brothel. In the words of Miss Brooking,

> we frequently see girls who, in the old country have lived virtuous and respected lives, often bringing over with them the best of references, coming out here and falling during the first few months.[28]

It is difficult to determine how frequently incidents such as those described by Miss Brooking actually occurred in Toronto during this period. There is no record of the number of young women who were led into prostitution without their knowledge or consent. To Miss Brooking, as to many other middle-class reformers, the prostitute appeared to be a victim of deception and of her own ignorance. She was then an appropriate object for the reformer's educational and redemptive efforts. Miss Brooking did not view the prostitute as a worker who might be forced to sell her body in times of extreme financial need. In addition, Miss Brooking's urban bias may have caused her to exaggerate the gullibility of young women from the country.

Clergymen and women's organizations continually emphasized naïveté and ignorance as the root causes of prostitution. Reverend J.G. Shearer, Secretary of the Moral and Social Reform Council of Canada, thought that young women should be warned of the dangers to which they might be exposed, so that they would not be lured so easily into brothels disguised as respectable boarding houses.[29] The Toronto Council of Women argued that ignorance, especially with regard to sex, was a major factor responsible

White Slave Traffic in Toronto

A young lady employed at the glove counter in one of the large department stores in this city was recently requested by a male customer to consent to take a drive with him after store hours. He told her that he would present excellent references as to his good character. The young lady indignantly refused, saying that she would have nothing to do with a stranger. She then walked away to the other end of the counter. A woman, dressed in deep mourning who observed the incident congratulated her, saying that she had had two daughters, but they had passed on to the better world, but, who, if they had lived, she could have wished no more for them, than to have them thus resent the approaches of strange men. She told the girl where she resided, and invited her to call upon her. She also remarked that she had two tickets for a Massey Hall entertainment for that evening and invited the girl to attend. The invitation was gladly accepted.

On the way to the Hall, the "widow" produced a box of dainty chocolates, offering the girl some. The young girl ate several of them.

At the door of Massey Hall, a Methodist deaconness accosted the girl and warned her that she was in company with one of the worst women of the city. The "widow" soon lost herself in the crowd, and within a few minutes time, the candies which had contained "the knock-out drops" accomplished their work, rendering the girl unconscious.

Had she been in the care of the woman in black she would have been hustled into a closed cab, and within a very short time would have been another recruit to the already large army of white slaves.

—quoted by Rev. R.B. St. Clair in "Recent Canadian Happenings" in Fighting the Traffic in Young Girls, edited by Ernest A. Bell

for leading young women into prostitution. The Council felt it was important to give talks on this subject to groups of mothers, women in factories during the lunch break, women's clubs and church groups.[30] It also wanted to distribute moral reform literature to women in shops, factories, offices and homes. Other suggestions included the inspection and licensing of all boarding-houses and the establishment of Travellers' Aid Societies. These Societies were to be responsible for meeting single women at the train station and the wharf.

Although helpful in some respects, these recommendation reveal a narrow understanding of the problem posed by madames' and pimps' recruitment of young women. Initially, naïveté and ignorance may well have led some young women into Toronto's brothels. However, it was more likely the societal attitude towards prostitutes which kept these women there. During this period, most Torontonians believed that an unmarried woman who had lost her virginity (or, in the vernacular of the day, who had "fallen") was unredeemable. When it was publicly known (usually through pregnancy) that an unmarried woman was no longer "virtuous", she was ostracized from so-called normal society, and had great difficulty in finding either regular employment or a husband. It is no wonder that women in this situation became prostitutes.

At the annual conference of the National Council of Women in 1912 and 1913, several other factors were suggested to explain why women entered prostitution. Poor relations between girls and their parents sometimes forced them to leave home at a very young age when they had little education and few skills to offer. These young women might have viewed prostitution as their only means of survival.[31] Feeble-minded women and defectives, so it was argued, often chose to enter prostitution because it was the easiest way for them to earn a living.[32] There was some confusion as to the causal relationship between feeble-mindedness and prostitution. Sometimes middle-class reformers argued that feeble-minded women were very likely candidates for prostitution. At other times they argued that women who worked as prostitutes were likely to become feeble-minded. At the turn of the century many people felt that excessive sexual activity consumed vital energy that could be more productively utilized in other ways. It thus was assumed that the prostitute would become mentally debilitated because she had sex so frequently, and because of the alcohol, drugs and disease which so often accompanied her work.

The Economic Roots of Prostitution

> *What is really the cause of the trade in women? ...Exploitation, of course: the merciless Moloch of capitalism that fattens on underpaid labor, thus driving thousands of women and girls into prostitution. With Mrs. Warren these girls feel, "Why waste your life working for a few shillings a week in a scullery, eighteen hours a day?"*
>
> —*Emma Goldman*
> Traffic in Women, 1917

The marginal postition occupied by the majority of women in Ontario's labour force at the turn of the century is a crucial factor in explaining why some women worked as prostitutes. Because of this economic reality, the labour power required to maintain prostitution as a social institution was always available. However, few Torontonians attributed the entry of women into prostitution to economic causes. There was a general reluctance to admit that poverty, that is, economic need, was the prime motivating force for women who became prostitutes. But there were a few exceptions to this myopic perspective. At the National Conference of Women in 1912, two delegates, Mrs. Dennison and Mrs. Leathes, argued that those working women and girls who were unskilled and underpaid were most likely to take up prostitution, on either a full-time or part-time basis.[33] They called for technical training for women through the establishment of trade schools and emphasized the necessity of providing equal educational and employment opportunities for men and women.

The Social Survey Commission also argued that poverty, although not the sole cause of prostitution in Toronto, was an important contributing factor. The Commission thought that overcrowded housing conditions in the poorer districts of the city tended to lead to sexual immorality.[34] Numerous cases of overcrowding were documented by the City's Medical Officer of Health, Dr. Hastings and by social workers who testified before the Commission. In some working-class homes, lack of space meant that brothers and sisters well past the age of puberty were forced to sleep together in the same room. In other homes, adoles-

cent girls had to share sleeping quarters with their parents. According to the Commission Report, such housing conditions deprived young people "of that sense of modesty which is one of the most valuable barriers girls possess in safeguarding them against temptations that they are exposed to, especially when they are forced to earn their own livelihood."[35]

But the Social Survey Commission realized that poverty was linked to prostitution in a more direct manner than that described above. Of the thirty-seven prostitutes interviewed by the Commission regarding their reasons for entering the "profession", nineteen stated that they could not live on the wages they were earning.[36] Of these nineteen, four were full-time prostitutes and fifteen were part-time prostitutes currently working at other jobs. At this time, wages for women were set on the assumption that the woman was living at home, either with her parents or her husband. The woman was not usually considered the chief bread-winner in these households; her earnings were seen as a secondary source of family income. Thus, single women living on their own in boarding-houses found it difficult to survive on the low wages they received and, consequently, sometimes turned to prostitution. The Commission recommended the passage of a minimum wage law to help reduce the economic pressure which evidently drove some women into brothels or streetwalking.[37]

> *Hundreds of women and girls are engaged in Cleveland making shirts at three cents apiece, and are able to make a dozen per day, making their daily pittance 36 cents...In Toronto and other Canadian cities there are many girls employed at about the same rates, their wages ranging from $2 per week and up, and the shirts they make are sold at from 60 to 75 cents each. Does any man suppose that girls can live respectably upon such wages? Those living with their parents may do so, but it is a lamentable fact that many of these, and more who board, increase their income in ways far from honorable, and in a manner which can only result in degrading our own and future generations.*
>
> —The Labor Reformer *December 1, 1886*

It seems, then, that the major attraction of prostitution for women workers was the income it provided in times of financial need. The prostitute's income varied somewhat according to the income of her clients and/or to the kind of brothel, house of assignation, or hotel in which she worked. The fees she charged were primarily determined by the market forces operating in Toronto at the time, that is, by the law of supply and demand, and by the general state of the city's economy. During boom periods men had more money to spend and could afford to pay the prostitute more. During periods of economic recession, the prostitute's earnings must have dropped considerably.

Unfortunately, it is impossible to find any information regarding the fees which prostitutes charged for the service they performed. Nowhere in the moralistic literature, police reports, or newspaper stories of the period, is the income of the prostitute ever mentioned. Court records of women convicted as prostitutes might have indicated how much these women earned. But since prostitutes were only convicted of summary offences, their court files were destroyed several years after conviction.

Thus it cannot be proven that women decided to work as prostitutes because the earnings of the "profession" were lucrative. However, there is proof that the average woman worker in Ontario during the period from 1890 to 1914 was just barely making ends meet; for her, prostitution offered the means of economic survival. The Annual Report of the Ontario Bureau of Industries for the year 1889 gives the following wage and cost-of-living figures for female workers:

Table 3

Female Workers Over Sixteen Years of Age Without Dependents[38]
Average number of hours/week worked54.03
Average number of days/year worked259.33
Average wages/year from occupation$216.71
Extra earnings aside from regular occupation
Total earnings/year$216.71
Cost of clothing$67.31
Cost of board and lodging$126.36
Total cost of living$214.28
Surplus ..$2.43

Table 4

Female Workers Over Sixteen Years of Age With Dependents[39]	
Average number of dependents	2.10
Average number of hours/week worked	58.52
Average number of days/year worked	265.43
Average wages/year from occupation	$246.37
Extra earnings aside from regular occupation	$23.05
Earnings of dependents	$16.48
Total earnings/year	$285.90
Total cost of living	$300.13
Deficit	$14.23

From these statistics it is clear that, in the late nineteenth century, women workers in Ontario, with or without dependents, were hard-pressed to make do with their meagre earnings.

By the second decade of the twentieth century the situation of women workers had not substantially changed. In the *Labour Gazette* of June, 1913, Professor C.M. Derick of McGill University stated that the average wage of female factory workers in Canada was $261/year or $5/week.[40] The living wage at that time was considered to be $390/year or $7.50/week.[41] In Ontario, professional and skilled women workers, such as nurses and stenographers, earned relatively good wages, averaging about $20/week.[42] But the majority of female workers at that time were engaged in non-professional, unskilled work (see Footnote 18, Table B). Women working in factories in Ontario made an average of $6 to $8/week,[43] more than the national average, but just enough to survive if they worked steadily. However, their work was subject to seasonal fluctuations and they were frequently laid off. Their wages were not high enough to tide them over a lay-off period of several weeks.[44] Waitresses in Toronto earned only $5/week in 1913-1914,[45] as did young girls employed in offices[46] and factories.[47] Thus at the outbreak of World War I, those women and girls in Ontario who worked at jobs requiring little skill or training received very low wages and were forced to live in poverty.

The evidence demonstrates clearly that during the period from 1890 to 1914 most women workers in Ontario occupied a

marginal position in the labour force. This economic marginality was crucial in determining some women's decision to take up work as prostitutes. Undoubtedly other women were tempted by the idea of earning a living wage without having to work nine or ten hours a day, five or six days a week in a noisy factory or office. The entry of such women into prostitution probably indicated a rejection of the working conditions offered by the legitimate work world.

Work and Consciousness: The Case of the Prostitute

Were the conditions under which the prostitute worked really much of an improvement over those of the factory and office worker? Did they encourage the development of a consciousness similar to that of other women workers? Unfortunately there are no accounts written by prostitutes themselves describing their day-to-day lives during this period. However, on the basis of the available empirical data and knowledge of the working conditions and consciousness of today's urban prostitute, one can speculate about the working life of the Toronto prostitute at the turn of the century.

The nature of the prostitute's work situation was determined by a number of factors. These included how much work time she devoted to prostitution (that is, whether she worked on a full-time or part-time basis), where she worked (inside or outside of a brothel), and for whom she worked (for a madame, pimp or for herself). Those prostitutes who operated on a full-time basis probably had a regular, though unconventional, work-day. Most of their business was conducted during the late afternoon and well into the night. The part-time prostitute, who was otherwise employed, probably worked in the evenings and on weekends.

Many full-time prostitutes lived at their place of employment, the brothel. Although these women enjoyed the companionship of other prostitutes in an artificial home setting, they had little privacy or time to themselves. Prostitutes working in brothels were not personally responsible for the solicitation of clients; they relied on madames to provide them with a steady flow of customers. Some madames had agents in hotels and restaurants who furnished information to prospective clients. Others had special arrangements with taxi-drivers who agreed to take customers to and from the brothels.[48] The double fares charged for such trips and the payments received from madames (in the form of beer and/or money)

explain the willingness of cab drivers to participate in the social network which supported prostitution. In addition to supplying prostitutes with work contacts, madames provided room and board, occasional "cooperation" with the police, and an element of security in an otherwise tenuous existence. In return for these benefits, prostitutes were obligated to pay the madames a large percentage of their earnings.

The work situation of prostitutes who operated out of houses of assignation, hotels, boat-houses and rented rooms was more privatized than that of prostitutes working in brothels. It often involved the hustling of clients in streets and other public places, which, by its very nature, encouraged stiff competition among prostitutes.

Some prostitutes who "plied the trade" in rented rooms did so under the tutelage of a pimp. According to the Social Survey Commission, the pimp was often the prostitute's lover.[49] He procured business for his woman and acted as a scout when she was soliciting on the streets, warning her of the approach of the police. He looked after the prostitute's interests when she was arrested, and when she was convicted in court, he paid her fine. In short, he was her business manager. In return for the contacts and protection he provided, the pimp often demanded a large share of the prostitute's earnings.

Other prostitutes who offered their services outside of brothels were self-employed. Many of these women worked at prostitution on a part-time basis. Without the supervision of madames or pimps, they exercised greater control over their work situation. To some extent, they could determine their working hours, their clients, and the length of time spent with each client. Although self-employed, these prostitutes still relied on various sources, including hotel owners, keepers of houses of assignation, cab drivers and bar tenders, for their rooms and clients; despite the fees exacted by these middlemen, self-employed prostitutes were able to retain a sizeable proportion of the money they earned.

One of the main occupational hazards faced by all prostitutes during this period was the possibility of pregnancy. There is no readily available information regarding the frequency of pregnancy among prostitutes or the steps taken to deal with such pregnancies. Birth control techniques were in a relatively primitive stage of development at the turn of the century. Thus prostitutes must have encountered the problem of unwanted pregnan-

cies which would have temporaily incapacitated them in their work. In such cases, some prostitutes probably resorted to coathangers, saline solutions, etc. in an effort to terminate pregnancy, while others visited quack abortionists. Those who were unsuccessful in their attempts to abort and who gave birth to "illegitimate" children were probably forced to place them in foundling hospitals or to send them off to be cared for by members of their families.

Another hazard of the working life of many Toronto prostitutes involved the physical and mental effects produced by alcohol and drugs (primarily morphine and heroin).[50] Reliance on the bottle and/or the needle probably resulted from severe dissatisfaction on the part of women working as prostitutes. In combination with the high incidence of venereal disease, the heavy use of stimulants tended to make the prostitute's career a short-lived one. According to Reverend J.G. Shearer, Secretary of the Moral and Social Reform Council of Canada, five years was the average time in the trade before "vice, drugs and disease do their deadly work."[51] The National Council of Women agreed with Reverend Shearer on this point.[52] And Harry Woodson, an observer of the Toronto Police Court, also claimed that most women who worked as prostitutes became physically and mentally debilitated after a few years in the "profession". He described a madame and her half-dozen "ladies-in-waiting" in the following terms:

> Not yet has the social vice destroyed youth, but, like worms at the root of a flower, it is slowly, but surely, consuming strength and shortening life. A few more years shall roll, then the eye will lose its lustre, the heads their steadiness, the memory its strength, and spirit its buoyancy.[53]

Not only was the prostitute's career brief, but it was also characterized by downward movement on the social scale. According to the reporters of the *Toronto News*, the descent from a high-class brothel to a bawdy house was a rapid one. They observed of one young woman:

> She's on the hilltop of shame now, where the sun is shining, but God help her when she goes down, as surely she will, amongst the slime and dirt which she will find at the foot, and in nine cases out of ten, it does not take over three or four years to go from top to bottom.[54]

The moralism evident in these descriptions was typical of most of the writing on prostitution in Toronto during this period.

Prostitution, gambling, drunkenness, and the illegal sale of liquor were often associated in the minds of Toronto's moral reformers. Prostitution was "entrenched between the saloon on one side and the dance halls and the low theatre on the other."[55] Because prostitution was illegal, the woman who worked as a prostitute was viewed as a criminal. In the process of earning her living, she countered both the accepted norms and the laws of her society, and thus was forced into the lumpenproletarian milieu.[56] This milieu in which the prostitute operated was peopled by madames, pimps, gamblers, petty thieves, boot-leggers, and drunkards.

Living and working on the social fringes of society, the full-time prostitute developed a unique and ambivalent kind of consciousness. She was not clearly a member of the petty bourgeoisie or of the working-class. Like the doctor and lawyer, she offered a service to her clients on a contractual basis. Since she did not sell her labour power to an employer, she enjoyed greater autonomy than did the wage worker. Within the bounds set by the market, she was able to choose her clients and negotiate her fee. In a

manner similar to the doctor and lawyer, the prostitute faced competition from others who offered the same service she did. This made it difficult for her to develop a sense of solidarity with other prostitutes. Her work was characterized by a high degree of petty bourgeois individualism. This individualism was most pronounced in prostitutes working outside of the brothels.

Although the prostitute enjoyed some autonomy, she was restricted by the illegal nature of her work. Like the wage worker, for example, the factory or office worker, she relied on others to supply the conditions necessary for her labour. As has been described above, madames, pimps, cab drivers, hotel managers, and bar tenders provided her with a convenient work-place, access to the market (work contacts), and protection from the police. In return for helping the prostitute, these people demanded a share of the receipts from her work.

Full-time prostitutes involved in the collective work situation of the brothel might be expected to have formed workers' societies or unions, as factory and office workers sometimes did. However, there is no evidence that a collective consciousness of themselves as exploited workers ever emerged among prostitutes. The emotional dependence of full-time prostitutes on either madames or pimps obscured the exploitative nature of the relationship between supervisor and worker. Madames and pimps offered prostitutes a welcome source of stability by acting, in effect, as a sort of family substitute. Prostitutes' awareness of the very real limitations on their upward mobility reinforced this dependence on their supervisors. A few prostitutes, who were able to maintain their health over the years, might have managed to save enough money to open up a brothel themselves. A number of others might have become the mistresses of wealthy men who had formerly been their clients. But the proportion of prostitutes who actually moved up the social scale was very small.

Since madames and pimps provided tangible material benefits and emotional security, it is no wonder that prostitutes failed to recognize the ways in which these people exploited them. Prostitutes did not perceive their interests as being substantially different from those of their supervisors. During this period, prostitutes, madames, and pimps were all rejected and stigmatized by the vast majority of Torontonians. In the face of such hostility, all three groups developed a kind of bohemian solidarity in opposition to "legitimate" society.

But it was not only the contradictory strains of petty bourgeois individualism and bohemian solidarity which distinguished the prostitute from other female workers. Her work was unique in that it required the sale of her sexuality as a commodity on the market. While some might argue that the sale of one's time and energy in the factory or the private home is just as alienating as the sale of one's body on the street, it cannot be denied that for many workers (male and female), their sexuality is one of the more human, less commercialized and less alienating dimensions of their lives. At the turn of the century market relations had not heavily penetrated the sexual realm of most workers' lives. The prostitute's sexuality, however, was almost totally commercialized. She became alienated from her body in the performance of her labour; her body was an object to be bought, not an integral part of her person. More than any other worker, she was, and still is, forced to detach herself, her identity, from her body in order to feel human.

Society's Response to the Prostitute: Social Control and Reform

As a criminal and a deviant, the woman who worked as a prostitute in Toronto encountered institutions which sought to control and/or reform her. The illegal nature of her work brought her into frequent contact with the Toronto police. At the turn of the century, madames, prostitutes, and the men who used their services were all subject to legal penalties. They were prosecuted under By-Law No. 468, Section 4. Passed in October, 1868 by Toronto City Council, it read as follows:

> That any person or persons who shall be found guilty of keeping or maintaining, or be an inmate or habitual frequenter of, or in any way connected with, or in any way contribute to, the support of any disorderly house, or house of ill-fame, or such other place for the practice of prostitution, or otherwise, of any such house, shall be subject to the penalties of this By-Law.[57]

The penalty upon conviction was a fine (maximum of fifty dollars) or imprisonment (maximum of six months, with or without hard labour). Under the law regarding vagrancy every keeper or inmate of a house of ill-fame was also considered to be a vagrant. The penalty for conviction under this law was lighter than that under By-Law No. 468.

According to the Social Survey Commission, the Toronto Police Department did not deal as severely with prostitution as it did with other crimes. Two-thirds of the cases involving prostitution which the police handled between January 1, 1911 and June 30, 1914 were never brought to court.[58] Of those brought to court, almost one-half were discharged, withdrawn or remanded. The majority of keepers, inmates, and frequenters of houses of ill-fame who were sentenced were let off with a fine.[59] While 43 percent of the convicted keepers and 33 percent of the convicted inmates were sent to jail, only 22 percent of the convicted frequenters were imprisoned. This indicates that the frequenters, that is, the men, received the lightest sentences from the court. Prison sentences for all convicted offenders sent to jail averaged less than two months. Of those who were fined by the court, inmates and frequenters had to pay an average of $5 to $10, while keepers paid an average of $20 to $30. The Social Survey Commission argued that fines of this size were too small to act as a deterrent, since prostitutes and madames could easily afford to pay them out of the profits of their business.[60] The Commission further charged that such small fines were merely a means of licensing prostitution in Toronto.

The Annual Reports of the Staff Inspector's Department of the Toronto Police for the period from 1890 to 1914 indicate the ambivalent attitude of the police towards prostitution. Publicly the police claimed to follow a consistent policy of repression, which meant frequent raids on brothels and strict enforcement of the law against vagrants. The police argued that tough action on their part was effectively reducing the incidence of prostitution in Toronto. In 1904 Staff Inspector Archibald wrote as follows:

> The attitude of the Police...having been one of close supervision and repression for years, the result seems to be that women of the town are diminishing in number, and houses of prostitution becoming fewer.[61]

However, according to C.S. Clark, raids on brothels by the Toronto police had not substantially reduced the incidence of prostitution in the city. When police action became more repressive, men visited brothels less frequently because they feared arrest. As a result of this, some prostitutes found it necessary to shift operations from the brothel to a rented room or hotel.[62] Clark also argued that arrests did not deter Toronto's street-walkers; they simply made these prostitutes more cautious in plying their

trade.[63] In times of police repression, street-walkers probably relied more heavily on pimps, cab drivers and bar-tenders to supply them with clients. Thus the prostitute's choice of workplace as well as the means she used to obtain clients were often determined by the rigour with which the police enforced the laws against her. Police repression changed the manner of operation of prostitution in Toronto, but it probably did not force many women to leave the "profession" and take up other types of work.

The Toronto police themselves recognized that they could not effectively eliminate prostitution by following a policy of strict repression.

> While the police have nothing to do with the ethical phase of the "social evil" question, their duty merely being to apply the law as they find it, it should be borne in mind that a policy of repression in too severe a form may lower rather than improve the moral tone of the people, by causing women of the town to seek the shelter of private lodgings in respectable localities instead of confining themselves to places where their presence is not objected to.[64]

Many statements in the Staff Inspector's reports imply that, in reality, the police policy regarding prostitution in Toronto was one of toleration and regulation. What follows is just one example of such statements:

> That to a certain extent...loose women are to be found in secluded places, are facts that cannot be disputed, but these are evils which will always exist, and total suppression would be as impossible as it would be injudicious.[65]

The implication is that one cannot eradicate prostitution by punishing the individual prostitute, madame or "john" with fines or jail sentences. The Toronto police seemed to understand that prostitution performed a necessary social function in their society. Of course, the police reports did not deal with the nature and origins of this social function, nor did they discuss the reasons why certain women worked as prostitutes.

Those who operated prisons and work-homes for "fallen women" during this period displayed a narrower understanding of prostitution than did the Toronto police. There were three main institutions dealing with Toronto's prostitutes at this time: the Haven and Prison Gate Mission, the Good Shepherd Refuge, and the Toronto Industrial Refuge. The Haven and Prison Gate Mission cared for, and tried to rehabilitate, female alcoholics and women who had been in trouble with the law.[66] The Good

Shepherd Refuge was a Roman Catholic institution which worked with three types of women: prostitutes, destitute girls, and older women.[67] The inmates were employed in the laundry business by the Refuge; in this way they contributed to the upkeep of the institution.

The only institution which concerned itself exclusively with the reformation of Toronto's prostitutes was the Toronto Industrial Refuge. The purpose of the Refuge, as stated in the Annual Report for the year 1896, was as follows:

> ... to give women, who through infirmity of nature or evil environments have fallen into evil ways, a shelter where they will not be beset by temptations, and where they may be led to live honest, Christian lives.[68]

Unlike most Torontonians, the middle- and upper-class ladies who ran the Refuge believed that women who had worked as prostitutes could always climb back to a life of "decency and Christian morality."

The Industrial Refuge had accommodations for approximately fifty inmates at any one time. Prostitutes committed themselves

House of Refuge, Broadview Ave. (Metropolitan Toronto Central Library)

voluntarily to the Refuge, thereby supposedly demonstrating their "desire... to break away from their evil past associations."[69] The Refuge insisted that the women remain there for a period of at least twelve months. "That class of women needs restraint and a considerable period of probation, as a necessity as well as a test of their real desire to lead a virtuous life."[70] After a year the Refuge would help the ex-prostitute to find work as a domestic servant and would give her two new sets of clothing. If a woman left before her twelve-month term was up, she received no assistance in finding employment and no new clothing.

To the women who ran the Industrial Refuge, the prostitute was a sinner, guilty of sexual immorality. They could not conceive of her as a female worker. In contrast to other moral reformers who viewed sexual licentiousness, ignorance or feeble-mindedness as causes of prostitution, these ladies believed that a woman became a prostitute because of moral weakness in her character.[71] They claimed that this weakness stemmed from the lack of healthy moral influence during the early years of the woman's life. Thus the Refuge saw as its duty the reformation of the individual prostitute through the improvement of her moral character. One way of doing this was to expose the woman to the "healthful" influence of religion. The prostitutes at the Refuge were required to attend religious services every morning and evening on week-days as well as three times each Sunday.[72] The educative efforts of the reformers focused not only on Bible teaching, but also on job training for the ex-prostitute. Refuge inmates were taught how to do laundry work, knitting, and sewing. The purpose of such training was threefold: to improve the woman's moral character by providing useful work which would supposedly give her a sense of accomplishment; to enable her to contribute to her room and board; and to prepare her for her future employment as a domestic servant.

Why did the women on the Board of the Refuge encourage the inmates to enter domestic service when they left? In the first place, the only contact these middle- and upper-class reformers ever had with working-class women was likely to be through their own domestic servants and those of their friends and relatives. To these reformers, domestic service represented a way for ex-prostitutes to gain respectability. Since they often employed and trained domestic servants themselves, the women who ran the Industrial Refuge could relate to the teaching of laundry and sewing skills. The teaching of factory and office skills, on the other hand, would

> *Q. Do you believe that the underpayment of these women (shop-girls and girls who do sewing at home and get paid by the piece) draws them into prostitution?*
>
> *Mayor W.H. Howland of Toronto: I have only got to answer this—that a good woman will die first, but there are a great many unfortunate girls, who are young and careless and like pleasure and who have not had a good training, who are under the influence of temptation, with possibly starvation, in spite of the best work they can do. It is only too possible; I do not see how it can be avoided with the temptation it offers for an easy living....But it is rooted laziness which is the great difficulty with those who are really prostitutes. Their laziness becomes a matter of education and training; they have led a lazy life for such a time that they become unfitted for industry. Take a girl when she first begins and there may be some hope for her; she might overcome the tendency to laziness, but with those tendencies to laziness and idleness, of course, it is almost a certainty that she will drift into such courses.*
>
> —Royal Commission on the Relations of Labour and Capital, *1889*

have been far removed from the realm of their experience.

In addition, these reformers believed that a woman's place was in the home as housewife and mother. In their eyes, it was improper for a woman to work outside of the home in a factory, store or office. However, the option of being a housewife and mother was practically ruled out for the ex-prostitute. Few men in Toronto at that time would take a so-called fallen woman in marriage. The woman on the Board of Refuge felt that the next best thing to caring for one's own household and family was caring for someone else's, thus their emphasis on training the ex-prostitute for domestic service.

Obviously, these reformers were unaware of the movement of women workers from domestic service to prostitution. It probably never occured to them that some of the prostitutes whom they

were trying to reform had previously worked as domestics and had, perhaps, been sexually exploited in their capacity as household servants. Their failure to recognize the more basic economic causes of prostitution can be explained by the privileged position these women occupied in society. Since their husbands' incomes were large, and since they could usually afford to employ domestic servants, they did not have to work either outside or inside of their home. Because of their comfortable financial situation, they were completely removed from, and therefore unable to understand, the day-to-day life of Toronto's working women. They thus failed to see the importance of economic need as a factor which motivated some working women to enter prostitution. Despite the limitations of their analysis, these middle- and upper-class reformers must be given some credit. The Industrial Refuge did offer the prostitute an alternative to jail or the street, which was more than any government agency did at that time.

But in terms of its stated goal of reclaiming "fallen women," the Industrial Refuge was not particularly successful. Certainly some women who obtained positions as domestic servants after leaving the Refuge did not again engage in prostitution. However, those women who left voluntarily, that is, before their twelve-month term was up, usually went back to work as prostitutes. And according to the Annual Reports of the Industrial Refuge for the ten-year period from 1890 to 1900, in any one year 30 to 60 percent of the inmates left voluntarily.[73] These women seemed to have been unaffected by their contact with moral reformers.

Patriarchal Society: The Double Sexual Standard and Prostitution

In attempting to reform the individual prostitute, the women who ran the Industrial Refuge failed to come to grips with prostitution as a social institution in their city. They did not understand that social attitudes towards male and female sexuality were important in explaining the existence of the "social evil." However, many moral reformers and clergymen, including Reverend Father L. Minehan, the Pastor of St. Peter's Roman Catholic Church in Toronto, Reverend Shearer, Miss Brooking, and delegates to the National Council of Women, did recognize this fact. They frequently decried the double standard of sexual morality:

> One of our great weaknesses has been that we have construed the social evil as a female proposition; and our criminality has been the

persecution of the woman, while permitting the easy escape of the man... Both the men and women who "fall" should be condemned.[74]

Since sexual freedom for men was thought to be necessary in order to satisfy their greater sexual desires, looseness in men was regarded as something to be expected, if not praised. However, looseness in women brought with it social stigma and ostracism.[75] In the words of Mrs. Spofford of the National Council of Women:

> For one-half the race unchastity is virtue, while for the other half through whom this virtuous necessity is accomplished, it is impure, unclean, unchaste, the sin from which there is redemption neither in this life, not in that to come.[76]

Father Minehan stated that the double standard of sexual morality was inculcated in children by their mothers at a very early age.[77] Boys were permitted liberties which were indignantly denied to their sisters of the same age; they were allowed to stay out on the streets late at night and to indulge in "promiscuous" reading. Father Minehan demanded that a single standard of sexual morality be taught to all children. This was to be the task not only of parents, but also of clergymen, teachers, moral reformers and the press.

Thus during this period in Toronto there was some understanding of the relationship between society's double sexual standard and prostitution. As members of the middle- and upper-classes, Toronto's moral reformers and clergymen were unlikely to express a thorough-going critique of the society in which they lived. They did not realize that both the double standard and prostitution were mechanisms used by capitalism to maintain the patriarchal family.

In order to fully understand the role of the prostitute as a worker in Toronto, it would have been necessary for the reformers to analyze the social institution which was dependent on her labour power. In a patriarchal capitalist society, as was North America at that time, descent and inheritance of wealth were traced through the male line. For this reason, the paternity of the child had to be guaranteed.[78] This was done by insisting that women have sexual relations only with their husbands, that is, that they be monogamous.[79] There was no need, however, to interfere with the husbands' sexual freedom, as long as this freedom did not threaten the emotional stability of the patriarchal nuclear family.

Prostitution made it possible for the married man to enjoy his

sexual freedom on these terms. His sexual relationship with a prostitute was defined by himself, by the prostitute, and by society generally, as a strictly commercial transaction. The prostitute regarded her participation in the sex act as work for which she would be financially rewarded. This, and the fact that she was alienated from her body in the performance of her labour, made it highly unlikely that she would view her sexual partner in a subjective and personal way. Since the prostitute was condemned by, and ostracized from, the larger society, there was little danger that the married man would become emotionally involved with her. Thus, prostitution performed a necessary social function in this patriarchal capitalist society. It satisfied the male prerogative for extra-marital sex without threatening the nuclear family with extra-marital emotional attachments. In a similar manner, it satisfied the male prerogative for pre-marital sex without threatening the institution of marriage. Prostitution also safeguarded the virginity of the majority of society's single women. If single men could satisfy their sexual needs through association with prostitutes, then so-called respectable girls would be less likely to have sexual relations before marriage.

* * *

One can see why the Toronto police were justified in feeling that repressive action on their part would never effectively eradicate prostitution. The law which they were supposed to enforce punished the prostitute for doing work which was socially useful. But for most moral reformers at the turn of the century the social utility of this work was obscured by the woman's sexual "immorality." They did not realize that as long as wages and job opportunities continued to limit the ability of women to maintain themselves outside the institution of marriage, there would always be a ready supply of prostitutes. Nor did these concerned Torontonians understand the important relationship between prostitution and patriarchy within the framework of a capitalist society. They failed to see that where the double sexual standard and the patriarchal family prevail, prostitution will also thrive. Their moralistic analysis, which pointed to sexual licentiousness, naïveté, poor family relations, feeble-mindedness, and defects in moral character as the causes of prostitution, focused primarily on the deviant behaviour of *individual* women. Hampered by this individualist bias, the moral reformers could not possibly have attacked the broader social and economic roots of prostitution.

Footnotes

1. C.S. Clark, *Of Toronto the Good*, p. 106.
2. For the purpose of this article prostitution will be defined as the selling of one's body in the sexual act for commercial gain. Those cases in which sex is not explicitly exchanged as a commodity on the market will not be examined. Thus the question of sexual objectification in the work-place, for example, in the factory or the office, or in a marital relationship, falls outside the scope of this article.
3. *Report of the Social Survey Commission*, p. 12.
4. *Ibid.*, p. 4.
5. Lucy Brooking, "Conditions in Toronto," *Fighting the Traffic in Young Girls,* ed. Ernest A. Bell, p. 371.
6. *Social Survey Commission*, pp. 9-10.
7. *Ibid.*, p. 17.
8. *Ibid.*, p. 12.
9. Clark, *Toronto the Good*, pp. 93-5.
10. *Ibid.*, p. 134.
11. *Social Survey Commission*, p. 13.
12. Clark, *Toronto the Good*, pp. 134-5.
13. *Annual Reports on the Houses of Refuge and Orphan and Magdalen Asylums in Ontario*, Ontario Legislative Assembly, Sessional Papers, vol. 23 to vol. 32, 1890 to 1899. A study conducted in New York City in 1858 by Dr. William Sanger corroborates the findings of both Clark and the Ontario Sessional Papers. Of the two thousand prostitutes interviewed by Dr. Sanger and his associates, 75 percent stated that they were between sixteen and twenty-four years old. See William W. Sanger, *The History of Prostitution*, p. 452.
14. The census data in Table A (below) indicates that more than half of the female domestics in Toronto in 1911 were born outside of Canada.
15. Clark, *Toronto the Good*, p. 97.
16. *Social Survey Commission*, p. 37.
17. Sanger, *History of Prostitution*, p. 524.
18. This connection only requires explanation if domestics were, in fact, over-represented in the ranks of Toronto prostitutes. To establish if this was the case, it is necessary to determine what percentage of Toronto's female labour force as a whole was engaged in domestic service. Although no statistical breakdown of the occupations of

Toronto's working women exists for this period, such a breakdown is available for Ontario (see Table B below).

19. According to the *Report of the Ontario Commission on Unemployment* (p. 166), domestics working in Ontario in 1914 earned an average of $18 to $20 per month, over their room and board. The same report (p. 171) states that factory workers at this time earned an average of only $6 to $8 per week or $24 to $32 per month.
20. *Ontario Commission on Unemployment*, p. 168.
21. Clark, *Toronto the Good*, p. 104.
22. *Ibid.*, p. 89.
23. Sanger, *History of Prostitution*, p. 488.
24. Reverend R.B. St. Clair, "Recent Canadian Happenings;" *Fighting the Traffic in Young Girls*, p. 355.
25. "Report of the Committee on the White Slave Traffic," in *National Council of Women Yearbook*, 1907, p. 83.
26. "Report of the Standing Committee on Equal Moral Standard and Prevention of the Traffic in Women," in *National Council of Women Yearbook*, 1913, p. 125.
27. Brooking, "Conditions in Toronto," *Fighting the Traffic in Young Girls*, pp. 367-8.
28. *Ibid.*, p. 374.
29. Reverend J.G. Shearer, "The Canadian Crusade," *Fighting the Traffic in Young Girls*, p. 350.
30. *National Council of Women Yearbook*, 1913, p. 128.
31. *National Council of Women Yearbook*, 1912, p. 53 and *National Council of Women Yearbook*, 1913, p. 125.
32. *Ibid.*
33. *National Council of Women Yearbook*, 1912, p. 107.
34. *Social Survey Commission*, pp. 39-40.
35. *Ibid.*, p. 41.
36. *Ibid.*, p. 36.
37. *Ibid.*, p. 39.
38. *Annual Report of the Bureau of Industries for the Province of Ontario*, pt. 4, 1889, Ontario Legislative Assembly, Sessional Papers, vol. 22, pt. 7, p. 49.
39. *Ibid.*, p. 43.

40. Salaried women workers who comprised only a small proportion (less than 10 percent) of the female labour force in Canadian factories at that time earned an average of $447 per year. (*Labour Gazette*, vol. 13, no. 12, June 1913, p. 1373.)
41. *Ibid.*, p. 1377.
42. However, most trained nurses at that time were employed for an average of only eight months each year. Their yearly earnings averaged about $600. This was still high when compared to the yearly income of most female factory workers. (*Ontario Commission on Unemployment*, pp. 184 and 186.)
43. *Ibid.*, p. 171.
44. Dr. William Sanger commented on a similar situation in New York City in 1858: "A large number of females, many of them operatives...earn so small wages that a temporary cessation of their business...is sufficient to reduce them to absolutely distress." (Sanger, *History of Prostitution*, pp. 491-2.)
45. *Labour Gazette*, vol. 14, no. 12, June 1914, p. 4009.
46. *Ontario Commission on Unemployment*, p. 184.
47. *Labour Gazette*, vol. 13, no. 12, June, 1913, p. 1377.
48. *Social Survey Commission*, p. 9.
49. *Ibid.*, p. 13.
50. Harry M. Woodson, *The Whirlpool—Scenes from Toronto Police Court*, p. 205.
51. Shearer, "The Canadian Crusade," *Fighting the Traffic in Young Girls*, p. 335. Dr. William Sanger's study of prostitution in New York City in 1858 revealed that the average duration of the prostitute's career was only four years. (Sanger, *History of Prostitution*, p. 455.)
52. *National Council of Women Yearbook*, 1907, p. 84.
53. Woodson, *The Whirlpool*, p. 155.
54. *Toronto News*, p. 22.
55. *National Council of Women Yearbook*, 1907, p. 88.
56. The term "lumpenproletarian" is used to describe those modes of social behaviour which are rooted in illegitimate commerce and which lie outside the dominant industrial and agricultural mode of production. One cannot give a rigid definition of the lumpenproletariat because its composition varies according to the historical situation. The lumpenproletariat is a social category characterized by considerable mobility; people often move freely in and out of its ranks (as in the case of the part-time prostitute).

57. Today the situation is substantially different. It is only the prostitute who is viewed as a criminal, not those who use her services, nor those who supply the conditions necessary for her labour. (*By-Laws of the City of Toronto*, p. 106.)
58. *Report of the Social Survey Commission*, p. 27.
59. The Social Survey Commission lists the following convictions for the period January 1, 1912 to June 30, 1914 (p. 28):

Table C

Category	No. Convicted	No. Fined	% Fined	No. Imprisoned	% Imprisoned
Keeper	153	87	57%	66	43%
Inmate	104	70	67%	34	33%
Frequenter	89	69	78%	20	22%
	346	226	65%	120	35%

Of the thirty-four inmates of houses of ill-fame who were imprisoned after conviction, thirteen were sentenced to thirty days in jail, seven were sentenced to sixty days and fourteen were given more than sixty days.

60. *Social Survey Commission*, p. 29.
61. *Annual Report of the Toronto Police Department*, Appendix C, 1904, p. 9.
62. Clark, *Toronto the Good*, p. 92.
63. *Ibid.*, p. 132.
64. *Annual Report of the Toronto Police Department*, Appendix C, 1893, p. 15.
65. *Annual Report of the Toronto Police*, Appendix C, 1891, p. 29.
66. Brooking, "Conditions in Toronto," *Fighting the Traffic in Young Girls*, p. 365.
67. *Annual Report on the Houses of Refuge and Orphan and Magdalen Asylums*, 1890, Ontario Legislative Assembly, Sessional Papers, vol. 24, pt. 1, p. 96.
68. *Annual Report of the Toronto Industrial Refuge for the year 1896*, p. 5.
69. *Annual Report of the Toronto Industrial Refuge*, 1895, p. 5.
70. *Annual Report of the Toronto Industrial Refuge*, 1888, p. 5.
71. *Annual Report of the Toronto Industrial Refuge*, 1902, p. 6.

72. *Annual Report on the Houses of Refuge and Orphan and Magdalen Asylums*, 1894, Ontario Legislative Assembly, Sessional Papers, vol. 28, pt. 3, p. 122.
73. *Annual Reports of the Toronto Industrial Refuge*, 1890-1900.
74. *National Council of Women Yearbook*, 1913, p. 124.
75. Minehan, "A Priest's Protest," *Fighting the Traffic in Young Girls*, p. 383.
76. *National Council of Women Yearbook*, 1907, p. 86.
77. "A Priest's Protest," *Fighting the Traffic in Young Girls*, p. 387.
78. See Leo Johnson's article in this anthology, p. 5ff., p. 13.
79. Frederich Engels, *The Origin of the Family, Private Property and State*, p. 100.

Table A

Ethnic Breakdown of Female Domestics in Toronto in 1911					
Occupation	*Number*	*Canadian-born*		*Immigrant*	
		No.	%	No.	%
Charworkers	416	207	50	209	50
Cooks	360	137	38	223	62
Housekeepers	386	230	60	156	40
Laundresses	638	251	39	387	61
Nurses and Nursemaids	338	165	49	173	51
Servants, n.o.s.	6534	2759	42	3775	58
TOTAL	8672	3749	43	4923	57

Source: Census of Canada, 1911, vol. 6, pp. 262-5.

Table B

Occupational Breakdown of the Female Labour Force in Ontario in 1914*

Occupation	Number
Domestics	30,000 to 50,000
Factory Workers	53,729
Saleswomen	12,000 to 18,000
Stenographers	26,000
Trained Nurses (in private nursing)	2,000 to 3,000
Women who work by the day	5,000 to 6,000

Source: *Report of the Ontario Commission on Unemployment,* p. 59.

*This table only includes the six *major* occupations employing working women in Ontario at this time.

According to the Report of the Ontario Commission on Unemployment, there were 175,000 women workers in Ontario in 1914. Using the high figure of 50,000 domestics given in Table B we can calculate that domestics comprised a maximum of 28 percent of Ontario's female workforce in 1914. Domestic service probably employed a similar percentage of the working women in Toronto. Thus, since 48 percent of the prostitutes in the Social Survey Commission sample had previously worked as domestics, it is evident that domestics were over-represented in this sample.

Domestic Service in Canada, 1880-1920

Introduction

The history of domestic service is an important part of women's labour history, both because of the number of women once employed as servants, and the nature of the work. Domestic labour—housework and childcare—has traditionally been women's responsibility, and domestic service offered large numbers of women a wage for the same work they had always done. The history of service allows some general insights into the relation of domestic labour to the economy, and how that relation changed with industrialization.

A full study of domestic service in Canada would span several eras of social, economic and political development, and this article touches on only a part of that history. The period 1880-1920 has been chosen because it was a transitional period which clearly revealed the incompatibility of domestic service and modern, industrial trends. Although urbanization and industrialization were well advanced by 1880, only 14 percent of Canada's population then lived in towns and cities.[1] By 1921, half of the population was urban,[2] the prairies were settled, and the modern form of the nuclear family was firmly established. In 1891 domestics accounted for 41 percent of the female work force, and were by far the largest single group of workers; by 1921 domestics represented only 18 percent of all employed women, but were still the second largest category of female workers.[3] Although domestic service remained a major occupation for women until World War II, the tensions that were to drive women from this field were clearly visible between 1880 and 1920.

Table A

Number of Women in Domestic Service in Canada, 1881-1921

Year	Total Population	Number of Female Servants	Total Servants in Work Force	% of Female Servants in Work Force	% of Female Servants in Total Pop.
1881	4,258,364	49,345*	—	—	—
1891	4,734,272	79,473	195,990	41%	1.68%
1901	5,323,967	81,493	237,949	34%	1.53%
1911	7,191,624	98,128	364,821	27%	1.36%
1921	8,775,853	88,825	490,150	18%	1.01%

*from 1881 Census (all other figures are from the 1921 Census)

Sources:
Sixth Census of Canada. Volume III—Population, (King's Printer, Ottawa, 1927), p. 3.
Ibid., Volume IV—Occupations, pp. 2-3.
Census of Canada, 1880. Volume II, Table XIV.—Occupations of the People, (Ottawa: MacLean, Roger & Co., 1884).

Industrialization had displaced production from the home, created new jobs, allowed women some choice as to how they would earn a living, and transformed the home and the nature of domestic work. Outside the home, industrialization brought workers together in larger and larger numbers, in factories and shops which were open to public view. This led to protective legislation, standardization of working conditions, and the potential power of workers through collective action. Because the isolation of her workplace made standardization impossible, the domestic servant could not enjoy any benefits of industrialization, such as a minimum wage or a shorter working day. Industrialization also changed work done within the home, by transforming it into service labour. Domestic work became less and less satisfying as its productive aspect was reduced; it became a never-ending round of maintenance chores—necessary for life to continue, but easy to ignore.

Domestic service, like domestic labour in general, declined in status with the progress of industrialization. It was not considered an integral part of the economy, and to a large extent was excluded from economic and political discussion. It was "non-productive" service labour; it took place in the home and depended upon a personal relationship between employer and employee; it involved no significant outlay of capital and produced no direct profit. In a society based on the production of commodities for sale and profit, domestic labour was progressively devalued as production was removed from the home.

However, the vast amount of energy poured into procuring domestic help in Canada by recruitment agents and the Immigration Department, reveals both the great importance of domestic labour, and its specific relation to the Canadian economy at different points of industrial development. Domestic labour has generally been ignored by historians and economists, but on a practical level, its importance could not be ignored.

The situation of the live-in, female servant has been emphasized in this article because many of her problems have been inherited by today's housewife. Historically, the domestic servant has had a special relationship to the family structure, which justifies some comparisons between the servants, women and children of a household. Surplus women and children, "poor cousins" and maiden aunts, have always provided free domestic labour for the household's needs, and women, children and servants have

traditionally been accorded a similar kind of status by law-makers, employers and moralists. In Canada, the need for domestic workers was often filled by enlarging the family through marriage or adoption. Spinsters were encouraged to immigrate as domestics and marry Canadian farmers, and orphans from British workhouses were brought to Canada by the thousands to work in the kitchens and fields of their adoptive parents. There were crucial differences between servants and housewives in terms of social status, power, and living conditions. Because of her waged status, the domestic servant was much more visible than the unpaid worker; both, however, were affected by the nature of the workplace and society's attitudes towards their work.

By the twentieth century, women were rejecting domestic service whenever the opportunity arose, because working conditions were better elsewhere. At the same time, a new, streamlined type of household emerged which was a better complement to industrial capitalism than the old, extended family. The development of birth control and household technology, changes in Canada's class composition, and the ongoing removal of production from the home eventually made it possible and logical for most families to do without servants, and delegate all necessary domestic labour to the housewife. There are comparatively few live-in servants today, but the history of domestic service is still relevant in illuminating the situation and status of the unpaid housewife. By studying the domestic servant's work and society's attitude towards it, we gain insights into the nature, status, and importance of domestic work itself.

Service in Canada

The servant most in demand in Canada between 1880-1920 was the general maid-of-all-work, who could cook, clean, sew, take care of children, and perform all other household tasks. Few servant-employing households had more than two or three servants, and most had only one, in contrast to Britain where a certain number of highly specialized servants were required for the elaborate homes of the landed aristocracy and wealthy middle class. Household life in Canada was comparatively unsophisticated, according to a speaker at the first annual conference of the National Council of Women of Canada, held in 1894. She criticized both employers' standards, and servants' skills:

Most parts of Canada are so new that any such elaboration in household life as would require several trained servants is the exception not the rule. The deft and ready service accorded by the English servant who has risen stage by stage, carefully trained at each point by competent superiors, which is the ideal of so many Canadian mistresses, can hardly be expected from a girl who leaves a poor home in a town or village at the age of ten or eleven years to go as nurse to several children, afterwards passing into homes, hardly superior to her own, where she does anything that comes to hand of the rougher kind... [4]

The more specialized immigrant domestics often found that they had to combine duties they had been used to regarding as the work of several servants. The demand for specialized domestic servants increased with urbanization and the entrenchment of the middle class. England reached this stage much earlier than Canada, but by 1916 W.D. Scott, the Superintendent of Immigration, was instructing his assistant in London that

> the greater demand is still for general servants, but I think that the demand (for specialized servants) is increasing, and it would be safe to encourage the immigration of any really good girl who has a reasonable amount of experience.[5]

Table B

Ratio of Female Servants
To Number of Households in Canada, 1881-1921

Year	Total Population	Households	Female Servants	Female Servants to Households
1881	4,268,364	800,410	49,345*	1 to 16.2
1891	4,734,272	900,080	79,473	1 to 11.3
1901	5,323,967	1,058,386	81,493	1 to 13.0
1911	7,191,624	1,482,980	98,128	1 to 15.1
1921	8,775,853	1,897,227	88,825	1 to 21.4

*from 1881 Census (all other figs. are from 1921 Census)

Sources: See Table A

Although it is difficult to estimate how many households employed servants, or to characterize the employers of servants, it is clear that servant-employing households form a much smaller fraction of the total population today than fifty years ago, and that servants' employers are now more consistently from the privileged upper and upper-middle classes.

Table B shows the changing ratio of female servants to households between 1881 and 1921. Heavy immigration increased the servant population after 1881, and 1891 is the census year showing the largest proportion of servant-employing households. From 1891, the number of female servants per households decreased steadily, from 1 to 11.3, to 1 to 21.4. Census categories have changed since 1921, but in 1961 in two comparable categories (Babysitters, and Maids and Related Service Workers) a total of 129,244 female workers (or 1 to 35 households) were listed.[6]

The declining percentage of servant-employing families has coincided with the growth of capitalism and changes in Canada's class composition. The importance of waged labour has increased steadily in the past century; a smaller percentage of the population is self-employed today than in 1880 or 1920.[7] Between 1880-1920, urban employers were sometimes upper-class, but more often civil servants, professional men and small businessmen. Requests typical of those made to the Department of Immigration for servants came from such applicants as: a general merchant in Portage du Fort; the owner of a dry goods store in St. Catherines; the Chief Medical Inspector in Brantford; and the owner of a building supply company in Sudbury.[8]

Many servants worked on farms during 1880-1920, and their work was quite different from that of urban servants. A farm servant could expect harder work and lower wages than her city counterpart. Along with the usual household work (probably unaided by new technological devices) she was expected to bake bread, milk the cows, make butter, assist at seasonal events such as harvesting, and care for the extra labourers needed at those times. She suffered from boredom and loneliness, although the farmer's wife was more of a companion to her than the urban mistress was to her servant. In general, there was a more desperate need for farm servants because of the influx of farmers' daughters to the cities, and the reluctance of immigrants to leave their ports of arrival, where they might have friends or relatives.

Housework and Household Technology

Operating a household was a complicated business at this time, as the huge encyclopaedias devoted to household management show.[9] In 1880, most housework was accomplished with lots of muscle power and a few primitive tools. The work itself was considerably greater than it is today, because conveniences which are now built into most homes—electric power, heating and plumbing systems—had not been developed. Women needed a great deal of strength, knowledge and ingenuity to keep their homes running smoothly. By 1920 the precursors of most modern conveniences had been developed, but the burden of domestic labour was still very heavy.

A rough picture of changes in housework can be gleaned from the articles offered for sale in Eaton's mail-order catalogues.[10] Many articles not appearing in the catalogues were available on request, or in city stores, but the catalogues do indicate when products first became widely available, and which products were the most popular. The first catalogue appeared in 1885, and in 1887-88 Eaton's boasted that

> dwellers in sections which a few years ago could be found only on the most accurate maps now order merchandise through our mail order with the same facility as though present in person.[11]

It appears that most kitchens were not designed with efficiency in mind. An unorganized variety of tables, cabinets and bins took the place of today's built-in shelves and counters. A kitchen cabinet which appeared in 1897-98 reflects an attempt to rationalize kitchen activities and save steps. This cabinet combined a table top with two flour bins, a spice drawer and a cutlery drawer. More elaborate models, with many cubby-holes, shelves and drawers, appeared in later catalogues.

Wood and coal-burning stoves predominated throughout the period, though some oil stoves were advertised in the 1890s, and a combination coal and gas range finally appeared in 1919. Made of steel or cast-iron, these stoves were often used for heating as well; cooking over them must have been a very uncomfortable activity. The stoves were awkward and dirty, and left a residue of ashes which had to be cleaned away. From 1885 to 1920, the development of stoves was basically an elaboration of design. Later models were given impressive names, such as the "Royal Alexandra" or "Eaton's Gothic" and had many accessories and compart-

First Appearance of Household Goods in Eaton's Catalogues, 1885-1920

Clothes & Sewing	Stoves	House Cleaning	Laundry	Lavatory	Heating and Hot Water
1885 —large range of cloth goods	1893-94 —oil stove	1886-87 —3 carpet sweepers: "The World," "The Crown Jewel," and "Grand Rapids"	1892-93 —wringers, wash basins, wash rubs, wash stands —Mrs. Pott's "sad irons"	1892-93 —rolls of perforated toilet paper	1892-93 —water carriers
1888-89 —"The New Empress" sewing machine	1902 —large selection of wood and coal-burning stoves	1890-91 —"spring dump,"	1896 —washing machine: the "celebrated Dowswell washer"	1896 —commode chairs	1893-94 —gas & oil stoves & furnaces
1890-91 —Butterick's Patterns	1910 —range for burning hard coal	1909-10 —2 vacuum cleaners: 1. "The Chatham" (hand powered) at $25.00 2. The "Acme Electrical" at $100.00		1910 —"Daisy Dry Earth Closet"	1895 —"The Lightning Geyser"—a hot water tank fueled by gas
1901 —large variety of ready-made dresses	1919 —combination coal & gas range		1919-20 —Electric washer	1912-13 —Crematory closet, for separating & burning waste	1908-09 —"Huron Red Hot Warm Air Furnace"
1917 —"sew-E-Z" electrical attachments for sewing machines					1917 —"The Red Hot Pipeless Furnace"

(From the Archives, Eaton's of Canada Limited)

ments: warming closets, double ovens, high shelves, oven thermometers, and water reservoirs.

Electrical refrigeration did not appear before 1920, though insulated hardwood cabinets, sometimes with enamelled interiors, supplemented more rudimentary ice-boxes.

Household cleaning was a very primitive affair. A striking array of brushes, and a pail, seem to have been the domestic worker's only aids. Two vacuum cleaners appeared in the 1909-10 catalogue, but both models were very expensive and the electric model did not reappear in subsequent editions.

Laundry was done with simple washboards, wringers, and basins until rotary, hand-operated washing machines began appearing in the 1890s. Throughout the period, ironing was done with flat irons which had to be heated on the stove.

Houses were heated by small stoves and heaters, and presumably by fireplaces. The heaters were fueled by oil, wood and coal, and warmed a very limited area. The "Huron Red Hot Warm Air Furnace," which appeared in 1908-09, distributed warm air to the

39. Stable broom 40. Shoe brush 46. Stove Dauber 47. Crumb brush 48. Bannister brush 49. Shoe dauber 50. Window brush 51. Wool duster 52. Stove brush 53. Double bannister brush 54. Scrub brush, green corn 55. Bottle brush 56. Shoe brush 57. Heather sink scrub 58. Hearth duster 59. Wool wall duster 60. Dish mop 61. Feather duster, turkey or ostrich feathers 62. & 63. Silver brushes 64. Hairbroom 65. Table scrub fibre.

(Eaton's Spring & Summer Catalogue, 1902—*from the Archives, Eaton's of Canada Limited*)

"My wife will smile" when she sees this Bissell Carpet Sweeper

(*Eaton's Fall & Winter Catalogue, 1893-94—from the Archives, Eaton's of Canada Limited*)

floors above via a series of pipes. The "Red Hot Pipeless Furnace," which appeared in 1917, was located entirely below the main floor, and heated as much of the house as possible through one centrally-placed register.

Though plumbing systems were probably common in urban centres by the early 1900s, Eaton's continued to sell water carriers, wash stands and portable bath-tubs until 1920. Water was often heated on or in the stove, but as early as 1895 Eaton's offered "The Lightning Geyser"—a hot water tank fueled by gas. Chamber-pots and commodes were still prominently advertised in the 1920 catalogue, along with various devices for disposing of human waste.

Except for electric light fixtures, the power of electricity was slow to be turned to household needs. The "Electrical Department" of the 1902 catalogue offered only electric bells and electric fans for home consumption. An expensive, cumbersome washing machine appeared in 1920, and a "Sew-E-Z" electrical attachment for sewing machines in 1917, but the major tasks of cooking, cleaning, sewing and laundry were done throughout the period without the benefit of electric power. Many working-class women did without technological aids even after they became generally

available. As late as the 1940s, many Canadian women cooked on a wood range, washed diapers by hand, and did house-cleaning without the benefit of a vacuum cleaner.

Most products consumed in the home were produced elsewhere by 1880, though many women continued to make their own bread, preserves and clothing, especially in rural areas. The grocery section of the 1894-95 catalogue offered a large assortment of teas, coffees, jams, jellies, canned fruits, vegetables, meats and fish. A separate groceries catalogue was instituted in 1896, and became semi-monthly in 1907.

Home production of clothing is an interesting activity to examine, because it has continued to the present day (though on a reduced scale). From the early 1890s, Eaton's offered a large selection of ready-made men's and children's clothing, but certain articles of women's clothing continued to be made in the home until much later. A full selection of ready-made women's dresses did not appear until 1901. At one stage, Eaton's deliberately tried to woo women away from home production. A note in "Ready-Made Costumes" (1892-93) declared: "Women will come to it sooner or later. There's no good reason why costumes and wrappers shouldn't be bought ready-made and worn satisfactorily."[12] In 1893-94, a note under "Ladies Underwear Dept." read:

> As a matter of fact a woman can't afford to kick a sewing machine and clutter up the room at home making underwear for the little you pay here for the finest. You are our real competitors in this respect. We've got to get you into the notion of buying ready-made.[13]

Twenty-five years later, with a large line of sewing machines to sell, Eaton's was saying "Try Home Sewing; It Pays," but by this time women were in the habit of buying most of their clothes ready-made.

The domestic servant's work during this period cannot be equated with the housewife's, but servant and housewife would have used the same kind of tools and dealt with the same kind of workplace. The picture of home life suggested by Eaton's catalogues gives us many clues to the domestic's day-to-day work.

The "General" and the "Situation"

In households where only one servant was kept, she was usually expected to cook. She might be called a general, a cook, or a cook-general, but since a cook could demand higher wages and limit her duties, this position was usually described as a

"general's." Where two servants were kept, the division might be "Cook and Housemaid" or "Cook and Parlormaid." If the mistress herself participated in housework, she would take care of the children and perhaps do the "upstairs" work as well. Often laundry was sent out or done by a day worker who came to the house once a week. Laundry was an enormous task; it made a great difference to the servant whether laundry was done in or out of the house.

Within domestic service, cooks and housekeepers had the highest status and were the best paid. They were often older women, and sometimes formed part of a husband-and-wife team, with the man working as handyman, kitchen man, gardener, stableman, coachman or chauffeur, or labourer. The man would do the heavy and the "outside" work, while his wife worked inside the house. Nursemaids and "mother's helps" were usually young, inexperienced, and very poorly paid. Other servants were tablemaids, governesses, wet nurses, and needle-women.

The most common servant, however, was the general. She did the work of all other servants combined, but her ability to perform a wide range of tasks did not bring her a higher wage, or enhance her value in the eyes of her employer. Outside the home, skilled work was increasingly associated with specialization and a clear job definition. This conception of skill was carried over to the home, where a house-parlormaid might be better paid than a general, though her duties were fewer.

Society held a very ambivalent attitude towards domestic skills. On the one hand, employers were extremely vocal in their demands for experienced domestic help. They often perceived a gap between their ideal of home life and the reality of their own ill-functioning households. A pervasive feeling was that standards and skills were deteriorating—"You can't get good help nowadays." On the other hand, employers had little real respect for domestic skills, especially when it suited their pocketbooks. Domestic skills were very familiar, and easy to ignore. Most working-class women had some experience in housework and childcare, simply because of their female upbringing. This background was not sufficient preparation for service in a middle-class home (hence the demand for "good" help) but it went a long way. The only large group of workers to be given extensive training before recruitment into domestic service were the orphan children who had missed the normal socialization process. An amazing

amount of learning was needed to perform the simplest cooking task, but as long as cooking was considered a natural function of womanhood, the learning and skill involved could be ignored. An application for a "Scotch servant girl" in 1907 stated:

> The duties required are simply those of a quiet home. prepare meals. sweep and dust etc. etc. such work as can be done by any girl of 14 or 15 years... [15]

This ambivalent attitude towards the domestic's skills went hand-in-hand with a vague definition of her work. As Jean Scott pointed out, "The work of a girl in a factory or shop is definite and soon learned, while the work of a domestic, especially of a 'general', is more indefinite and varied."[16]

This indefiniteness was inevitable because of the servant's workplace. It was impossible to standardize housework, because each household was unique. The domestic did not so much take a job as enter a "situation" which was different from any other. Whereas the trend in industry was to minimize variables in order to maximize efficiency, a complicated mixture of variables determined the domestic's work.

The amorphous nature of the servant's work was one reason her mistress felt compelled to investigate her character before hiring her. A domestic was not hired for specific services, but for general availability; above all, a servant had to take orders well. Many domestic skills were moral skills, or skills of deference, and this is another reason employers looked for certain qualities of personality in their servants. A servant's "character" was her most important possession, as losing it could mean economic ruin. A good servant was clean, celibate, obedient, respectable, hardworking, and an early riser.

Submissiveness was considered an especially important quality in domestic servants. In 1915, the Assistant Superintendent of Immigration wrote to his booking agents in England that

> the true test as to whether a girl was qualified, and would stay in domestic service, was not complete unless the girl had already worked for money and taken orders from some other woman in a household.[17]

After World War I, an independent recruiting agent named Mrs. Yemans offered to bring a number of demobilized war workers to Canada as domestic servants. She described them as

a very large number of capable young women who were inspired by a splendid ideal of service... These women... are already recruited, drilled and organized... They have had a stiff practical experience in human relationships.[18]

The passivity and deference which servants were supposed to display, if not feel, prevented many of them from clearly recognizing their oppression and acting against it. Any show of rebellion would cause a servant to "lose her character," and the role a servant was forced to play inevitably influenced her consciousness of herself. The church played an important part in promoting an image of the "good" servant, which helped to keep her in her proper place. Domestic servants were encouraged to model themselves after Christ, the Suffering Servant, and sacrifice their own interests for their employers' without complaint.

"Another Servant Girl"

I am a general servant myself, and I want to say that no one enjoys more of the sweetness and richness of life than I do, and I would like to tell the girls the secret.... my motto is: "Not slothful in business; fervant in spirit, serving the Lord." Try it, girls; you will find it will make service a delight. Do your best, and no one can do more; and if you do have to spend most of your time in a kitchen, there are worse places than a nice tidy kitchen. Some of my happiest hours are spent in my kitchen, with my feet in the oven, and one of my favourite books, and in this age of literature and with the wages that a good servant can command no one need be without plenty of reading material. What care I if some people live in rooms carpeted with Brussels, etc...? And then, girls, remember that the only one who ever had a right to think anything of Himself took upon Him the form of a servant; and I do pray that the mind of Christ may dwell in us. At the same time we stand before God on an equal footing with Queen Victoria....

—*from a letter to the Editor,* The Toronto Globe, *January 27, 1886.*

Advantages and Disadvantages of Domestic Service

Although domestic service remained a major occupation for women until World War II, from the earliest days of industrialization women rejected domestic service whenever possible by taking other jobs. Employers found it hard to understand why women should reject work which seemed to offer such strong moral and material advantages:

> One manufacturer says: "The crying necessity is domestic help. I can get dozens of girls, 16 to 20 years of age, at $2.00 per week, for store or factory, but cannot get any, or only with difficulty, at $2.00 to $2.50 per week, including board and comfortable home, for domestic help.[19]

Though wages varied considerably from household to household, and fluctuated with conditions of supply and demand, servants did not have to face the biggest problem of most women workers —trying to live on less than a living wage. Even when a servant was paid nothing, she had food to eat and a roof over her head. In good times, with a rich employer, she might earn more than a shop clerk or factory worker, without the expenses of board and lodging, transportation, laundry, special working clothes or equipment.

A domestic's situation was a home as well as a job—this was an important consideration in view of the lack of proper boarding houses for women. Though many servants were sexually exploited by their employers, a domestic situation was associated with respectability and protection by members of Victorian society, in contrast to the "public" employment that more and more women were taking outside the home. Domestic service developed the womanly skills of home-making and childcare, and was less debilitating to the health than factory work.

Why, then, were women so reluctant to enter service? The few records left by servants themselves undermine the picture of easy work and material plenty presented by their middle-class employers. Many domestics worked sixteen or eighteen hours a day at exhausting physical labour, and lived in crowded, ugly, unhealthy attics or basements. In her novel *Lummox*, Fanny Hurst speaks of

> the body tiredness at the end of a seventeen-hour day from stoking the coal range at six a.m. to placing the two shining apples and a silver pitcher of water beside the Farley black walnut bedstead at eleven p.m.[20]

The reason most often given for the unpopularity of service was its low social status. The servant could never forget her inferior status; part of her job was to be subservient. Mary Pattison wrote in 1915:

> The very class who are involved in the heart of the situation, who come closer to one's real and intimate standards of life than many a friend, or relative...who administer to our first and really intimate needs and come into contact with us at every stage of life, is the class that Society has relegated to the lowest plane of human beings claiming respectability. Housework and house-workers are classified at the very bottom of industrial occupations...[21]

In her paper "Mastered for Life," Leonore Davidoff points out that "rituals of deference" became a more important part of the servant's job with industrialization and the growth of the middle class.[22] As production was displaced from the home, the servant's mistress became a lady of leisure and the co-operative, economic bond between mistress and servant disappeared. An immigrant domestic who wrote to the editor of the Toronto *Globe* in 1886 refers to the rural past, and indicates how the servant's status has declined:

> I was brought up in Scotland; my parents were tenants of a small farm and my mother used to tell how, when she was feed* with Andrew Howit, of Burnhead, the young folk would come in at evening and supper time, and such fun they would have. And how the young folk of the house would be bidden to the neighbour's house, and herself among the rest. Now that kind of thing is all done away with. Now there is no such thing as inviting a servant to a party along with the farmer's family. The farmers are all gentry now-a-days.[23]

Even the sweatshop conditions of factory work were preferred by many to the social stigma of taking up service. A speaker at the NCWC's 1894 conference asked:

> Why is it that shop girls and even factory girls look down on servants and will not associate with them? And why also is it that young men getting on in business... will marry a shop or factory girl who knows nothing about house-keeping, in preference to a good well-trained servant...[24]

Long hours of work, lack of freedom, and lack of privacy must have made domestic service seem like a kind of modern-day slav-

*engaged for a fee

ery. A factory worker who worked twelve or more hours a day for a subsistence wage may not have had many real choices in her life, but she was much more independent than a domestic servant. Her job represented a contractual agreement between herself and her employer;[25] she left her job behind her at the end of the day, and her personal life was her own affair. Servants, on the other hand, had very little time off; except for one afternoon a week and the occasional Sunday, the domestic servant was tied to her workplace and her employer's supervision twenty-four hours a day. Her role was not only inferior by definition, but one she could not escape at the end of the day. Her work role and personal role merged. In her employer's home, the servant was allowed very little privacy or personal dignity. Employers limited the number of friends their servants could have, because they did not want their homes overrun by "strange girls." Being in the family, but not of it, servants could only entertain in the kitchen or their own rooms, at specified times.

The loneliness of domestic service was another major drawback which caused many women to seek work in shops, factories

> *I am a woman, a daughter of Martha, one of those whose business it is to smooth the paths of others. My day's work begins at six in the morning and ends any time before twelve at night. All day long I serve and scrub and bake and then wash dishes, polish silver, press clothes until well into the night. I wear a frilly head band that seems like a lead weight on my throbbing temples. My shoes are felt soled and light as gossamer but at times they feel like cast iron. I say "Yes sir," and "Yes madame" with a pleasant smile, when I feel like screaming and telling the whole shooting match to go to hades... I am tender with little children and I humor their childish whims; my own are in a foster home and indifferently cared for. But I do it all gladly, and I am well satisfied that my meagre wage is enough to pay for the bite that keeps my children alive.*
>
> —*from a letter by Florence Worthington to the* Mail & Empire, *Jan. 14, 1934*

and offices, "where there are a number of girls employed."[26] The urban servant could expect little companionship from her mistress, and where she was the only servant kept, she was totally alone most of the time.

Although most domestics preferred to work in the cities, some chose farm life because of the higher social status they would have within the household. Farm servants' status had also been undermined by industrialization, but not to the extent that the urban servant's had. An Irish domestic wrote to the Superintendent of Immigration in 1907:

> Having worked in the country all my life, I prefer going into a farm house as help or mother's companion where I would be treated as one of themselves... [27]

A servant girl is composed, like her mistress, of a social nature accompanying her physical, but the former one is of no account to a mistress' consideration. She considers the servant a piece of machinery to perform her work. The kitchen is not infrequently partly underground, poorly lighted, etc., where the servant lives for the 24 hours. The view, likely a back one, is not enlivening or cheering; some dull shed or 10 foot fence view facing the north. With these and the daily routine of work, are her whole enjoyments. Where no other servant is employed, she is very lonely—perhaps from the country and having no friends in the city. The mistress, perhaps, once or twice a day, visits the apartments to give orders. If a kind-hearted woman, may give the girl a kind word, compliment her on her neatly-ironed clothes, the clean floor, a bright stove. The servant's daily task ended, she can sit in this kitchen alone (alone also all day) or go to her own room, perchance a cold one at that, and when she gets tired of it retire. What is such a life but slavery! And yet there's many just as lonely!

—from a letter to the Editor, The Toronto Globe, January 22, 1886

Recruitment pamphlets, such as *Women's Work in Canada* (1921) continued to stress the democratic atmosphere of country homes: "It makes a tremendous difference when work is shared between mistress and maid, as it is on the farms during the busy season..."[28] But since farm servants in general suffered from isolation, hard work and low wages, most domestics chose to work in cities.

The Labour Market

The most important factor affecting the number of women in service was the availability of other work, as Lucy Salmon concluded in 1897 from her thorough study of domestic service in the United States.[29] In 1892, Jean Scott wrote: "Of late years so many employments have opened up for women that the supply is rather short of the demand," and referred to the "general reluctance of girls to go into service in Canada."[30] In England, an immigration official found (in 1914) that

> compared with 20 or 30 years ago, the ranks of female domestic servants are already depleted by the demands of commerce and industry in the U.K.... In the Mother Country, as in the Dominions, the tendency is for women to adopt industrial and commercial life and to abandon domestic service.[31]

Women were forced back into service during depressions or times of personal crisis, but they generally chose other jobs when they had a choice of occupation.

Judging from the complaints of employers, there were never enough good servants, and the demand for them was increasing daily. One observer went so far as to call the lack of domestic help "the root-cause of the diminishing birthrate in the higher strata of society."[32]

In fact, the percentage of servants in the population and in the female work force did decline throughout the period, after a sharp rise from 1881 to 1891. Table A shows that female servants constituted 1.68 per cent of the population in 1891, a percentage that dropped steadily in the pre-war years, despite a strenuous drive to recruit immigrant domestics. The war interfered with the immigration of British domestics, since women were needed in Britain's munitions factories and were refused passports that would allow them to emigrate;[33] this cause a further drop in the percentage of female servants.

The absolute numbers of women in domestic service are even more revealing. Though Canada's population almost doubled from

1891 to 1921, the number of female servants increased by less than ten thousand. At the same time, the number of women in paid employment more than doubled.

Though statistics give some indication of the supply of domestics, they fail to give a true picture of the demand. The President of the Interprovincial Council of Farm Women pointed out (in 1919) that

> the Government Bureau returns as regards applications are not indicative. So many individual demands had been refused that many others in like need never filed the applications or even made them to the Employment Bureau.[34]

In rural areas, the unfulfilled demand for servants was particularly acute. Besides the drawbacks to rural situations already mentioned (harder work, lower pay, the isolation of country life), many farmers' daughters saw little future for themselves in older sections of the country where all the land had been settled. There were fewer single, independent farmers left to marry; as a result, rural women moved in great numbers to the cities.

In towns and cities, the demand for domestics was aggravated by a high turnover rate. Jean Scott pointed out that

> the majority of servants do not stop long in one place. Of course there are many exceptions, but the fact that a girl knows that she can get a place at any time makes her more independent.[35]

Changing "situations" was often the only outlet for a servant's work frustrations, and employers became used to a "procession of maids through the kitchen."[36] For many women, service in Canada was only a temporary introduction to a new city or country; after establishing themselves they often took other jobs or got married.

Though seemingly removed from the mainstream of economic life, the domestic servant was directly and immediately affected by changes in the marketplace. There were great fluctuations in supply and demand, depending upon such factors as the country's general economic health, the ratio of unmarried women to men, the immigration rate, and migration to the western provinces after the seizure of Indian lands. The years of 1914 and 1915, in which there were tremendous changes in the labour market, are an extreme example of a general pattern of variation.

There was a great shortage of servants in 1914, until the depression of that summer, aggravated by the outbreak of war, threw many people out of work. Factory, shop and office workers

flooded into domestic service and lowered wages with low-priced competition.[37] An article in the September 14, 1914 edition of the Toronto *Telegram* reported: "Women who a few months ago had to advertize two or three times before getting one application for a maid now have from fifty to one hundred anxious applicants."[38] In November, the superintendent of a Montreal hostel reported to W.D. Scott, the Superintendent of Immigration: "The domestic labour market is at a crisis caused by outsiders attempting domestic work."[39]

At the same time, employers (also affected by the depression) fired their servants or lowered their wages. A Calgary hostel reported in November, 1914, that "ladies are dismissing help,"[40] and in the same month a Winnipeg hostel reported: "Wages have decreased twenty percent since last spring and some girls are working in the country for board only."[41] Thus the depression and the war led to both the increase in the supply of domestics, and a decrease in the demand for them.

By mid 1915, however, there was again an increased demand for domestic help,[42] which continued to grow throughout the war. A new shortage of servants, partly caused by the suspension of British emigration, led Scott to encourage the immigration of Belgian domestics. At first, the increased demand was for "real good domestics"[43] but the Department of Immigration gradually became less selective as the supply of servants shrank and the demand for them grew.

The Department attempted to match supply and demand as closely as possible, but recruitment agents sometimes created an oversupply of servants while serving the interests of the middle and upper-class employers they represented. They were most concerned with guaranteeing a constant supply of domestics; this attitude sometimes resulted in a surplus of labour power, and great hardship for the women who could not find jobs. In an unpublished paper, Patricia Alexander records one example of this:

> In Winnipeg, in the summer of 1915, "At a meeting of City Council, the attention of members was drawn to the fact that the Salvation Army was advertising in English papers for domestic help to be brought to Canada and a resolution passed 'protesting against any further movement of the kind as it is impossible fo find situations for those aIready here.'" A copy of the resolution was ordered to be sent to Salvation Army headquarters. Nevertheless in 1916 objections were again raised to Salvation Army plans to bring 5,000 war widows from Britain.[44]

During depressions, it was often the more skilled worker who suffered as competition for situations intensified. In November 1914, Rev. Father Singleton of the Catholic Immigration Home in Montreal reported to the Department of the Interior that

> stenographers, salesladies and factory workers are taking up domestic work at very low wages and that this has resulted in throwing hundreds of regular domestics out of employment.[45]

Skilled domestics were thus either displaced by cheaper labour or forced to accept an unskilled domestic's wage.

Untrained workers were encouraged to enter service but were easily dismissed by their frustrated employers when a more skilled replacement came along at the same price. According to Rev. John Chisholm, servants' lack of training sometimes led to prostitution. He denounced labour bureaus and

> the placing of incompetent servants in homes to do work of which they had no previous knowledge, resulting in their dismissal from one place of employment to another; and by growing discouraged they become the easy victims of commercialized vice or the white slave traffic.[46]

The ambivalent status of domestic skills thus caused problems for both trained and untrained domestics. Although employers demanded a high level of skill, they were reluctant to pay for it. Because her skills were believed common to all women, the domestic was more vulnerable to competition than other workers. Experienced domestics distinguished between themselves and "outsiders," but many people looked upon service as a catch-all occupation that could absorb society's misfits.

Employers exploited the ambivalent status of domestic skills. They complained loudly that trained servants could not be found, and that the shortage was approaching a national emergency. They put extreme pressure on government and recruitment agents to import large numbers of highly trained servants, thereby raising the general level of skill. At the same time, they would employ unskilled workers whenever it was convenient or economical to do so. In a pinch, any woman could do housework, though her work might not be as good as employers would like. Competition from untrained workers kept down the wages of trained servants, and the demand for skills undermined job security for the untrained. Employers, however, won either way.

The ideal of domestic service (From the Archives, Eaton's of Canada Limited)

Immigrant children brought over from Dr. Barnardo's Homes to be domestic servants, seen here at Landing Stage, St. John, N.B. (Public Archives of Canada)

Sex and Violence in Toronto, 1915

On the evening of Feb. 8, 1915, Charles Albert Massey, a prominent member of the city's first family, walked up to the door of his Walmer Road home after work and was shot dead. A newsboy up the street witnessed him stagger out of the doorway, and a second shot felled him to the sidewalk.

Massey was shot by his 18-year-old domestic servant, Carrie Davies, who had come to Canada two years earlier. Her mother, still in England, received regular letters and money from her daughter; Carrie's sister and husband-in-law lived in Toronto. Carrie's boyfriend had left for the war three weeks earlier.

Why did Carrie shoot her employer? At first the Massey family tried to give out the story that she was mentally deranged, and suggested she be put away without prosecution (or court procedings). However, the case went to court and the following story came out:

Massey's wife had gone off to Connecticut to visit relatives, leaving Massey, Carrie and Massey's young boy alone in the house. On Friday, Feb. 5, Massey hosted a wild party at the house; on Sunday he attempted to seduce Carrie, by presenting gifts (a ring, his wife's stockings) and coaxing her into bed. Carrie ran away to her sister's house, and returned on Monday. Overcome by fear Massey would harm her when he returned home, she grabbed one of his pistols and shot him when the door opened.

The trial started on Feb. 25 or 26, and ended the next day. There was considerable sympathy for Carrie in Toronto, as shown by the raising of a defence fund of more than $700 among 1,000 contributors. After a half hour's deliberation, the jury found her not guilty of murder and a tremendous cheer went up in the courtroom.

—David Frank

Source: *Evening Telegram, Toronto, Feb. 9 - 27, 1915*

Recruitment of Domestic Servants

Despite the reluctance of women to enter domestic service, employers were remarkably successful in maintaining a large supply of servants until World War II. Women's groups like the YWCA directed the homeless, the unemployed, and reformed prostitutes into domestic service, believing that the demand for servants could never be filled. Women who had no other skills, but who could do housework passably well, took domestic situations as a last resort.

Most domestic servants had little choice of occupation. They were immigrant women, workhouse children from Britain, Canadian children whose families could not support them, ex-convicts, reformed prostitutes, single mothers or widows with one or two children, older women, and women whose husbands were unemployed. In the United States, Lucy Salmon reported that many women entered service because they didn't have enough education to do anything else.[47] Strangers and homeless women naturally gravitated towards domestic service or were directed into it by the officials of half-way homes.[48]

One of the most effective means used to maintain a supply of servants was the recruitment of immigrant labour. Table C shows how important immigrant women were as a source of domestic labour. In 1911, for example, immigrant women formed 35 percent of the female work force in domestic and personal service, even though they made up only 24 percent of the female work force in all occupations including service jobs. Female domestics were "preferred immigrants" long before 1880, but the drive to recruit immigrant domestics intensified as industrialization diverted women from service into other occupations. In 1915, the Protestant Directorate of Female Immigration reported that "during the ten years preceding the war, 129,000 domestic servants entered Canada from overseas."[49] In 1903-04, 3,504 domestics immigrated; the number rose annually until 1913-14, when 21,476 servants immigrated.[50]

Originally, church groups and women's organizations recruited immigrant domestics on an *ad hoc* basis. They supplied receiving hostels, organized job placements, and sent individuals to Britain to search out and bring back suitable domestic help. In 1891, Rev. Canon Pentreath of Winnipeg asked the government to pay the fare of immigrant domestics from Quebec (their port of

Table C

Females 10 years of age or over engaged in gainful occupations in Canada (1911 Census)

	Total	Canadian-born	Immigrant	Percentage of Immigrant Women in Total
All Occupations	364,821	277,985	86,836	24%
Domestic and Personal Service	138,879	90,904	47,975	35%
Charworkers	2,532	1,758	774	31%
Cooks	3,027	1,610	1,417	47%
Hotel & Boarding House Keepers	3,845	2,858	987	26%
Hotel & Boarding House Employees	11,672	7,169	4,503	39%
Housekeepers	6,762	4,654	2,108	31%
Launderers & Laundresses	8,267	5,930	2,337	28%
Nurses & Nursemaids	3,144	2,056	1,088	35%
Servants not otherwise specified	79,609	50,445	29,164	37%

arrival) to Manitoba. He himself had been bringing out single women from the British Isles for nine years, and felt

> a small amount of expenditure will bring to Manitoba a large number of the very class we want, most of whom eventually marry and make their homes here.[51]

Though government gradually became more involved in the mechanics of recruitment, it continued to rely heavily on the energy and private funds of individuals like Rev. Canon Pentreath, and organizations such as the YWCA.

Looking back on the evolution of recruitment practices, W.D. Scott wrote, in 1919:

> In the early days it was customary for a few women to go overseas and select small parties of girls who were brought out under their immediate supervision and placed in situations awaiting here. Before long it became evident to those engaged in that occupation that some sort of receiving and distributing centre in Canada was required and out of this has grown the various homes and hostels which just before the outbreak of war had become quite numerous. The demand for domestic help in Canada became the basis of many movements or organizations for bringing girls out to Canada.[52]

As the need for servants grew, the number of recruitment agents multiplied, and government's support of recruitment increased. The war, and the resulting shortage of servants, acted as a catalyst for the co-ordination of recruitment activities, and in 1919 two national conferences were held because of the need for greater control over the screening and care of women emigrating to take up service. Chaired by Vincent Massey,[53] these conferences were attended by representatives of Dominion-wide organizations such as the YWCA, the IODE, the National Council of Women, the Women's Christian Temperance Union, the Social Service Council, the Federated Women's Institutes, and the Interprovincial Farm Women.[54]

The second conference adopted a motion "to create an organization Dominion-wide to further develop the work undertaken in the past by various societies and persons in a more or less hap-hazard way."[55] This organization was the Canadian Council of Immigration of Women for Household Service," which will co-operate with the Government in the reception, placing and care of domestics."[56] Its purposes were to manage hostels, control Federal or other financial aid, study the immigration of women for household service, and make recommendations to the Department

of Immigration and Colonization. Provincial representatives were to be appointed, and the Council was to co-operate with federal and provincial employment services. The 1919 conferences represented a consolidation of the forces involved in recruiting labour power.

The main source of immigrant domestics from 1880-1920 was Great Britain, though a significant number also came from Scandinavia and northern Europe. Servants were first recruited in England and Scotland, then in northern and southern Ireland (in that order). Recruitment agents looked further afield as the supply of potential immigrants in one area decreased, or as the criteria for good Canadian servants changed. For example, when domestic help was needed on Canadian farms, recruitment agents looked to the country for servants. H.M. Murray, the immigration agent in Glasgow, wrote to the Commissioner of Immigration in Winnipeg, in July, 1898: "I note that you would like some of the rougher element, big, strong, barefooted lassies accustomed to outdoor work."[57] J. Bruce Walker, another immigration official, wrote from Glasgow in August 1903:

> with the system of responsible Agents we now have in the rural districts of Scotland as well as in the larger cities, I find it comparatively easy to obtain a fairly good supply of first class servant girls... whose general domestic accomplishments are just what is wanted in the homes of the West.[58]

Agents of Recruitment

The agents of recruitment were the government, the church, and volunteer associations of upper and middle-class women. The three worked closely together, although their specific activities varied; and Canadian institutions and groups co-operated closely with British ones. Often, the structures that were created to recruit immigrant domestics (such as hostels and training programmes) were used to recruit Canadian women as well.

Through a selective immigration policy, the government encouraged the immigration of workers who could not be supplied by the native-born population.[59] Two kinds of workers were in great demand during this period—farm labourers and female domestics—and they were allowed to immigrate when others were not. The government also provided financial incentives to specified groups and individuals involved in recruiting and placing these workers. The "bonus system," as it was called, was adapted to the economy's need for labour power. In December 1914, for

example, when a depression had flooded the labour market with unemployed women, restrictions were placed on the granting of this bonus.[60] Provincial employment bureaus were not established in Ontario until 1915, but in March 1907 the *Labour Gazette* reported employment agents placing immigrant farm labourers and female domestics in over 180 towns and villages in the province. These agents were paid a $2 bonus for each placement in these occupations.[61]

As a rule, the Department of Immigration refused to advance prospective immigrants their passage money; it handled the money advanced by employers to enable potential servants to immigrate. The usual arrangement was that an employer applied for a servant and sent her passage money to the Superintendent of Immigration. An immigration agent would then choose a domestic in the Old Country, have her sign an agreement which bound her to service with her employer for six months or a year, advance her passage money, and arrange for her transportation, housing, and placement upon arrival. The amount advanced would later be deducted from the domestic's salary in monthly installments.

Occasionally, the government took more initiative in recruiting servants. In 1898, for example, a Mrs. Livingstone was commissioned by the Department of the Interior to travel to Scotland and select one hundred girls for service in the North West.

Mrs. Livingstone attempted to match servant and employer when choosing women for immigration, by allowing servants to evaluate employers and decide where they would like to work—"actually realising the oft laughed at idea of the kitchen demanding that the drawing-room, like it, should give references."[62] However, this arrangement was considered troublesome. It was soon discarded, while employers continued to specify the age, physique, race, character and experience of the servants they wanted. As Scott wrote in 1914, "Many of the girls do not know by whom their passage money was advanced, but are trusting the agency to whom their passage money was advanced for their situation."[63] An immigrant domestic complained in 1919 that the agent in London

> has so much to say about the good time maids have and how *free* you are, that you decide you will come The lady meets you at Union Station, takes you to her house, where she has employers waiting to engage you. You have no choice of a place or work—just have to go where you are sent. . . [64]

> *They are building a new house here and we have had five extra men to attend to besides the three that are always here so I have had very little time to spare....Dear Mrs. Livingstone must I stay here for the whole year. I am afraid I don't like this place well enough for that. I heard Mrs. Downing say she had got me for a year. I have had the offer of better situations with more wages but I thought I had better consult you first, and have your opinion. I like the people here well enough, but the children are so spoiled and cheeky they keep one in attendance on them all the time, in fact it is with a rush I ever get my face washed. I never get my dress changed from mornings I never have time. I am sorry to trouble you with a letter like this, but I should like to know if I am at liberty to leave here after the harvest is over, perhaps in October....*
>
> —extract from letter from Janie Macleod, Indian Head, 1898, Records of the Department of Immigration,

Church organizations in Canada and Great Britain furthered the recruitment of servants in many ways. They produced handbooks, screened applicants, sometimes trained them, advanced them their passage money, organized their transportation, and housed and placed them upon arrival in Canada. Women's groups performed similar activities. Some of these, such as the Catholic Women's League of Canada, were affiliated with a particular church; others, such as the YWCA and the National Council of Women, were autonomous, or only indirectly connected with a church. International link-ups were common. The United British Women's Emigration Association, for example, maintained several receiving homes in Canada, and Canadian women's groups also established homes to receive women sent over by the UBWEA.

An area of responsibility which fell largely upon women's groups was the housing and care of the female immigrants. Women's organizations or women's church auxiliaries operated many hostels across Canada. They were financed by federal and

provincial grants, and by private donations. In 1919, W.D. Scott wrote:

> The problem of the management and support of these hostels is a rather difficult matter. Such an organization as the National Council of Women would perhaps be about the best means of management. I do not think they should be managed by the Government, but they should be inspected by us.[65]

These hostels, or girls' welcome homes, functioned as drop-in centres, training schools and employment agencies before social services were taken over by the state. The volunteer labour of the women who ran them was vital to the smooth running of the economy, as it integrated thousands of badly-needed immigrant domestics into the Canadian labour force. Unemployed and homeless Canadian women were also housed and helped to find employment. The Dominion Council of the YWCA, for example, reported in 1919:

> There are committees in 30 cities where the Association has boarding homes, who are interested in caring for homeless and friendless girls who are strangers, or otherwise in need of help.[66]

Recruitment was primarily a response by members of the employing classes to their need for domestic help, but it was usually portrayed as a charitable activity. Servants often came from the most underprivileged sections of society; they were the poor, the homeless, the unemployed; they were female, and sometimes they were children. Entering service often meant a relative improvement in their lives, and recruiting agents were quick to point this out, thus rationalizing their own exploitation of domestics.

Recruitment of immigrants was seen as beneficial to all parties involved, and in this connection the active part played by British institutions must be noted. Overpopulation, high unemployment rates and severe poverty threatened the stability of British society during this period, and it is possible that Britain had even more to gain than Canada from the relocation of large numbers of people. The United British Women's Emigration Association, a society "mainly composed of very influential ladies" (Her Royal Highness, the Princess of Wales, was its patroness) proposed an elaborate immigration scheme to the Canadian government in 1890.[67] This society sent out about 3,000 persons between 1884-1894, "the great majority of whom were women."[68] The Duchess of Suther-

land (speaking to the Staffordshire branch of the UBWEA in 1894) stressed the selfless nature of their work:

> She only wished she could influence them with the belief...that they were doing clean, healthy, robust work; that they snatched up people who otherwise would sink, that they saved them from crime and penitentiaries, and gave them health and hope...She wanted them to see that this work of emigration was a very noble work in its relation between themselves and their fellowmen, between themselves and their Father who was in Heaven, she wanted them to see that it was the purest philanthropy because it was so absolutely unselfish—"for their good will we spare them." She wanted them also to feel that there was a higher ground, that it was a religious work.[69]

Earlier in her speech, however, the Duchess of Sutherland acknowledged that "the great army of unemployed"[70] presented a threat to the *status quo*; emigration was a solution to this problem:

> There could be no doubt that emigration was one of the most interesting subjects which could engage their minds, inasmuch as it touched upon those vast problems which every government and every country in the civilized world was confronted with, and which were found up with the distribution of labour... A large proportion of the unemployed, she feared, their Colonies would not thank them for; but the able-bodied men and women who formed the other portion, and heard the daily cruel cry of their families for bread, would appreciate the joys that could be got out of life in its purest and best sense beyond the seas, which they would never learn in the over-crowded cities of the Old Country.[71]

And as the 1898 Report of the UBWEA pointed out, "Every pound spent on sending out a successful emigrant saves the need of supporting other (philanthropic) societies, which would not exist but for over-population."[72]

The benefits to the intending emigrant were glowingly described, but opportunities for men were considerably greater than those for women:

> ...by a wise and protected emigration they placed the man where he was wanted and employed, without excessive toil, and where he might rise to any position of substance and responsibility—the woman where her poorest work was well paid, her virtue respected, and prospects of successful marriage awaited her.[73]

The benefit to Canada was two-fold. Immigration aided settlement of the country (thereby protecting the West from Ameri-

> ### Immigrant Girl Works Twelve Years for $690
>
> The case of immigrants lured to this country for purposes of intensive exploitation is fast becoming a national scandal.
>
> One of the latest cases came to notice in Judge Merideth's court in Toronto when Kate Lees attempted to recover wages covering a period of twelve years. She was sent out from the old country over twelve years ago as a slave of the farm at a wage of $8 per month, but she didn't get much of even that miserable pittance.
>
> The lawyer who defended her exploiter advanced the argument that in view of the advantages she had of getting an eye full of the superior people she was slaving for she shouldn't ask for so vulgar a thing as money.
>
> The Judge "awarded" her $690.00 although she asked for $3,703.00 saying that the "statute of limitations" prevented him from giving more. But there was no "statute of limitations" to prevent her twelve-year peonage.
>
> —*from* The Worker, *December 7, 1929.*

can annexation), and provided a ready supply of workers for unpleasant jobs that native-born Canadians didn't want.

The church groups and women's organizations involved in recruitment of domestics were essentially operating in their own class interests, but they also had other motivations for this work. The church wanted to retain authority over its own members. Rev. John Chisholm, Secretary of the Protestant Directorate of Female Immigration, wrote to the Minister of Immigration and Colonization on 17 November:

> As the religious bodies we represent voluntarily and enthusiastically used their pulpits and organizations to secure for the Government of which you are a Minister, the man and money power by means of which you were able to carry on the Great War to a successful issue, so we now present ourselves, mobilized as never before, asking your Department to use us for the purpose of securing the best possible class of immigrants...

> Whilst we strongly approve of the State holding in its strong hand exclusive control of all classes of immigrants, we see no reason why your department cannot permit the churches to keep their hands on, especially the female portion of their respective communities, from the time they leave the overseas parishes and congregations to which they belong, until they are safely and comfortably settled in the bosoms of the corresponding churches in Canada....The Hon. C.J. Doherty, Minister of Justice, enunciated the following principle in the name of the Roman Catholic Church and forwarded the same to us,—'The interests of the female immigrants are best looked after by the religious bodies to which they belong.'[74]

Recruitment of domestics was seen by volunteer women's groups as a respectable and socially useful activity for upper and middle-class women. The UBWEA praised the actions of a Miss Fowler, who prepared herself with a knowledge of domestic life, moved to Canada, and opened a Girls' Welcome Home in Winnipeg:

> In no other country in the world are there so many women of means and of leisure as in England; there are splendid spheres of action open for helping their fellow country women in the wisest way, by going out and founding and superintending such Colonial Homes or Clubs.[75]

Control of the Labour Force

Because domestic service was so unattractive, various pressures had to be exerted on working class women to enter and remain in service. With regard to immigrant women, policy-makers were anxious that these women take the domestic situations for which they were intended, rather than seek other kinds of work. At the 1919 conferences of those involved in recruitment, Thomas Molloy of Regina urged that "no girls be brought to this country who would do outside work, as our men are now walking the streets."[76]

Since it was so difficult to enter the country in any other way, a number of women immigrated under false pretenses. When his Irish domestic left him after five days, an angry employer wrote to the Immigration Department:

> It is quite clear that she deliberately made use of this easy opportunity to get to Canada where she has already arranged to get into a factory.[77]

The "assisted passages" which helped many women to immigrate was also a method of keeping those women in their places—at least until they had paid off their debt. A government

agent in Glasgow complained to Ottawa about two servant girls who
> backed out at the last minute, and did not sail by their line. As they both intended paying their own passage, we will have no authority in the matter of looking them up.[78]

Normally, servants entering Canada by means of an assisted passage signed an agreement committing themselves to six months or a year with their first employer. If required by provincial law, this agreement was re-signed in Canada so that it would be legally binding.[79]

The advanced passage allowed many women to immigrate who otherwise would have faced a life of poverty in Europe, but its charitable aspect should not be exaggerated. As W.D. Scott pointed out (October 1913):
> It is now pretty generally known that girls who come to Canada as domestics have to pay a good deal more to get out here than ordinary passengers. I am aware that many of them come out on advanced passages and the risk must be paid for in some way. Most of the Societies undertake to investigate references in the Old Country, have the girl travel in a protected party with a matron and give her free board and lodgings for, at least, 24 hours after her arrival, and the Department agreed some years ago to allow such Societies to collect an additional amount (not exceeding $7.00) over and above the ordinary fare.[80]

The hostels and "protected parties" served the real needs of immigrant women, but also exercised a certain amount of control over their activities. In 1914, Mrs. E.A. Burrington-Ham complained to Ottawa about the lack of hostel space for immigrant domestics:
> If our Association cannot take them in, they are sent to an Inn, or Hotel.
>
> In the interval of waiting to be placed, the girl makes friends with any one that she may meet, and gets into the habit of walking around the town, and being taken to "shows" etc., consequently when given a position, she cannot, or will not keep it, not wishing to settle down to work.[81]

The hostels provided not only shelter, but also protection from temptation.

In many cases, the disadvantages of those recruited into service were used to control them. The Winnipeg Commissioner of Immigration pointed out the poverty of some of the Irish domestics immigrating to the North West: "some...are so entirely without

clothing that their employers tell them that the first wages must be taken up to purchase clothing."[82]

Servants in the North West

One of the most important aspects of recruitment was what the Winnipeg Commissioner of Immigration called "this matrimonial agency business."[83] The hope of marriage was a strong inducement for single women to immigrate as domestics. The Canadian government publicized the need for women, especially in the North West, and as wars in Europe had caused a shortage of men, many women responded to this publicity. Two women from Ireland wrote to the Department of Immigration:

> Sir,
> Seeing your article in the "Ulster Echo" entitled "A Girl Famine," and reading the account of the high wages that are given to servants in America, a friend and I have decided to emigrate shortly.[84]

Surplus women were causing great economic problems for Britain. Mr. Chamberlain, addressing the UBWEA on 15 March 1901, said that these women

> were jostling one another in the struggle for existence, so that the wages of women were greatly reduced.... It was, therefore, of the greatest importance that the disproportion here should be reduced by sending women to places where the disproportion is exactly in the opposite direction.[85]

Many women who immigrated as domestics soon married —sometimes to their employers. In *The Book of Small* Emily Carr writes:

> English servants who came out to Canada did so with the firm determination of finding a husband in a hurry and of making homes and raising families who would not be servants but masters. While waiting for the husbands these women accepted positions, grumbling from morning till night at the inconveniences of the West. There were hosts of bachelors trying to make good in this new world—men who were only too willing to marry a helpmate. Love did not much matter if she was competent and these women in their turn were glad enough to go through drudgery and hardship if they were working for themselves and for their own independence.[86]

As the Canadian High Commissioner wrote to the Hon. Mrs. Joyce (2 March 1903), these marriages were not "a difficulty which should be deprecated, but rather a source of very great satisfaction

to the Officials of the Government, and one that it is a pleasure to be able to record."[87]

Throughout the period, single servant women were encouraged to immigrate—presumably because of the scarcity of women in Canada. As late as 1917, an immigration official was writing to the Superintendent of the Passport Office in London that

> there is, as obviously is well-known, a great disparity in the sexes of the population in Canada, and urgent need for some of the over-plus women of the British Isles.[88]

The propaganda used to populate the North West, however, may have disguised the truth. An article in the *Daily Nor'Wester* (11 April 1896) stated:

> While we are not prepared to make any statement as to the proportion of the sexes in Manitoba and the Northwest, we are still under the impression that the one is not greatly in excess of the other, the proportions having materially changed within the last five years.[89]

But in the early part of the period, at least, there *was* a real need for single women in Western Canada. The attraction of free land drew many bachelor farmers to the North West and, in their wake, single women like those celebrated in the folksong "Poor Little Girls of Ontario"; the marital and economic opportunities of the West attracted Canadian-born, as well as immigrant women.

An influx of female domestics to the Canadian North West solved two problems at once—the shortage of domestic workers, and the slow progress of settlement. An article in the *Canadian Gazette*, London, England (1896) stated:

> The Land Commissioner of the Canadian Pacific Railway Company again reminds us that the great want of the Northwest is more women. The bachelor farmer is, he says, the greatest drawback to the prairie country. His home unkempt, and his life unsweetened by human companionship save that of his own stern sex, he becomes dissatisfied and careless. As a Canadian journal truly remarks, a few thousand loyal and sensible women would probably do more to make that country than any other influence that could be brought to bear upon it just now. They would give some energy to the now weak and ineffectual efforts of lone young farmers. Suitable immigrants of that kind can find employment at excellent wages, and are not likely to have to do long without husbands, if they are so inclined.[90]

After working their land for a certain number of years, settlers gained title to the land and could sell it. Domestic servants who married Canadian farmers and established roots in the North West

helped to stem the flow of Canadian men to the United States, where economic opportunities were greater once you had acquired a stake. The Winnipeg Commissioner of Immigration wrote to the Superintendent of Immigration in Ottawa (June 1899):

> Now, it is needless for me to point out to you the great desirability of getting servants into this country, not only as helps to the farmers, but as future wives for young men, a large percentage of whom leave the country, some before they have earned their patents and others just as soon as they have acquired titles to their lands, solely on account of the solitude occasioned by leading a bachelor's life.... You cannot go into this matrimonial agency business in any other way except by the importation of English-speaking general servants of good morals, who would make good farmers' wives.[91]

The role of domestic servants in promoting settlement was important enough to the government that, for example, it organized and financed Mrs. Livingstone's trip to Scotland in 1898, in order to procure candidates for service. Even though Mrs. Livingstone's party "was of considerable expense to the Department,"[92] another party was organized by the government shortly afterwards.[93] In reference to the Scottish domestics recruited, one immigration official wrote to another (in July 1898): "I accept your bet in the hope that what you say will come true, i.e., that fifty percent of the girls will marry within a year."[94]

The female servant who married a bachelor farmer could "assume the dignity and responsibility of an employer rather than of an employee,"[95] according to the Canadian High Commissioner. As a wife and mother, she could work for herself and her family on land that they owned. This goal of economic independence was also attractive to women from the eastern part of Canada, who otherwise would have had to marry factory workers or hired labourers. The CPR, which, like the government, had an economic interest in settling the West, promoted and glorified the image of servant-turned-mistress, who enjoyed propertied independence in the West: "In the old country a servant remains a servant always; here she becomes mistress of her own house."[96]

To the agents of recruitment, however, servants and wives performed similar functions in the development of the economy. Both supplied badly-needed domestic labour, thus maintaining a labour force which worked outside the home. An ad placed in the *Winnipeg Free Press* (March 1896) by the Department of the

Interior, addressed itself to "farmers who are in want of female help, or wives,"[97] and offered to procure them.

The recruitment of single domestics for the North West illustrates the thin line between paid and unpaid domestic labour, as far as the general economy is concerned. The labour provided by immigrant domestics and farm wives was one of the main building blocks of Western development. By caring for their husbands and children, they made their labour power available to the Eastern and British capitalists who raked off huge profits from the West, particularly during the wheat boom. The crucial importance of domestic labour to the economy was apparent in the West at the turn of the century simply because that labour was in short supply. In the long-settled provinces of the East, domestic labour was never that scarce and therefore could remain unnoticed. In the letters quoted above, government officials pinpoint the servant's relation to her prospective husband as the main reason for her economic importance. By maintaining him and his home, she made it possible for him to work and create a profit for the owners of industry. *Domestic labour was and is the precondition for all other labour.*

Women in the West, however, were also essential because of the productive work they themselves did. In the 4 July, 1904 edition of *The Virden Advance*, an article called "The Manitoba Women's Burden" described the need for more domestic help:

> One of the most urgent problems before the farming community in Manitoba is the securing of help in the house and in such branches of the industry as dairying and poultry raising, so essentially feminine. Manitoba is past the pioneer stage of her development... but her women are from necessity the veritable slaves of their environment. We scarcely even hear them complain, so inured are they to the continual grind, and so conscious are they that it is next to impossible to secure help. Such a state of things is a clog on the progress of the Province. Many men have to abandon farming as a profession because their wives are unequal to the physical strain which the endless duties of a farm house imposes on them... It is meet that our women should have leisure to enjoy the fruits of their industry.[98]

Servants' Organizations

While the activities of the employers' recruiting organizations were both well-organized and well-documented, the opposite is true for the few servants' organizations that did exist. In a letter to the Toronto *Globe* (1886), a domestic servant said:

> There is no association more needed than for servant girls. So many wrongs could be righted, so much ignorance be enlightened by forming themselves into a band of mutual helpers. Their grievances are manifold....A servant girls' association should be properly established, lectures in cookery, laundry work, & c., labour bureau attached, and all members looked after; a small monthly fee attached to membership and weekly meetings; a general aim at the elevation of the despised, poor, isolated, degraded servant, who is so important to the welfare of the household.[99]

Several attempts besides this one were made to form a servants' union,[100] but none were very successful for more than a short period of time. As Bonnie Kreps noted in the March 1973 *Chatelaine*, there is still no domestic servants' union. Why has this aspect of houseworkers' history been a history of failure?

Many factors made it difficult for servants to organize themselves into protective associations, but the biggest drawback was the isolation of the servant's workplace. In contrast to the factory or office, which brought workers together, revealed their common interests, and provided a base of action, the private home separated the domestic employee from her sister workers and overemphasized the personal aspect of her relationship with her employer. This meant that the impetus for organizing had to come either from outside the workplace, or from highly motivated individual servants. But even after this first hurdle was passed, isolation and lack of freedom created practical problems for servants. In his study of domestic service in Britain, E.S. Turner notes that

> attempts were made, in Dundee and Leamington to form unions of domestic servants, but the scattered nature of their employment and the difficulty of attending meetings rendered these efforts fruitless.[101]

Servants also had a low image of themselves; in Canada, many women viewed being a servant as a temporary phase in their lives. Those who had not been indoctrinated with the "virtues" of passivity and self-sacrifice were more likely to leave service than to strive for better working conditions.

The same problems that made establishing unions difficult made taking collective action almost impossible. It is hard to imagine what kind of successful strike action servants could take. Servants who lived in were especially vulnerable to reprisals. Emily Murphy encountered several women in her court who had been led to prostitution when stranded without lodgings for the night:

> It was heart-breaking to find how small a cause had often brought about a girl's downfall. One such tragedy occurred when a mistress had locked the nursemaid out all night because she was late returning home. Often a girl hadn't the price for her lodging, and so, for lack of a few cents, had been drawn into a life of infamy and disease.[102]

Many workers in domestic service were from the most vulnerable and desperate sections of society. Strike action was riskier for them than for other women workers (who in a pinch could always fall back on domestic service).

The nature of servants' work also affected their bargaining power. This work increasingly became service labour; withdrawing this labour might cause great hardship to the family but it did not interfere directly with industrial production and profit-making. With industrialization, domestic work was increasingly being taken on by family members, particularly the housewife. The trend was towards small self-sufficient households that didn't need servants. In 1892, Jean Scott wrote:

> At present there does not seem to be any expectation of the supply of domestics being increased. Wages have risen, so that many families who formerly were able to keep a servant now do without, and those who kept two or three can keep only one or two. In Canada the majority of housekeepers are able to do their own work in an emergency; so that the interval between the leaving of one servant and the advent of another does not mean a complete interregnum in the work of the household. Owing to the invention of many modern conveniences it is possible to reduce the work to a minimum; and by getting partial assistance for the very heavy work many are able to do without house servants altogether.[103]

The establishment of the first unions provoked a defensive reaction on the part of employers. At the 1919 Conference on Immigration it was stated:

> Already both in Great Britain and Canada there are Unions of Houseworkers. They demand no standard of efficiency, no certificate of attainment, no period of apprenticeship, and yet are asking

the same recognition as qualified members of an established trade, such as a minimum wage, an agreement, hours of labor, hours of freedom, etc.[104]

Mrs. Yemans, an independent recruiting agent, supported minimum standards for workers, but said "There must first of all be a standard of the efficiency and serviceableness due to the employer."[105]

In turn, servants were often timid or apologetic about advancing their demands, sometimes offering something in return, such as guaranteed skills. A survey by the Dominion Council of the YWCA in 1919 reported:

> A Housekeeper's Association was organized in Calgary 3 or 4 years ago, the housekeepers asking certain privileges from their employers and pledging themselves to greater efficiency by arranging to take a special course in cooking in the public schools. The young women who took the course felt it was too simple after their practical experience.[106]

Others saw the gulf between their own interests and their employers' very clearly, and took a more independent stand. In 1886, Mary Brown wrote to the editor of the Toronto *Globe* from Guelph:

> Sir.—I wish I could get in correspondence with the two servants whose letters you published. I have thought on the subject for many years, and it seems to me that now is my opportunity. There really is need for reform....Of all classes of work people the servant girls ought to have an association; but if we wait until the ladies help us we will wait a while. I say let us form an association ourselves. Mr. Editor, can I ask "Kathleen O'Neal to write to me, and the one who signs herself "Another Servant"?[107]

A by-product of the isolated workplace was the apparent chaos, or lack of standards, within domestic service. Lucy Salmon wrote:

> Wages are too often regulated by the employer's bank account, hours of service by his personal caprice, and moral questions by his personal convenience.[108]

The lack of standardization meant that there were no limits to servants' exploitation, but also that any struggle for better working conditions would have had to take place without a clear frame of reference. A servants' union might have to deal with a hundred different employers, all having their own codes of fairness and their own individual requirements.

Most of the factors making it very difficult for servants to organize themselves stemmed from the isolated nature of their workplace, and the personal, one-to-one relationship between employee and employer.

The Effect of Industrialization on Domestic Labour

After 1880, domestic service in Canada was a remnant of feudal times in an industrial age. Employees did not have the same privileges and freedoms as other workers, or the protection provided by unions and legislation. The laws enacted to govern workmen's compensation, minimum wages, hours of work and conditions of labour were all inapplicable to domestic servants in 1920,[109] and many of them still are. Also, industrialization had stripped the mistress/servant relationship of its traditional security[110] and made it an impersonal relationship,[111] though it involved personal service in the private setting of the home. Many people felt the servant's presence to be an extraneous element in the family circle, in contrast to pre-industrial times when the servant was a permanent, full-fledged member of the household.

Many observers noted the contradictions of industrial principles and the demands of housework, and sought to correct "the servant problem" by bringing conditions of labour into line with other forms of work. At the 1919 conferences, the Superintendent of the Trade and Labour Branch advocated "standardizing housework and the possible giving of a diploma and button of completion of training by the girls."[112] Mrs. Yemans outlined various regulations for employers, which she felt were necessary to remove "the social stigma at present attaching to domestic service":

1. The uniforms of members of this service whilst on duty should not be such as to injure their self-respect.
2. They must be free from the control of their employer while off duty.
3. They must be addressed, as are women in stores and factories, by their surnames.[113]

Lucy Salmon also felt that domestic service should be drawn "into the general current of industrial development,"[114] but she alone recognized the difficulty of accomplishing this goal in the privacy of the home. The solutions she suggested aimed to increase this privacy, by taking domestic labour out of the home as much as possible:

> ...the problem is not so much how to improve the personal relationship between the employer and the employee as it is to decrease this relationship...not how to merge the individual home into the co-operative home or boarding house, but how to keep it still more intact by taking out of it as far as possible that extraneous element—the domestic employee... [115]

She rejected the alternative solution of co-operative housekeeping on the grounds that it was incompatible with the American ideals of privacy and individualism:

> But the most insuperable objection to co-operative housekeeping as a remedy for the troubles with servants is the fact that the majority of persons do not wish it....When its friends say in its favour, "Every time an apartment house is built having one common dining-room and one kitchen a blow is aimed at the isolated home," the great majority of Americans rise up in protest... [116]

Lucy Salmon was prophetic; the privacy of the home has increased, and industrialization has eased the domestic burden, by creating a wide range of products for home consumption, from canned food to vacuum cleaners. Necessary domestic labour has been reduced to the extent that it can be handled by the family itself (usually in the person of the wife and mother).

It is interesting to examine Lucy Salmon's predictions which have *not* been fulfilled. She foresaw the solution to "the servant problem" as part of a large-scale industrialization of housework through the socialization of labour, as well as through mechanization, technology, and the production of "convenience goods." She recommended the development of catering services and laundry services outside the home. As for general housework: "Much, if not all of this work can be done by the piece or hour, and men and women everywhere are taking advantage of this fact."[117] Cooking would largely be done outside the home: "It seems inevitable that eventually all articles of food will be prepared out of the house except those requiring the last application of heat."[118] These developments would have done for housework what had been done for all other work—removed it from the home and placed it in the realm of waged labour. Domestic workers, who could be either men or women, would operate from a position of greater industrial independence than the live-in servant or unpaid family members.

These developments have not occurred, at least on the vast scale which Lucy Salmon envisioned. Instead, domestic labour has become the main responsibility of unpaid housewives, who appear to operate outside the economy altogether. Industrializa-

tion has affected housework through the proliferation of consumer goods rather than through the development of large-scale service industries. When the domestic servant left the home, she left the housewife behind to operate her new household gadgets alone. Transforming domestic labour into consumerism was the most profitable and efficient way for industry to deal with the problems of housework. Lucy Salmon's predictions were based on social planning and people's needs, but these do not motivate capitalism.

Housework and childcare are vital to well-being, and to the functioning of industries which depend on labour power, but with industrialization, less and less official recognition was given to domestic labour. Early censuses, such as the 1851-52 *Census of the Canadas*, list female servants in a separate category, even though occupations were not regularly broken down by sex until the 1891 census. However the 1901 census did not list servants at all, because

> the whole tendency of industries is towards the concentration of capital, management, skill and labour. No doubt there are reasons for desiring to know the variety and value of individual employment; but in any well-conceived scheme for collecting the data of manufacturers regard should be had for the idea of a factory as a modern going concern.[119]

Later censuses listed all paid workers, and the 1901 figures appear in their comparative charts. However, 1911 and 1921 censuses demonstrate the low value generally placed on domestic work by allowing all workers, paid or unpaid, to be described as "gainful worker" *unless* they were engaged in housework.[120] The 1916 Report of the Ontario Commission on Unemployment protested against this devaluation of domestic work:

> ...a step in advance in the interests of all women's employments would be taken should educational authorities and the State recognize home-making and the care of children as women's employments requiring training, skill, and efficiency. It would aid women who are home-makers and engaged in taking care of children if the importance of these employments, both economic and social, was nationally and definitely recognized.[121]

The view that domestic labour is strictly a family affair is as false today as it was when the Canadian government sought "farm help, or wives" to promote settlement of the western provinces. Though technology has transformed housework, wives still perform the essential service of caring for the workers who produce goods and profits outside the home.

Conclusion

Domestic service has changed greatly since 1920, though many of its oppressive aspects have lingered on. Most servants now live outside the home, and work for a number of employers on an hourly or daily basis. These day workers, or "cleaning ladies", have much more personal independence than the live-in servants of 1880-1920. Nevertheless, many disadvantages of service still exist: low status, low pay, isolation, irregular working conditions, and lack of protection from unions or legislation. An amorphous group with an ambiguous status, these workers are still unorganized.

Live-in servants are no longer needed for heavy, physical drudgery. The huge tasks of cleaning, dusting, water-carrying and laundry have been simplified or taken over by technology. Servants are today most in demand for childcare, which remains one of women's most demanding and time-consuming responsibilities.

The history of domestic service is most relevant, however, to the situation of housewives and other unpaid domestic workers today. Most working- and middle-class wives are responsible for the home, whether or not they are also in paid employment. Although servants and wives had very different roles in 1880-1920, many analogies can be drawn between the situations of servants during that period, and of housewives today.

The housewife has inherited many of the disadvantages of domestic service. The skill and the economic importance of her work is unacknowledged, and she works in isolation. She has also inherited to some extent the servant's low social status; her relationship to her husband, like that of maid to mistress, is characterized by inferiority and economic dependence. She is expected to display the skills of deference and the moral qualities of the "good" servant: submissiveness, cleanliness, sexual virtue and passivity.

Today's housewife experiences many of the frustrations which drove domestics from the home, but she finds it much more difficult to leave. Her work revolves around and is seen as benefitting only the family, but, being a part of that family, the housewife cannot go on strike against it. Though she provides the crucial social and economic service of reproducing and maintaining the present and future labour force, the housewife cannot struggle outside the family for better working conditions; the split between home life and work outside the home has camouflaged the impor-

tance of her role in the economy, and thus, has devalued her labour. Her powerlessness stems from the contradiction between her official status and her real contribution; this contribution is not likely to be recognized under a capitalist system for which it is both profitable and advantageous to have the housewife working as unpaid and socially unrecognized labour. The inhumanity of a system which devalues work that is socially useful, because it does not directly produce a profit, must lead women to question the justice of that system, based upon the profit motive and not upon human needs.

Footnotes

1. *Census of Canada, 1921, Volume I—Population*, p. xxxi.
2. *Ibid*.
3. See Table A.
4. Mrs. Bloomer, "The Problem of Domestic Service from the Mistresses Point of View," *Women Workers of Canada. Being a Report of the Proceedings of the First Annual Meeting and Conference of the National Council of Women*, (April 1894), p. 156.
5. Letter from W.D. Scott, Superintendent of Immigration, Ottawa, to J. Obed-Smith, Assistant Superintendent of Immigration, London, England, February 28, 1916. Records of the Department of Immigration, listed under Domestic Servants, Public Archives of Canada, Ottawa. (Further references to these records will be abbreviated as RG76, Domestics.)
6. *1961 Census of Canada*, Table 81, Bulletin 1.3-2, *Population*, and Table 21, Bulletin 3.3-7, *Labour Force*.
7. See Leo Johnson's article, "The development of class in Canada in the twentieth century," in *Capitalism and the National Question in Canada*, ed. Gary Teeple.
8. These examples are taken from a survey of approximately 300 applications for servants, made to the Department of Immigration between 1891 and 1918. RG76, Domestics.
9. For example, *The Household Encyclopaedia of Business and Social Forms* by James Dabney McCabe (Paris, Ontario: John S. Brown, 1883).
10. Eaton's Catalogues, 1885-1920, Eaton's Archives, Toronto.
11. *Eaton's 1887-1888 Fall & Winter Dry Goods Catalogue*, p. 3.
12. *Eaton's 1892-93 Winter Catalogue*, p. 12.
13. *Eaton's 1893-94 Fall & Winter Catalogue*, p. 24.
14. *Eaton's 1919-20 Fall & Winter Catalogue*, p. 211.
15. Letter to W.D. Scott, Supt. of Immigration, from John Madill, St. Catharines, Ont., June 14, 1907. RG76, Domestics.
16. Jean Thomson Scott, "The Conditions of Female Labour in Ontario," p. 19.
17. Letter from J. Obed-Smith, Asst. Supt. of Immigration to his booking agents, Jan. 8, 1915. RG76, Domestics.
18. Memorandum from Mrs. Yemans to Hon. Mr. Calder, Minister of

Immigration and Colonization, 1918. RG76, Domestics.
19. *Women of Canada. Their Life and Work*, compiled by the National Council of Women of Canada, 1900 for distribution at the Paris International Exhibition, p. 108.
20. "The Servant Problem": A Sketch from Fanny Hurst's Novel "Lummox," *The Worker*, March 26, 1926.
21. Mary Pattison, *Principles of Domestic Engineering*, p. 54.
22. Leonore Davidoff, "Mastered for Life: Servant, Wife and Mother in Victorian and Edwardian Britain," presented at the Anglo-American Conference in Comparative Labour History, Rutgers University, April 26-28, 1973.
23. Letter to the Editor from Mary Brown, Guelph, *The Toronto Globe*, March 8, 1886.
24. *Women Workers of Canada*, p. 163.
25. A comparison of the legal status of servants with the legal status of other kinds of employees appears in *Ontario Reports 1973 Volume 2*, p. 558 at 562 by Mr. Justice Kelly (Ontario Court of Appeal) in Genereux et al. v. Peterson, Howell and Heather (Canada) Ltd. et al.
26. Jean Scott, "The Conditions of Female Labour in Ontario", p. 19.
27. Letter from Mary Bain to W.D. Scott, Supt. of Immigration April 23, 1907. RG76, Domestics.
28. *Women's Work in Canada. Duties, Wages, Conditions and Opportunities for Household Workers in the Dominion* (Department of Immigration and Colonization, 1921), p. 2.
29. Lucy Maynard Salmon, *Domestic Service*, p. 87.
30. Jean Scott, *The Conditions of Female Labour in Ontario*, p. 19.
31. Letter from the Asst. Supt. of Emigration to W.D. Scott, February 18, 1914. RG76, Domestics.
32. Miss Watson of the Macdonald Institute, Guelph, quoted in a letter from Roberta MacAdams to James Calder, Minister of Immigration and Colonization, Jan. 27, 1919. RG76, Domestics.
33. Letter from J. Obed-Smith, Asst. Supt. of Emigration, to the Superintendent, Passport Office, Foreign Office, London, January 17, 1917. RG76, Domestics.
34. Report from Mrs. John MacNaughton, President, Interprovincial Council of Farm Women, Proceedings of the Conference on the Care and Housing of Women Immigrants, May 14, 1919. RG76, Domestics.
35. Jean Scott, *The Conditions of Female Labour in Ontario*, p. 20.

36. "Secret of Keeping Servants," *The Evening Telegram*, Toronto, August 5, 1914.
37. Letter from W.D. Scott, Supt. of Immigration, to J. Obed-Smith, Asst. Supt. of Immigration, December 1, 1914. RG76, Domestics.
38. "What Women are Doing," *The Evening Telegram*, Toronto, September 14, 1914.
39. Report to W.D. Scott, Supt. of Immigration from Miss Johanna Malone, Supt. of St. Anthony's Villa, Montreal, November 11, 1914. RG76, Domestics.
40. Report to W.D. Scott, Supt. of Immigration from Miss Bertha M. Thomas, Matron of the Women's Hostel, Calgary, November 8, 1914. RG76, Domestics.
41. Report to W.D. Scott, Supt. of Immigration, from Mrs. Jessie Matheson, Secretary of the Girls' Home of Welcome, Winnipeg, November 9, 1914. RG76, Domestics.
42. Cable to W.D. Scott, Supt. of Immigration, from Dominion Immigration Agent, St. John, New Brunswick, May 29, 1915. RG76, Domestics.
43. W.D. Scott, Supt. of Immigration, to J. Obed-Smith, Asst. Supt. of Immigration, April 7, 1916. RG76, Domestics.
44. Patricia Alexander, "Women in the Work Force: The First World War and the Twenties", (Ottawa, 1972).
45. Letter quoted in memo of the Department of the Interior, Immigration Branch, Ottawa, November 9, 1914. RG76, Domestics.
46. Letter from the Rev. John M. Chisholm, Secretary, Directorate of Protestant Female Immigration, to J.A. Calder, Minister of Immigration and Colonization, November 17, 1918. RG76, Domestics.
47. Lucy Maynard Salmon, *Domestic Service*, p. 113.
48. A brochure published about 1885 by the YWCA, in response to public criticism of its boarding houses, protested: "Some have been alarmed that we would make it so easy for servant girls to leave their places when they could come to our house...We have always encouraged girls who are fit for it to work as domestics." YWCA Minute Book, 1885, Ontario Archives.
49. Rules and Regulations of the Protestant Directorate of Female Immigration, adopted June 22, 1915. RG76, Domestics.
50. Memo from W.D. Scott, Supt. of Immigration, to Mr. Cory, March 13, 1919. RG76, Domestics.
51. Letter from the Rev. Canon Pentreath, Winnipeg, to G.H. Campbell,

Sept. 24, 1891. RG76, Domestics.
52. Memo from W.D. Scott, Supt. of Immigration, to Mr. Cory, March 13, 1919. RG76, Domestics.
53. Cousin to Charles Albert Massey (*See* "Sex and Violence in Toronto, 1915").
54. Letter from the Minister of Immigration and Colonization to the Governor General in Council, September 17, 1919. RG76, Domestics.
55. *Ibid*.
56. Memo from the Department of Immigration and Colonization, September 25, 1919. RG76, Domestics.
57. Letter from H.M. Murray to W.F. McCreary, Commissioner of Immigration, Winnipeg, July 9, 1898. RG76, Domestics.
58. Letter from J. Bruce Walker, Glasgow to J. Obed-Smith, Winnipeg, August 20, 1903. RG76, Domestics.
59. The same attitude towards immigration exists today. Former Minister of Immigration Bryce Mackasey was quoted in the June 23, 1973 edition of the *Toronto Star* as saying that unskilled immigrants must be brought in to fill the jobs Canadians don't want.
60. Letter from W.D. Scott, Supt. of Immigration, to J. Obed-Smith, December 1, 1914. RG76, Domestics.
61. *The Labour Gazette*, Vol. VII, July 1906 to June 1907, p. 1012.
62. Notice in the *Evening News*, Glasgow, May 1898. RG76, Domestics.
63. Letter from W.D. Scott, Supt. of Immigration, to Col. Sherwood, Chief Commissioner of Dominion Police, Ottawa, September 29, 1914.
64. Letter from Mrs. J.C. MacIver, Chairman, United Women Workers, Toronto to J.A. Calder, Minister of Immigration and Colonization, April 14, 1919. RG76, Domestics.
65. Memo from W.D. Scott, Supt. of Immigration, to Mr. Cory, March 13, 1919. RG76, Domestics.
66. Survey made by the Dominion Council of the YWCA, February 1919, RG76, Domestics.
67. Report of the Sub-Committee of the Select Standing Committee on Agriculture and Colonization, May 1, 1890, Records of the Department of Immigration, listed under United British Women's Emigration Association, Public Archives of Canada, Ottawa. (Further reference to these records will be abbreviated to RG76, UBWEA.)

68. Reported speech of the Duchess of Sutherland, *Rugeley Advertiser*, February 3, 1894. RG76, UBWEA.
69. *Ibid.*
70. *Ibid.*
71. *Ibid.*
72. United British Women's Emigration Association Report, 1898. RG76, UBWEA.
73. Reported speech of the Duchess of Sutherland, *Rugeley Advertiser*, February 3, 1894. RG76, UBWEA.
74. Letter from the Rev. John M. Chisholm, Secretary of the Directorate of Protestant Female Immigration to J.A. Calder, Minister of Immigration and Colonization, November 17, 1918. RG76, Domestics.
75. Report from the Emigration Committee at Vancouver City, UBWEA Report, 1898. RG76, UBWEA.
76. Proceedings, Conference on the Care and Housing of Women Immigrants, May 14, 1919. RG76, UBWEA.
77. Letter from P.H. Bryce, Chief Medical Inspector, to J. Bruce Walker, Brantford, September 17, 1906. RG76, Domestics.
78. Letter from the Acting Canadian Government Agent, Glasgow, to W.D. Scott, Supt. of Immigration, October 15, 1906. RG76, Domestics.
79. Master and servant legislation was enacted in most provinces around the turn of the century. In some provinces, this legislation stated that a servant could not be bound by the terms of a contract signed outside the province; this protected the servant from an exploitative contract which she might have signed in order to immigrate. However, the Department of Immigration circumvented this legislation by having immigrant domestics re-sign their contracts upon arrival in Canada. See, for example, the letter from W.D. Scott to J.V. Lantalum, Dominion Immigration Agent, St. John, New Brunswick, November 28, 1907. RG76, Domestics.
80. Letter from W.D. Scott, Supt. of Immigration, to Miss Mary Carmichael, October 11, 1913. RG76, Domestics.
81. Letter from Mrs. E.A. Burrington-Ham, Immigration Department, Quebec to Col. A.P. Sherwood, Ottawa, September 22, 1914. RG76, Domestics.
82. Letter from W.F. McCreary, Commissioner of Immigration, Winnipeg to Frank Pedley, Supt. of Immigration, Department of the Interior, Ottawa, December 7, 1899. RG76, Domestics.

83. Letter from W.F. McCreary to Frank Pedley, June 21, 1899. RG76, Domestics.
84. Letter from L. Kelly and J. McKay, Derrytagh, Lurgan to Mr. R. Colmer, January 25, 1899. RG76, Domestics.
85. Report of Mr. Chamberlain speaking to the annual meeting of the UBWEA, article in *The Western Morning News*, Plymouth, England, March 15, 1901. RG76, UBWEA.
86. Emily Carr, *The Book of Small*, p. 151.
87. Letter from the Canadian High Commissioner to the Hon. Mrs. Joyce, March 2, 1903. RG76, UBWEA.
88. Letter from J. Obed-Smith, Asst. Supt. of Emigration to the Superintendent, Passport Office, London, January 17, 1917. RG76, Domestics.
89. Article in the *Daily Nor'Wester*, April 11, 1896, RG76, Domestics.
90. Item in the *Daily Nor'Wester*, quoting from the *Canadian Gazette*, London, England, April 16, 1896, RG76, Domestics.
91. Letter from W.F. McCreary to Frank Pedley, June 21, 1899. RG76, Domestics.
92. Letter from J.A. Smart, Deputy Minister of the Interior, Ottawa to D. Nicoll, Passenger Traffic Manager, C.P.R., Montreal, July 15, 1898. RG76, Domestics.
93. Mrs. Helen Sanford was asked to bring out a similar party of immigrant domestics in 1899. RG76, Domestics.
94. Letter from H.M. Murray (agent in Glasgow) to W.F. McCreary, July 9, 1898. RG76, Domestics.
95. Letter from the Canadian High Commissioner to the Hon. Mrs. Joyce, March 2, 1903. RG76, UBWEA.
96. *Women's Work in Western Canada*, issued by The Canadian Pacific Railway Company, (1906).
97. Letter from William Weeks of Cleverton, Chippenham to the High Commissioner, January 4, 1896. RG76, Domestics.
98. Article from *The Virden Advance*, Virden, Manitoba, July 4, 1904. RG76, Domestics.
99. Letter to the Editor, signed "Another Servant," *The Toronto Globe*, January 22, 1886, p. 5.
100. For example, in Vancouver, the Home and Domestic Employees Union was formed in 1913 and dissolved in 1915. In 1916, the Calgary Housekeepers Association was formed. (References to them can be

found in the *Labour Gazette*.)

101. E.S. Turner, *What the Butler Saw: Two hundred and fifty years of the servant problem*, p. 236.
102. Byrne Hope Sanders, *Emily Murphy, Crusader ("Janey Canuck")*, p. 156.
103. Jean Scott, *The Conditions of Female Labour in Ontario*, p. 20.
104. "New Basis," Report, Conference on Immigration, 1919. RG76, Domestics.
105. Memorandum from Mrs. Yemans to the Hon. Mr. Calder, 1919. RG76, Domestics.
106. Survey Made by The Dominion Council of the YWCA, February 1919. RG76, Domestics.
107. Letter from Mary Brown, Guelph, to the Editor, *The Toronto Globe*, March 8, 1886, p. 5.
108. Lucy Salmon, *Domestic Service*, p. 121.
109. Provincial Statutes, 1880-1920.
110. Under the old English common law, a servant was entitled to free food and lodgings, necessary livery, and protection from attack. She could not be fired during sickness or old age, when her employer was obliged to pay her wages as well as care for her. She was treated as a member of the family. (See *Ontario Reports 1973 Volume 2*, p. 558 at 562.) Servants in Canada lost this traditional security without gaining the protection of legislation enacted for the benefit of other workers. For example, a Scottish immigrant domestic complained to her placement agent: "One thing I see wrong with this country is that there is no justice for servants if a girl takes ill here her wages is kept of her and she also has her own expenses to pay." (Letter from Wilhelmina Murray, Souris, Manitoba, 1899. RG76, Domestics.)
111. With industrialization the servant became more of an employee than a member of the household, because of her increased mobility, and the change in her status already described.
112. Proceedings, Conference on the Care and Housing of Women Immigrants, May 14, 1919. RG76, Domestics.
113. Memorandum from Mrs. Yemans to the Hon. Mr. Calder, 1919. RG76, Domestics.
114. Lucy Salmon, *Domestic Service*, p. 203.
115. *Ibid.*, p. 198.
116. *Ibid.*, pp. 190-191.

117. *Ibid.*, p. 224.
118. *Ibid.*, p. 219.
119. Archibald Blue, Special Census Commissioner, Introduction to the *Fourth Census of Canada 1901, Volume I. Population*, p. ix.
120. Introduction to the *Fifth Census of Canada 1911, Vol. VI, Occupations of the People*, p. ix. Introduction to the *Sixth Census of Canada, 1921, Vol. IV, Occupations*, p. viii.
121. "Women Day-Workers", *Report of the Ontario Commission on Unemployment*, printed by Order of the Legislative Assembly of Ontario (1916), p. 192.

"I See and am Silent": A Short History of Nursing in Ontario

Introduction

Women have always been healers. They were the unlicenced doctors and anatomists of Western history. They were pharmacists cultivating healing herbs and exchanging the secrets of their uses. They were midwives, travelling from home to home and village to village. For centuries women were doctors without degrees, barred from books and lectures, learning from each other, and passing on experience from neighbor to neighbor and mother to daughter. They were called "wise women" by the people, witches or charlatans by the authorities. Medicine is part of our heritage as women, our history.[1]

There is a widespread misconception that the replacement of the healing folklore of women by the medical science of men was an inevitable process. The decline of women's role in medicine was not due simply to the progress of science, for it was the "witches who had developed an extensive understanding of bones, muscles, herbs and drugs, at a time when physicians were still deriving their diagnoses from the ancient Greek theory of "temperaments." Paracelsus, considered the "father of modern medicine," burned his text on pharmaceuticals in 1527, confessing that he had "learned from the Sorceress all he knew." Massive sadistic witch hunts were carried on by the Church and state in Europe from the fourteenth to seventeenth centuries in attempts to eliminate the heretical acts of female healers by burning and torturing them. The primary heresy of these healers, besides that of being autonomous women, was the empirical nature of their prac-

tice which contravened both the Church's anti-materialism and the hocus-pocus practice of university-trained physicians. Far from representing a triumph of science over superstition, the witch trials were, in fact, an early example of the professionals' repudiation of the skills of the non-professionals and their right to minister.[2]

It was not until the nineteenth century that advances in medical science put the specially trained medic ahead of the self-taught healer. The medical school and the hospital rapidly became *the* institutions responsible for health care. Women were refused access to the new technology in the very field to which they had contributed so much. They were left with the task of serving those with the scientific knowledge. This was called nursing.

Although it is true that a certain class of men had access to education and took the more prestigious function of "curing" away from women, leaving them with "caring" (often indistinguishable from domestic work), the decline of the woman's role in medicine cannot simply be described as a male takeover. Certainly, the sexism of our society is fundamental to any understanding of our history, but we also must consider the more general historical context in which the nursing "profession" arose: the rapid technological and scientific developments; the industrialization of the economy; the movement of men, women and children from their farms, cottage industries and rural communities into the factories and slums of the cities—these form the backdrop for the origins, in the late nineteenth century, of present day nursing. The great upheaval of people's lives at that time was related not only to the transformation of the means of producing goods, but also to the consequent transformation of social organizations, from the family and the community, to health and education.

This article will briefly examine the end of the female medic period in Canada, particularly Ontario. It will describe the main forces which shape the "profession" of nursing: the institutionalization of medical knowledge and medical services; the crippling power of the ideology of the feminine role; and the lure of professionalism (the status promised to nurses by the medical profession and the university community in return for certain educational and behavioural requirements). The interaction of these forces was, and remains, crucial in the consciousness of nurses (as well as of other "semi-professional" women) regarding the real nature of their work, the nature of the medical hierarchy—and the necessity of alliance with other wage workers.

Early Health Care in Canada

Although for over three hundred years nurses have been caring for the sick in that part of the New World which is now known as Canada, and although from the day on which the Augustinian Sisters landed at Quebec, nursing in this country has often been a dangerous trade requiring supreme courage and devotion on the part of those who plied it, the Sisters and the Lay Nurse have had far less than their due recognition from Canadian historians.[3]

In Canada, women carried the major responsibility for healing from the time of the first French settlement, in the early seventeenth century, to the late nineteenth century. Nursing sisterhoods arrived during the French regime and moved west with the frontier. Working under severe physical hardships and constant lack of funds, they provided medical services to settlers, soldiers and Indians through long winters, wars and epidemics of typhoid and smallpox.

Nursing in France traditionally had been in the hands of ecclesiastical orders and wealthy patrons of secular nursing charities; this heritage assured its respectability and a high degree of competence among nurses. Many women who served as nurses in these first French settlements, including the now-famous Jeanne Mance, were from wealthy families. These French nurses exhibited a great deal of pride in as well as devotion to their work, unlike the despised English nurse who came from the servant class. It has been suggested that Canadian nursing is very fortunate to have been built on the accomplishments of these French nurses.[4] However, it must be remembered that the ecclesiastical character of nursing in New France also bequeathed to future generations of nurses a strong tradition of subservience and sacrifice.

The French nursing orders established the first Canadian hospitals, beginning with the Hotel Dieu in Quebec City, founded in 1639 by a French duchess along with the Augustinian Hospitallers of Dieppe. In 1641, Jeanne Mance founded a second hospital, the Hotel Dieu in Montreal. So dependent were these early communities on their hospitals that Mance's struggle for the continued funding of the hospital was also a struggle for the existence of the little settlement itself. Another significant contribution of the French nursing tradition was the formation of a non-cloistered order, the Grey Nuns, by a group of charitable Montreal women in

1738. This order was responsible for the introduction of district nursing to many areas of Canada.

Where pioneers in Canada did not have the benefit of the nursing orders, they relied on the self-taught and handed-down skills of women. The mother or grandmother served as doctor, nurse and apothecary for the whole family, and it was common for a skilled woman to be singled out to minister to an entire area. In 1713, for example, the women of Montreal elected a midwife, Catherine Guerbin, for the entire community. After the British conquest and the American Revolution, this practice of delegating responsibility for the community's health care to a woman was strengthened by the arrival in Upper Canada of the United Empire Loyalists, who traditionally used community healers. Mrs. Trull, who began to serve the medical needs of the Loyalist settlers in Ontario's Darling township in 1794, displays some of the qualities of these enduring women:

> She had rare skill in the preparation of these herbs and she was further fortified by a book of directions in midwifery and the healing of the sick. Her services were frequently called on over a wide stretch of country and as there were, at that time, no bridges across the numerous streams... she many times had to swim her horse through them on her mission of mercy.[5]

Great tides of immigration to Canada from Great Britain and Ireland followed the settlement of the United Empire Loyalists in the mid-eighteenth century. The mass transport of undernourished poor in overcrowded ships resulted in cholera, typhoid and smallpox epidemics in eastern Canada, which reached disastrous proportions in 1832, 1847, 1851, and 1854. Hospitals were erected and when these were filled to capacity, sheds and tents were used. In one week in 1832, the Quebec hospitals admitted 257 cases of cholera, of which 161 were fatal. In Montreal and its neighbouring villages there were four thousand deaths, amounting to one-seventh of the population. In the mid 1840s, of nearly 100,000 Irish immigrants destined for different parts of the country, more than 20,000 died of typhus. Immigrants had been encouraged to come to Canada because they were necessary for the country's economic growth. The epidemics then threatened their numbers and also endangered the established populations.

In response to these epidemics, lay nurses working for a wage were introduced. They were drawn from the domestic servant class—mainly immigrant women—and employed for low pay and

room and board, such as it was. The University Hospital of Montreal, for example, paid its nurses four dollars a month, "if necessary." In this hospital,

> nurses were obliged to occupy a bed in the midst of the sick. Their food was the same as that given the patients and had to be taken in haste around the effluvia of the sheds and in this was they were often inflicted with fever.[6]

The mortality rate among the nurses was often as high as 20 or 30 percent.

Because of their low status and the conditions under which they worked, the attitude toward these women was one of contempt. A doctor of Montreal General Hospital commented:

> Age and frowsiness seemed the chief attributes of the nurse, who was ill-educated and was often made more unattractive by the vinous odour of her breath. Cleanliness was not a feature, either of the nurse, ward or the patient; the language was frequently painful and free...Armies of rats frequently disported themselves about the wards and picked up scraps left by the patients and sometimes attacked the patients themselves.[7]

Elizabeth Innes, a lay nurse in New Brunswick during the period of the worst epidemic, describes in her diary some of the medical practices of her day:

> Surgery was done without benefit of washing up and other preliminaries—often on kitchen tables and with very few instruments. Sterilizing instruments was unknown, so germs had their heyday. Some old surgical instruments folded into a little case like an ordinary pocket knife; some had beautifully engraved frames, sometimes an animal's head or a lady's figure formed the handle but all were far from being aseptic as one can well imagine.
> The surgeon used to hand a leash of waxed thread through the buttonhole of this coat, so he wouldn't have to hunt for sutures during an operation.
> There were no face masks, no nurses done up in caps and gowns. And the patients kept most of their clothes on—sometimes even to their boots... patients often used a stiff hooker of Jamaica rum to bolster up their intestinal fortitude... calomel, oil and bleeding were used as healing agents.[8]

Obviously, cleanliness was not a feature of medicine in general! The early hospitals were dreaded by most residents of the rapidly growing towns. Anyone who could afford it received medical treatment at home, including surgery, rather than risk the dirty, crowded, disease-ridden hospitals.

Settlements outside the few large eastern towns resisted for a longer time the institutionalization of their health services and the subsequent hiring of practical nurses. The few doctors practicing in Canada tended to concentrate in the towns where a clientele existed who could pay for their services and where distances and climate were not so grueling. Thus, where doctors were few and communities were more closely knit, medical care remained a concern of the housewife-cum-nurse-doctor-apothecary. This was true in the 1870s in the Red River Colony, for example, where community midwifery was vital; and it was evident in Winnipeg in 1873 where volunteer housewives nursed in the province's first public hospital.[9] However, the repercussions of the Industrial Revolution, which broke down skills into simple repetitive tasks in order to employ the cheapest workers, would soon be felt in health care, as well as in goods production, in most parts of Canada. (See Table B at end of article for statistics regarding numbers of doctors and nurses.)

The Institutionalization of Health Services

The first priority of the young Canadian state in the late nineteenth and early twentieth centuries was to promote capital formation: to subsidize railway enterprises; to populate the west as an essential new market for eastern producers; and to control industrial unrest. Public welfare programmes—and the public sector to which they would give rise—were still embryonic. However, the introduction of a formal compulsory education system in Ontario in 1871 indicated the state's growing awareness that railways and immigrants were not enough. Schools, hospitals, and other social services, which could provide infant Canadian industries with a stable, controlled, social environment, began to grow in importance.

As part of the pre-industrial labouring class in Canada, women provided the social services of teaching, nursing, and medicine in their own homes. As industrialization increased from the 1880s onward, their services were no longer adequate. Production shifted from family to factory, whereupon the working family lost its viability as an economic unit and was forced into the town to sell the only thing that was left to it—the labour power of men, women and children.[10] In this new setting, the family could not provide the disciplined, literate, healthy worker that industry required, so the state stepped in.

In Ontario, families from outlying areas joined the thousands of immigrants who crowded into industrial centres. The state was faced with growing slums, high disease and mortality rates, vagrant youth, large numbers of unemployed and destitute old and sick. As industry and industrial centres expanded without concern for the squalor they created, it became apparent that more schools and hospitals would be needed, though such financing continued to have low priority. Soon after Confederation, the Ontario government arranged for an inspection of the hospitals. In 1872 the subsequent report recommended a system of provincial grants to hospitals on the basis that three-quarters of hospitals' patients,

> if not in indigent circumstances, were of that class who have to work for the daily bread of themselves and their families, and who, if Hospital treatment had not been open to them, when overtaken by sickness or accident, might have been permanently withdrawn from the working and wealth-producing population of the Province, and placed upon the charity of friends or the public.[11]

Between 1880 and 1914, ninety-six new hospitals were built in Ontario. Although provincial grants to hospitals increased greatly during this period, a large number of hospitals continued to be financed by charitable organizations, mostly composed of women. Women, with their traditional responsibility in the area of health care, were to prove very useful to the state. In their roles as inexpensive benefactors, organizers and health-care workers, as well as mothers, they were to provide the state with a healthy labour force.

Besides the social upheavals caused by a rapidly growing economy, another important factor that changed the nature of medicine in the nineteenth century was the organization of the medical profession. In the United States, a distrust of professional elitism had given rise to the Popular Health Movement of the 1830s and 1840s, which attacked the medical establishment and promoted the continuation of traditional community medicine.[12] Such a movement did not exist in Canada, even though a medical establishment was clearly visible in Ontario. The leaders were men trained in medicine in British universities, many of whom were adopting a second career following military or legal positions; most of them were aligned through family ties, church activities and political sympathies to the Family Compact.

As early as 1795, doctors had pressured the legislature of Upper Canada into enacting legislation that limited the practice of

medicine to graduates of universities within the Empire. The act proved unenforceable because of the lack of doctors in Canada and had to be repealed in 1806.

> Nobody above the rank of a common cowleach would travel around a circle of forty or fifty miles in the wilderness for the pittance which could be collected long after this law was made; and, save in the large villages, Kingston, Niagara and York, nothing like a genteel subsistence could be obtained.[13]

By Confederation, a strong medical profession had established schools in Ontario and the number of doctors increased considerably. In 1869, the College of Physicians and Surgeons of Ontario gained provincial control over the education and licensing of doctors. However, rivalry between competitive medical schools and the continued popularity of unlicensed healers, male and female, hindered the medical profession's attempts to monopolize health care until 1900.

More than anything else, it was the advances in medical science in the late nineteenth century, placing new demands on hospital staff and the organization of hospital procedures, which facilitated the rise to dominance of the medical profession. French and German scientists had brought forth the germ theory of disease which provided for the first time in history a rational basis for disease prevention and therapy. Louis Pasteur discovered the process of pasteurization in 1860, touching off many further advances in the field of bacteriology. Joseph Lister caused a major revolution in surgery by using carbolic acid to keep open wounds free from infection; this technique was first practiced in Canada in the Montreal General Hospital in 1877. Robert Koch proved that every infectious disease was caused by a specific micro-organism and found a method for identifying them. Immunization and vaccination became common practice following Behring's introduction of the preventative use of serum from immunized animals, Pasteur's rabies vaccine and the discovery of a diptheria antitoxin in 1891. The Curies' investigation of the detective property of the X-ray led to their discovery in 1895 that radium could destroy certain malignant cells.

These developments in medical science created a demand for hospital workers with basic medical training who could assist in the increasingly sophisticated medical procedures. Hand in hand with medical advances went the increasing institutionalization of health services, which also had serious implications for the health

care worker. Medical knowledge came to be monopolized by those educated in medical schools, and medical services came to be increasingly centralized in hospitals. Although the medical advances led to a decrease in mortality rates, the new institutions were hierarchic, undemocratic and removed from the community to such an extent that many extremely valuable aspects of the old community health care system were lost. The institutionalization of health care had serious implications for women's role in medicine. Once independent practitioners, they were denied training and were thus relegated to a subservient position within the medical profession.

* * *

The Nightingale School of Nursing

In the 1860s in England, Florence Nightingale established the new nursing "profession," which set the pattern for nursing in many countries. The Nightingale reforms must be examined as part of a general tendency among upper-class women, who when faced with the enforced leisure of Victorian ladyhood, often focused their energies on charitable activities. Their efforts were directed to those areas where women's work outside the home would be acceptable. During the nineteenth century these women increasingly pressed for abolition of child labour, introduction of compulsory free education, prohibition, health care for the poor, and other reforms directed toward alleviating the more unsightly effects of industrialization.[14] Often patronizing and superior, they prided themselves in teaching the poor the values of frugality, hard work, sobriety, and moral restraint. Few of them looked beyond moral maxims to question what forces lay behind the existence of great masses of paupers. However, given the vested interests of their class in maintaining a cheap labour pool, and their expected role as women within that class, this is not surprising.[15]

Led by Nightingale in the 1860s, reformers challenged the Victorian notion of the bourgeois family by insisting that women of the middle and upper classes could make a respectable career out of being a mother to the destitute in the various charitable institutions, and to the fighting men at the Crimean front. The Victorian ladies involved in these campaigns perceived no irony in the fact that women of the working class had worked outside of their homes since the beginning of the Industrial Revolution.

The Victorian reformers shocked many with their insistence that the new nurses be given medical instruction, a subject regarded as completely unseemly for the ears and eyes of ladies. To promote the respectability of their actions, nursing was extolled as the epitome of a woman's nurturing, serving role—it was not to be regarded as an occupation like others. Although training was to include medical lectures, the educational emphasis was to centre on high moral character, not skills. This was of utmost importance in order to "rescue" nursing from the working-class and destitute women who had been employed in the pre-Nightingale hospitals. Nightingale and other reformers were not interested in the problems of these women but in the creation of a respectable occupation for their own class. Nightingale, writing from the Crimea in 1854, revealed her own sentiments: "I must bar these fat, drunken, old dames."[16]

In spite of Nightingale's intentions, there were many factors working against the integration of middle-class women into nursing: the working conditions at most hospitals, the menial nature of the tasks delegated to the nurses, the low pay, etc. The administrators of the Montreal General Hospital, for instance, wished to establish a "respectable" nurses' training school, and solicited guidance from Florence Nightingale in 1875; they were sent a graduate from her training school, St. Thomas, which had been operating in England since 1860. This proper young woman was horrified by the conditions at the Canadian hospital, and she and her three successors resigned in despair:

> Hospital funds were taken to purchase champagne to be used in building up the reserve forces of patients to be operated upon, while ragged ticks filled with straw were the only beds provided for the patients, and a basket of straw could be swept up after the students' rounds.
> The nurses were sleeping in cubicles built into an old ward, and after a stormy night, their beds were often festooned with snow. No sitting-room was provided. The dining-room was presided over by an autocrat who required each nurse to take her food from a side table, wash her own dishes, and place them in a cupboard after the meal. There was small inducement for women of a refined type to enter the school.[17]

The first successful training school for nurses in Canada began in St. Catherines, Ontario, in 1874. It was organized by a doctor and two Nightingale nurses, but even after the advent of

Miss Nora G.E. Livingston, Lady Superintendent, 1890-1919, The Montreal General Hospital (Three Centuries of Canadian Nursing)

The staff and students of the first graduating class, The General and Marine Hospital, St. Catherines (Three Centuries of Canadian Nursing)

training schools, the unpleasant living conditions, such as those at the Montreal General, and the heavy-duty, unpleasant work required by hospitals in Britain and Canada did not appeal to the

refined women whom the reformers had hoped would respond. The daily tasks of the Victorian nurses included laundering, mending, changing bedding, making up bandages, supervising the kitchen and diets, preparing and administering medicine, keeping wards and equipment scrubbed, and seeing to the toileting, turning, feeding and changing of the patients. Thus the majority of nurses, after the opening of Nightingale training schools, still came from working and lower-class homes; these were women whose only other options were factory or domestic labour.

The schools' emphasis on high moral character constituted an imposition of upper-class values on working-class women. The socialization process during training rested largely in the hands of middle and upper-class nursing educators—women whose financial and social position allowed them to receive the necessary qualifications to teach. Nightingale's own school, St. Thomas, was geared more for the training of matrons than to that of ward nurses or the despised English work-house nurses. In this school there was a distinction between women who were "habitually employed in earning their own living" and the "ladies": the former were given free maintenance; the latter were paid and received separate accommodation and dress.[18]

> *Creating a proper lady-like image for the nurse also meant that a great deal of attention was paid to their costume:*
>
> *"The uniforms of the nurses (of the Toronto General) were made to fit the figure in princess style out of a cotton material which had an open check of brown against a white ground. They had a row of buttons from the waist line to the chin, and the skirts touched the floor. They wore large round muslin caps frilled at the edge, and white cuffs at the wrists. They were supposed to change in the afternoon to a dress uniform of grey serge with a small blue bow at the throat, but this custom was gradually discarded. Their aprons had no bibs, but in 1894 kerchiefs were added...etc, etc."*
>
> —*Three Centuries of Canadian Nursing, p. 152.*

The first uniform in Toronto General Hospital
(Three Centuries of Canadian Nursing)

A very important aspect of the socialization in the Nightingale schools (reinforced in Canada by the long history of ecclesiastical nursing) was the instillment of strict authoritarian values. The nursing sisterhoods took their teachings from St. Vincent de Paul, who stressed the need for complete subservience to the doctor. The Nightingale schools of nursing also emphasized this message. These teachings not only defined the "proper" relationship with the medical profession, but also defined authority relationships throughout the entire hospital hierarchy. One of the first graduates of the Montreal General Hospital's school vividly remembers the Superintendent Miss Livingston's parting words to her class:

> Young ladies, you are the pioneers in the field of professional nursing. It will be your task to educate the public and to blaze the trail for those who will follow you. Many of the untrained nurses have been eating with the maids. Make arrangements when you enter a home to have your meals served on a tray. Be dignified and wise, and remember you have your Training School and the M.G.H. at your back.[19]

The "ideal lady" transplanted from home to hospital was to show wifely obedience to the doctor, motherly self-devotion to the patient and a firm mistress/servant discipline to those below the rung of nurse. This was to be even more important later, as functions within the hospital became more and more specialized, creating a multi-layered hierarchy with many positions below that of nurse.

Most Canadian nursing administrators were from prominent Canadian families, and educated in the United States, since there were no graduate programmes in administration in Canada until 1920. These administrators were women who had been brought up in an environment that required demure gentility of its females. They saw the task of educating their lower-class applicants as one of instilling in them similar genteel characteristics. The by-laws for nurses laid down in the regulations of the St. Catherines' Training School were clearly influenced by the principles laid down by Florence Nightingale. The first of the by-laws reads:

> The nurses in the daily discharge of their duties must observe strictest secrecy, carefully avoid gossip, their demeanour should be kind and respectful on all occasions, and when on duty at private houses, they are expected, in addition to taking the complete charge of their patients, to avoid giving unnecessary trouble, to wait upon themselves, and to pay the closest attention to the preparation of aliments for the sick, as well as to cheerfully assist in many matters not strictly within their duty—to faithfully carry out the physician's directions. To evince no bias to any favourite medical practitioner. To attend scrupulously to the special duties to the patient with the gentleness and exactitude taught by their superiors, and never to interfere with or criticize the treatment.[20]

They didn't want nurses, they wanted saints! The most astounding example of the attempt to socialize the quality of passiveness in the new nurses is the motto chosen for this first school of nursing: *"I see and am silent."*[21]

The Student Nurse

The nursing educators, administrators, and women reformers like Lady Aberdeen, founder of the Victorian Order of Nurses, envisaged the possibility of meeting the desperate need for nursing services in Canada as well as of establishing nursing as a respectable profession for women. They could not see how the feminine mystique they were promoting obscured the harsh realities of an exploitative situation in which lower-class women were drawn into low-paid, hard work by the promise of respect and upward mobility in this new women's "profession."

In fact, the educational recommendations of Florence Nightingale were used to facilitate the use of nurses as a source of cheap labour for hospitals. At the time when the Nightingale reforms were affecting England and the United States, the public sector in Canada was still small and hospitals were funded largely by private

donations and municipal grants. Hospital boards, generally composed of doctors, the Women's Auxiliary, and concerned local businessmen, were hard put to find ways of economizing; the two-year training programmes based on practical nursing experience in the hospital offered a partial solution. Hospitals quickly realized the advantages of forming schools, and by 1909, there were seventy schools for nurses in Canada. Fifty-seven of these had extended the course from two to three years. This move was of doubtful educational value and frequent complaints appeared in the nursing journal, *Canadian Nurse,* about the wasted third year which contained no new material.[22] The Toronto General School of Nursing, the largest and one of the most reputable schools in Canada, typified the hospitals' exploitation of trainees as sweated labour—their student nurses composed *the whole nursing staff.* Except for instructors, no nurse remained longer than her three years of unpaid labour.[23] Even when trained nurses were employed, the expense to the hospital was minimal. In 1889 a trained nurse at the Montreal General earned twelve to fifteen dollars a month. The hospital rat catcher earned twenty dollars a month.[24]

Worse still, the hospitals were also able to reap benefits from student nurses in the private nursing business. The great demand for private nursing in well-to-do homes made it common practice for the school to send out student nurses to care for private patients, under the guise of providing a variety of nursing experiences. For this service, the hospital collected the patients' fees. As late as 1922, the Canadian National Association of Trained Nurses was still protesting this practice.[25]

No mention can be found in writings of the time to elucidate the plight of the former untrained hospital nurses. One would suspect that some were kept on as maids and the rest "let go." Under the new system, nurses, or rather student nurses, continued to work an average twelve-hour day or night shift in the wards, six-and-a-half days a week, in return for wretched quarters (whose miseries frequently included rats) and mandatory lectures after exhausting shifts. In the early Ontario training schools, successful applicants were taken on probation for two or three months. Since probationers had the most unpleasant domestic chores of the hospital thrust upon them, usually about 50 percent of them found the work unbearable and left.

During her first year, the student nurse would go on the night shift for a term of four months, the other months being spent on

different wards. The proportion of the course dedicated to lectures was very small. In 1891, at the training school of the Toronto General Hospital, the lectures occupied just 160 hours spread over nine months in a two-year programme. "In between the practical nursing were sandwiched lectures on anatomy, physiology, medical, surgical and obstetrical nursing, communicable diseases, and diseases of the eye, ear, nose and throat. Miss Snively (Superintendent) found time for this theoretical work by relieving the nurses of duties such as washing dishes, and by inaugurating evening seminar groups."[26]

Student nurses were completely at the mercy of the expedience of the hospitals whose operations went unchallenged by provincial authorities. Since no accreditation procedure was necessary, there was no limit on the size of a hospital or the quality of its programme. Very small hospitals (under twenty-five beds) advertised for students without regard to their educational background; consequently, many students had not finished public school before they began their training. Furthermore, these small hospitals generally had no qualified nursing instructors. Two or three years of sporadic lectures from doctors, who often made no attempt to adjust their medical terminology, was accepted as a nursing education.[27] At the end of this time the graduates left their cloistered existence with nervous exhaustion, a nursing certificate, and no job.

In some quarters it was recognized that the continual physical and mental strain on nurses was too severe. In 1914, a committee on Nursing Education headed by the President of Toronto University concluded that the decrease in desirable candidates was due to:

> the unneccessarily arduous course making it imperative for the women while training to cut themselves off from all means of culture. They work to the limit of their strength and are expected to profit by lectures when they are physically worn out. Often they are obliged to listen to lectures from people wholly unfitted to deliver them.[28]

The committee suggested that the nurses' training should take place in a university setting rather than in a hospital, but nothing was done. Fifteen years later, in 1929, the Weir Survey of Nursing Education, the product of a joint committee of the Canadian Medical Association and the Canadian Nurses Association, detailed very similar conditions. The survey contained frank admissions

from a majority of nursing school superintendents in Ontario that "the prime reason for the existence of training schools, especially in the minds of the trustees...was the supply of cheap labour." The survey found that "the average student nurse is keyed up to a high pitch of tension for twelve hours of the day: namely, nine hours on duty, one and a half hours of lectures and one and a half hours of study," and that "she spends 37 percent of her time on active duty in doing housemaid's work."[29] These conditions persisted despite the enactment in all provinces by 1929 of registration laws containing various criteria for training schools. The survey concluded that no other profession would tolerate such working conditions. Again, no action was forthcoming.

Conditions changed very slowly for nurses. Helen Morrison, a woman who took nurses' training in Edmonton University Hospital during the Depression and graduated in 1938, in an interview described the lives of the student nurses. Their day began before six, with prayers held at six-thirty. Students were on the wards by seven and although the shift was supposed to end at seven p.m. with time off for meals and a rest, it generally continued until work was done at eight or nine p.m. The students had to leave the ward to attend the four-thirty to seven o'clock lectures, and return to complete their work. As there were few nursing aides or maids, a good deal of the work was heavy maintenance.

"One hears of so many probationers breaking down with T.B. in the larger training schools that I think it advisable that the age (of admission) be raised in the hope that they will have acquired a little more sense in learning how to take care of themselves."
—*A doctor.*
 Weir, Survey of Nursing Education *p. 225.*

"I find that most doctors want nurses to know a good deal but not to use it unless asked to—which is seldom."
—*A nurse.*
 Weir, Survey of Nursing Education. *p. 66.*

Night shift was from seven p.m. to seven a.m. and there was no compensation the next day—the lectures were compulsory at four-thirty as usual. This meant a fifteen-hour day at the minimum. Students were given a half-day off each week (if this did not interfere with lectures) and an extra hour on Sunday. The incidence of tuberculosis was high among the trainees, whose rundown condition and constant contact with tubercular patients was at times a fatal combination.

A short distance from the hospital was the residence, an old, unpleasant building with a generous supply of bedbugs and cockroaches. Rules were very strict and social activities very controlled. Lateness for prayers meant forfeiting one of the four monthly late leaves, these being the few opportunities the student nurses had to associate with people outside the hospital. There was no place in the residence to visit with friends, male or female.

Mrs. Morrison felt that the education her nursing class received was adequate, although "knowing your place" in the hospital was stressed. She recalled that the pecking order of the hospital was the nurses' first topic of instruction. It was necessary for nurses to learn immediately how to behave if, for example, confronted with a crowded elevator and various staff wishing to use it. Nurses were always expected to stand if a doctor was present. The hierarchy of the hospital, from doctor, to nurse, and on down, had to be respected at all times. Complaints were repressed, as expulsion was the result of insubordination. The supervisors were generally feared and there were incidents of rather sadistic treatment. Mrs. Morrison remembers well the head operating room nurse who continually prodded the nurses with her forceps until they were quite bruised.

Life was bleak and harsh, a monthly stipend of ten dollars had been introduced out of which books and uniforms had to be bought. Even so, a number of women were sending part of their earnings home to their impoverished families. The greatest number of girls were from low-income families, from small towns and farms. "There was no possibility of any of us even affording cold drinks at the local soda fountain." Mrs. Morrison knew girls who married in order to escape the schools, and others who had frequently to be persuaded not to pack their bags and run off. She regarded their three years of training as three years robbed from the young lives of these young women.[30]

Supply and Demand

The hospitals' reliance on student nurses as their work force meant that there were very few institutional positions for graduate nurses; as the number resorting to private nursing swelled with each new set of graduates, unemployment became a chronic problem. It is estimated that 85 percent of all active graduates were engaged in private nursing prior to 1909.[31] In 1929, 60 percent of active graduates were doing private nursing.[32] Private employment fluctuated according to economic trends. In times of depression, the demand for private nurses fell off drastically because fewer people could afford their services. According to the Report of the Ontario Commission on Unemployment, this was the case in 1916, when private nurses in Toronto could get work, on the average, for only eight months of every year.[33] Unemployment was constantly aggravated by the numbers of trained nurses coming from the British Isles to Canada under the impression that they could readily find work. There were also a great many practical or untrained nurses available who were less expensive and more willing to do housework as well.[34]

At the turn of the century, central registries were established by nurses in the larger cities to regulate the supply and demand of private nurses. Their records as quoted by the Commission on Unemployment, indicate that in 1916, a private nurse could earn twenty-one dollars a week but an average yearly income of only six hundred dollars.[35] The waiting lists for these registries were very long. Nurses could wait as long as six weeks between cases.

Every nurse endured many hardships but the private duty nurse was the worst off:

> The nurse usually lives in cheap lodgings, a small room and more or less comfortable lounge-bed. She has a right to a fractional portion of the bathroom at off moments. There is usually more noise than agrees with her strained nerves and much more than enough when she lies awake most of the day on night duty. When off a case she does light housekeeping in her room for two meals, perhaps, and walks some distance to another at a poor restaurant. There is often no sitting-room where she can receive a friend, and no one in the house who is congenial.
>
> The hours were long, usually twelve-hour duty, but so-called nineteen-hour duty was very common, which meant that the nurse stayed with the patient day and night, getting what rest she could during her five hours off in the afternoon or evening and sleeping on a couch in the patient's room at night.[36]

Exhaustion would often give way to the "nerve-wracking, morale-destroying effects of long periods of unemployment...during which she remains in a condition of feverish anxiety wondering whether she will be called up on another case before her money is spent."[37] The Ontario Commission on Unemployment in 1916 feebly suggested that the effect of the strain upon the nurses' health should be studied.

Certain periods did witness a shortage of nurses, specifically in the early and mid-twenties. Shortages were due to the prevailing unattractive conditions of nursing and the opening up of other competitive fields of work for women. The post-war period was also a time of prosperity, when the demand for private nurses was at a peak. (The nursing associations of Manitoba and Saskatchewan, the provinces most severely affected by the shortages, suggested that nursing attendants be trained. These suggestions were only briefly implemented.) In 1921, a Red Cross survey showed that 50 percent of all training schools had a shortage of student nurses.[38] In 1926, the Canadian Nurses' Association submitted a report to the Federal Department of Health detailing the increased difficulty of recruitment of student nurses and the increased number of dropouts.[39] Given the conditions described in training schools as late as 1930, it is little wonder that other opportunities had begun to lure women away from nursing.

With the economic collapse of 1929, nurses found themselves in a surplus situation again. Private nurses were making an average of thirty-four dollars for a full week, but had paid work for only seven months of the year.[40] This might have given them a yearly income of 1020 dollars. To a private-duty nurse this wage reduction would have meant curtailing her estimated cost of living by approximately one-third. (See Tables 1 and 2.) Nurses in the West had an even harder time. Mrs. Morrison, who was a gold medalist of her graduating class in 1938, could only find a job paying eighteen dollars for a six-day week, doing twelve-hour night duty in the home of an asthmatic.[41]

Another serious problem for private-duty nurses mentioned both in the Weir Survey and the *Canadian Nurse* was the constant worry of facing a poverty-stricken old age, or even middle age. As 92 percent of all nurses were unmarried, their survival depended entirely upon their own earning ability. In addition, many were supporting a family member. Sixty percent of the private duty nurses who answered the Weir Survey said that they were unable

to put aside savings for their retirement. Many stated that they could not have made ends meet if they had not been living at home. Conditions for those nurses were so severe that 37 percent told the survey that, if they had a chance to relive the past, they would not go into nursing.[42] Marriage was, very understandably, looked upon as a lifesaver by these women.

Table 1

Median Annual Gross Income of Nurses in Ontario, 1929
Private Nurse $1,091.00
Institutional Nurse 1,370.00 *
Public Health Nurse 1,597.00
Superintendent of Nurses 2,030.00
Source: *Weir Survey of Nursing Education,* pp. 125 and 150.
* This amount includes the equivalent in money that otherwise would have been paid by the nurse for lodging, board and laundry which the hospital provided.

Table 2

Cost of Living, 1929
(Typical budget for private duty nurse)*

Item	Annual Budget	Item	Annual Budget
Rent	$440.00	Church/Charity	$60.00
Board/		Recreation	60.00
Clothing	300.00	Dentist	40.00
Uniforms	91.05	Health	36.00
Laundry	144.00	Dry Cleaning	12.00
Fees	21.00	Presents/Sub-	
		scriptions	75.00
Car Fare	45.60	Sundries	30.00
Insurance	132.00	Holidays	100.00
		Total	1586.65

Source: *Weir Survey,* p. 79.

* The budget of the institutional nurse would be approximately $200 less because rent, board and laundry only amounted to about $360 at the hospital. Public health nurses estimated their rent, board and laundry to be $600 annually.

Institutional nurses were not much better off. Mrs. Morrison took a private nursing position rather than comply with the Edmonton University Hospital regulation that required a graduate to do at least two years of twelve-hour night duty in the hospital before being accepted for daytime staff. Furthermore, she found that while larger hospitals required nurses to treat the doctors as absolute gods, the opposite case was true in small municipal hospitals, where the nurse was expected to carry out many of the doctor's normal activities. "In maternity cases the doctor might appear at the last minute in a difficult delivery and handing the nurse a can and a towel, tell her to put the patient under."[43] Among all institutional nurses who were able to get work eleven months a year, only 55 percent were able to save anything. Although they had a greater degree of economic security and did not face the severe isolation of private nurses, 23 percent said they would not enter nursing if they had the chance to do it again.[44] One might guess that many of the others saw no alternative.

Provincial responsibility for public health nursing in Ontario began with medical inspection programmes initiated by the Provincial Department of Education in 1909 in order to counteract excessive school absenteeism resulting from widespread childhood disease.[45] The minimal nature of the province's activity in the field of health meant that some communities were forced to take their own initiative. Thus in numerous cases public-health services (school nursing, "well-baby" clinics and district nurses) were arranged for by women's groups in the communities in order to meet their local health needs. The Women's Institutes, for example, were community organizations primarily concerned with mothers' lack of information on family health care. In numerous towns the Women's Institutes petitioned for a district nurse to tend to immediate health problems and to educate mothers in preventative health care and self-help.[46] In the West an equivalent organization called the Saskatchewan Homemakers was formed. Public-health nursing afforded the nurse a close relationship with a community and its health problems and offered her a chance to initiate programmes.

By 1922, there were one thousand public-health nurses in Canada, including the Victorian Order of Nurses (the oldest national nursing organization), the public-health and district nurses of the newly formed provincial health departments, hospital outpatient nurses, industrial nurses, the Red Cross nurses (including

School nurse examining children, c. early 1900s (Ontario Archives, Toronto)

> The Victorian Order of Nurses was formed in response to a request by local Councils of Women in Vancouver and Halifax (affiliates of the National Council of Women), who saw the need for a group of visiting nurses to bring medical care to the sparsely settled areas of their provinces as well as to the urban slums. They petitioned Lady Aberdeen, wife of the Governor General of Canada, for a national organization of such nurses based on England's Queen's Jubilee Nurses. The V.O.N. was founded in 1897 and played a crucial role in providing medical care to needy areas of the country, establishing twenty-five hospitals in such areas and running them until the last were taken over by the provincial governments in 1924.

the war nurses), and several other local organizations of nurses. They are noteworthy because they were much more independent than hospital or private nurses and their responsibility was often to a community rather than to a hierarchic institution.

Removed from the authoritarian hierarchy of the hospital and the desperate life of the private-duty nurse, the public-health nurse was able to exert her independence. This, in turn, made her unpopular with the medical profession.[47] Usually isolated, travelling long distances by horse, sleigh, on foot or even riding a sectionman's railway jigger, and rarely having easy access to a doctor's advice, these women lived rugged lives and assumed a great deal of responsibility, as had the original community "nurses" in Canada. Midwifery accounted for a large part of their time. In 1925, the V.O.N. hospitals and Red Cross Outpost Hospitals looked after 38,634 births, while the V.O.N. looked after 14,700 additional obstetric cases in homes.[48]

Midwifery is described in *Witches, Midwives and Nurses* as women's last foothold as independent practitioners. Its fate differed from country to country. In England, Germany and many European countries, midwifery was simply upgraded through training to become an established, independent occupation. In the United States, although a 1912 study done at Johns Hopkins University proved that most American doctors were less competent than midwives in obstetrics, doctors pressured state after state to pass laws outlawing midwifery.[49] In Canada, aside from the untrained midwives practicing in remote areas, midwifery was incorporated into the public-health nursing programme very early under the control of a coalition of upper-class women reformers, the provincial governments and the medical establishment. (See Tables A and B at end of article.) Thus, although nurses' duties often overlapped with the doctors, the duties were regulated in such a way that they did not pose a threat to the doctors' control of medical services. The Alberta Nursing Act of 1919 points out how the possibility of competition from public-health nurses was eliminated:

> Any trained nurse who has taken a course in obstetrics and who has obtained the consent of the Minister may practice midwifery in any designated portion of the province where in the opinion of the Minister, the services of a registered practitioner are not available and to charge such fees as the Provincial Board of Health may decide fair and reasonable.[50]

Hand-car used by Public Health Nurses in Northern Ontario, c. 1915 (Ontario Archives, Toronto)

Registration: The Struggle to Become a Profession

Originally, Canadian nurses were organized into the Canadian National Association of Trained Nurses not by their own leadership but by the Canadian Nursing Superintendents Society for the purpose of affiliation with the International Council of Nurses (founded in 1899). In 1912, the CNATN agreed upon a constitution and formulated their main goal: to elevate the educational standards of the profession. Although this was a laudable goal, the formation of the CNATN did recall Nightingale's desire to rescue her "girls" from the stigma of the early working-class nurse. For the first ten years of its existence, the organization was largely occupied by the struggle to obtain legislation regulating the registration of nurses. It did not attack hospitals, governments or the medical profession with the vigour warranted by their abysmal working conditions because of pressures exerted on the nurses' organization which directed its development along conservative lines.

Registration was a crucial issue in establishing the skilled nature of nursing and was clearly intended to limit the title "trained nurse" to those who had the requisite education. Its adherents could be accused of falling prey to that characteristic instinct of professionals, the desire to assert a monopoly in a field. Indeed, a

number of articles and letters in *Canadian Nurse* indicate that some graduate nurses desired to rid themselves of the untrained women who were competing for jobs in private nursing.[51] However non-militant the registration struggle, it was also comparable to the struggles of unions for closed-shop rights which were going on in the same period. Nurses were arguing from a powerless position for protection against the "practical" nurses who were forced to accept even lower pay and the broadest range of domestic duties in order to survive. Unfortunately (as was the case with many unions), nurses did not combat the problem by including these unorganized women within a registration scheme which could have recognized different levels of nursing. As it was, the exploitation of this cheap source of labour continued to plague the nursing associations into the 1940s and even later.

The registration struggle was long and frustrating. Petition after petition was rejected by the provincial governments which were involved in hospital financing and thus had some vested interest in the economical nursing system which existed. When legislation was enacted, beginning with Manitoba in 1913 and including all provinces by 1922, the acts were full of loopholes. The minimum number of beds a hospital had to have before qualifying to conduct a training school ranged from "no mention," to fifteen, to fifty. The curricula outlines were not stringent (the dietetics course for at least one hospital was limited to practical experience in the hospital kitchen). Educational requirements for training-school admittance ranged from grade eight (in Alberta), to one or two years of high school. The number of instructors required before a training school was approved varied from "no mention," to one or three; others simply depended upon arbitrary decisions. (Certainly schools without teachers were not common.) The boards of examiners in five provinces were composed of a majority of nurses; in another, a parity of nurses and doctors; and in three other provinces, the composition of the examining board was left to the university.[52] In fact, it was not until 1951 that legislation was passed giving the Ontario Nurses Association full power over admission and certification, eighty-two years after the medical profession in Ontario had been granted this power.

Side by side with this campaign for registration was the campaign to take nursing education out of the hospital and place it in the university. Traditionally, recognition as a profession has implied some sort of training beyond the bachelor-degree level. One

historian of nursing ascribes the difficulty in getting university acceptance of a nursing programme to: 1)social disapproval of women stepping outside the home; 2)the close relationship of nursing to medicine, which doctors took pains to keep distinct; and, 3)the hospitals' vested interest in holding onto the training schools for nurses.[53]

Women have always had to fight hard for every small gain in the privileged area of education. Acceptance of a university programme for nurses was won only after a great deal of public-relations and organizational work by many women. The University of Toronto graduated its first student in 1836; however, women were not officially admitted until 1884, when an act of the Legislature opened the doors of University College to them. Medical education in Ontario was exclusively male until 1908, when a very reluctant medical college gave in to pressure from women like Dr. Augusta Stowe Gullen. In 1920 there was still opposition to women receiving university education in preparation for "professional" careers, even in a "profession" labelled female.

Before Canadian graduate programmes existed, many of the ambitious Canadian nurses who had sufficient financial support went to the United States for further training. Nursing degree programmes had been accepted in 1907 at Columbia University, but graduate classes had existed even earlier. Some Canadians remained in the United States, Canadians like Isabel Hampton Robb, who helped set up the forerunner to Columbia's degree nursing programme in 1899, Adelaide Nutting, who held the first University Chair of Nursing on the continent, and Isabel Maitland Stewart, who succeeded her. Others brought their ideas back to Canada: Agnes Snively, Nora Livingston, Flora Shaw, Ethel Jones.

The first degree nursing programme in Canada was started at the University of British Columbia in 1920 directed by Ethel Johns, who is remembered by Canadian nurses for her leadership abilities. This was a five-year course which combined administration and public-health nursing.[54] A second degree programme followed shortly after at McGill, directed by another prominent nursing figure, Flora Shaw. Even after these courses were approved, they did not receive full funding from the universities but were dependent on money raised by such nursing organizations as the Red Cross.

Throughout the first two decades of the twentieth century the Canadian National Association of Trained Nurses was caught up in the movement on the part of organized labour for an eight-hour day. Doctors were quick to disabuse the nurses of their misguided union aspirations. In 1915, the *Modern Hospital,* a Canadian magazine for hospital administrators and doctors, contained an editorial replying to the Ontario Commissioner of Labour's decision that nurses were eligible for inclusion under the new eight-hour legislation, since they did not belong to a strictly learned profession. The *Modern Hospital* editorial began by saying that it had frequently warned the nursing profession that it was "leading their high calling toward a maelstrom of labour unionism."[55] It called attention to California's eight-hour law (proposed to affect nurses), and threatened that this was a parting of the ways between professionals and labour unions. It predicted that this would cost the nurses

> years of woes and hard work on the part of their friends to undo the evil...That time is now come and it becomes the duty of all of us to put our shoulders to the wheel and lift the nursing profession out of the rut in which it finds itself and set it upon the high plane of a recognized learned profession...to reopen the case with the department of labour by striking off our lists of demands all reference to fixed hours, regardless of conditions, and fixed arbitrary wages for graduate nurses without reference to their efficiency.[56]

It was not until 1919 that the *Canadian Nurse* published an editorial favouring the eight-hour day, and it was not until 1938 that a committee was formed by the CNATN to actively campaign for it.[57] This reticence is understandable in light of the doctors' and hospital administrators' attitudes towards the aspirations of the young "profession" and their considerable power to determine its future status. Until this time nurses had been obliged to adopt a humble stance to suit their "benefactors."

The views of the CNATN, later called the CNA, and the journal are not necessarily to be equated with those of the general body of nurses, for it was the opinion of Mrs. Morrison that few of her colleagues ever subscribed to the journal or had a sense that they were being represented by their association.[58] This sense of alienation no doubt stemmed from the high turnover rate among nurses as they left the field for married life and the consequent lack of participation in their associations. The organization tended to

stay in the hands of older, more conservative nurses who were more likely to defend the idealization of nursing.

* * *

The Feminine Mystique and Professionalism

Nursing has historically been bent under the weight of two powerful ideological forces. The first, the bourgeois ideology of femininity, has sought to contain womens' work outside the home within the duties of homemaking; and in the case of many occupations, particularly nursing, it has sought to prescribe a complementary set of acquiescent female attributes. The second was the lure of a "professional" status within a working class situation, professional being a role which, like the feminine role, carried with it a list of proper attitudes.

The ideology of femininity absorbed, without weakening, a number of contradictions when the demands of the economy required it. In fact, popular ideology as to the proper place for women sanctioned employers' exploitation of women's work outside the home. The low wages paid to women were accepted since the work was only supplementary to the primary duties of a woman to her family. The public sector, as an employer of women, made particularly profitable use of the feminine mystique. It was hardly necessary to justify low wages for nurses when their work was considered a public service and similar to unpaid work in the home. Like housework—nursing the ill, teaching small children and tending the poor were "esteemed" as familial labours of love. Thus hospitals, and city and provincial governments refused nurses, as well as other female service workers, decent wages and working conditions, and blocked legislation recognizing the skilled nature of their work.

Governments were able to obtain women at low pay to perform necessary work within the public sector by arguing that these duties were not only an extension of the work they would soon do in the home for free, but also a training ground for married life. The 1916 Report of the Ontario Commission on Unemployment stated that one of the advantages of nursing as a career was that a trained nurse was better fitted for marriage by virtue of her training in health care, diet, cleanliness and so on.[59] All of these arguments put women's work into sharper focus. Bearing children and servicing the family must be seen as constituting an extremely important social function, since so much of the manipulation of women in the

work force has been accomplished in the name of "woman's place." The attitude that women's work in the home was her primary duty, was reflected in hospital regulations, as well as the pressures of public attitudes, prohibiting women from remaining in the "profession" after marriage.

Florence Nightingale encouraged the myth that women's work outside the home was not "real work," but rather an extension of the home work. She responded to the suggestion that nursing be modelled after the medical profession with the statement that "nurses cannot be registered or examined any more than mothers."[60] One could also say that nurses should not be paid any more than mothers!

It is interesting to note that around the turn of the century the Canadian women who broke through the barriers of the medical profession to become doctors were almost exclusively ardent feminists determined to change the educational, social and political status of women. This was certainly not true of nursing. The fact that the first women doctors were pursuing work that was seen as inherently masculine, freed them from the mystique which confused nursing with feminine duties. Unlike these feminist doctors, nurses were forced to repress their discontents behind the two-fold image of silent nurse and sacrificing mother, thus never developing a feminist consciousness.

The feminine mystique was complemented by a set of professional attitudes which nurses adopted as the price of admission into the professional realm.

> A profession [like the medical profession] attains and maintains its position by virtue of the protection and patronage of some elite segment of society which has been persuaded there is special value in its work. Its position is thus secured by the political and economic influence which drives competing occupations out of some areas of work, that discourages others and that requires others [like nurses] to be subordinated to the profession.[61]

This quotation defines the nature of the medical profession at the turn of the century, when it had been accorded control over health matters through the auspices of the Royal College of Physicians and Surgeons. It describes the medical profession's relation to the nursing profession, which had been allowed to develop but under the condition of subordination.

The authoritarianism inherent in the ideology of medical professionalism was necessary to impress upon nurses their own

position in the medical hierarchy, in relation to the doctors, different classes of patients and the rest of the hospital staff. The *Canadian Nurse* abounds with lectures on appropriate behaviour:

> She owes to the attending physicians absolute silence regarding their professional demerits or blundering. No nurse who has not learned the lesson of implicit obedience to authority and practised it until it has become a habit of life, is fitted to command others.

As women, nurses were socialized to be subordinate to male doctors, but as graduates of nursing programmes, they were taught to feel superior to aides and practical nurses.

Yet the gap between the professional rhetoric of nursing and the objective realities was huge. Work in the hospitals closely resembled industrial conditions in a number of important aspects, especially when the divisions of labour grew more complicated. In industry, increasing specialization led to the alienation of workers from the product of their labour. Specialization in health care began with the rise of the modern medical profession and the irrevocable split between "curing" and "caring." The nurse's activities, for a large part of the period this article covers, were difficult to distinguish from those of a servant's. Later "caring" was further compartmentalized, creating a complex of technicians, aides, maids, cooks, clerks and cleaners, all of whose work was essential, but who were, and continue to be, accorded no power or credit. All credit for patient recovery went to the doctor since it was supposedly only he who participated in the science of "curing." As in industry, wages were very low and there was no chance of upward mobility, from maid to nurse or nurse to doctor. Nevertheless, nurses and other allied health "professionals" remained workers who did not see themselves as workers. The belief that all jobs were valued equally in a cooperative humanitarian effort, obscured the great variation that existed in work conditions, wages and status among the hospital staff. Alienating, hierarchical situations were offset by the "team" notion of professional work. Solidarity with other staff over common grievances was largely sacrificed to a primary institutional and professional loyalty.

Professionalism among skilled health care workers not only isolated them from each other, but resulted in their working in opposition to the unskilled workers in the hospital:

> Skilled workers are seduced by the ideology of professionalism into foregoing both qualitative and quantitative satisfactions in return

for an abstract sense of status. The result is an increasing division of the non-managerial hospital work force into two groups with opposing class identifications: on the one hand, a proletarianized body of unskilled and semi-skilled workers, and, on the other hand an equally large group of skilled workers who, through the device of professionalism, are allowed to participate—however vicariously—in the very real status of the doctors.[62]

Sexism and the lure of professionalism have been crucial factors in the transformation of women's role in medicine from that of independent practitioners to alienated workers. Nevertheless, in the post-World War II period, nurses continued to strive for upgrading in order to win the acceptance of established professionals rather than seeking the support of other health workers.

The professional drive of nurses has improved their educational standards but has not been reflected in their working conditions, their degree of power, security, or in their wages. Nurses, for example, are still fighting the competition of less skilled women whose cheap labour is a boon to hospital administrators.

Nurses have had an especially difficult road to travel in overcoming both the feminine mystification of their work and the illusion of professionalism used against many skilled hospital workers. However, their position as women in a highly discriminatory setting, and as part of an oppressed class of waged workers is unlikely to remain obscured by the rhetoric as the increasing alienation of hospital "efficiency" systems prove it a lie. The growing big-business orientation to health care has already led to a break from professional ranks by Canadian and British nurses who have recently engaged in militant strike actions to protest their conditions. The task remains to forge an alliance between skilled and unskilled alike to completely abolish the divide and rule of professionalism.

Footnotes

1. Barbara Ehrenreich and Deirdre English, *Witches, Midwives, and Nurses—A History of Women Healers*, p. 3.
2. *Ibid.*, pp. 3-20.
3. Gibbon and Mathewson, *Three Centuries of Canadian Nursing*, p. 1.
4. *Ibid.*, p. 1.
5. *Ibid.*, p. 66.
6. *Ibid.*, p. 93.
7. *Ibid.*, p. 146.
8. *Ibid.*, p. 68.
9. *Ibid.*, p. 139.
10. See the article by Leo Johnson for a better picture of the transition from a primarily agricultural society to a primarily urban one, as mechanization and industrialization transformed the means of production.
11. *Ontario Sessional Papers*, 1872-73, pt. 2, pp. 66-67, as quoted in Richard Splane, *Social Welfare in Ontario 1791-1893*, p. 209.
12. The apparent non-existence of a widespread popular health movement in Canada and the emergence of the Canadian medical profession would be an interesting subject for further study. *Witches, Midwives and Nurses* gives a very interesting analysis of the ascent of the American medical profession and the repression of community medicine through organized ruling class intervention as represented by the Carnegie and Rockefeller foundations. Possibly the Canadian experience was influenced by the large Loyalist population which was less opposed to the medical elite and its Family Compact ties, while in the United States, the influence of dissenting religious sects gave the popular health movement great support. Perhaps the Canadian experience was influenced by the church's early development and control over many health services and the pattern of authority it established. It is possible that there *was* opposition to the growing power of the medical profession from supporters, yet undiscovered, of community medicine.
13. Robert Gourlay, *Statistical Account of Upper Canada*, p. 364, as quoted in Splane, *Social Welfare*, p. 195.

14. Within the milieu of Victorian lady reformers, a few stand out for their successful reform campaigns. Nightingale contributed significantly in the field of hospital reform, bringing in many improvements in sanitation and general organization complementary to her desire to introduce a new class of women to the hospital.

15. In Canada as in England, middle- and upper-class women did what they could to aid victims of rapid capitalist development. These reform organizations included the women's hospital charities (whose fund-raising made possible the construction of hospitals in Kingston, Montreal and Toronto), the National Council of Women, the Victorian Order of Nurses, the Temperance Leagues, the Young Women's Christian Association, and the Social Service Council of Canada.

16. Gibbon, *Three Centuries*, p. 110.
17. *Ibid.*, p. 147.
18. Brian Abel-Smith, *A History of the Nursing Profession*, pp. 61-80.
19. Gibbon, *Three Centuries*, p. 149.
20. *Ibid.*, p. 144.
21. *The Mack Training School for Nurses 1874-1949*, St. Catharine's Alumnae Association, 1949.
22. *Canadian Nurse*, October 1908.
23. Jean T. Scott, *The Conditions of Female Labour in Ontario*, p. 16.
24. MacDermit, *History of the School of Nursing of the Montreal General Hospital*, Montreal Alumnae Association, 1940, p. 335.
25. Gibbon, *Three Centuries*, p. 163.
26. *Ibid.*, p. 154.
27. G.M. Weir, *Survey of Nursing Education in Canada*, p. 287.
28. Gibbon, *Three Centuries*, p. 162.
29. Weir, *Survey*, p. 177, pp. 363-4.
30. Interview with Mrs. H. Morrison of Toronto.
31. Gibbon, *Three Centuries*, p. 163.
32. Weir, *Survey*, p. 66.
33. *Report of the Ontario Commission on Unemployment*, 1916, pp. 185-6.

34. Doctors replying to the 1929 Weir Survey estimated that untrained practical nurses tended, on the average, 62 percent of cases of "average acuteness." The *Survey* put the actual number of practical nurses at 10,000, about the same as the number of active graduate nurses. Prior to the serious competition from trained nurses, the numbers of women engaged in this work must have been even larger. Many advertisements for Nurse-Domestics in the Globe around the turn of the century testify to this. Their lack of recognized skills categorizes them with the other paid domestic workers. (See Weir, *Survey*, pp. 23 and 420.)

35. See Cost of Living Chart in L. Rotenberg's *The Wayward Worker*.
36. Gibbons, *Three Centuries*, pp. 163-4.
37. Weir, *Survey*, p. 417.
38. *Canadian Nurse*, (Fall, 1921).
39. CNA, *The Leaf and the Lamp*, (Ottawa: 1968).
40. Weir, *Survey*, p. 75.
41. Interview with Mrs. Morrison.
42. Weir, *Survey*, p. 81.
43. Interview with Mrs. Morrison.
44. Weir, *Survey*, p. 108.

45. A wealth of information on the living conditions, and the high rates of disease, of families in Ontario, particularly in the isolated rural areas, can be found in the medical diaries (often in photo-album form) of these early public health nurses. (Department of Public Records, Records of the Ontario Department of Health.)

46. Adelaide Hoodless was the founder of the first Women's Institute, started in Stoney Creek in 1897. Her interest in public health problems began with the death of one of her children from contaminated milk. She was also active in the YWCA and the WCW.

47. The Ontario Medical Association had opposed the conception of the VON in 1897 saying, "in all work of public health, and preventative medicine, the medical profession should never surrender its right to lead." Some ill-will apparently continued, for the Weir Survey of Nursing Education in 1929 found public health nurses were named the least agreeable by the doctors surveyed.

48. D.M. Percey, "VON for Canada," *International Council of Nurses*, (July 1928).
49. Ehrenreich, *Witches*.
50. Gibbon, *Three Centuries*, p. 329.
51. Canadian Nurse, 1907.
52. Weir, *Survey*, p. 60.
53. Vern and Bonnie Bullaugh, *The Emergence of Modern Nursing*, pp. 162-66.
54. Margaret Jones, *Watch Fires on the Mountain*, p. 121.
55. *Modern Hospital,* as quoted in *Canadian Nurse*, (September 1915).
56. *Ibid*.
57. C.N.A., *The Leaf and the Lamp*.
58. Interview with Mrs. Morrison.
59. Ontario Commission on Unemployment, 1916, p. 187.
60. Seymer, *Nightingale's Nurses*.
61. John and Barbara Ehrenreich, "Hospital Workers" in *Monthly Review*, (January 1973), p. 21.
62. Ehrenreich, "Hospital Workers," p. 25.

Table A

Statistical Breakdown of Nurses for the Year 1930

Status	*Numbers*	*Percent*
Students	12,336	30
Inactive	7,651	19
Active	10,523	26
Institutional	12,635	6
Private	6,361	16
Public Health	1,527	4
Total	41,033	100

Survey: Taken from Weir, *Survey*, p. 52.

Note: The total number of active nurses is approximately the same as the estimated number of practical nurses. (See Table B)

Table B

Numbers of Physicians, Nurses, Midwives and Practical Nurses for the years 1851-1930.

	Physicians [a]		Nurses [b]		Midwives [c]		Practical [d] Nurses
	Can.	Ont.	Can.	Ont.	Can.	Ont.	Can.
1851	792	410	—	—	17	8	—
1861	1559	603	—	—	34	16	—
1871	2792	1565	—	—	89	21	—
1881	3507	1778	—	—	—	61	—
1891	4448	2266	—	—	—	—	—
1901	5442	—	280	—	—	—	—
1911	7411	3053	5600	2763	—	—	—
1921	9278	3459	21385	9951	—	—	—
1930	9292	3860	30510	—	—	—	10,000

[a] Statistics taken Urquhart, *Historical Statistics of Canada*, B 108-115, with the exception of 1930, which is taken from the *Weir Survey*.

[b] "Nurses" includes student nurses and all registered nurses.

[c] Statistics taken from Census 1851, 1861, 1871 and 1881. As midwives had to be approved by the College of Physicians and surgeons of Upper Canada in 1839, or face possible legal action, census data will not include those untrained women practising midwifery. The numbers given refer only to women trained in other countries who moved to Canada and continued to practice. After 1881 trained midwives were categorized with "public health nurses."

[d] Taken from an estimate of the *Weir Survey of Nursing Education*, p. 420. Newspaper ads at the turn of the century indicate a great demand for practical nurses and one might speculate that their numbers were much greater before 1930 when competition from trained nurses was smaller. Occupationally, untrained nurses were categorized with "domestic servants."

Schoolmarms and Early Teaching in Ontario

On the function of learning:
> She prompts the sacred duties of mankind,
> Gives fear to God from whom all blessings spring,
> To parents reverence—honour to the King;
> To laws obedience, Magistrates respect,
> Britain's just rights and honour to protect.[1]

In this nineteenth century writer's view of learning, the feminine pronoun presides over a veritable thesaurus of virtues. Here virtue springs not only from the font of Learning, but also from the pedestal of Womanhood. The social environment which spawned this sort of rhetoric presented women in the nineteenth century with two formidable obstacles: male supremacy and the complementary female role of noble self-sacrifice. Ingrained though these ideals were, women managed to challenge them by struggling against the bonds of socialization which dictated their place in the home and by entering the labour force in increasing numbers. This challenge was just the beginning of a struggle that continues today, a struggle for recognition of women's right to equality as workers in the labour force. For when women took jobs in the work force, they found themselves face to face with a growing capitalist state that was careful to maintain their new status as workers only as long as their labour was cheaper than men's and they retained jobs that were specifically oriented to the service sector of the rising new industrial state. Women found the doors of teaching, nursing, clerical work, domestic service and factory work open to them; the professions, executive and managerial positions in business and industry, politics and academia remained unapproachable male domains.

An examination of teaching illuminates only too well the ways in which the developing state was able to utilize this new labour pool of female workers to its best advantage. By following the struggle of women teachers in Ontario from the period of their entry into the field until the Depression, we can gain some understanding of the discrimination and countervailing forces female teachers experienced and are still undergoing today.

* * *

Early Education in Upper Canada

During the nineteenth century, Canada's population expanded at a phenomenal rate. Largely as a result of immigration, the population increased from approximately 362,000 in 1801 to 1,650,000 in 1841 to 7,200,000 in 1911.[2] During this period, settlement patterns shifted from the wilderness to small communities and cities. Upper Canada experienced a transition from a primarily rural agrarian distribution of population to a more urban, industrialized one.

The growth of the cities was linked inextricably to both the growth of population and the rise of industrialization. Shoes, furniture, textiles, clothes and other household goods could now be made by machines in factories instead of by hand in the home. The development and growth of technology and industry meant a new demand for great numbers of easily trainable workers, as well as the erosion of women's productive role in the home. By mid-nineteenth century both of these developments had taken root and had implications for the field of education. Industry demanded employees who were amenable to training, competent at learning skills and used to authoritarian, hierarchial systems of control. Its needs focused on the institution of a system of compulsory education for the masses which could provide a pool of such malleable workers. At the same time women were beginning to explore new work roles outside the home; teaching became one of the new fields open to them.

Education before the 1840s took place in an assortment of schools patterned on English models, usually under philanthropic and paternalistic auspices. Colonel John Simcoe, the first governor of Upper Canada, believed that the state's duty began and ended with the education of an administrative and ruling class.[3] Simcoe supported the concept of grammar schools, which rapidly became the exclusive preserve of the rich and privileged (e.g.

Upper Canada College). These institutions met the needs of the elite very well indeed. Private ventures, like Mrs. Cockburn's School in York, established exclusive and high-paying clienteles. Similarly, governesses and tutors were frequently hired to educate the children of well-to-do families.

Advertisement for Mrs. Cockburn's School:

Terms per Quarter

For Education in the English Language, Grammatically, History, Geography, the use of the Globes, with plain and fancy Needle-work,	£2. 0. 0.
Writing and Ciphering,	0.10. 0.
The French Language,	1. 0. 0.
Drawing and Painting on Velvet,	1.10. 0.
For Board and Lodging,	8.10. 0.

Music, Dancing, Flower and Card-work, are also taught in the School and charged moderately.

Mrs. Cockburn will receive a Junior Class of little children from four to seven years of age, for five dollars per Quarter each.

Entrance One Guinea

Every lady to provide a Table-, and Tea-spoon, Knife and Fork, Sheets and Towels, and to pay for her own washing.

—Upper Canada Gazette, *30 May 1822.*

Elementary education for the poor was often sponsored by private and religious bodies (e.g. the Society for the Propagation of the Gospels, an Anglican missionary society), whose interests were:

> to inculcate religion, gratitude, industry, frugality and subordination—in short, to make their pupils loyal church members and

to fit them for work in that station of life in which it had pleased their Heavenly Father to place them.[4]

Sunday schools evolved as vehicles for the teaching of reading to the children of the illiterate masses, and were common throughout Upper Canada by the 1830s.[5] Charity and infant schools also served working class children; often these were little more than child-minding centres.

Women have conventionally been seen as "natural" teachers of small children—an extension of the nurturing function of child-bearing. More often than not, the education children in the early nineteenth century received was provided in a haphazard manner by their mothers. It was not uncommon for women to take other children into their homes and attempt to run small private schools in order to add to the family income.

The new industrial ideal of efficiency found an extraordinary proponent in the monitorial schools which were established after 1815. Here the poor were subjected to a factory system of education "par excellence." In England, reformers such as Lancaster had developed schools that resembled Lancashire weaving sheds. A foreman-teacher supervised older students who in turn supervised hundreds of children all disciplined to react in specified ways to rigid commands (e.g. "Raise pencils!"). "Thus the child was placed in the Three R's factory, which by its very nature required him to drop his personal life in order to fit into the machine."[6] The monitorial school in York was the only one in Upper Canada which really caught hold for any length of time; it did serve to introduce

Positions to be taken by a pupil in response to commands in a Lancastrian school

ideas of grading and teacher training. However, it was ill-suited for the small rural communities which still constituted the bulk of the population at this time.

The needs of these communities had been grudgingly acknowledged in 1816 by the legislation of a Common School Act. It provided a small grant to be divided among the elementary schools which had begun to spring up on the initiative of local people.* Such government patronage, despite its financial insignificance, was quite a departure from the idea of private patronage; however, it was some time before the Ontario Legislature expressed much more than indifference to popular education:

> In 1832 . . . it was reported that the Legislature was spending less for the education of the youth of the population of 300,000 than for the contingent expenses of one of its own sessions.[7]

By 1844 the government education system was in such a sorry state of neglect that the Superintendent of Education for Toronto, George Barber, was attacked in the press and "charged with withholding teachers' salaries, with arrogance in office and with neglect of duty."[8]

The lack of serious support by the Government reflects the general lack of enthusiasm at this time for common education beyond the three R's. One result of the low financial priority given to education in the first half of the nineteenth century was the employment of what a contemporary called "worthless scum under the character of school-masters."[9] "With few exceptions, the early common school teachers were a sorry lot: ignorant and immoral persons, old soldiers, idlers of all descriptions, notorious for habits of drunkenness!" They were "shipwrecked characters, who, to keep body and soul together, were compelled to teach."[10] Indeed, J.H. Sangster, Principal of the Toronto Normal School in 1898, tells of carrying home in a drunken stupor two of his teachers—a former sailor and a former cobbler. He also relates the tale of a legendary West Toronto teacher who made good use of his wooden arm "wherewith to hammer the Three R's into unreceptive scholars."[11]

Still, despite such horrific tales, the incidence of parent-initiated common schools increased, particularly in the rural areas.

*These were usually one-room schoolhouses built by parents and taught by teachers they had hired and paid for themselves.

Attendance may have been erratic,* and classes rough and ready, but most parents wanted little more than reading, writing and ciphering for children whose labour was often needed in the fields or at home. Parents were willing to initiate and pay for the establishment of such schools; however, they expected the teachers they hired to be flexible enough to accommodate the exigencies of farm life.

Mid-Century Educational Reform

The development of the state and its industry in Upper Canada was paralleled strikingly by the evolution of state-controlled education. With Confederation just around the corner, and the ideals of democracy on the minds of every citizen, the political climate was ripe for Egerton Ryerson and his reform campaign for "equalization of educational opportunity for all." The period from 1830 to 1860 was one of rapid expansion, accompanied by new pressures for educational facilities and teachers. It was an era of history which witnessed a dramatic change in the disinterested attitude of government regarding education.

The mid-nineteenth century was, as well, a time when it was in the best interests of the ruling class to assimilate immigrants by making and keeping them British. Egerton Ryerson voiced the fears of the establishment when he spoke of immigrants in 1842 as possible harbingers of a "worse pestilence of social insubordination and disorder to come."[13] The necessity of control and order in society assumed greater and greater proportions in the minds of legislators; increasingly, they saw compulsory education as one of the means of "civilizing" the "natural" depravity of youth and curbing the insubordination of the labouring poor. The factories of the new age required of their workers restraint, punctuality and the "quiet and respectful deportment and ... cheerful submission to authority" outlined by one educator as the aspiration of all schools.[14] Mid-century reformers saw in education the panacea for many of the evils of industrial society.

At this time there was much discussion of the "beneficial" effects of compulsory schooling as a means of doing away with crime. "Street Arabs" and vagrant youths were a mushrooming

*Often children of ages 3-12 would go to school in summer and older people aged 14-30 would attend in winter.[12] Students would generally squeeze in schooling whenever their labour wasn't essential at home.

problem in the cities, and it was felt that schooling would keep them off the street and inculcate them with "proper" values. This attitude gained wide popularity, and twenty years later we find it echoed by a school inspector:

> Let me repeat once more that school houses are cheaper than jails, teachers than officers of justice; moreover, they stand towards each other in an inverse ratio... The education of the masses, in connection with the moral and religious training of youth, constitutes the only efficient means of drying up the sources of crime.[15]

The appointment of Egerton Ryerson as Superintendent of Education in 1846 stands as a turning point in Ontario education. With Ryerson's appointment the real organization of both an ideological framework within which to shape ruling class demands and a system to make this framework operable was set into motion. He did such a thorough job that "for many years the people of the Province were convinced that they had the best school system in the civilized world."[16] Much of the literature about Ryerson suggests that his sweeping changes were brought about single-handedly, with gracious magnanimity and in the spirit of true wisdom. Perhaps he would be better seen as the personification of the often-ruthless developing bourgeoisie, struggling to establish and maintain itself through the machinery of education. His effectiveness as a catalyst cannot be denied; he brought into focus the prevailing tendencies of his time. Ryerson himself considered his opinions to be similar to those of "any common sense practical man, whose connections and associations and feelings are involved in the happiness and well-being of the *middle-class*."[author's emphasis]*[17] His pronouncements echoed the sentiments of many who felt that "the investment in education guaranteed the safe possession of the tax-payer's goods, for a disciplined and moral working class would not steal or rise up against property."[19]

The educational reformers of the mid-nineteenth century saw schools as agents of social reformation and social discipline. Egerton Ryerson's Common School Acts of 1846, 1847 and 1850 promised education "as free as the air"[20] and as the right of all men. The ideals of the new education were cloaked in the rhetoric of democracy, eloquently expressed by Ryerson. He saw mass education as

*Indeed, Ryerson's identification with the elite rather than working people and the democracy he espoused was so complete that he educated his son privately, rather than in a common school![18]

the motor of social harmony and progress, while simultaneously suppressing the facts of social and political conflict.[21] Beneath the rhetoric of the reformers lay the reality of loss of freedom of choice; the individual was now subjected to compulsory schooling controlled by the state. Ryerson's interests lay not with the betterment of society, but with the interests of a bourgeois elite who wished to preserve the sanctity of status quo and property.

The Reverend Dr. Ryerson came from Tory, United Empire Loyalist stock. He worked on a farm, taught school, became an itinerant Methodist minister and edited the *Christian Guardian*, with which he helped to challenge the hegemony of the Church of England. In 1842 he became the Principal of the newly-formed Victoria College. The consummation of Ryerson's career was his appointment as Superintendent of Education in Upper Canada, a position which he held from 1844 until 1876.[22] In him we can see the victory of middle class Methodism over the old forces of church, king, and privilege, which had for so long held sway in Bishop Strachan's Upper Canada. Ryerson championed the ideals of his Methodist heritage, which embodied the Protestant precepts of individualism, energy, plain-living, thrift and optimism—qualities all admirably suited for the blossoming of business and industry. Drawing upon the Scottish precedent of free national education, Ryerson set about forging a system of non-sectarian education for the masses.

From his journeys abroad while he was Assistant Supervisor of Education, Ryerson had synthesized what he considered to be the best methods existing modern education had to offer: attendance was to be compulsory; textbooks were to be supervised by the central authority; schools were to be systematically inspected; teacher training was to be regulated; and a system of local participation was to be ensured by the municipal election of trustees to local Boards of Education. The new system was to be supported financially by local property taxation supplemented by government grants.[23] Teething pains were felt immediately.

Ryerson's institution of a centralized educational authority, backed by the force of the law, did not come about without considerable opposition. The advocates of denominational, local and individual freedom argued against uniformity and coercion, although the rationale most frequently espoused against state schooling fell along the lines that the wealthy would continue to educate their children privately, leaving the public schools as the

Egerton Ryerson,
Superintendent of Education
for Upper Canada

domain of the poor, and that *general* taxation to support such schools would be unfair. A Barrie man of means, blunter than most, put it plainly at a meeting called to establish a Common School:

> What do we need such schools for? There will always be enough well-educated Old Countrymen to transact all public business, and we can leave Canadians to clear up the bush.[24]

Ryerson, however, managed to tenaciously override his critics with what was sometimes termed "Prussian despotism."

In 1848 the schools of Toronto were closed for one entire year over the issue of the property taxes required by Ryerson's new Common School Act which were needed to run the city's fifteen schools without student fees.[25] Ryerson stood fast on the principle of non-fee schools, and in 1851, the Toronto Board of Education capitulated and endorsed this principle.[26] Still, despite the forcefulness of the factions Ryerson represented, it took twenty years of manoeuvering on his part to overcome the stubborn resistance of the people to centralization. In 1871, all remaining school districts were required by law to provide free schools by means of local taxation.[27]

The School Act of 1871 also made school attendance compulsory for children aged seven to twelve for a period of four months per year.[28] (It wasn't until 1930 that the school year was broadened to ten months.) This legislation was an attempt to deal with massive truancy; in the 1850s less than half of the children in Toronto actually attended schools.[29] Free universal education was obvi-

ously not above the suspicion of many parents who needed their children to work on the farm or at home. Even in the 1880s the great majority of students left school before age fifteen, with boys usually going into trades and girls into domestic service.[30] The class nature of common schools was such that those with the money and aspirations to back ambitious children continued to send them to private schools in contempt of the state system. The children of the poor and working classes resisted the compulsory nature of the educational system, because they did not see in it the potential of bettering their lives.

The system of financially supporting schools by property taxation was gradually supplemented by increased grants from the provincial government made through the Council of Public Instruction. These grants were used as a lever to encourage adoption of approved educational practices and as a means through which Ryerson could expedite his programmes. What began as paternalistic grants-in-aid eventually stabilized to the point where municipalities could expect fairly constant assistance. This was accompanied by an important shift in power: the curriculum became the responsibility of a central authority—the Council of Public Instruction with the Superintendent of Education at its head. The local boards were responsible for the mechanics of running a school system: hiring and firing personnel, buildings, supplies and policy supervision. But the content, the ideology to be propagated, had become the prerogative of the new state.

The struggle between local tenacity and centralized government control was Ryerson's chief problem; his attempts to organize township boards in order to replace the local school sections met with opposition throughout his career.[31] The debate between centralized bureaucratic efficiency (and its accompanying depersonalization), and the need for local control over and responsiveness to local problems continues to this day in the community schools movement. "Equal educational opportunity for all" must be seen in the historical context of loss of local control and the benefits that thus accrued to the state.

Teacher Training

Consistent with Ryerson's efforts to propagate compulsory mass education throughout the land was his attempt to standardize educational methodology. In order to ensure that the new reforms reached the broadest possible audience, uniform course content,

controlled textbooks in schools, and control of teacher training in centralized state institutions were implemented. The Toronto Normal School opened in 1847; it was modelled on the Dublin Normal School, and was the first of its kind in Upper Canada. Here teachers were instilled with the responsibility for the inculcation of the high moral and spiritual ideals cherished by an emerging capitalist state—industriousness, thrift, duty and self-discipline.

Candidates for the Toronto Normal School had to be at least sixteen and had to produce a certificate of good moral character signed by a clergyman.[32] Academic standards were low since the level required of candidates would be approximately equivalent to present-day Grade Six.[33] However, the workload expected of students was staggering. It included nine hours a day of lectures supplemented by one hour of observation and practice at a model school.[34] Initially, great emphasis was placed on subject content, and this persisted until the late 1860s, when increasing numbers of normal school students with a year or two of post-secondary education began to apply for admission. The enrollment of better qualified students meant that it was possible to shift the emphasis from subject content to pedagogy—teaching methodology and professional techniques. However, regardless of these improvements, the amount of cramming required to achieve certification led to such excesses of overwork that the normal schools came to be blamed for producing "slave-driving" teachers who made life miserable for their pupils and themselves.[35] Miss Emily Ames of Toronto says of her year at the Toronto Normal School that "I never worked so hard before nor since!"[36] In 1881, J. Workman, a Toronto physician, addressed the Ontario Educational Association on "the Morbid Results of Persistent Mental Overwork." He stated that "the proportion of deaths from consumption among teachers was more than twice as high than among skilled workmen... that the number of women teachers admitted to asylums for the insane was disproportionately high..."[37]

Despite Ryerson's efforts to promote normal school training, less than a quarter of the teachers in Ontario were normal school graduates by 1875.[38] His failure to recruit more candidates was in part due to lack of government funding and in part due to the continued and overwhelming popularity of the county model school system. These alternate training schools provided a steady flow of Third Class teachers who were in constant demand by penny-pinching local Boards of Education. They persisted as an

alternative to normal school training until well into the 1920s.

County model schools, which had at least four normal school trained teachers on staff, took on aspiring teachers after a year or two of high school for a period of three months.[39] A brief period of instruction qualified a teacher for a Third Class Certificate granted by the County Board of Education, which was valid in that county only. The Certificate was renewable by petition after three years of teaching, and after 1885, by writing Third Class non-professional exams. It could be upgraded after a year's teaching by further high school and normal school training.[40]

The model schools of Ontario were described by a professional journal in 1880 as "fifty-two mills or teacher manufactories that bid fair to swamp, by their over-production of an article which is now a drug on the market, the profession of teaching in this province."[41] J.G. Althouse, a later luminary in education circles in Ontario says of model schools that their "effect . . . upon the status of the profession was devastating. . . (They) succeeded only in handing over the vast majority of the schools to the half-trained and the immature."[42] Teachers with higher ambitions and seeking professional status tried to exert more control over the job market by tightening admission requirements to the model schools. However, the attempts by Ryerson and these "professionals" to deter "underqualified" teachers began a conflict which was not resolved in Ontario until 1971. Not until then were all elementary school teachers finally required to have a university degree before commencing "professional" training.*

In contrast to model schools, normal schools reflected the increasingly strong movement of educational authorities towards

*A degree has been customary since the turn of the century and has been formally required of secondary school teachers since 1920. Less than 20 percent of Ontario teachers had a degree at the beginning of World War II.[43] Until 1971, normal schools maintained some aspects of the old model schools (which persisted until the late 1920s), in that student teachers could study for two summers and begin teaching one fall after Grade Twelve. This arrangement proved to be particularly attractive to rural girls who had few illusions about career teaching and the grand ideals of "professionalism." "Trousseau teachers" knew their career would only last as long as they remained single, since married women were not hired by Boards of Education. They also knew that jobs were always available for those with a minimum of qualifications and low salary demands.

upgrading teaching through controlled training. Ryerson's insistence on the importance of this kind of "professional" training underlines the connection he made between certification and control of the form and content of teaching and schools.

The professionalism Egerton Ryerson hoped to engender by controlling teacher training in normal schools did not materialize to any great extent among female teachers. Women were more eager to attend the model schools than they were the normal schools, which led to a proliferation of Third Class Certificates. Normal school training, in reality, did little in terms of establishing teaching as a true profession, mainly because the majority of both men and women thought of teaching as an occupation that would last no more than a few years. In the graduating class of the Toronto Normal School in 1856, the majority of the twenty male graduates ended up in business, medicine, law, the clergy, farming and civil service;[44] for them, teaching was little more than a stepping stone. Women had less choice; marriage ended their teaching career. Only widows and spinsters taught longer than a few years. Those who did remain often suffered the caricatured reputation of embittered self-righteous "Miss Grundy's"—disappointed shrews rather than dedicated careerists.

The flood of women into teaching in the latter half of the nineteenth century was precipitated by the pressure of women seeking entrance to the work force. After the Common School Act of 1850, the trickle of women entering teaching became a torrent. Opportunities in teaching were opening up as population grew and as compulsory attendance was increasingly enforced by the central authority.* In 1847 women teachers were listed separately in provincial government records for the first time;[46] by 1861 one teacher in four was female, and by 1869, women were in the majority.[47] By 1919 they outnumbered men five to one.[48]

In mid-nineteenth century Upper Canada, very few of the career options open to men were available to women. Women who were interested in working outside the constraints and dependencies of the home had to select their occupation from a very restricted range of employment possibilities. Once they saw that teaching held opportunities for them they flocked into the field.

The attraction of teaching over domestic work and factory

*In 1846 there were 2,925 places in the common schools for teachers; in 1876 the number of places had increased to 6,185.[45]

Elementary school c. 1910-15, Timiskaming District (Rev. W.L.L. Lawrence Collection. Ontario Archives)

jobs, which were becoming increasingly available to women, was cemented by an aura of genteel respectability cultivated by educators and the public alike. Though working conditions and salaries might be worse than her sisters' in factories, the young female teacher had the assurance of society that hers was a high calling, untainted by the grimy reality of the everyday world.

The middle of the nineteenth century witnessed a considerable controversy over the questions of co-education and women's intellectual accomplishments. Previously, educational opportunities for most women had consisted of elementary education; for the rich, there was the hothouse variety of schools for young ladies, such as the Eclectic Female Institute in Brampton.[49] Here girls were trained in music, needle work, elocution and other subjects of an ornamental rather than a practical nature. The right of women to intellectual development and to roles within the working world was challenged as women increasingly entered the work force; this evoked grave pronouncements from the male elite on the nature of female potential. Woman's role as queen of the home was the prevailing bourgeois ideal, and Ryerson and many others opposed co-education as an interference with this ideal.*[50]

*Ryerson instigated the removal of co-education from Victoria College when he was principal from 1842-44, a ban that lasted until 1878.[51]

However, by 1867 the demands of women for broader participation in society had forced some compromises and girls were admitted to secondary education and grammar schools. Rather tellingly, in the eyes of government, the entry of women into secondary education was of such little consequence that at first girls only counted as one-half a boy for grant-giving purposes.[52] The doors of the university were finally opened to women in 1884;[53] by 1902, 277 women had graduated from that august institution, the University of Toronto.[54]

Ryerson, despite his disapproval of co-education, was unable to stem the demand by women for higher education in institutions such as normal schools. By 1848 the Toronto Normal School was flourishing, and twenty women were enrolled in the new "female department" (total enrolment: 118).[55] At the outset, women faced considerable discrimination in gaining admission to the Normal School, but the pressure of increasing numbers of poorly qualified women entering the teaching field through model schools had the effect of lowering the resistance of normal schools to women. By the 1860s female students were in the majority in the Toronto Normal School; females outnumbered males 92-76.[56] The undeniable reality that women were in teaching to stay finally provoked an admission from Ryerson in 1886 that the increase in women in the common schools was "a progression in the right direction."[57]

> In 1849 Martha Hamm Lewis, after repeated refusals, was finally granted an Order-In-Council by the Lieutenant-Governor granting her admission to the new Normal School in New Brunswick—under certain conditions...
>
> "She had to enter the classroom ten minutes before the other students and was required to wear a veil. She was asked to sit alone at the back of the room, retire five minutes before the lecture ended, and leave the premises without speaking to the male students."
>
> —*C.E. Phillips,* The Development of Education in Canada, *p. 383.*

Working Conditions of Early Ontario Schoolmarms

The public school teacher in the 1850s faced the prospect of an extremely demanding job both mentally and physically. Despite Ryerson's vision of teachers as embodiments of virtue shaping the morality of a young nation, teachers had to face the legacy left them by the incompetents and rejects of the old regime. Fighting for new "respectable" status was not easy when physical conditions remained so wretched.

Conditions in the common schools were formidable; classrooms were sometimes crowded with over one hundred children per teacher.[58] A Hanover public school teacher, Alex Stephen, writes in 1869 that he and a female teacher looked after 400 pupils between them for two years until their objections caused the trustees to engage another teacher![59] "In Kingston it was reported in 1850 that children of all ages were ... packed in their seats as close as one's fingers, and were equally in danger of suffocating as of freezing to death."[60] "A school in Uxbridge crammed sixty children into a space 18 by 20 feet."[61] James Porter, Superintendent of Toronto Schools from 1858-1874 estimated that the maximum number of pupils per class in Toronto in 1864 was seventy-five; he admitted, however, that most teachers had from ninety to a hundred pupils in their registers.[62]

S.S. #4, Amabel. Teacher: H. Hanah Sophia Parr, 1898, Bruce County (Ontario Archives)

In response to such over-taxing numbers of of students, discipline was often fierce. Caning and cuffing were everyday occurrences. The Toronto Board's disapproval in 1851 of the use of a rawhide whip, and of corporal punishment in general was considered an advanced position for its time.[63]

Though many citizens had doubts about women's ability to handle such matters as discipline and organization, trustees readily perceived the advantages of hiring women. Women, inferior though their capabilities might be, were bound to be an improvement over the male misfits who had infested the field previously; the new country and its ideals would be well served by injecting some of the saintliness of womanhood into its educational system. There was also the question of salaries: women would only have to be paid half of what men demanded, and they could be counted on not to complain as well! In fact, the accusation of bargain-hunting for cheap services has been levelled at parsimonious trustees right up to the present; hiring young women at the lowest level of qualification and salary for a year at a time has traditionally been the cheapest way for school boards to deal with the criticisms of tight-fisted local ratepayers.

In the cities, it rapidly became clear that the easiest way for the Board of Education to make savings was to hire women. Salaries were based on the grade level taught, and women were invariably given the youngest children to teach. In contrast to rural boards who administered many one-room schoolhouses, urban boards developed elaborate hierarchies within their larger city schools which stratified positions and left women at the bottom of the ladder. (See Table 1 over) This policy had a double-edged effect: it catered to Ryerson's vision of teaching as a profession by paying men teachers substantial salaries and thereby increasing their "professional" status, but it was only possible to create this salary money by cutting back on the wages of those who made up the vast majority of the lower ranks—women. Thus, "the respectability of some would be bought with the cheap labour of others."[64]

The victims of trustees' money-saving policies were often sincere teachers like Lizzie Overend. Although she began her career at the tender age of seventeen* and in the most trying condi-

*The average age of teachers in Dufferin County in 1896 was twenty. Educators promoting "professionalism" and the elevation of the status of

Table 1

Hierarchy in the Toronto Common School System 1858

Titles	Salary for the Rank
Superintendent	$ 1,200.00
Secretary (male)	$ 600.00
Headmasters	$ 700.00
Male Assistants	$ 520.00
Headmistresses	$ 400.00
Female Teachers (variously titled: Senior Female Assistants, Acting Headmistresses, Senior Assistants in Charge, or Teachers).	$ 320.00
Female Assistants	$ 280.00
Female Assistants, (usually titled Female Junior Assistant)	$ 240.00
Monitor Teachers (female)	$ 170.00

From *Report of the Past History, and Present Condition, of the Common or Public Schools of the City of Toronto* (Toronto, 1859) pp. 108-25.

tions, her Inspector reports her as being an exceedingly good teacher. She attended Normal School, and began teaching at School No. 1 in Orillia in 1874 at the princely salary of $275. The unplastered log school where she conducted classes of seventy children was condemned by her Inspector as a shamefully inadequate and tumbledown disgrace. Nonetheless, he records that the schoolhouse was kept scrupulously clean at Miss Overend's instigation, and rails at the trustees for allowing such intolerable conditions to persist.[66]

Lizzie Overend was faced not only with an inadequate and

teaching often deplored the practice of flooding the field with exceptionally young and inexperienced teachers. "In Simcoe County efforts were made in the mid '60s to raise the minimum age for getting a school to seventeen for girls and eighteen for boys.[65]

"A meeting of School Trustees" by Robert Harris *(National Gallery of Canada)*

rundown schoolhouse, but also with such day to day maintenance problems as sweeping the floor, disposing of garbage, hauling water and repairing broken utilities. Teachers were usually assumed to be responsible for the general maintenance of the schools in which they taught. In many cases, money-saving trustees could not or would not provide funds for improvements and repairs, forcing teachers to either provide the money out of their own pockets, or else allow their schools to deteriorate. Such menial work and demands on a teacher's time were not uncommon. Rural schoolhouses in the 1870s were generally in such a deplorable state that the central educational authority in Toronto authorized an investigation into the sanitary conditions of rural schools, from which it was ascertained that thirty-eight cases of illness were chargeable to poor physical conditions.[67] Toilets, drinking water and heating facilities were often inadequate; teachers had to look after such affairs as best they could. If they were lucky, the Board might hire one of the older boys to do some of the janitorial work. Teachers' complaints on this matter finally elicited a statement from Ryerson in 1861 in the Journal of Education: "The Teacher is employed to teach the school, but he is not employed to make the

fires and clean the schoolhouse!"[68] The effectiveness of this reprimand is questionable; even today complaints by teachers about caretaking can be heard.

The physical environment in which teachers worked was fairly primitive for years after Ryerson's legislation. "As late as 1862... one [school] in six in Canada West was conducted in a rented building or room,"[69] and "Ontario in 1875 still had more than 1,000 log schoolhouses."[70] Conditions improved gradually as the public began to see school building as an expression of civic pride, and later there were several bursts of new construction of a more imposing sort (e.g. the redbrick Collegiate Institutes built in the 1920s).

Lizzie Overend was luckier than some, for in 1879 the Orillia trustees built a new school in her district. Irene Ireland who taught in Augusta Township from 1863-76, did not have the same good fortune and had to give up her post because of the poor physical conditions of her school. Ms. Ireland's school board failed to repair the door of her schoolhouse, making it impossible to keep out the elements. In a letter written in 1896, she gives us a few glimpses of her problems as a schoolmarm:

Elementary school, Aylesworth. Teacher: Miss M.K. McCrae, 1905 (Ontario Archives)

The teacher and larger girls attended to the sweeping and dusting...; and the fires were built in the morning by the one who first arrived on the spot, were he so disposed. I found this was the usual custom in the country. In some cases, though, boys were hired to build fires.... As might be expected, when the second winter rolled around I resigned, from ill health. In justice to the community I will say that a good home for the teacher was provided amongst them, and pleasant social relations existed between teacher and people. It may seem strange that the teacher put up with such a state of affairs. But how soon we female teachers learned, that in order to be a success in our schools, we must "take things as we find them," and that people *dared* (even with our own sex) find more fault with us than with male teachers. We were at a disadvantage too, because with out own hands we could not make repairs, thereby saving the *additional expense*—that horrible bugbear to some sections in the community.[71]

It is not difficult to imagine the sense of isolation many rural women teachers must have experienced teaching alone in one-room schoolhouses. Their only contact with other educators was the twice-yearly visit paid by the Inspector. Contact with other adults came only from the local parents with whom teachers boarded—people who frequently looked upon teaching as super-fluous to the realities of the struggle of farm life.

Miss Ireland was indeed fortunate to enjoy good relations with the community. For years one of the trials of teaching was adjusting to the customary system of "boarding round." Earlier teachers often had to scramble for accommodation. They sometimes lived in hotels, occasionally in the schools; but most often teachers were required to suffer the indignity of "taking part of their pay in board provided by parents of pupils. Contracts often indicated washing and mending as services to be provided for the teacher in addition to food and lodging."[72] One suspects that this applied more to men than women, for Phillips tells us that "women teachers handy with the needle were welcome guests." Many teachers complained that being shuffled from family to family put them in a position of degrading dependence. However, on their meagre salaries it was impossible for them to establish themselves in a more settled existence. Many abandoned teaching because of the treatment received.[73]

Teachers had traditionally been considered as a rather special class of servants: the nature of the work done by governesses, tutors and teachers was service-oriented, and was by no means

indispensible if more important things came along. The Superintendent for Brock District in 1848 declared that "in his opinion, most female teachers were not superior to household servants."[74] One educator asserted that teachers were treated as "mere hirelings, seen and engaged by school trustees essentially as labourers."[75] As late as 1867, Ryerson disclosed the existence of "young people who taught for a few months and then returned to farm labour or to service as maids or cooks for the remainder to the year."[76]

Ryerson attempted to elevate the status of teachers by "professionalizing" them, but it was some time before teachers, particularly if they were women, could expect to be treated with more than condescension by the local patriarchs. Paradoxically, the community expected young women teachers to behave like refined saints and paragons of virtue despite their low salaries and less than enviable working conditions. Florence Irvine, past president of the Ontario Teachers' Federation, sums up the dilemma of schoolmarms and their relationship to the communities in which they worked:

> Some teachers entered the profession as young pretty girls to be married with great expediency. Far more, though, seem to have been regarded as the dedicated Nightingales of our profession, holding the teaching of children as a sacred trust. They eked out an existence on faith and charity, in somebody else's spare bedroom, and if they were lucky died in genteel poverty. They were ever

In 1894 the bicycle was very popular. [Women's] dress of the time was unsuitable for riding, and one teacher was brave enough to wear bloomers. A rumour of this reached the ears of Trustee Bell and he moved at the Board "that the inspectors be instructed to find out which teachers wore bloomers". He considered such dress marked women as immoral. Trustee Hambly, in a jocular vein, moved that any woman teachers who wore spike-toed shoes, coloured stockings or had corns should be dismissed. Trustee Bell was known thereafter as Bloomer Bell.

—The Story of the Women Teachers' Association of Toronto, *p. 19.*

conscious of the narrow confines of the community in personal freedom. Smoking and drinking and a lot of other social activities were *out*. They taught Sunday School, sang in the choir, directed community plays... were expected to be walking dictionaries...[77]

Irene Ireland confronted both reactionary attitudes and intolerable physical conditions with more audacity than many pioneer schoolmarms. Criticism was not only considered "unladylike," it was also the fastest way to lose one's job! Without the protection of binding contracts, most women teachers accepted their dissatisfactions without much complaint and tried to make the best of things. It was not until the 1880s that women began to perceive organizing as a possible means of improving existing conditions.

Early Elementary School Teachers' Organizations

The struggle of teachers to organize themselves was a confused one from the outset. Efforts to promote "professionalism" on the one hand and basic workers' rights on the other often led to conflicting interests which minimized the effectiveness of teachers' organizations. Women teachers saw this dilemma from a position that was doubly handicapped—as unorganized workers and as women, subject to the oppressiveness of female socialization and its characteristic passivity and impotence.

In the early days before Ryerson's legislation, some self-operating teachers' organizations did exist. The Eastern District Schools Association's views on the independence of teachers and belief that their members were "fully competent to manage their own affairs"[78] presented a threat to the control Ryerson hoped to establish over teaching. Ryerson countered this spirit of self-sufficiency by promoting the concept of "professionalism," and in its name established teachers' "institutes," ostensibly for the purpose of upgrading and in-service enrichment of teachers. General regulations would, "as a matter of course, emanate from the Chief Superintendent."[79] In many areas throughout the province, local superintendents held educational gatherings attended by both teachers and trustees.[80] Some groups called themselves "teachers' associations" while others called themselves "teachers' unions" (e.g. the Asphodel and Percy Teachers' Union, formed in 1860). These organizations, including the Toronto Teachers' Federation, were modelled along lines encouraged by the government authorities; their memberships included trustees

and school administrators and thus, were not particularly useful in formulating and advancing the cause of teachers alone. In *The Ontario Teacher: 1800-1910*, J.G. Althouse criticizes these early organizations as being "departmental agencies for the training and improvement of teachers in service—useful beyond all doubt but not especially conducive to the development of a sense of unity or independence.[81]

Gradually, self-interested groups began to develop associations independently of government sponsorship, for the protection and welfare of their own members. The objectives of these teacher associations tended to evolve around two basic viewpoints: one was oriented towards identification of teachers as working people whose needs would best be served by a union, and the other tended towards support of the establishment of teaching as a genuine profession with its own controlling college. There were advocates of both points of view in these first autonomous teachers' associations; it was partly the inability of members to discern a clear identification of interests which led to the ineffectiveness of these organizations. Two such associations are of particular interest: the Teachers' Protective Association and the College of Preceptors.

In 1886 the Teachers' Protective Association in Perth County was organized by local teachers; trustees and administrators were excluded from membership. This new association attempted to control admission, encourage the organization of other local teacher unions, elevate the social standing of teachers and agitate for the highest possible salaries.[82] Officialdom viewed all these demands with alarm, and immediately questioned whether strikes and boycotts might not be next.[83] The apprehensions of members and the administration over the possibility of trade union methods were great enough to lead to the early demise of the Teachers' Protective Association.

Control of admission was a radical demand in that it meant wresting certification and licensing power from the provincial authority and vesting it in a self-patrolling, self-governing body. The short-lived College of Preceptors, modelled on the lines of the Ontario Law Society and the College of Physicians and Surgeons in 1886, was one attempt to organize teachers around this basic demand.[84] The educational elite perceived the development of a true professional college as an even more potent threat to their control over teaching than the development of teachers' unions;

the College of Preceptors was quickly accused of "savouring too much of trade unionism" and money-grubbing instead of caring about teaching as a mission.[85]

The connotations of both unionism and professionalism implied too much autonomy to be tolerated by the central provincial authority, which was by this time busy consolidating an efficient bureaucracy.* Instead, the authorities supported the compromise organizations which grew out of these first efforts: the autonomous but less threatening local teachers' associations. Sporadic interest in the trade union movement continued in these associations, but after the first tentative explorations, this tendency was lost in the haze of conservative "respectability" that soon descended on the teaching field.

Female teachers outnumbered men, but discrimination in terms of salary and advancement was plain to see. In 1888, eight Toronto women teachers joined together to form their own unique organization: the Lady Teachers' Association of Toronto, later known as the Women Teachers Association of Toronto (WTA of Toronto). The "ladies," realizing that their interests were not about to be furthered by men teachers, principals, trustees or inspectors, set down resolutions concerning better representation in the Toronto Teachers' Association, salaries, and sick leave benefits.[86] Women teachers in other centres gradually followed suit: by 1907 local organizations had taken shape in London, Galt and Ottawa.

The WTA of Toronto in the 1890s had still not seen its way clear of the trade union/professional organization debate. Middle-class opinion was strongly against teachers identifying their interests with workers and "the likes" of the Toronto Trades and Labour Council. Professionalism was acceptable as long as it supported a sense of sacrifice to calling and improved education, and not control over terms of work. Despite the exhortations of the press and the city fathers, the women did display some interest in unionism. In approaching the Toronto Board of Education about the question of salaries in 1901, the WTA of Toronto used a scheme sponsored by the Toronto Trades and Labour Council.[87]

*After Ryerson's retirement in 1876, the Council of Public Instruction became the provincial government's Department of Education, with a Minister of Education at its head.

Some members felt strongly that "no increase in standing or salary could be expected without the co-operation of other organized bodies of workers."[88] However, such gestures towards trade unionism faded under the influence of the increasingly popular vision of women teachers as genteel creatures whose concerns should be in the realm of service and duty, uncontaminated by more worldly thoughts. Any doubts about the WTA of Toronto were eventually laid to rest by its refusal to join the Trades and Labour Council in 1912.[89] Indeed, much of the opposition of female teachers to the Association stemmed from the "ardent, even venomous, dislike many teachers had for trade unionism."[90] At the mention of the word "strike" the dignity of the profession would raise its Victorian head; backs would stiffen at the idea of even thinking of means used by labourers. Even twenty years

How to make Teaching a Real Profession

There is no need to stumble over the question of trades-unionism. No member of the C.T.F. Executive has ever contended that an organization of teachers, any more than of any other professional group, can adopt successfully the tactics of trades-unionism. In fact, delegates to the Annual Meetings have stated repeatedly and without challenge that the principle of "shorter hours and more pay" is not an adequate basis for a professional guild. On the other hand, it would hardly be wise or expedient for a young organization such as ours, still far from our objective, to refuse what help we may glean from the well-disciplined experience of organized labor. Few are the successful organizations, either of business or professional men, that have not, upon occasion, torn a leaf from the trades-unionists' book. Our primary concern, however, is not with the pros and cons of trades-unionism, but with the problem of creating for teaching a social prestige that will justify its general recognition, by Statute if necessary, as one of the major professions.

—The Bulletin, *Federation of Women Teachers' Associations of Ontario, May, 1924, Vol. 2, No. 1, p. 17.*

later, organizers like Harriet Carr, "although she spoke with passionate conviction about strength through unity... felt a distaste for trade unionism that made her disclaim any identification with the labour movement."[91]

Whatever notions of gentility female teachers were entertaining, the necessity of organizing on their own behalf became increasingly apparent. Wages barely met the cost of living, and it was obvious that conditions were not about to improve unless female teachers were willing to take up their own cause. Local women teachers' associations continued to spring up throughout the province. These local associations often evolved into harmless gatherings for literary and social interests; travelogues, music nights and other polite events were interspersed with usually fruitless discussions about salaries and conditions. Occasionally public figures were asked to air their views. Agnes McPhail, an Ontario country schoolteacher for seven years and the first woman in Parliament, was often guest speaker at WTA meetings. However, political concerns were generally tempered by concern for the attitudes of authority, for stable, cautious behavior, for ladylike manners and that over-riding sense of duty and service.

Efforts were made by various locals to be relevant and effective on behalf of their members. By and large, women teachers' support of the campaign for suffrage was one of their most overt political ventures during this period. Lydia Pankhurst championed the cause of suffrage for women at WTA meetings across the province, leading to support of the suffrage movement among teachers. Later, teachers were urged by their associations to exercise their franchise and to have their names placed on the voters' list.[92]

Most of the local WTA's centred their activities around social or political events of immediate concern. Various beneficial schemes were devised for their members; one women teachers' association in Ottawa tried out a co-operative laundry to save its members money! WTA's over the years also addressed themselves to the problems of contracts, employment bureaus, legal aid for teachers in difficulties with their boards, and better pensions for impoverished, retired teachers.

Superannuation was a topic of controversy from the beginning; by 1860 the average annual pension in Ontario was only $26.54.[93] The Minister of Education in 1881 replied to a petition for superannuation by saying that he was "against making pensions

compulsory, especially for women, and was also against giving a higher pension to those who remained for more than twenty-five years of service, for fear that teachers who had outlived their usefulness would continue teaching in order to get a larger pension."[94] It was not until 1917 that the ministry finally supported pension plans which gave a degree of security to teachers. Some older teachers even opposed this respectable request as having overtones of "charity."[95]

One of the most predominant concerns of all local associations was the continuing problem of salaries. Before the introduction of the Common School Act in 1846, salaries for school teachers had been appallingly low. A District Report of 1839 noted that "the wages of the working classes are so high that few undertake the office of schoolmaster"; the McCaul Commission of 1840 recommended that the teacher's wage should be increased "to be equal at least to that of the day labourer."[96]

Ryerson's attempts to upgrade and systematize the teaching field had led to some advances for men in particular, but salaries generally remained low and depended upon the grade taught. Women were at the bottom of the scale.

Table 2

Average Salary in 1900	
Beginning female teacher in Toronto	$324
Charwoman at Post Office	321
Street Sweeper	421
Labourers at Stock Yards	546

Source: French, *High Button Bootstraps*, p. 20.

The marked differentiation between city and rural salaries increased after Confederation, until by the turn of the century, city salaries were in some cases shown to be three times that of rural salaries. This discrepancy was mainly due to the large numbers of poorly-paid trousseau teachers with Third Class Certificates in rural districts.[97] In general, women received approximately 60 percent as much as men around 1860, about 75 percent as much in 1900, and about 80 percent as much in 1950.[98]

The determined efforts of the WTA to make the Board of

> Mrs. Georgina Riches enjoyed the distinction of being the first female principal in Toronto to be paid a man's salary, an eminence that she did not attain without a long and bitter battle. She expressed her appreciation to the Board of Education rather eloquently:
> Gentlemen:
> Kindly allow me to thank you for so ably acknowledging, from a financial standpoint, the principle of equal rights to British subjects, irrespective of sex.
>
> —E. Guillet, In the Cause of Education, p. 99.

Education acknowledge women teachers' salary demands met with more failures than successes. The WTA of Toronto was viewed by the Toronto Board of Education as such a minimal threat that they thought nothing of requesting the women teachers not to ask for salary increases in 1906.[99] Earlier in 1882, the board members had also exhibited their scorn for women teachers by replying to a request for a raise by sending every teacher on staff at Wellesley School in Toronto a letter intimating that if her position was not to her liking, the Board would accept her resignation.[100] From 1920-27 the Toronto Board had the effrontery to reduce the female teachers' increment of $100 per year to save money. Only women teachers suffered this cutback, but the strivings of the WTA to redress this outrage were of little avail until the Board was ready to be magnanimous.[101] "After fifteen years of hard work on the part

of the WTA since its inception, the maximum [salary for female teachers] was changed from $636-650."[102] Small reward for diligent labour, especially when men were receiving considerably more!

Table 3

Salaries of Teachers in Toronto

Date	Women	Men
1858	$ 240-400	$ 520-700
1870	220-400	600-700
1881	200-600	750-1100
1901	225-675	600-900
1910	400-900	900-1400
1920	1000-2000	1625-2500
1930	1000-2400	1200-3000

Source: Annual Reports of the Local Superintendent of the Public Schools of the City of Toronto.

Table 4

Average Rural Teacher's Salary in Ontario

Date	Women	Men
1870		
country schools	$187	$260
town schools	200	450
1901	262	359
1928	609	743

Sources: French, *High Button Bootstraps*, p. 20.
Phillips, *The Development of Education in Canada*, p. 555.

In 1922 in Owen Sound the salary question became so crucial that local WTA members were beginning to talk of strike action, apparently the first local to go to such "drastic" lengths.[103] The threat of a strike was enough to persuade the Owen Sound Board of Education to raise their minimum to $1200. Such strike action was highly unusual, and is one of the few historic examples in Ontario of teachers' successful use of the only real recourse of the worker.

The Federation of Women Teachers' Associations of Ontario

In 1918 the cost of living had risen 60 percent from pre-war levels.[104] Consequently, the issue of salaries was so desperate that local women teachers' associations across the province banded together to form a united front, to be known as the Federation of Women Teachers' Associations of Ontario (FWTAO).

Since its inception, the FWTAO has been a rather unique organization; it is one of the few women teachers' organizations in the world.[105] Women teachers were the first to organize on a province-wide basis; the OSSTF and OPSMTF* were not formed until 1919 and 1921 respectively. The FWTAO was also more careful to acknowledge local rank-and-file needs than other teacher organizations; it was the only teachers' federation in Ontario to incorporate "Associations" into its official name. Though common concerns often brought the FWTAO into a working rela-

*Ontario Secondary School Teachers' Federation and Ontario Public School Men Teachers' Federation.

> *Pressure from the Ontario Men Public School Teachers Federation for amalgamation of elementary women and men teachers' organizations at the provincial level has reached such proportions in 1974 that one male teacher has adopted highly provocative tactics to draw attention to the issue. Howard Moscoe of North York, Toronto, is presently seeking the direct intervention of the Minister of Education to force the FWTAO to accept him as a voluntary member, regardless of his sex. His complaint against the FWTAO (concerning their supposed discrimination against males) has already been thrown out by the Ontario Human Rights Code and the Ontario Teachers' Federation. Such "politics of agitation", needless to say, have had a less than persuasive effect on the FWTAO, who see amalgamation as a reactionary move in their struggle for the improvement of the position of women teachers.*

tionship with the men's elementary school teachers' federation, different interests were, and continue to be, strong enough to ensure that the two organizations function separately despite intense agitation for amalgamation on the part of OPSMTF.

An astonishingly long time had passed before women teachers felt justified in acknowledging and registering their resentment at being paid much less than men for doing the same work. From the outset, one of the main focuses of the FWTAO was the eradication of the discriminatory treatment experienced by women teachers in receiving salaries far below men's. *Equal pay for equal work* was placed on record by the FWTAO in 1919.[106] This demand was still surfacing in 1921 at the FWTAO Annual Meeting. One delegate endeavored to allay members' doubts about women's right to equal pay by noting that "the argument that men have more responsibility than women is a hollow one. Men are not paid on that basis (otherwise wouldn't the married lawyer with six children demand higher fees than his bachelor rival?) and besides, talk of responsibility is mere camouflage for a man's sense of superiority."[107] That her words fell on skeptical ears is all too clear when one considers that equal pay for men and women in the field of teaching did not become a reality until the 1940s. Gains were made only when women teachers took their own cause in hand and negotiated determinedly with intractable Boards. The FWTAO was instrumental in stimulating and supporting its locals in this struggle.

The FWTAO failed to assert itself in taking up the cause of married female teachers, who were customarily discharged when they married despite qualifications equal to those of men teachers. Right up until the early '30s, the Federation urged boards to "give preference to the unmarried woman except in cases where the married teacher [was] the sole support of the family."[108] Eventually, with the pressures of wartime and teacher shortages, and married women entering the work force in increasing numbers, the Federation supported the right of married teachers to work. However, efforts to initiate such a move did not originate with the organization which had set itself up ostensibly to protect the welfare of its members; the eventual support of married women teachers by the FWTAO came only as a response to pressure by its membership. Such a basic oversight constituted a serious failure on the part of the Federation to identify its strategy with the needs of its membership.

> *The Windsor Board of Education in Ontario has practiced discrimination against married women as recently as the 1960s, when men teachers enjoyed a bonus of $450 on the occasion of their marriage. Women teachers who married received neither a bonus nor a renewed contract! At best, they lost the protection of a permanent contract and were kept on with a probationary contract, which guaranteed no job security whatever!*

Building membership was a constant struggle. In 1918 there were 11,359 women teachers in Ontario, but by 1919 the FWTAO roll stood at an unrepresentative 4,236.[109] Despite drives to stimulate the organization of new local WTA's throughout the province, membership remained the exception rather than the rule among most women teachers. Organizing was particularly difficult in the rural areas; it was in the country that the system of "trousseau teachers" produced by the model schools predominated. It was not easy for young women who worked in isolated situations and who knew they probably wouldn't be working long to organize themselves. They were often more pre-occupied with the everyday realities of poor boarding accommodation and crowded classrooms than with the vagaries of the new ideas of "professionalism" which they identified with the FWTAO. Since the FWTAO was supported mainly by fees paid by its members, lack of widespread participation was disastrous financially. Lack of both resources and a strong constituency of members seriously undermined the political clout of the FWTAO, particularly in its dealings with the Ministry of Education.

The Ministry's offhand approach to such basic demands as a request in 1922 for the appointment of a tribunal in cases of dispute between teachers and their boards is demonstrated by the fact that such a Board of Reference did not materialize until 1938.[110] Perhaps most telling of all concerning the central authority's attitude to the Federations is the fact that in 1944, membership in the Ontario Teachers' Federation* was made compulsory by law.

*An amalgamation of the FWTAO, OPSMTF, OSSTA, the Ontario English Catholic Teachers Association, and L'Association des Enseignants Franco-Ontariens.

Obviously, the Department of Education had so much interest in maintaining the kind of lukewarm, undemanding "professionalism" that the teachers' federations had developed, that it suited government to protect their existence by legislation. The fact that Canada stands as the only nation in the world with such legislation[111] points out the peculiar relationship between government and teachers which has arisen in Ontario. The complicity of the representative organizations of teachers with the demands of the educational elite is a far cry from the direction hinted at by Miss A.E. Marty, Toronto's first female Inspector of Public Schools. She declared to the FWTAO that teachers should be running the educational system in Ontario:

> A mere classroom teacher will soon be a creature of the past. Education is no longer limited to the walls of the classroom. In the future, it will be more and more demanded of us that we link up our profession with the industrial life of the people. We must understand educational problems. It is part of a democracy that the teachers should evolve the educational system of the province.[112]

Although advances on the salary and equal pay question were few and far between for many years, progress was made by the FWTAO in other important struggles. For women in particular, job security remained tenuous. Marion Gow recalls teaching in 1920, under contract, for the Lanark County Board for $750 a year. At Christmas a former teacher reappeared and offered her services for $700, which was promptly accepted by the Board.[113] The FWTAO, in conjunction with the OPSMTF and other federations, worked for some time towards the formulation of a uniform compulsory contract to correct the haphazard and inconsistent agreements between teachers and boards that were generally the rule. The contract form agreed upon was presented to the central authority in 1928; its value was acknowledged by all and legislated in 1931.[114]

A great deal of the credit for the progress the Federation did make in its early years can be attributed to Harriet Carr, Secretary, organizer, editor, and general trouble-shooter for the FWTAO between 1924 and 1944. For many years she edited the Federation's official publication *The Bulletin* (later *The Educational Courier*). To many teaching in isolated communities, this provided a fragile but invaluable link with the controversies debated by their fellow-workers. Much of her work consisted of defending members who were being treated unjustly—speaking on

their behalf and arranging for legal aid provided by the Federation when it was necessary. She diligently promoted "equal pay for equal work" and the salary schedules supported by the Federation and fought an uphill battle against apathy and women teachers who underbid one another in the job market. Through her efforts, an Employment Service was set up to co-ordinate positions for unemployed teachers.[115]

Despite its ups and downs, the FWTAO has provided one of the few opportunities women teachers have had to learn public speaking, organizational and political skills, as they attempted to formulate and serve the interests of their unique constituency. That the FWTAO has often been involved in a downhill struggle can be seen in the polite ineffectiveness of the Federation in many areas. However, the difficulties the Federation faced in making its presence felt must be seen in the light of attitudes to women's role in public life, and which still prevail today. For women teachers, respectability was part and parcel of teaching, and it tempered all relations at both the community and government levels. As Doris French says in her history of the FWTAO, "evidence of good breeding was to be modest, retiring, deferential. The decision to attend a meeting, to accept an office, to rise to her feet and speak, all these were acts of anguish."[116] Women have been socialized to avoid the public eye; the cost has been that their voices in matters concerning them has gone unheard and unsolicited.

The FWTAO has provided an important forum for debate, and in this role has recognized the necessity for encouraging women teachers to articulate needs that stem from both their working lives and their lives as women in a male-dominated society. However, its potential as an organizational tool through which women might take control over their lives as women workers, has remained largely unfulfilled.

* * *

The question posed by these events remains: why were women teachers and their representative organization so ineffective in pressing such easily justifiable demands as equal pay for equal work? I would like to examine the problem of why women teachers have tolerated their second class status for so long from the point of view of both sexism and professionalism,—two attitudes which permeate our society and help to explain the exploitation of female teachers.

Teaching, along with nursing, developed quickly in the mid-nineteenth century as one of the few acceptable occupations for young single women. In 1850 Ontario employed 2,697 male teachers and 779 female; by 1902 the number of male teachers had decreased to 2,200 but the number of female teachers had increased to 6,297.[117] The growth of industry and the public sector with their corresponding new labour needs, the increasing demands of young women for some degree of respectable financial independence and personal freedom, and the economies Boards of Education were able to make in hiring women, had precipitated a situation where women eventually comprised three-quarters of the teaching workforce.

The popularity of teaching as a career for women can perhaps best be understood in relation to the prevalent nineteenth-century conception of the role and nature of Womanhood. Woman was considered predestined for a sanctified fulfillment as wife and mother; all other concerns were purely secondary. Her natural sphere was the home, where she was continuously at the service of the family. Ryerson went so far as to claim divine sanction for the subservient place of women in society: "Jesus forbids a woman to usurp authority over the man."[118] The thought of a married woman working outside the home was out of the question unless she was the unfortunate victim of widowhood or desertion.

Teaching as an occupation for young single women fitted admirably into this scheme of things. The functions of motherhood included nurturing, moral and spiritual guidance, selfless devotion, and the basic instruction of small children that inevitably fell to her in bringing up a family. These were all qualities much-prized in teachers; indeed, one of Ryerson's favourite sayings is reputed to have been: "No matter if the young ladies do not teach many years in the school-house, they have to be teachers all their lives, and if we can educate the mothers of our country, we shall have accomplished much that we desire."[119] Women, then, were considered to be "naturals" for teaching, particularly when it came to younger children. So persuasive was this attitude that we find it cropping up in the 1930s in a rather narrow view of education proposed by Sir Fred Clarke, Chairman of the Department of Education at McGill University:

> ... For if education is a ritual of the school, a thing of *puerilia* and "keeping-out-of-mischief", then it is really a nursery concern and women are its proper hierophants.[120]

Young women could consider teaching not only as a livelihood, but also as training for their primary function as married housewives and mothers. Conversely, the state could conveniently exploit the "natural" female maternal instincts women brought to teaching—and at a minimum of expense. Low wages were justified by the expectation that women would only teach a short time before they assumed their "real" duties in marriage, and that women would never be breadwinners for their families. Even if their work was equivalent to men's, Boards of Education felt it was unnecessary to pay them equal wages.

Ryerson's early efforts to instill "professional" pride in teachers were a reaction to the low esteem in which teaching had been held previous to his reforms. Giving teaching a "professional" aura would elevate its status in the community and underline the new importance of education in the propagation of the state's policy. Through the establishment of controlled teacher training institutions and teachers' associations, and through the *Journal of Education for Upper Canada* (which continued to outline guidelines for correct teaching practice and behaviour throughout his career), which he distributed free to every local Board of Education, Ryerson was able to exert a controlling influence on the development of teaching. By advocating these vehicles as "professionalizing" devices, the central authority was able to imply links with more prestigious professions such as divinity and law, and thus attempt to upgrade the status of the teacher.

By 1880-81 teaching was listed in the Census of Canada as part of the Professional Class. The validity of such a categorization is questionable. The professional ethic had traditionally promoted institutional loyalty rather than identification of interests with fellow-workers. Professions like law and medicine had consolidated this loyalty in largely self-governing Colleges which controlled admissions, certification, self-regulation and conditions of work. The abortive College of Preceptors was an attempt by teachers to form a professional body with similar functions.

However, in spite of such efforts to professionalize, it is clear that teachers have been consistently denied control over all of these important characteristics of professionalism, despite the formation of independent federations serving the interests of different groups of teachers.* Teachers have had little say in how

*e.g. women teachers, men teachers, secondary school teachers, Catholic teachers, and French-speaking teachers.

they teach, what they teach or who they teach. The federations are only now struggling for the right to assume responsibility for certification.

Teachers have always been aware of the double standard that surrounds admission to the "profession": the Minister of Education determines certification procedures and promotes high qualifications, whereas Boards of Education continue to hire teachers with low qualifications as cheaply as possible. Teachers themselves have no choice in who is admitted to their vocation as long as Principals, who are hiring agents, are members of the federations.

"Professionalism" as applied to teaching and certain other occupations (particularly those related to women), has acquired a somewhat specialized meaning: the service ethic has come to predominate over other attributes more conventionally associated with the professions. The FWTAO has repeatedly used *professional status* as its slogan; generally it has been backed up by statements like "... service to others is paramount",[121] and "always questions were raised as to whether it was right to ask anything for themselves in a career of service."[122] However, those who have supported the concept of teachers as paragons of virtue sacrificing all for the sake of young souls in the making (and co-incidentally for their employers), as the most worthy objective of professionalism, have done so at the expense of salary improvement, wage parity, job security, working conditions and the personal development of responsible teachers governing their own affairs.

It would appear that the federations which developed to serve the so-called professional interests of teachers in Ontario have not in any way acted like a professional college. The primary demands made by the FWTAO to Boards of Education and to the Ministry have centred around concerns which are more readily identifiable with the trade union movement than with an autonomous self-governing body. Recent events in Ontario have shown that this is becoming increasingly clear to some teachers; the use of picketing tactics in November, 1974 by Windsor teachers claiming the right to strike is an unprecedented identification of where power really lies and how best to deal with that reality.*

*In Quebec, teachers have refused the institutional loyalty of professionalism in favour of identification of interests with fellow-workers; their

Yet, in Ontario, the mystique of professionalism is still courted by government and educators alike. Many teachers cling to the enhanced status which they see professionalism bringing. The halo of respectability surrounding teaching has perhaps led to some psychological upward mobility; however it has served as little more than a blinder when teachers were faced with the fact that their wages were on a par with workers rather than those of the traditional professional classes.

The ambiguous position of the federations has often shown up in their eagerness to interpret and administer the central authority's policies rather than protect the interests of their constituency. The teacher as servant of government is reflected in the declaration of the President of the Canadian Teachers' Federation* in 1925 that "It is the teachers' task to correct the restlessness of the age."[123] Government has increasingly attempted to exert control over the work lives of teachers; often it has been aided by the federations' compliant policies of appeasement and their confusion between promoting "professional" standards and promoting government's view of preservation of the status quo. Not until 1973 did Ontario teachers clearly perceive this move towards more complete government control. The Minister of Education's recent bid to control salary negotiation procedures and wages finally crystallized the federations' dawning realization of the impotence of teachers as "professionals" clinging to the skirts of a monolithic central education authority. On Dec. 18, 1973, 30,000 Ontario teachers demonstrated their opposition to government's manipulative approach to teaching at Queen's Park. Their support of teachers' right to strike is indicative of a new direction in the old trade union-versus-profession debate.

It has been particularly easy for the state to divert the prevailing ideal of Womanhood to the ideal of a selfless and service-oriented professionalism. Woman's role as handmaiden to husband and family was from the outset easily adaptable to the ethic of uncomplaining work and service which was to facilitate the creation of the new education system. Teachers were often described

union, the CEQ, has shown militant support of the working class in Quebec.

*a loose nation-wide amalgamation of all Canadian teachers' federations.

> ### The Education Act 1974
>
> *Section 229 Duties of the teacher:*
> *(c) to inculcate by precept and example respect for religion and the principals of Judeo-Christian morality and the highest regard for truth, justice, loyalty, love of country, humanity, benevolence, sobriety, industry, frugality, purity, temperance and other virtues.*

as bearers of the moral standard of the nation—"missionaries of culture and light in darker places."[124] The teacher was expected to be a somewhat superhuman exemplar of diligence, thrift, godliness and other virtues. Women, because of their self-effacing dedication and supposed refined sensibilities, fit into this scheme of things with ease. The ideal schoolmarm would never drink, swear or engage in petty politics; she was expected to be an unquestionable model of all the state held dear.

The notion of women as spiritually purer than men due to their passive deference to the needs of others made it particularly difficult for women to identify and act against their exploitation. The struggle to come to terms with the discrepancy between the popular imagery of society's ideal of women's role and the everyday realities of the oppression encountered in their work has been long

> ### Quick Quiz:
>
> *There are 600 secondary school principals in Ontario. How many are women?*
> *9, most of these in girls' schools.*
>
> * * *
>
> *What percentage of Educational Administrators in Ontario are women?*
> *1%*
>
> *—Faculty of Education (University of Toronto) Student Handbook, September 1972.*

and relatively ineffective for women teachers. The inferior position of early schoolmarms exists today; the gains made by the FWTAO over long years of struggle for equal pay must now be seen in the light of the necessity for agitation for equality of opportunity. Women have been strongly socialized to "know their place"; as teachers, this has made effective strategy exceedingly difficult to formulate. Forces such as "professionalism" and the feminine mystique serve to doubly obscure women teachers' consciousness of themselves as an oppressed group. The FWTAO exists as a mechanism which has defined and spoken for the special problems of schoolmarms in the past, however tentatively. The part it has to play in voicing the needs of women teachers as an integral part of today's controversies will only be as successful as the support accorded it by the women it serves.

Footnotes

1. C.E. Phillips, *The Development of Education in Canada*, p. 425.
2. *Ibid.*, p. 165.
3. Doris French, *High Button Bootstraps: Federation of Women Teachers' Associations of Ontario: 1918-1968*, p. 13.
4. Phillips, *The Development of Education in Canada*, p. 39.
5. R.D. Gidney, "Elementary Education in Upper Canada: A Reassessment," in *Ontario History*, Vol. LXV, No. 3, Sept. 1973, p. 175.
6. Edwin Guillet, *In the Cause of Education*, p. 264.
7. D.C. Masters, *The Rise of Toronto 1850-90*, p. 387.
8. J.E. Middleton, *The Municipality of Toronto: A History*, p. 227.
9. Phillips, *The Development of Education in Canada*, p. 140.
10. *Ibid.*, p. 547.

11. *The Toronto Normal School Jubilee Report 1847-1897*, p. 69.
12. R.D. Gidney, "Elementary Education in Canada: A Reassessment," p. 182.
13. Alison Prentice, "The School Promoters: Education and Social Class in Mid-Nineteenth Century Upper Canada," p. 73.
14. *Annual Report of the Chief Superintendent of Schools for Upper Canada for 1868*, Appendix A, p. 23.
15. *The Ontario Teacher*, Vol. I, p. 156.
16. Middleton, *The Municipality of Toronto*, p. 536.
17. D. Lawr and R. Gidney, *Educating Canadians: a Documentary History of Public Education*, p. 261.
18. *Ibid.*, p. 265.
19. Prentice, "The School Promoters," p. 207.
20. French, *High Button Bootstraps*, p. 16.
21. Prentice, "The School Promoters," p. 199.
22. Phillips, *The Development of Education in Canada*, p. 258.
23. Masters, *The Rise of Toronto 1850-90*, p. 42.
24. French, *High Button Bootstraps*, p. 14.
25. Middleton, *The Municipality of Toronto*, p. 228.
26. *Ibid.*, p. 539.
27. Phillips, *The Development of Education in Canada*, p. 187.
28. Guillet, *In The Cause of Education*, p. 17.
29. *Ibid.*, p. 11.
30. *Ibid.*, p. 17.
31. *Ibid.*, p. 35.
32. Phillips, *The Development of Education in Canada*, p. 572.
33. *Ibid.*, p. 574.
34. *Ibid.*, p. 572.
35. *Ibid.*, p. 574.
36. From a personal interview with Miss Emily Ames, who attended the Toronto Normal School in 1910.
37. Phillips, *The Development of Education in Canada*, p. 574.
38. *Ibid.*, p. 576.
39. *Ibid.*, p. 577.

40. *Ibid.*
41. *Ibid.*, p. 564.
42. *Ibid.*, p. 577.
43. *Ibid.*, p. 597.
44. *The Toronto Normal School Jubilee Report 1847-1897*, p. 121.
45. *Annual Report of the Chief Superintendent of Schools for Upper Canada for 1846 and 1876.*
46. French, *High Button Bootstraps*, p. 19.
47. Prentice, "The School Promoters," p. 302.
48. Phillips, *The Development of Education in Canada*, p. 555.
49. *Ibid.*, p. 377.
50. *Annual Report of the Chief Superintendent of Schools for Upper Canada for 1865,* Appendix A, p. 69.
51. Prentice, "The School Promoters," p. 169.
52. Phillips, *The Development of Education in Canada*, p. 381.
53. Masters, *The Rise of Toronto 1850-90*, p. 198.
54. Guillet, *In the Cause of Education*, p. 206.
55. Phillips, *The Development of Education in Canada*, p. 572.
56. Prentice, "The School Promoters," p. 302.
57. *Ibid.*, p. 302.
58. Dent, Melville, Mitchell and Ross, *The Story of the Women Teachers' Association of Toronto*, Vol. I, p. 7.
59. Letter from Alex Stephen to Dr. J.G. Hodgins of the Department of Education, Toronto, 1896, RG 2, E2 Box 1, Department of Education Records, Ontario Archives.
60. Prentice, "The School Promoters," p. 254.
61. *Ibid.*, p. 254.
62. *Annual Report of the Chief Superintendent of Schools for Upper Canada for 1869,* Appendix D, p. 112.
63. Middleton, *The Municipality of Toronto*, p. 540.
64. Prentice, "The School Promoters," p. 310.
65. *Annual Report of the Chief Superintendent of Schools for Upper Canada for 1864,* Appendix A, pp. 26-28.
66. Inspector's Detailed Report of Miss Lizzie Overend's school at

Orillia from 1874 to 1879, RG 2, F3D Box 1, Department of Education Records, Ontario Archives.
67. *Summary Report on the Sanitary Condition of the Rural Schools* for 1895-1896, RG 2, F3D Box 4, Department of Education Records, Ontario Archives.
68. Prentice, "The School Promoters," p. 281.
69. Phillips, *The Development of Education in Canada*, p. 275.
70. *Ibid.*, p. 276.
71. Letter from Irene Ireland to Dr. J.G. Hodgins, 1896, RG 2, E2 Box 1, Department of Education Records, Ontario Archives.
72. Phillips, *The Development of Education in Canada*, p. 548.
73. *Ibid.*, p. 548.
74. Prentice, "The School Promoters," p. 277.
75. *Ibid.*, p. 276.
76. *Annual Report of the Chief Superintendent of Schools for Upper Canada for 1869*, Part 1, p. 5.
77. French, *High Button Bootstraps*, p. 157.
78. Prentice, "The School Promoters," p. 312.
79. *Ibid.*, p. 313.
80. French, *High Button Bootstraps*, p. 22.
81. *Ibid.*, p. 23.
82. Phillips, *The Development of Education in Canada*, p. 557.
83. French, *High Button Bootstraps*, p. 24.
84. Guillet, *In the Cause of Education*, p. 119.
85. *Ibid.*, p. 119.
86. Dent, Melville, Mitchell and Ross, *The Story of the Women Teachers' Association of Toronto*, Vol. I, pp. 12, 19.
87. *Ibid.*, p. 24.
88. *Ibid.*, p. 35.
89. *Ibid.*
90. French, *High Button Bootstraps*, p. 31.
91. *Ibid.*, p. 59.
92. *Ibid.*, p. 43.
93. Phillips, *The Development of Education in Canada*, p. 559.

94. *Ibid.*, p. 559.
95. French, *High Button Bootstraps*, p. 40.
96. Guillet, *In the Cause of Education*, p. 267.
97. Phillips, *The Development of Education in Canada*, p. 554.
98. *Ibid.*, p. 555.
99. Dent, Melville, Mitchell and Ross, *The Story of the Women Teachers' Association of Toronto*, Vol. I, p. 28.
100. *Ibid.*, p. 9.
101. *Ibid.*, pp. 45,46.
102. *Ibid.*, p. 24.
103. French, *High Button Bootstraps*, p. 43.
104. *Ibid.*, p. 29.
105. According to Ruth Foster, Executive Assistant of the Federation of Women Teachers' Associations of Ontario, 1974.
106. Dent, Melville, Mitchell and Ross, *The Story of the Women Teachers' Association of Toronto*, Vol. I, p. 42.
107. French, *High Button Bootstraps*, p. 46.
108. *Ibid.*, p. 85.
109. *Ibid.*, pp. 34,35.
110. *Ibid.*, p. 62.
111. *Ibid.*, p. 106.
112. *Ibid.*, p. 38.
113. *Ibid.*, p. 44.
114. *Ibid.*, p. 65.
115. *Ibid.*, p. 64.
116. *Ibid.*, p. 26.
117. Guillet, *In the Cause of Education*, p. 190.
118. Prentice, "The School Promoters," p. 167.
119. *The Toronto Normal School Jubilee Report 1847-1897*, p. 24.
120. French, *High Button Bootstraps*, p. 8.
121. *Ibid.*, p. 72.
122. *Ibid.*, p. 9.
123. *Ibid.*, p. 7.
124. Guillet, *In the Cause of Education*, p. 148.

Besieged Innocence: The "Problem" and the Problems of Working Women—Toronto 1896-1914

Donning her newly-bought hat and her starched shirtwaist, the well-to-do Miss Maude Pettit found her first job in a biscuit factory.[1] Normally employed with Methodist Publications, Miss Pettit left the comfort of middle-class discussion circles, assumed a disguise and an appropriate pseudonym ("Videre") and proceeded to tug at the hearts of *Star* readers with a month-long report of her "journey into the land of toil."[2] She began her new career at $5 weekly, placing dabs of jelly on rows of biscuits all day long.

As was customary at the time among people in her social position, it did not take long for her to become an expert on the problems, conditions and needs of the "working girl." She came to appreciate many facets of the working girl's life—her habit of singing (although Videre did not delude her readers into thinking that the factory was a saint's refuge, she did hear some beautiful hymns being sung);[3] the informal solidarity of workers who would just as readily help a mate in trouble with the boss as they would pressure other workers who worked too fast, lest the piece rate be lowered;[4] the tricks of stretching a $5 weekly budget by skipping meals in order to pay for a 5 cent show and a church collection; the "foolish" pride in finery and dress; the status distinctions based on skill in the shop; the working girl's tendency to lie about her low wages in order to gain status.[5]

Videre shared her hard-earned conclusions with her readers. She had undertaken her journey promising to deal with the viewpoint of the employer, employee, and consumer. She assured her readers that devotion to the Golden Rule would not undermine her impartiality; she knew that the brotherhood of man did not mean

equality for all. Nor did she have sentimental qualms about efficiency as the main pillar of the business world. On the contrary, she saw individual employer and employee incompetency as a major problem. She suggested that the incompetent employer should get out of business and that the slow or incompetent girl be placed under public guardianship.

Her insights and solutions purported to be well-balanced. Noting that women changed their jobs frequently because of monotony, she suggested that higher wages might counter this trend and save the employer in the end. Pointing out that her friend Sadie bought jewelry on time when she could not afford to keep up the payments, she explained that the working girl needed more than a living wage—she needed to know how to spend it.[6]

In one column, she recounted how she had caught herself glowering resentfully at a neighbouring capitalist while peering out the window of her home one day; she realized that the church also had its role to play. "It is yours to reconcile us, your Church of God, to bring us to your knees and make us comprehend one another," Videre cried, her heart "filled with impotent rebellion." She urged the preaching of sermons the wealthy churchgoers persuading them to pay higher wages.[7]

This month-long feature in the popular *Star* gives us an appreciation of the interest in this topic. Nor was Videre's column alone. An equally prominent series by the well-established journalist Marjory MacMurchy was featured by the *Canadian Courier* in 1912.[8] MacMurchy saw the problem in much the same way as did Videre. Her magazine series was devoted in large part to the need for reform to increase the productivity of the female worker in order that she might deserve a living wage. The working girl also required education on how to live with her income.

These series demonstrate how very much alive the issue of the working girl was to reformers of the time. Their views on the "problem of the working girl" were common to many layers of society, although they have commonly been typed as middle-class attitudes. At this time, liberals, conservatives and to some extent socialists; leading philanthropists, moral reformers and trade unionists; Protestants and Catholics—all had very much in common in their views on the woman worker.

The consensus held by those defining themselves as spokespersons for the working girl did not see the problems of women in the workforce as related to those of male workers; that is, as a part

of the class question. Rather, they judged their problems as part of a grave and generalized social crisis. The increasing number of women in the work force and the dismal conditions they faced was primarily a threat to the reformers' definition of the social and moral fibre of society. In particular, it touched anxieties flowing from their traditional view of women. Since women were defined as the bearers of the moral standard of the nation, their entry into a workforce dominated by an amoral male ethic that subjected them to temptation and distracted them from their true calling of motherhood was indeed a critical aspect of the social crisis.

There was, however, one source of dissent from this overwhelming consensus. Inasmuch as this dissent was from the working girls themselves, it deserves some attention. Some of their criticisms reached the letters to the editor column during Videre's "journey." For example, one woman wrote in to confirm that working girls were respectable and that they were widely read. But, "as to music, the girls do not confine themselves to Sankey's hymns."[9] Another wrote in response to Videre's comments on the boarding house situation. To Videre, boarding homes were useful as a source of income for widows and troubled families. She had opposed the idea of common rooms as a place for girls to entertain their beaus, asserting that they had the right to some privacy. What she did favour was an open door policy on the girls' rooms in order to allow privacy and at the same time preserve "safety."[10] This brought a sharp response from one correspondent, who found it amusing that "the so-called sociological workers" were so nervous about entertaining in rooms when these "propriety sticklers" find it quite reasonable to entertain their beaus in the privacy of their plush parlours. The bed sitting room, she asserted, is no more private. As for some reformers' idea of club common rooms to entertain boys: "those who form the boards of such institutions would not entertain their intimate friends under such restrictions." This reader spurned Videre's idea of a club to investigate the conditions in boarding houses as "another red tape farce." "Our society is overflooded with such societies," she continued, "the so-called Christian workers, in many instances are like a lot of children at play. The results are invisible."[11]

These hints of resentment at the popular view of the problems and needs of the working woman appeared in every area dealt with by the reformers. It is the contrast between these two views that we wish to scrutinize in this paper, for it is important that future

studies comprehend the dichotomy between the official view and that of the working women themselves.

The most available source of information on working women—documents published by reformers and their organizations—must be seen in the light of the viewpoint they represent, perceptions of reality that are filtered through the interests and anxieties of a particular social layer. In order to glean a meaningful understanding of working women from these sources, it must be understood that the dominant imagery of the reformers' legacy to today's historians, at its best and closest to the truth, is inaccurate. At its farthest from the truth, it represents something more dangerous than middle-class prejudices and narrow-mindedness. It represents a view founded in antagonistic social relations, a distortion based on and serving class interests hostile to those of the working women. Indeed, more than once the reformers' views were enlisted on behalf of the employer class. The reformers' view must be repudiated before an effective study of the real story of women workers can begin. The first step is to examine in detail the views of the reformers themselves.

National Council of Women

The National Council of Women, an organization of influential and wealthy women concerned with social issues, early espoused the cause of the working girl. This was consistent with its self-definition as Canada's "national mother"[12]—a role that suited their assumption of the responsibility for guardianship of all those who, in their eyes, needed protection. In the course of their work, they attached the issue of women workers to the broad moral and social concerns of their age and milieu. As befits guardians, they clung devoutly to the notion of the working woman's helplessness in society's web of amoral forces.

One important aspect of their work was the promotion of protective legislation. It was in keeping with their patronizing attitudes that they linked the problems of women with regulations relating to youth—curfew hours, child labour, and raising the age of consent to 18. The NCW's disposition to interfere in the free enterprise economy with protective legislation was tempered somewhat by their recognition that sudden and violent changes with regard to working hours, even when undertaken on behalf of the defenceless, "might prove injurious to the community and ultimately provoke reaction." But their protective impulse won

Committee of the National Council of Women, 1898 (Public Archives of Canada)

out. They overcame their trepidations and concluded that "present working conditions as a whole not only sacrifice unnecessarily the health and strength of the workers and thus degrade the community but also correspondingly impair and reduce the industrial output and power of the country."[13]

The major focus of their concern was the woman as a future mother—the sacrifice of whose health would degrade the community—not as a worker. Their obsession with separate lavatories, considered one of the key goals of factory inspection, demonstrates their focus of issues pertaining to the maintenance of purity, modesty and other necessary qualities of wifely and motherly virtue. Another key issue, seats for shopgirls, brings this concern into sharp relief; seats were deemed important because extended periods of standing up were thought to be harmful to the reproductive organs.

Concentration on these issues had an additional benefit. As Mrs. Cummings explained while urging that inspectors concentrate on lavatories and seats: "Of course there are many other points she has to see but these two you can easily get information about."[14] This search for visible and easily regulated evils rein-

forced the tendency to avoid dealing with those issues not easily subject to bureaucratic perusal like intimidation, authoritarianism, exploitation, tedium, etc. They were concerned with safeguarding the moral fibre of society, not with the problems of women workers as part of the working class.

Although their efforts at protecting female workers through legislation may have been well-intentioned, they were limited in effectiveness precisely because this legislation applied only to women. Legislation restricting hours made women's labour less competitive in certain industries. Moreover, it compounded their problems of survival in industries like the garment industry, which were based on seasonal work, since it prevented them from working the long hours of overtime necessary to tide them over the long periods of unemployment that followed. Perhaps for these reasons, the NCW saw fit to include the demand for reasonable hours for both men and women in their 1913 programme. That year, their programme expanded to include compulsory education up to age 14, technical training for girls, and—under the pressure of suffrage forces—"equal pay for equal work."[15]

The progressive nature of this programme could lead one to misinterpret the curious dynamic of NCW policies. Their programme's reflection of certain real needs of working women was not the outgrowth of empathy with them as working-class people. More often, it was the reformers' fear for the women workers' femininity—endangered by the conditions in the work-a-day world—that prompted them to act on behalf of the female members of the working class.

Christian Reformers

"Toronto the good" was an ideal environment for the Christian reformers who did their best to add a note of piety to the definitions of the problem of the working girl. Although Dr. T.A. Moore, secretary of the Temperance and Moral Reform Department of the Methodist Church, carried out an investigation of women's wages that aroused considerable public attention,[16] the real centre of concern was the maintenance of the innocence and purity of the working woman. For example, the Women's Christian Temperance Union worried about the 40,000 working women in Toronto, especially the ones not residing at home (boarding mostly in the area south of College), and urged the formation of

clubs of women who would swear off "undesirable dress, deportment, and conversation."[17] Miss Elwood of the Evangelina settlement also worried about the degeneration of the race caused by work on the part of married wives, children and young girls.[18]

The Evangelical and Social Service annual report saw the following factors contributing to the downfall of the young working girl: lack of character due to parental inefficiency; attending theatres that pander to the passions; seeking pleasure at the dance halls and even going to Chinese restaurants; too much liberty at night on the streets; insufficient wages; inordinate love of fine clothing and desire for the easy life.[19] Wages came only fifth on the list and hours were not mentioned. Thus the real inability of working women to support themselves without illicit employment on the less-than-subsistence wages common at the time received little consideration from the Methodist ministers.

In the general category of Christian reformers, the Young Women's Christian Association merits attention. Founded in 1874 with the objective of promoting "the temporal, moral and religious welfare of young women who are dependent upon their own exertions for support," the "Y" pioneered endeavors to sustain the purity of the working girl.

Introducing the first Annual Report, Mrs. Laird said:

> The rapid growth of our city, and the constant influx of young women from the country seeking employment together with the dangerous temptations to which they are often exposed and the difficulties they experience in obtaining suitable homes, have suggested the opening of a Boarding House for young women.[20]

Boarding houses were established, then, to provide women workers with a suitably Christian home environment to counteract the temptations of the work-a-day world.

In addition, the "Y" was interested in a broad variety of issues ranging from low wages to the lack of training of many women. In the course of a speech on these problems, Miss Lapkin could not resist noting the evil influences of "fashion, as it results in a desire to keep up with one's neighbor; and public amusements such as picture shows, etc... which prompt a girl to do the reckless thing that... ends up... in the Women's Court."[21]

The "Y" maintained a variety of projects in the early twentieth century with a focus on needed recreation facilities. Around 1913, it was very involved in initiating clubs for girls. They were especially active in the west end of Toronto, starting off one club

with eighty members.[22] In their fund-raising campaigns, it was often businessmen who donated the necessary money or space. These employers obviously felt that they had some benefits to reap from the YWCA's activities.

The "Y" had real problems with the younger generation, because so many of the girls were unskilled and apparently still wanted high wages. "Her great problem," they wrote of one of their job placement workers, "is that she has hundreds of unqualified factory girls applying for the situations. Not only are these girls unfit for housework, but they are not prepared to take low wages while they learn."[23]

The intense anxiety about moral rectitude evidenced by these Christian reformers took some of its attributes from sheer class prejudice. "Vices" that the moral reformers either ignored or treated with indifference among the upper classes were vehemently denounced in members of the working class. The Earl of Dufferin, an individual in a position to know, wrote for his sister-in-law:

> Fair ladies of the "Upper Classes"
> Who ante-prandial Bohea sip—
> Be not hard on those who nip
> O' mornings, 'mongst the toiling masses.[24]

Their often compulsive concern for the working woman's purity was rooted in profound anxiety about the changing roles and endangered status of women. Goldwin Smith, an important social commentator of the time, expressed these fears in the following way. The factory, he thought, was monstrous, and also made women unfit for maternity. "They want, some of them say, to live their own lives," and he adds defensively, "as though the life of a woman could be perfect without domestic affection."[25]

This anxiety partially accounts for the ironic coupling of two dialectically opposed images by the middle-class moralists —images probably rooted in the Christian dichotomy between Eve and the Virgin Mary as the two principal symbols of womanhood. Ever ready to believe the worst about women's inclinations when unleashed, they nevertheless, at the same time, proclaimed absolute faith in women's intrinsic bent towards untarnished purity. This theme, which we call besieged innocence, runs through all their thoughts and actions. It encompasses both their fears and their lamentations, their sexual preoccupation and their naiveté.

The following poem dedicated to the working girl captures the image of besieged innocence.

> Sickness sought her, and it brought her,
> For those aching fingers rest.
> For the soiling and the boiling
> That those fingers know,
> God will take them yet, and make them
> Soft and white as falling snow.
> Few her years are, yet her tears are
> Bitter drops, and numberless,
> Through sin, surely, she walked purely,
> And the bitterness is less.
>
> * * *
>
> Ah! what is it, that exquisite
> Look of rapture in her eyes?
> Heaven neareth, and she heareth
> Angels' harps beyond the skies.[26]

Trade Union Movement

On the surface, it appears that the union movement generated a more advanced and modern conception of the problems of the working woman. The Independent Labour Party candidate in 1911, J. Richards, and the 1902 Constitution of the Toronto and District Labour Council (TDLC), both included in their programmes "equal pay, civil and political rights for men and women, and the abolition of all law discrimination against women."[27] Reacting to the "daily hints to the girl worker" that appeared in the pages of the standard press, the *Industrial Banner* suggested, "Join a union."[28]

Nevertheless, the trade unionists' definition of the problems of women workers was dominated by their acceptance of the traditional moralistic definition of women's place. This was partially a result of the overwhelming influence of the prevailing ideas of the time. The lure of this ideology was reinforced by the hopes of the trade unionists to break out of their social and political isolation and establish links with various reformers who held these views. For example, D.J. Donohue, a prominent Toronto labour spokesperson, often collaborated with the National Council of Women, providing them with certain basic information. Following a resolution of thanks for his efforts, "he further dwelt upon the need of

some women of leisure and education to assist women workers to form benefit societies and other organizations for their help and improvement."[29]

The pressures to affirm the traditional view of women were reinforced when they fused with the narrow craft consciousness permeating large segments of the union movement. The craft organization's central thesis of restricting entrance into the trade as a means of preventing competition and ensuing lower wages, influenced the attitudes of significant layers of the trade union movement towards the entrance of women into the work force. One labour organization suggested, "We think that women should not be allowed to work in the foundries, as it has a tendency to degrade them, to lower the wages of the men and to keep a number of young men out of work."[30] Both the foundry workers themselves and the Trades and Labour Congress of Canada favoured "abolition of child labour by children under 14 years of age, and of female labour in all branches of industrial life, such as mines, work-shops, factories, etc."[31]

Their fear of the "menace of the unorganized woman"[32] paralleled their work in favour of immigration restrictions to women.[33] The slogan "woman's place is in the house" legitimized their appeal for her exclusion from the workplace—a beneficial measure, in their minds, in order to reduce competition amongst labourers.

An article in the *Toronto Labour Day Souvenir Book* for 1907 entitled "The Influence of Women in the Labour Movement" illustrates the current of thought that attempted to deny the very existence of working women. This article deals exclusively with the role that women as consumers, wives, and mothers can play in the union movement. There is not a hint to be gleaned from this article that there is such a thing as the employed female. Rather they are concerned about carrying on educational work beyond the union and into the home, because it is "women who spend at least eight-five percent of the total earnings of their husbands, fathers, and brothers and by a careful and discrete use of this money create such a force that would of itself do more for organized labour than all craft organization has been able to accomplish in the last fifty years." Thus women's role in the labour movement was to support the Union label—that is, to buy only those products that were union-made—a role as consumers, not fellow workers.

There was, then, considerable tension in the union view of

women workers. On one hand, the unionists were committed to "brotherhood" and equality; on the other hand, the old view of women's place still held sway. These conflicting views are reflected in the Toronto labour papers of the early 1900s.

In 1902, *The Toiler* carried exclusive reprints of articles on women workers,[34] fashion news and stories suggesting ways to economize.[35] In 1903, "Pauline" wrote in calling for a women's page, reasoning that "there are a great number of women toilers who toil but do not belong to a union" and that women influence young children greatly. *The Toiler* should not just be a "papa's paper", she argued.[36] In 1904, they carried a number of letters and articles urging a broader sphere for women,[37] or urging social change from a "woman's point of view." Woman's plight showed the necessity for a "different system," one apparently socialist writer argued.[38]

The Tribune also tried to carry a women's correspondence column, assuming that woman's sphere was expanding.

> Ideas, like conditions are changing, and the old idea that woman must confine her attention entirely to the home and the raising of children is fast becoming a thing of the past. Men are beginning to recognize the important factor women are and can be in the industrial field and know that the time has come when she must be educated along broader lines than in the past.[39]

Two months later, however, their women's page was reduced to a recipe column.[40]

A later paper, *The Lance*, is especially interesting because it drops its normal cynical stance toward moral reform when it comes to women, and shows a profound anxiety about modern trends. Referring to female employment, *The Lance* queries,

> It's good for trade no doubt. It enables manufacturers to produce more cheaply and so extend their markets. Good for trade; but is it as certainly good for humanity?[41]

They carried some material on husband management, and a number of sermonettes for the working girl that mainly amounted to advice on proper dress.[42] They also carried odes to the old-fashioned wife and fretted about the trend of women working outside the home.

This anxiety accounted for their position on a minimum wage for women—"Give the male workers a decent living wage and a minimum wage for women will be unnecessary"[43]—and for their opposition to the suffragettes. "The lunatic suffragettes are fur-

nishing the most conclusive arguments why they should not have equal political rights with men," according to Brother Bill.[44]

The view of the trade union movement towards the entrance of women into the work force was obviously one of apprehension! They feared this process because of its effects on the male work force and on the traditional role of women. They were anxious to define very clearly the limits to which women's sphere could be extended and still be compatible with their notion of femininity. Yet often the logic of their own interests pressed them to take a progressive stance on key issues of civil and industrial rights, thus causing considerable internal tension and ambivalence in their overall view of women workers.

Factory Inspectors

The factory inspector and factory legislation in some respects promoted an amalgam of the interests of the middle-class reformers and the trade union leaders. Protective legislation placed the parameters of reform well within their traditional notions of womanliness and femininity. Through factory inspection, the state acted as a watchdog (albeit somewhat ineffective) over the morality and cleanliness of the environment of women workers.

The task of the factory inspector was defined by legislation in the Ontario Factory and Shops Act passed in 1884. By 1901, this Act had expanded to include limiting hours of labour for females and children to no more than sixty hours per week without a special permit, and banning the employment of children under fourteen, young girls (14-18) or women in cases where their health might be permanently injured.

The rationale for this legislation is eloquently argued by one factory inspector:

> When I tell you that today we have in this province, women working in the foundries, machine shops, and breweries, some of the weaker sex, and not a few of their champions will be surprised. I do not mention this as meaning to say that labour for women and children is degrading, but rather to show ample reason why they should be protected... the effect of propagation by the present race and the degeneration of future generations.[45]

Explaining the need to keep the doors of the factory unlocked because of the fire hazard it entailed, another inspector revealed the assumptions behind the association of women with children in this legislation:

> Woman is a helpless creature of impulse. Some would beat at the door vainly with their hands; others would faint away. Some would rush for the window and if there were any real danger, might throw themselves headlong into the street.[46]

There were two major figures in the field of factory inspection. Miss Marg Carlyle was regarded as an intelligent Christian woman of sound character, "sound discretion and sympathetic disposition." She had been employed as a worker in large establishments in her native Glasgow and in Toronto for years before going into business for herself. She was then appointed first female factory inspector in 1895.[47] Mrs. James Brown, a woman of some previous experience "organizing and agitating" around the issue of women workers joined Miss Carlyle in 1904.[48]

Factory inspection was not conceived as a measure condoning the interference of government in the most private affairs of business. Mrs. Brown, for example, explained that legislation was necessary, in fact, to protect the employer who wanted to initiate reforms but was unable to because of the competition.[49] Another inspector reported that "factory laws are for the mutual benefit and protection of both manufacturing and labouring classes."

The aspiration to serve both employer and employee proscribed interference in the central nexus of their relationship —wages. It by definition limited the concerns of inspection to peripheral issues.

Thus year after year, while there is no mention made of the right to higher wages, there is reference after reference to the ill effects of factory and shop work on the nervous system of women. One factory inspector comments:

> If under existing circumstances women and girls must take their place as labourers in factories and workplaces, their health, safety and comfort must not be left to chance. Here if anywhere the law must be invoked against all preventable causes of evil and danger incidental to such employment.[50]

Demands to aid the nervous state of the factory girl involved provision of lunchrooms, regular breaks, seats for women in shops, restriction of overtime, abolition of home work after working hours, and abolition of the piece-work system.

The obsession of these factory inspectors with questions of ventilation (pure air), good lighting, and particularly with separate, modest and clean lavatories, dominated the majority of their government reports. There were also repeated complaints with regard

to drinking water available to the women. The following is a typical example:

> Several women have complained to me of the method of supplying drinking water by pail. When one considers that 50 persons, male and female, will make use of the same drinking cup in an hour or so, and that a good number of male factory workers perpetually chew tobacco, it is only natural that a woman with cleanly instincts would resent being compelled to use the same vessel.[51]

A communal drinking pail is not mentioned as a health hazard, although epidemics of cholera and typhoid occurred frequently at that time. The concern expressed was for the virtue of cleanliness.

It is noted, in inspectors' reports, that complaints were received from "females having to work in the same room as those afflicted with tuberculosis," and it is suggested that

> there should be a medical examination from time to time... if tubercular patients are allowed to work in factories and shops... it should only be in special cases... Above all there should be no spitting, except in vessels provided which should contain a disinfectant.[52]

The provision of spittoons is a common refrain in reports of factory inspectors. Yet much of the apparent anxiety for the health of the women workers cloaked their main anxiety for the health of the consumer of products manufactured under such circumstances. Margaret Carlyle commented that "allowing spittoons in factories contributes to the health of the women and the public," pointing out that "unsanitary conditions in some factories are a danger to the general public."[53]

Exposure of women to spitting and smoking men was considered among the grave disadvantages of the contact between the sexes necessitated by the factory system. It was recommended that "separate rooms should be provided for men to smoke as the smoke bothers the women." Any intermingling of male and female factory workers was frowned upon by the inspectors. The most objectionable aspect of this contact was the male foreman. Miss Carlyle reports having received repeated complaints about the use of abusive language towards the girls by the foreman. The solution, in her opinion, was to have women managed by forewomen.

> Where young girls and women are employed... they should have a forewoman. No one can visit factories without being struck by the enormous influence for the good effected by the presence of a forewoman of high moral character.[54]

Food processing plant. Green, Matthews & Co., Ottawa, Ontario, 1907 (Public Archives of Canada)

Forewomen were advocated not only as a beneficial antidote to the abuse of working women by their foremen, but also as examples to "the girls"—models of virtue and cleanliness. Carlyle notes in particular how much cleaner the lavatories were when a forewoman was present to reprimand any young lady who was remiss in so far as cleanliness was concerned.

In their self-appointed role as guardians of the working woman, they felt called upon to comment on their progress with their charges. Far from dismayed by their task, nearly every report was prefaced by celebrations of their success. "We have nothing to report but marked progress," was a typical introduction to a factory report. Naturally, once separate lavatories are defined as central indices of progress, each new firm which complied was a victory in the inspector's eyes.

Factory inspectors were also sensitive to the concerns of union men about the entry of women into the work force. Indeed, several inspectors were drawn out of active service in the trade union movement. This accounts for several of their remarks and recommendations that touch on issues broader than the cleanliness crusade.

> The adverse side of the question of women entering the work force is the fact that in the fields of labour which women have entered the tendency is toward lowering the wages of men. It would seem that the remedy lies in the equalization of the compensation of both sexes for like work.[55]

But even here, the point of departure for wage increases for women derives from the needs of union men. It did not grow out of the inspector's sense of the needs of women workers.

* * * * *

This review of the images of the working women's problems presented by a variety of reform constituencies reveals a number of widely held assumptions. In this portrait, the working woman appears with her calling of motherhood endangered, her womanly innocence besieged from all sides by temptation and lack of proper sanitation, and her helplessness in a cruel world requiring intervention by the well-meaning. None of these assumptions are warranted, judging from what testimony we have from the working woman herself.

Indeed, one business girl [office girl] complained to an editor of a woman's supplement in a popular magazine:

> I wish someone would write against the foolish stuff that is being written about the working girl. Some of it makes me quite ill... To read those silly women's journals you would think that every girl who goes into business life was in mortal danger of losing her head, her heart—or both... It is quite disgusting to read most of the advice that is given us. You would think the writer was addressing very little children or born idiots.

She asserted that her mentors were not even well-intentioned.

> They don't mean any kindness to anyone. They're misrepresenting most women who earn their own living and these articles are written just for the sensational side of the question.[56]

Another indignant business girl replied to a "Homemaker" who had offered some insulting remarks accompanying an offer to supply free room and board for a working girl in exchange for help with domestic duties. "Her idea is to suppress... business girls and make servants of us," she fumed. She argued that it was necessity and not the desire to flaunt $10 hats and $5 shoes that lead women to work.

> Has it ever occurred to "Homemaker" that perhaps some girls' salaries are doing more than support impertinent shop girls?... She

shouldn't feel badly about our chances of not getting married... Nowadays we don't sit around and wait for offers of marriage, as our grandparents did. Marriage isn't attractive to the average girl.[57]

The evidence implies that the working girl was quite independent, regardless of her marital intentions, in comparison with the docile, helpless picture often presented by the reformers. A small indication of this is that banking institutions found it to their advantage to capitalize on this sentiment with large advertizements in *The Lance*, a labour paper, in bold type: "Accounts for WOMEN are treated as strictly confidential and are subject to their own order."

There was, naturally, a strong consciousness of their femininity among working women, yet this differed quite radically from the reformers' preoccupation with their future maternal capabilities and roles. The working women, most of whom were young and single, were much more oriented towards the present, and thus more interested in fashion and attracting beaux. Considering that most women's desire at that time was to get married, this concern for their appearance makes a lot of sense. The reformers' contempt for their "foolish" pride in finery, and expenditures on clothes and jewelry was not only short-sighted, but often served to detract attention from the women workers' pressing need for and right to higher wages.

An incident regarding the passage of protective legislation illustrates these divergent preoccupations. In 1904, an amendment was added to the Factories and Shoes Act stipulating that women in factories were to wear close-fitting hats and keep their hair rolled or plaited and fastened securely to the head. This legislation was designed to solve a serious problem. In the absence of adequate safety devices, elaborate dress and long hair were potentially dangerous for women working close to machinery. The leader of the opposition in the House commented that "I am inclined to think that the suggestions come from the blue laws of Connecticut, which defined not only how men and women should wear their hair, but named days on which a man may kiss his wife."[58] There are indications that he was articulating a fairly widespread sentiment amongst the women themselves. Women interviewed by the *Star* were "not too pleased." One commented that "If I have to wear my hair plastered down like a Chinaman, I won't do it... I might resign... I think Mr. Dryden (promoter of

the bill in the legislature) might have consulted us before drafting the bill. I wish women had votes."[59] The women must have sensed that it was easier and more profitable for the companies to inconvenience them than to install the proper safety devices on their machines.

In fact, after the passage of this bill, Carlyle had great difficulty in enforcing it. She reports with shock and dismay that "We note too frequently... insubordination on the part of the girls themselves." Thus Carlyle, ardent crusader on behalf of the working girl, in fact found herself, probably over more than one issue, enforcing protective legislation perceived by the women themselves as oppressive.

There is one example of working women establishing a society with much the same purposes as those of some middle-class groups.

> A novel secret society, promoted entirely by women, and having its object the study at first hand of actual working conditions in factories or other establishments where large numbers of girls and women are employed and the protection of female workers has just been organized in Toronto. This society, according to the report, is composed entirely of working women. Its first object is to act as a clearing house of data which may be of relief. An attempt will also be made to secure some idea of the extent of white slavery in these trades.[60]

Interestingly enough, the Toronto Vigilance Society,* which was formed to clean up the slums, fight prostitution and generally engage in the work of moral reform, amended its constitution three months after its founding. The amendment was "to include among the other objectives of the Association a demand that we receive the full social value of the wealth we created." A paragraph demanding immediate relief in the shape of "laws prohibiting sweatshops and other social and individual wrongs" was also inserted.[61] This is a trend in reform activity quite distinct from any initiated by the middle-class reformers.

The above examples, however, are mere sketches. A more definitive treatment of the working woman's rebuttal to the reformers' attitudes is necessary. It must be recalled that there were approximately forty thousand working women engaged in a wide

*Most evidence leads us to believe that this is the same society as that mentioned above.

variety of occupations in Toronto in this period. The concentration of women in any given enterprise was low, even in areas like the food and clothing industries in which large numbers of women were employed. In the light of both the size and the diversity of the female working population, we have chosen to present a number of representative incidents and issues that illuminate the contradictory points of view of the reformers and the working women. We hope that the variety of material covered will suggest an overall pattern.

Servants and the Servant Question

It's always been "hard to get good help." But for the reformers, the National Council of Women in particular, the scarcity of domestic servants was an indication of social crisis. Discussions of this question were given foreboding titles like "Difficulties surrounding domestic life in Canada".[62] No other problem inspired so much agonizing or innovation in social thinking.

Mrs. Helliwell addressed an early convention on the question, presumably from "The Servant's Point of View,"[63] although her credentials were from the other side of the employment fence. She conceded that

> the servant question is growing more and more difficult each year, and perhaps naturally so, since every class is rising and trying to force itself into the class above it—a not ignoble aim, if at the same time it educates and fits itself to enter that class; but it mostly does not do this...
>
> There have been big changes in the occupation. Servants now demand more pay for less work and the worker is seen as a machine and put in the worst part of the house where she is underfed and overworked. Sometimes she is not even allowed to entertain her beau in the kitchen and has to resort to going to concerts with her beau. The tie between the classes has been loosened and must be restored around a personal pivot.

Continuing on the same train of thought, Margaret MacMurchy admitted woefully that "as the world stands today, there is no servant class." She lamented that those who served loyally and in perpetuity had disappeared and reasoned that they would therefore have to be replaced by efficient professionals, certified in training schools and renamed houseworkers. "The coming of the trained houseworker is inevitable. When she comes, she will be as great a blessing as the trained nurse."[64]

In fact, the National Council of Women was willing to try

almost anything to find servants.

 The Toronto Council suggested that in view of the fact that the present scarcity of servants seems likely to continue partly as the result of changed conditions, and as many homes are being given up in the cities as a consequence, the matter of plans that are being tried in other countries such as cooperative housekeeping, Laboratory Kitchens, and the like, as affording relief to housekeepers be discussed fully, as a possible solution of the present difficulty which menaces the home life of the country.[65]

Of these schemes, perhaps the most fatuous were those designed to raise the status of the domestic artificially, without changing her actual subservience. One resolution promoted the establishment of an "Honorable Order of Domestic Servants" to raise the status of the work and thus rescue women from factory life, which was taken up, they imagined, because of its supposed independence.

More serious were their efforts to enlarge the labour pool through an ingenious variety of methods. They pressed the government to encourage the immigration of domestic servants.[66] In addition, the *Evening Star* reported that at one meeting, "they

Cooking class, Ladies College, Ottawa, Ontario, 1906 Public Archives of Canada)

bent their massive and regenerative intellects to the question of a training school for Domestic Science, in plain English, a housekeeping school."[67]

A true *piece de resistance*, however, was the founding of the Girl Guides. Lady Pellat, and other influential members of the National Council of Women started the project. One pamphlet described their purposes:

> It is a purely womanly scheme and the aim of the pursuits engaged in is to make girls better housekeepers, more capable in womanly arts for cooking, washing, and sick-nursing to the training and management of children...[68]

The Girl Guides laid an emphatic stress on domestic work, and girls were awarded proficiency badges in laundry work, cooking and household management.[69] Knowing the NCW's other concerns, it is safe to assume that this programme was aimed at producing a new generation of young women better socialized to fit domestic roles, both as servants and as wives.

Of all these schemes, the most sophisticated was the attempt to professionalize the occupation of domestic servant. C.C. Hamilton, one of the most prestigious members of the NCW, was a well-known advocate of this approach. She proposed the formation of associations of mistresses to meet the problem in a businesslike way. Reasoning that many rejected the occupation because of its low status, she created a far-reaching scheme to make domestic service competitive with other occupations by regulating hours, thus making a normal social life possible for the employee. Her efforts took on the aura of a crusade since it touched on not only the need for servants but the need to rescue would-be servants from factories. No effort was too great when it was considered that "our duty to the race demands that we should govern the conditions of this woman's work so that in late years she may have the chance of becoming the mother of a sound generation."

Apart from training schools she urged home-like situations for the girls and recreation time in normal hours, not only after dark, a time conducive to much evil. She even urged domestic clubs with proper supervision so that friends could be entertained. "I do not think it would be a very difficult matter to find out the standing of such friends and admit them according to their desirability," she assured her readers.[70]

As the above example indicates, in some respects the reformers depicted the problem accurately, despite the fact that their

attitude converged so clearly with the point of view of the employer. They saw, but simply could not come to grips with, many of the problems articulated by the girls themselves.

This dilemma was covered in a humorous vein in a satiric short story by S.F. Harrison, "A Philanthropic Failure." The good ladies of the 'NWGGA' prepared a dance for their servants to enhance their working conditions. Everything went wrong—the servants got uppity and the author concludes, "It is easier to elevate the masses than to amuse them in these desperate days."[71] This is more than a humorous aside; the same problem is also revealed in the serious literature of the reformers.

One of the most obvious problems of domestic servants to which the reformers seemed oblivious was the fact that the work itself was extremely arduous. Ella Sykes, a wealthy English matron who toured Canada to test the prospects for emigration made special note of this.

> There are few specialists in the domestic line in Canada; a girl will have as a rule to do the work of a general servant, and probably be expected to turn her hand to odd jobs that do not fall to the lot of even the maid-of-all-work in England. Though the wages are high, yet the work is hard in proportion and two friends of mine whose servants have left to seek their fortunes in the Dominion, have received letters, in each of which was the significant phrase—"I lived like a lady when I was with you and didn't know what real work meant."[72]

One woman interviewed by Videre said that her mother wouldn't allow her to enter domestic service because of the drop in social status. "You are not thought as much of," said another. "You have to worker harder at it," said one girl, referring to the long hours. Another told her, "I don't like being bossed so much. At the factory when your work's done, your time's your own; you can go where you like." She also found that the girls preferred the sociable life of the factory to the loneliness and isolation of the domestic, and that the desire for male companionship was a factor. "The girl in the factory has bows in her hair and 'beaux' in her brain." She reasoned that domestics don't like the long hours for that reason, nor do they like the necessity of meeting their dates in the kitchen and letting them in through the back door.

Although Videre, in her column in the *Star*, realized that the problem of caste was a major obstacle to recruitment to this occupation, she at the same time shuddered at the thought of incorporating servants into the family as equals. "We are not blaming you," she

assured her readers, "for not bringing the girl in to eat at your table and share your family affairs. That would be a harder cross than keeping a boarder." Yet she still considered that "undoubtedly the most practical way to remedy industrial conditions for women is to remove a large number of them from store and factory, back to the kitchen." This she proposed be accomplished through scientific training for houseworkers and regular business hours for workers.[73]

The crowning irony is that domestic work is most unlike those hazardous occupations about which the reformers fretted. In their minds, it was the occupation best suited to future mothers. Yet any glance through records of inmates of criminal and insane asylums shows a significantly higher proportion of domestics than of any other occupational group, an illustration of the special desperation and isolation of a domestic's life, as well as the fact that the occupation of domestic service absorbed many of society's misfits. Even though the reformers were able to perceive some of the servants' problems, as employers they were unwilling or unable to solve them.

Housing

Another outlet for philanthropic energy was the provision of housing for young girls. Many were aware of the need for such a service. One person signing herself "a Christian" complained that there were institutions for fallen women while they overcame their "vicious habits,"

> but what is being done by the many societies in the name of Christianity for the poor homeless virtuous young women, whom dire necessity may compel to apply for assistance on account of not being able to procure honest employment?... a case has just transpired; I mean that of Agnes Holland, who because she was unable to pay her board was cast adrift, died and received a pauper's burial without Christian service. This is enough to make one believe such societies are hollow mockeries and money grabbing concerns. I think it about time that a generous public had its eyes open... and see that their offerings were expended in aid to the unfortunate and not create fat offices for a few who are too indolent to work for a livelihood.[74]

Many institutions took up this work. Prominent among them was the Georgina House established by the Church of England on a non-sectarian basis.[75] The house catered mainly to business girls and white-collar workers; they were charged $4-$5 per week for their rooms. The key activist in this enterprise was Mrs.

Broughall, who, as one reporter described her,
> has for years taken a deep interest in the welfare of the girls who come as strangers to Toronto. Through her large Bible classes, she has been able to come closely in contact with their home life and has found in many cases that it is not what it should be. She realized the need for cooperation among them in order that they might have greater social, educational and religious advantages.

This reporter continued on the fate of the country girl coming to Toronto to work and live alone: "She may look up and fight on; but on the other hand, she may begin to drift with the downward tide of the unsuccessful."[76] Flora Macdonald Dennison commented ironically on those who say that home is woman's sphere while most of Toronto's working girls have no homes, but only board. There they have no sitting space and can only entertain in their bedrooms. She posed the problem delicately:

> Many of our girls prefer to walk the streets with their young men friends rather than ask them into a bedroom, but others do ask them in. Now, were the same girls at home a bedroom would be the last place they would ask a young man, but the desire for privacy in their friendships makes them choose to break with custom and there are possibly hundreds of cases where this act has been the first step towards their own ruination.

She went on to praise Georgina House as a noninstitutional house where the rules were lax and there were private and common sitting rooms so that evil would not tempt. In asking for patrons to finance these moderately priced rooms, she pledged, "What work more commendable than to take proper care of the future mothers of our nation? As a cold business proposition money might be better spent for this than for any one thing."[77]

The oldest establishment in the business was the "Y." By 1911, they were able to look after 4,000 of the army of 45,000 girl workers.[78] Their regulations demanded character testimonials, regular meal times, no alcohol, no visitors to the rooms without permission, daily praying and even more on Sundays, weekly Bible class, house closed by 10 p.m. and lights out by 11 p.m. If a girl was late by more than 15 minutes she must report and if her excuse wasn't good she would be evicted.[79]

One entry in their minutes is suggestive of how they creatively derived messages concerning the importance of the rules of the house from the overall designs of the Lord. The matron's report recorded the death of a bright young girl in the house from typhoid

fever, and that

> this had a very softening influence among the girls. Many of them seem much impressed and prayer has been made that they may heed the warning. The ladies of the board are requested to pray that this sorrow which has come into the house may be blessed to the girls.[80]

The matron's report noted

> several instances of homeless girls who come from the Country Ladies Colleges expecting to find suitable employment as stenographers and are often stranded and being young and inexperienced need a helping and guiding hand.

She mentioned how deplorably ignorant and untrained many of these girls were in domestic work, their lack of training adding to their helplessness.

Apparently the Board did not brook rebellion. It is recorded that one of the guests apologized for the manner in which she spoke to the members of the Board and it was moved that she be allowed to stay if she obeyed the rules.[81] There was a reference to a Miss Gregory who was giving trouble. At first she was sent a courteous letter telling her to obey the rules or leave. Thereafter she apparently found a co-conspirator who broke the rules with her deliberately and she was given orders to leave. They apparently stayed on for a short while after this and persisted in their "high-handed" and rebellious behaviour, creating so much disaffection that some of the girls left with them. Thereupon it was moved and carried that their behaviour was so offensive and rude that they should not be allowed back.[82]

The Women's Christian Temperance Union had provided a service since the mid-1890s when they were approached by the Morality Squad and Children's Aid Society to set up a house to protect young homeless girls who came to Toronto. They were too old for the Children's Aid and the police had no place to take them except where they would meet even further "degraded" sisters.[83] These girls were often placed in homes as servants:

> Hundreds of these working girls who come to the city without money or a knowledge of its dangers have been received into the home, where situations are secured for them in respectable homes. If the position does not prove congenial to the girl, or if she is not capable of filling it, she may return to the home until another situation can be secured for her. A general supervision is kept over her and she is always welcome to spend her afternoons out at the home, where first she found a welcome.[84]

The Canadian Manufacturers Association also tried to get into the business. Although they eventually turned the matter over to the YWCA, they still helped out administratively in the provision of housing. The CMA saw their work as the outgrowth of humanitarianism but they also saw its benefits to business.

> In asking you to support this proposition, we wish to emphasize the value of this home. Parents refuse to allow their daughters to come to the city, owing to their possible environment and the uncertainty of securing boarding houses. Strangers have difficulty in securing proper accommodation at a rate they are able to pay and in securing information as regards employment. The result is that frequently they become discouraged before they have obtained either accommodation or employment. The manufacturers not only lose their services but unjust reports of the conditions existing in the city are spread broadcast. A Home of the kind proposed would provide agreeable social conditions for the girls from abroad... Such homes are essential economic machines, making for the success of any city, and when properly established, are of immense value, providing as they will a channel to which girls from all points in the world can be directed and then in turn referred to you.[85]

There are few published reactions of the working girl to these charitable boarding houses. Responses to Madge Merton's woman's column give an idea of the motives of the girls who boarded in these houses. It seems clear that what they appreciated was that it was clean and reasonable and that goods could be left in the room safely, which could not be said for similarly priced boarding houses elsewhere. It was also a place to meet people and perhaps improve their knowledge of their respective trades.[86] However, the letters of response to Videre's column indicate some resentment. Most significantly, the labour movement was demonstrating reluctance to accept the legitimacy of the philanthropists' intentions. Instead they intimated that the motive for the provision of such cheap housing was to secure cheap labour.[87] Official women's labour organizations also opposed these schemes.[88]

Certainly this opposition and skepticism were justified, in the light of statements like that of the Canadian Manufacturers Association quoted above. Whether the philanthropists condoned or simply ignored the problem of these women's below-subsistence wages, there is no doubt that the campaign to establish and fund cheap and respectable housing for impoverished women workers made possible their continued exploitation as the cheapest available labour.

Nurseries

Nurseries were a major outlet for philanthropic energy, directed towards working women with children. Because of the financial drives that they sponsored and the general attention that they attracted, nursery organizers contributed greatly to the way in which the problems of this sector of working women came to be defined.

The East End Day Nursery, founded in 1892, was probably the earliest effort. It was the result of a local mission teacher's discovery that many women in the area were prevented from working because of their responsibility for their children.[89]

Their annual report for that first year expressed their guiding motto: "to help those who try to help themselves."[90] Unlike those reform projects oriented to the problems of single women, these were not concerned with their clientele being led astray or exploited sexually. Rather, their emphasis was on self-reliance and on maintenance of the home.

Their annual reports give some idea of how they envisioned the uplifting nature of their work. It often appeared that they saw themselves as surrogate mothers who could instill higher values in their charges than could their natural mothers. Their annual reports show their pride in their accomplishments:

East End Day Nursery children, Toronto, c. 1905 (Metropolitan Toronto Central Library)

> 1902—We have noted with pleasure the improved appearance of both mothers and children and also the increased comfort and tidiness of their homes.[91]
>
> 1909—As our city grows there will be a larger number of people in need of such assistance as nurseries can give, to keep them out of the slums.
>
> 1905—Many of these women after their first start from us procure their own work, and as soon as they prove their efficiency, have all their time employed.
>
> —We give these mothers an opportunity to provide for and maintain the home, as we both supply them with work and care for their children while they are thus employed. Many of these women are widows, some are deserted women, while not a few have sickly husbands or husbands who have no permanent work.[92]

In a 1900 report on the East End Creche, *Saturday Night* reported on the services rendered to sixty women, which included finding places to work and selling them cast-off clothing. They noted that

> people have a prejudice against women bringing babies with them when they come to work in their house... these nurslings of poverty cannot be expected to behave like little ladies and gentlemen and we cannot blame private families for objecting to their washerwoman or seamstress bringing their offspring along... The only way out of it is the Creche system, for by this means woman can obtain employment and by paying a small fee can leave her child in the Creche in the morning... have it well cared for and returned to her at night.[93]

This last comment illustrates how their nursery service became entwined with their role as an employment bureau, often for the most menial and lowest-paying jobs. The 1909 report explained that, apart from 25,005 children days looked after, 15,130 work days for the mothers had been found.

The nursery organizers thus won the applause of the *Star*, which commented that "what the nursery seeks most is to foster independence and thrift and to safeguard the life and health and morals of our future children."[94]

However, praise for the creche system was not all unqualified. May Darwin wrote a eulogy for the nursery in the labour paper, the *Tribune*, which she ended with an appeal for help from the unions. She then went on to lament the fate of those women forced to abrogate the duty and pleasure of looking after their own

children; forced to give this task to others. Their lot was worse than that of the slave mother who at least knew what was happening to her children. Surely, she thought, this was an outgrowth of a rotten society and probably was responsible for the declining population and "race suicide."[95]

May Darwin's views seemed to have struck a responsive chord among women workers. There is an interesting parallel between the case of the nurseries and that of the conflicting views of reformers and single working girls. The reformers were concerned in the latter case about femininity in a traditional sense, that is, seeing the girls' future role as the essence of their femininity. They missed the fact that the girls were concerned about their present roles and situation, not only about their appearance, clothes, and finding a husband or beau but also about such vital issues as wages and hours. In the case of the nurseries, the reformers were concerned about promoting the values that they considered central to home life, the virtues of thrift, cleanliness, etc., but ignored that the women felt an allegiance to their children that was violated by their well-intentioned efforts. Working women of that time identified most strongly with their role as caretaker of their children, and the reformers, for all their concern for the traditional woman's role, were facilitating their forced abandonment of this role.

Flora MacDonald Dennison, a prominent suffragette, also commented on this aspect of the problem of daycare. She saw it as a prime example of the sad manner in which humanity was subordinated to property, that women had to leave their children in a creche to go to work. Since Kelso was claiming that private homes were better for orphans, she wondered why they were not better for the children of working women.

She also described the efforts of Mrs. Rowan Ellsworth, who had a plan to organize day toilers (women domestics who are hired by the day), to have cooperative laundries, and model apartments where the babies would not have to be dragged out in the early morning down to some creche, but instead have a nurse in attendance. "Possibly some day," said Flora, "we will be civilized enough to take care of the mothers and not just talk about the 'sacredness of motherhood'."[96]

Mrs. Ellsworth was an extremely energetic woman who moved quickly to establish links with both the trade union movement and the suffragettes. A major goal of her initial efforts was the

organization of the day toilers.[97] She had to turn to non-philanthropic and radical organizations for help, since daycare organizers had actively moved to obstruct her efforts. The Victoria Street Creche went so far as to refuse any member of her Working Woman's Protective Union access to daycare facilities.[98] Her plans provided a radical alternative to the paternalistic charity of the creches, besides threatening to unionize the day toilers, thus depriving the day-care organizers of their source of cheap domestic help.

Mrs. Ellsworth's vision included the establishment of cooperative apartments, laundries and lunchrooms for working people. She aspired to make the operation self-financing, independent of charities.[99] In the building her union was to lease, they planned to look after each other when sick, to buy groceries collectively, and to establish a variety of businesses. Apparently their concept of home life in no way excluded collectivity. This was a dramatic departure from the orthodox nurseries in that it allowed the mothers real independence and self-esteem, since they could work and at the same time maintain contact with their children in the same building.

Some accounts indicated that "they were imbued with the spirit of ardent trade-unionism and when it was proposed by some well-meaning charitable people that they should just form an association and not a union, they emphatically declared that they were going to be a Trade Union, for the Trade Union was the only institution that could win them better conditions, and the word union must be prominently connected with the name of their movement."[100]

In her initial organizing efforts, she approached several unions who promised their patronage. At first, her efforts were endorsed by the local labour council, "as they thought it would be a great boon for the poor widows who were forced to get up early and work late and therefore could not give their infants and small children the amount of care that was necessary."[101]

A public meeting was planned with prominent suffragettes Flora MacDonald Dennison and Dr. Margaret Gordon.[102] The organization also succeeded in winning the support of the local school board.[103] Mrs. Ellsworth explained her tireless devotion to her vision, saying that she was planning to support herself while she concretized her plan.

I must do this thing. I must assist in protecting helpless motherhood.

I can easily pay the rent of this cottage by doing laundry work of a few families at night and I will gladly do it that other mothers may not suffer as I did when my child was an infant.[104]

For her pains, however, it is not certain how well she was rewarded. A motion with little background information in the Toronto and District Labour Council minutes instructed her that "as soon as she could produce a charter and show a labour union behind her we would certainly reconsider her case."[105] It seems that she had applied to affiliate with the TDLC and been refused. After this there is no known information of the fate of the project. It does indicate discontent among the day toilers and clients of the nurseries, who must have felt that the official nurseries were not speaking to their needs.

Strikes

Although accurate statistics on the number and incidence of women's strikes are not available, and although in some industries, like the garment, it is almost impossible to isolate the activities of women strikers, a selective review of some major non-garment women's strikes is possible and instructive. An impressionistic look at the evidence at hand definitely suggests that women struck less than men. At the same time, those strikes that did take place clearly reveal their class consciousness, a consciousness quite at odds with that projected by the reformers.

What follows is a brief and incomplete catalogue of women's participation in strikes during this period. Since this survey does not include the industry with the highest concentration of women, the garment industry, it can only suggest women's concerns and participation as a whole in the industrial labour force.

Women participated both as members of families of strikers and as strikers themselves. There is one report of wives of striking trackmen chasing scabs from the site of a prolonged strike in 1899.[106] In 1901, thirty women and ten men furriers struck, demanding the expulsion of a new man on the line who worked too fast.[107] Often, women acted in sheer solidarity with others. In one case, several bindery girls were discharged by Eaton's when they refused to do the work of striking printers and pressmen.[108] During a Teamsters' strike in 1900, in one firm sixty women refused to work if the firm received its deliveries from scabs.[109]

In 1902, women were quite significant in a dramatic weavers' strike against the Toronto Carpet Company. The company had

introduced the Rothester clocking system, which caused considerable loss of paid time, especially at lunch hour. When some workers were fired for refusing to clock in, 250 walked out in sympathy. Over half of those on sympathy strike were women.[110] They raised demands for a 55-hour week, no clocking out at noon, and five minutes for women to dress.[111] Although large numbers of the workers involved left for other cities,[112] a sufficient core of women remained to lead the delegation in the labour parade, proclaiming "We are still on strike."[113] The women sent at least their share of delegates to the Toronto District Labour Council,[114] where a Miss Wright spoke on behalf of the strikers.[115] They continued their participation after the strike; Miss Wright asserted that the employees hadn't rung up to clock since returning to work and that the members were determined to make their union stronger than ever.[116]

The strikers were able to gain considerable public sympathy; apparently boarding houses in the area refused to put up scabs.[117] There is evidence that the women took part in picket duty; in court, a Miss Hunter, arrested on a charge of intimidation, frankly admitted having hissed twice at scabs and claimed to be a union picket on duty.[118]

Thirty female and sixty male shoemakers struck to maintain wage rates in 1907.[119]

All but one of the women telegraphers walked out in a wildcat strike in sympathy with male counterparts dismissed for refusing to transmit scab messages from an American city. Since the majority who walked out were women, the union leadership cynically explained their solidarity in terms of their previous experience in a 1903 strike, when they had been forced to work with "unclean and undesirable" scabs.[120] The "girls," according to this same union official, went "home for a holiday [and] have proved to be a particularly loyal bunch of girls." The men apparently had not persisted in the struggle and had sought jobs elsewhere, since jobs were plentiful.[121]

There were three strikes in which women participated in the period of one month in 1910. Milligan's cigar factory had been struck for increased rates on piece work by sixty women.[122] Sixty-five women struck another firm along with the men protesting that there were too many bosses and demanding an increase in wages. The strike lasted a week.[123]

Less than a week later there was a strike of tobacco strippers.

The strikers, seemingly mostly young girls, were harassed by the police for no apparent reason.[124] Flora MacDonald, who wrote a column in *The World*, was extremely impressed by their organizing abilities despite the fact that most of them looked under fifteen years of age. The girls sent three representatives to the district labour council, although they asked a prominent labour spokesman, Mr. Stevenson, to represent them and speak on their behalf.[125] Indeed, the *Star* remarked on the girls sent there, saying that it was the first time in some years that women were there and that they took a keen interest in the affairs.[126]

Public commentary on this particular strike went off on an interesting detour. Flora MacDonald would not condemn the strikers for being forced into their trade, but she went into a tirade about the public's smoking habit, which created this disgusting, smelly, unhealthy work.[127] Her comments sparked off responses from her readers, one from a man saying it was bad enough to be a suffrage crank without being anti-tobacco. A tailoress wrote in supporting her, saying that a number of the "girls" had got together to rent a workroom so that they would not have to work with smoking, chewing and swearing tailors.[128] Flora then asserted that she was not against the right to smoke, and that when she was in Europe she had differentiated herself from the American delegates by smoking when a cigarette was offered her.[129] Despite her liberality in this regard, she had illustrated the differing passions which motivated middle-class reformers as opposed to women workers in defining the importance of strikes.

Women boot and shoe workers went on a union-endorsed strike on November 11, 1912, when their pay was short by $1 to $1.50. According to the *Industrial Banner*:

> It is felt that upon a presentation of these facts the injustice of the action perpetrated upon the female workers... will meet with the condemnation of the public at this time when the churches and other reform agencies are making a crusade against the evils of white slavery... The shoe workers feel they are entitled to the moral support, not only of the trades unionists, but the general public as well, as this is a fight for womanhood, and the maintenance of old existing (not better) conditions is at stake.[130]

The men walked and stayed out in solidarity with them.[131] On November 29, the *Industrial Banner* again headlined "It's a Moral Issue," likening the battle to that against white slavery.

The last known women's strike during this period is that of

twenty charwomen at the new CPR building. There were difficulties in red tape in paying them; they demanded immediate payment and refused to work again until paid.[132]

What is remarkable about these strikes is the similarity of women's grievances to those of men. Issues relating to motherhood, cleanliness etc. were absent, thus illustrating a clear divergence between their main concerns and those of the middle-class reformers who were supposedly struggling on their behalf.

Bell Telephone

Bell Telephone was subject to one of the most dramatic women's strikes of the period 1896 to 1914, a strike in which large sectors of the community took a position. On the surface, the major conflict was that between the corporation and the reformers, particularly those on the Royal Commission. Under the surface, however, lurked a more important conflict, that between the telephone women and those who assumed the right to speak for them. Indeed, one could say that the reformers' position was one of chiding agreement with the company. That is the irony of the supposed clash of opinions on this strike.

Bell Telephone began to be a major employer of women after 1888, when they switched from "boys" to "girls" on day and night work, because "boys lacked the tact and patience required at the switchboard."[133] Or, as one company pamphlet stated: "At first boys served as operators. Somehow they lacked the courtesy and patience the job required, and it was not long before the girls took over the work."[134]

Apart from the above traits, applicants had to be eighteen, tall enough to reach all wires, and had to provide three references, including one from their clergyman, and an excellent memory. A certain physical prowess must have also been required—girls operating long distance had to wear rollerskates to speed message delivery.[135]

Like other pioneers in the mass employment of women, Bell had to counter many prejudices about the special nature of women in order to exploit them as they wished. For instance, the District Labour Council severely deprecated the plan of Bell to have the women in Toronto work from 10:30 at night to 8:30 a.m., both because of the cruelty of the long hours and the night work.[136]

However, in the late nineteenth century the only reported action taken by the telephone "girls" themselves was an ul-

timatum signed by 28 out of 59 long distance operators threatening to walk out if changes were not made in terms of shifts and hours.[137]

The immediate issue in the 1907 strike was hours. In January, a notice was posted in the Toronto exchange notifying operators that, as of February 1st, the Bell would revert to the eight-hour day, the five-hour day experiment having proved a failure. The gross salary was to be slightly improved, but the operators complained about the increased strain and the low increase of wages relative to the increase in hours.[138]

According to the local manager, K.J. Dunstan, the five-hour day had been introduced to improve the service and the working conditions of the operators.[139] Another source notes that it had been introduced in the midst of construction work in the exchanges, the noise of which made an eight-hour day impossible.[140] Over the years, Bell found the experiment a failure, since the pay was not high enough to attract the right kind of women, and the service deteriorated because of the strain on the women due to the excessive speed of accomplishing all their work in five hours.

In response to the company's announcement, a group of operators met with prominent King's Counsel lawyer W. Curry, who helped them draft a petition on January 27th. Curry had also hoped to intervene on behalf of the women, but was denied an interview by the local manager. The latter resented the interference of a third party, and insisted that the petition was the work of six to eight agitators who were successfully prevailing on a minority of the staff. The company, he thought, was reaping the "inevitable result of giving a great deal and then trying to take something back."[141]

Tension continued due to complaints about the increased strain of the eight-hour day and the low salary increase. A strike was planned for January 30th. At the mayor's request, W.L.M. King, representing the Federal Labour Department, arrived in Toronto with the hope of intervening. While he was in conference with the local manager, the strike took place. It was precipitated by the action of the inspector of service demanding that the girls either resign or sign their compliance with the new schedule.[142]

The short strike attracted an enormous amount of public attention and support. Of course, the citizenry at large was already embittered against Bell for their own reasons. The company customarily used its monopoly powers to blackmail the city for higher

rates. When the company refused to renew their charter with the city, the *Globe* interpreted this as a precursor to a demand for higher rates, noted that what the Bell president called "unremunerative" could only be interpreted in a "comparative sense" and intimated that "They would very seriously object to an examination of the company's Toronto business by the city's auditors." The *Globe* thought that the city should either permit a competitor or hold the company to the strict letter of its charter.[143] The Labour Council also was in favour of a competitive system.[144]

Public and union support took shape in various ways. At noon on January 31st, a "mob" gathered around the exchange, and the boys and men tossed ice at scabs who sought entry to the building. They hooted at manager Dunstan when he came out. He tried to address the crowd but "began to find things coming his way, and deemed discretion the better part of valor." Then the crowd tied the doors to deny access. Finally, an hour and a half after the Bell had called for police help, a lone officer walked by and the crowd dispersed.[145]

On February 1st, the *Star* frontpaged the statement of city medical health officer, Dr. Sheard, calling on medical men to speak out against the menace to the women's health involved in the long hours. "It's not a question of wages, but of physical endurance," he asserted. The mayor also supported the women, arguing that the Toronto exchanges were more exhausting than those across the country.[146] By February 2nd, a church service in honour of the women had been planned by Reverend Starr. Furthermore, bell-boys at one of the local hotels refused to work if scabs stayed there, thus forcing the strikebreakers to move to another hotel.[147]

To some extent, all this attention overshadowed the viewpoint of the women themselves. The January 30th *Star* covered the meeting at the Labor Temple of 300-400 operators which called for an organization embracing the telephone workers. They agreed to submit all questions in dispute to a board of arbitrators and called for a public inquiry—confident that once the truth was known they would be supported. They agreed to return to work if this was established so as not to inconvenience the public. However, they decided to oppose in every way the new system, which involved a reduction of hourly rates from twenty-one to sixteen cents per hour, and which would increase the women's expenditures on meals out and carfare. One woman was applauded for her statement that Toronto rates were being changed because Montreal

operators were demanding the same. She insisted that they should not have their standards dragged down to the level of Montreal's.

A worker with Bell for several years told the *Star* that there had been grievances before but never such organization. She explained that the women worked overtime under the five-hour system because of the low daily wage. "While it is the extension of hours we complain about principally, it's the money too. In all other occupations for girls, the pay has increased during the last few years." She also complained about the uniform rate of wages because many did not earn it, not being physically fit for the job.[148]

A February 2nd report on a meeting by the *Star* reported the excitement of the women and their informal conversations. They overheard one woman complain of having worked for seven years for $25 monthly. "That's a hoodoo," a sympathizer said. "Then we'll change the hoodoo, that's what we're fighting for." The audience was reported as militant, applauding all statements that there would be no surrender.

The militancy of these meetings was not reflected in subsequent developments. On February 3rd, the government agreed to the investigation demanded by the January 31st meeting and designated a Royal Commission. The operators were informed of this and on the following Monday morning they returned to work on an individual basis; reportedly a large number were re-engaged. Subsequently arrangements were made to rehire all, although not necessarily at their former occupation and listing. The Commission began immediately. By February 18, the company agreed to space out a seven-and-a-half hour day with ample breaks of fairly long duration, so that there was no time when the women would work more than two hours at a stretch. The committee of operators themselves agreed that this was preferable to the old system with its pressures, and at this point the hearings stopped. Certainly the outlet for reform concerns provided by the Royal Commission allowed the subsequent intimidation of unionists by the company to go unnoticed. The women had been organized into the International Electrical Workers Union, and it was reported that members were asked to leave the union or resign. The company complained that the women were becoming too independent since the inquiry.[149] The reform hullabaloo simply avoided the subject of unionization, and persecution of union members. By September, when the Royal Commission report was released, about half of the women who had been there at the time of the strike were gone.[150]

The Royal Commission inquiry itself ignored the wage concerns of the women. They did, however, render harsh judgments on the company, replete with charges of "cupidity" and sweatshop conditions. The centre of criticism was the conflict between business and health, with the charge that the company had knowingly allowed their business to be conducted in a manner detrimental to the health of the women. As the report put it:

> We believe that where it is a question between the money-making devices of a large corporation and the health of young girls and women, business cupidity should be compelled to make way. The evidence given before us and the facts of experience as cited, go to prove that this is a matter which cannot with safety be entrusted to the parties concerned, but is one which, in this form of industrial pursuit calls for legislative interference on the part of the State."

The State was thus to replace the union in these functions. They also called for a further inquiry based on medical expertise.

> Because of the fact that the number of young women engaged in telephone operating is already large and is increasing from year to year, and because it is the nervous system of operators rather than the physical which requires special consideration, we believe that the interests involved are of so grave concern as to warrant a further inquiry....[151]

The published report itself was divided into a number of sections: wages in relation to cost of living; duration and intensity of work; methods of work and nervous strain; opinions of physicians; studies of schedules. These are the recommendations: appointment of a commission of medical experts; six hour work spread over eight to eight and three-quarters hours; no overtime; hiring age of eighteen years; health examination; better seats, etc.; no intrusion on calls; permanent board of conciliation. They did observe that the five-hour day had been very profitable because of the speed of work that had been exacted. There was no reference to wage proposals: they went so far as to represent the women as opposing a salary increase. They stated quite categorically:

> Notwithstanding the low rates of wages paid to operators prior to the change, the operators without exception stated it was a question of hours and not of wages which occasioned hostility to the new schedule and was responsible for the strike. Both the management and the operators admitted that under the old scale it would have been impossible for a self-supporting woman to maintain herself, the cost of living being what it was in Toronto. In view of this the bona fide of the operators in making protest against any change

which meant increased remuneration can hardly be questioned.[152]

Certainly the report makes the case for the legitimacy of "nerves"-based grievances. It referred to the overloading of the lines, the flashing of lights, and the noisy clattering in the operator's ear if an impatient subscriber clicked the phone. All of this intensified the strain imposed by the pace of the work. It also noted that operating assaulted all of the senses, which distinguished it from other occupations that were equally fast and from physical work that was not as exhausting mentally.[153]

What was even more upsetting for the inquiry was that medical evidence showed that after leaving the company's employ and marrying, "they turn out badly in their domestic relations. They break down nervously and have nervous children, and it is a loss to the community." This latter point was important because of the age of the workers. The report stated that the "girls" were mainly between the ages of seventeen and twenty-three, and were preferred by the company because of their dexterity. It lamented that these were also the years when the woman's nervous system is most susceptible to lasting injury. "The effects moreover upon posterity occasioned by the undermining or weakening of the female constitution cannot receive too serious consideration."[154]

The report concluded in the best tradition of "ceremonial reform." After repeating moral platitudes, it concluded that the matter calls for state intervention, and then immediately admits that the necessary proposals cannot be legislatively enforced! Instead, the report attempted to base its appeals on the efficiency concerns of the company, hoping to lead them to lighten the worker's load. In fact, however, they ended up duplicating management arguments for the extension of the five-hour day.

For all its agonizing, the real import of the Commission was equivalent to a ritual wrist-slapping of the company for a past policy that they had already decided to alter—that is, not even for the policy against which the women were protesting! The women's expressed needs for a union or for higher wages were forgotten.

* * * * *

What happened after 1907?

It is difficult to assess the position of the women after the strike. In 1907, R. Carlyle noted that the Lorimer system being introduced would eliminate manual labour by the operators and

We agree entirely with the view expressed by the local manager that it is the pace that kills, *and the working of women at high pressure work of this kind should be made a crime at law as it is a crime against Nature herself. On the other hand it is difficult to see wherein it is possible for the State to effectively regulate the speed of operating. Happily, the solution is to be found, at least in part, in another way. The efficiency of the service is something which a company in its own self-interest is bound to protect, and it has been found that operating carried beyond a certain rate of speed leads to an imperfect service. Even from the company's standpoint the question in the words of one of its experts has come to be "primarily one of service rather than of load." "There is much more question in my mind," wrote Mr. Hammond V. Hayes, Chief Engineer of the American Telephone and Telegraph Company, Boston, who reported on the matter for the Bell Telephone Company, "There is much more question in my mind, if an operator on a 5-hour schedule can carry appreciably more load than if she works 8 hours and gives an absolutely equivalent service. There is one point to be considered in this connection, and that is, that the load must be so adjusted as to leave a reasonable amount of spare time in each hour so that the unusual rush of business can be handled satisfactorily."*

Whatever may be urged to the contrary, the whole principle underlying the methods of operating is based, we believe, on having the "operating curve" follow the "traffic curve" as closely as possible and on an adjustment of the load to the ability of the operator. Under the 5-hour system as practised by the company, the effort seems to have been to discover "the breaking point," and cause the load given to each operator to approach as nearly to it as possible. Experience, how-

> *ever, went to prove that what was "the breaking point" with the operator was also a "breaking point" in the service and a change was accordingly decided upon.... There is always the possibility of a feeling on the part of those who have to do with the regulating of these matters, that "the reasonable amount of spare time" provided as a protection against emergencies is also a sufficient protection in the matter of health.*[155]

thus solve all the difficult questions raised by the Royal Commission.[156] On the other hand, the pointers given to the women for their job do not suggest a decrease in amount of strain. They were expected to call out and dial their numbers with great speed, and speak in an officious manner since become famous.[157]

It also appears that Bell had difficulty in retaining staff due to the long hours and short pay. The *Lance* reported that during the busy period there would be six-hour stretches with only a ten-minute break.[158] This did not stop Brother Bill, the *Lance* columnist, from a refrain in favour of the work based on the traditional attitudes. Under the column "Pencil and Paste" the writer notes "Young women who want ladylike employment with healthy surroundings... should endeavour to secure a position in one of the Bell Telephone exchanges."[159]

By 1913, there were 1200-1300 women working at eight Toronto exchanges. Rest rooms, a maid to prepare meals for the women who brought the makings of their lunch, club rooms and showers supplemented their seven-dollar weekly starting pay, which represented a voluntary increase by the company in response to employee agitation.[160] And despite all the former anxieties about the future maternal capacities of employees, the major obstacle to retaining a long-term staff was the "matrimonial problem."[161]

Conclusion

The image of the working girl of delicate moral and physical viability, her womanliness endangered, her capacity for self-protection presumably low, has hopefully been dismantled by the evidence. On the contrary, both the evidence derived from over-all patterns as well as particular highlights indicate that she aspired

towards independence and dignity. Like the working man, she found that wages and hours were the essential ingredients of this independence.

On the other hand, we mustn't overlook the fact that there was a feminine side to the working girl that the reformers either ignored or denounced as frivolous. At the other extreme, modern-day strategists who care to see her only as a member of a uniform working class may want to erase her femininity in order to portray her merely as a vehicle of the class struggle. This no more portrays her full human complexity than does the model of the reformers. Her self-definition and concerns as a woman were not relinquished because she was self-supporting. The evidence shows, however, that these concerns did not preclude the development of class consciousness.

We have undertaken this study in the hopes of making some contribution to the method and attitude that should accompany future studies into the history of women workers. We do not wish to join the company of the blasé and urbane who delight in mocking the anxieties of the past. Nor are we interested in seeing the compulsions of an earlier age of investigators replaced by the compulsions of our own age—dictated by the capacity of the computer to generate useless generalizations from minutely compiled data. Too many of the new social historians are using big computers to ask small questions. The old reform model at least had the virtue of addressing itself to some socially relevant problems. What we do wish to demonstrate is that the errors of the reform model were rooted in class prejudice and served ruling class ends. We wished to demonstrate, further, that the class struggle was not a male preserve.

A number of areas of potentially fruitful investigation suggest themselves. First, having established that they both existed, what was the degree of feminine consciousness and that of class consciousness and how were they related? What was the effect of such factors as the degree of intermingling of the sexes, and the classification of occupation on the interaction of class and feminine consciousness? What were the mainsprings of feminist (as opposed to feminine) consciousness in the productive and social process? How have they changed over time as women's occupations become more and more distinct from those of male workers?

Finally—the most obvious question arising from this paper—what explains the relative incapacity of women workers to

generate a sustained leadership that could have enabled them to utilize and penetrate the mainstream of radical and social movements of the time? This question can no longer be answered simply by reference to the working woman's feminine passivity and helplessness.

Future students, of course, will uncover many more questions; we can only hope to promote a healthy cynicism for the data and assumptions of the reform body of literature and a little overdue respect for the capacities of the working women of days gone by.

Footnotes

1. *Canadian Courier*, March 15, 1913.
2. *Toronto Star*, June 1, 1912.
3. *Ibid.*, pp. 1 & 13.
4. *Toronto Star*, June 4, 1912.
5. *Toronto Star*, June 6, 1912.
6. *Ibid.*, June 22, 1912, p. 16.
7. *Ibid.*, June 15, 1912, p. 10.
8. *Canadian Courier*, May-August, 1912.
9. *Toronto Star*, June 21, 1912.
10. *Ibid.*, June 28, 1912, p. 9.
11. *Ibid.*, July 3, 1912.
12. Official papers of the National Council of Women, vol. 105, meeting of May 19, 1898.
13. "Draft report of sub-committee on length of working hours for women and children," box 100, NCW official papers.
14. Letter from Mrs. Cummings to "Dear Madam," Jan. 25, 1913, box 68, "Restless 1913," NCW official papers.
15. *Labour Gazette*, June, 1913, p. 1377. Cf. also vol. 106, file "1907," NCW official papers.
16. *The Lance*, Dec. 28, 1912, p. 4.
17. *Toronto Star*, May 1, 1912, p. 16.
18. *Ibid.*, March 28, 1913, p. 8.
19. Evangelical and Social Service Annual Report, vol. 6, p. 32.
20. First Annual Report of Women's Christian Association, 1874, Toronto, Ontario, in YWCA papers, pp. 5-6.
21. *Toronto Star*, Oct. 7, 1913, p. 10.
22. YWCA Minutes, 1911-1918, May 13, 1913, p. 105. In YWCA papers.
23. *Travellers' Aid 1913-1916*, Nov. 13, 19 ?, in YWCA papers.
24. Earl of Dufferin, "Original Definitions," written for his sister-in-law's album, 1876.
25. *Weekly Sun*, report from a bystander, Dec. 16, 1903.
26. Charlotte Jarvis, "The Work Girl's Rest," in *Leaves from Rosedale*, Toronto: William Briggs, 1905.

27. *The Lance*, Sept. 16, 1911, p. 3. Also TDLC minutes, June 20, 1902, p. 118.
28. *Industrial Banner*, August 29, 1913.
29. National Council of Women Minutes, vol. 4, p. 233.
30. Bureau of Labour Report, 1910, p. 152, in Ontario Sessional Papers, 1911.
31. Harold A. Logan, *History of Trade Union Organization in Canada*, p. 189.
32. *Industrial Banner*, Jan. 31, 1913, p. 2.
33. *Globe*, Jan. 15, 1904, p. 10.
34. *The Toiler*, May 16, 1902, p. 3.
35. *Ibid.*, April 18, 1902, p. 4 and May 23, 1902.
36. *Ibid.*, Dec. 4, 1903, p. 4.
37. *Ibid.*, April 15, 1904, p. 2.
38. *Ibid.*, July 1, 1904, p. 2.
39. *The Tribune*, Sept. 30, 1905, p. 4.
40. *The Tribune*, Dec. 1905 and Feb. 1906.
41. *The Lance*, Dec. 17, 1910, p. 4.
42. *Ibid.*, Oct. 23, 1909 and Nov. 27, 1910.
43. *Ibid.*, May 17, 1913.
44. *Ibid.*, July 19, 1913.
45. Report of Factory Inspectors in Ontario Sessional Papers, 1905, vol. 37, p. 21.
46. *Ibid.*
47. Morgan, *Men and Women of the Time*, thirteenth edition revised by G. Washington Moon, London and New York: G. Rutledge and Sons, 1891.
48. *Toronto Star*, June 11, 1904.
49. Twenty-first Annual Report of Inspector of Factories, in Ontario Sessional Papers 1908, vol. 40, p. 58.
50. Report of Female Inspector of Factories, Ontario Sessional Papers 1901, vol. 33, p. 48.
51. *Ibid.*, 1902, vol. 34, p. 14.
52. *Ibid.*, 1903, vol. 35.
53. *Ibid.*, 1911, vol. 43, p. 19.

54. *Ibid.*, 1906, vol. 38, p. 46.
55. *Ibid.*, 1899, vol. 31.
56. *Canadian Courier*, July 5, 1913.
57. *Toronto Star*, March 22, 1910, p. 10.
58. *Ibid.*, March 23, 1904.
59. *Ibid.*, March 17, 1904.
60. *The Lance*, Dec. 1913.
61. *Cotton's Weekly*, March 15, 1914, p. 3.
62. National Council of Women Minutes, vol. 17, Jan. 1907-April 1908, pp. 55-65.
63. Proceedings of the National Council of Women, 1894, pp. 160-3.
64. *Canadian Courier*, "Future of the Houseworker," May 23, 1914, p. 7.
65. Letter from E. Cummings to "Dear Madam," March 1, 1904, "1904 folder," NCW box 106.
66. NCW Minutes, box 57, 1903, "notes in connection with minutes."
67. *Evening Star*, June 21, 1898.
68. *Canadian Courier*, Dec. 21, 1912, p. 13.
69. *Canadian Courier*, April 5, 1913, p. 23.
70. *Ibid.*, "Why of the Help Problem," Jan. 18, 1913, p. 16.
71. *Acta Victoriana*, Dec. 1908.
72. Ella Sykes, *Home Help in Canada*, p. 299.
73. *Toronto Star*, July 3, 1912.
74. *Telegram*, April 15, 1896, p. 3.
75. *Toronto Star*, May 16, 1914, p. 10.
76. Muriel Folinsbee, "The Georgina House," in the *Home Journal*, Jan. 1910, p. 7.
77. Flora Macdonald Dennison, "The Open Road," in the *Toronto World*, April 16, 1911, p. 2.
78. *Toronto Star*, Dec. 4, 1911, p. 9.
79. Eighteenth Annual Report of the YWCA, Toronto.
80. YWCA Minutes 1897-1904, p. 217.
81. *Ibid.*, Dec. 2, 1897.
82. *Ibid.*, Sept. 1, 1898-Oct. 6, 1898.

83. *Toronto Star*, May 26, 1910.
84. *Ibid.*
85. *Industrial Banner*, May 1910, p. 985.
86. YWCA Boarding House Minute Book, Nov. 6, 1885 to Jan. 4, 1892, p. 143, inserted clippings.
87. *Globe*, June 26, 1896, p. 7.
88. *Toronto Star*, July 7, 1910, p. 2.
89. School of Social Work Papers, University of Toronto, box 2.
90. Twenty-second Annual Report of the East End Day Nursery for the year 1914.
91. East End Day Nursery Minute Book, Nov. 21, 1902.
92. Toronto East End Day Nursery and Settlement Report.
93. *Saturday Night*, Nov. 10, 1900, p. 2.
94. *Toronto Star*, August 16, 1908.
95. *Tribune*, Nov. 18, 1905, p. 1.
96. *Toronto World*, "Under the Pines," Oct. 6, 1910.
97. *Ibid.*, March 29, 1910.
98. Toronto and District Labour Council Minutes, 1908-1911, pp. 290-1.
99. *Toronto Star*, Jan. 12, 1911.
100. *Industrial Banner*, July 1911, p. 4.
101. TDLC Minutes, August 18, 1910.
102. *Toronto Star*, Oct. 26, 1910, p. 10.
103. Public School Board Minutes, May 30, 1910, p. 110, and 1912, p. 143.
104. *Toronto World*, "Under the Pines," Jan. 29, 1911.
105. TDLC Minutes, Feb. 2, 1911.
106. *Daily Mail & Empire*, May 27, 1899.
107. Ontario Bureau of Labour Reports, in Ontario Sessional Papers, 1902.
108. *Labour Gazette*, May 1902, p. 647.
109. *Toronto Star*, May 3, 1900.
110. *Labour Gazette*, August 1902, p. 109.
111. *Globe*, July 22, 1902, p. 12.
112. *Toronto Star*, Sept. 20, 1902, p. 2.
113. *Daily Mail & Empire*, Sept. 2, 1902, p. 10.

114. TDLC Minutes, Aug. 4, 1902.
115. *Ibid.*, Sept. 11, 1902.
116. *Ibid.*, Sept. 25, 1902.
117. *Toronto Star*, August 16, 1902, p. 18.
118. *Ibid.*, August 7, 1902, p. 2.
119. Eighteenth Report of the Bureau of Labour for 1907, Ont. Sessional Papers 1908, p. 243.
120. *Toronto Star*, August 14-15, 1907.
121. *Ibid.*, August 17, 1907, p. 1.
122. *Labour Gazette*, April 1910, p. 1107.
123. *Ibid.*, p. 1185.
124. *The Lance*, April 16, 1910, p. 2.
125. TDLC Minutes, June 16, 1910.
126. *Toronto Star*, May 6, 1910, p. 2.
127. *Toronto World*, "Under the Pines," June 19, 1910.
128. *Ibid.*, June 26, 1910.
129. *Ibid.*, August 7, 1910.
130. *Industrial Banner*, Nov. 15, 1912, p. 1.
131. *Ibid.*, Nov. 22, 1912, p. 1.
132. *Toronto Star*, August 20, 1913, p. 4.
133. Letter from E.M.C. Geraghty, Bell Assistant Librarian, to Wayne Roberts, July 20, 1973.
134. Herbert Bruce, *Varied Operations: An Autobiography*, Toronto: Longmans, Green, 1958, chapter one.
135. Letter from Geraghty to W. Roberts, 1973.
136. *Globe*, Nov. 13, 1896, p. 10; *Daily Mail & Empire*, Dec. 10, 1896, p. 5; TDLC Minutes, Dec. 10, 1896.
137. *Daily Mail & Empire*, August 24, 1905.
138. *Labour Gazette*, March 1907, p. 987.
139. *Montreal Star*, Feb. 6, 1907.
140. *Toronto Star*, Jan. 30, 1907.
141. Report of the Royal Commission on a Dispute respecting terms of Employment between Bell Telephone Co. of Canada Ltd. and Operators at Toronto, Ontario. All material between pp. 10-61.

142. Evidence presented to the Royal Commission.
143. *Globe* editorial, May 7, 1896.
144. *Daily Mail & Empire*, April 29, 1904, p. 6.
145. *Toronto Star*, Jan. 31, 1896, p. 1.
146. *Ibid.*, Jan. 30, 1896.
147. *Ibid.*, Feb. 2, 1896.
148. *Ibid.*, Jan. 30, p. 1.
149. *Ibid.*, Feb. 16, 1907.
150. *Ibid.*, Sept. 12, 1907, p. 12.
151. *Ibid.*, p. 1.
152. *Labour Gazette*, October 1907, p. 397-9.
153. *Ibid.*, p. 402.
154. *Ibid.*, p. 403-4.
155. *Ibid.*, p. 405.
156. *Canadian Magazine*, Oct. 1907, p. 556.
157. *Toronto Star*, Oct. 2, 1909, p. 21.
158. *The Lance*, July 22, 1911, p. 1.
159. *Ibid.*, May 3, 1912.
160. *Toronto Star*, May 17, 1913, p. 1; *Labour Gazette*, July 1913, pp. 39-40.
161. *Labour Gazette*, July 1913, pp. 39-40.

Women during the Great War

World War I did not drastically change the role of Canadian women in the work force. The increased number of working women was merely an acceleration of a trend that began at the turn of the century and was to continue throughout the twentieth century. This steady increase was due to several factors. The gradual development of a market economy in which production increasingly took place outside the home meant that the family's productive role diminished, and that consequently the labour of single daughters was not as necessary within the home. It also meant that the daughters' outside income became essential to purchase those products which had previously been made domestically. The general population shift from rural to industrial centres, and the massive influx of impoverished immigrants encouraged the development of labour-intensive industry, which in turn created new markets for female labour. These markets developed in the manufacturing industries, such as the garment trade, which replaced the home handicrafts, and in the new white-collar clerical and sales positions.

World War I did not mark a significant departure from this slow rise in female employment, but it did produce a temporary influx into the work force, changes in occupations, and some changed attitudes. Their influx into the work force was less than in World War II because the Canadian economy was not mobilized

This paper includes research material from several women: Patricia Alexander, Patricia Deline, Gail Dzis, Dianne Martin, Vicki Trerise, Toby Vigod, Bonnie Ward.

for the war effort until fairly late in World War I, and conscription did not begin until the year before the war ended. The labour shortage was consequently much less serious and of shorter duration than during World War II. For these reasons and because mostly single women joined the labour force at this time, there were no government nurseries established during World War I as there were during World War II.

The ideological changes regarding employment of women reflected economic reality. It became acceptable, and indeed desirable, for single women to seek employment as work in the home diminished and the labour market expanded, but the patriotic fervour of World War I facilitated such changes in attitude that otherwise would have taken place more slowly.* The war provided an occasion for a number of beliefs about women to be questioned. Pre-war prejudices held that women were totally unfit for some jobs. During the war, women were admitted to almost every trade and performed successfully in spite of shortened training periods. Women used their war-time achievements and contributions to demand the vote and thus gain some political power. In the reconversion period following the war, many of the economic gains made by women in male-dominated areas of the labour force were wiped out, but the changes in attitudes towards single women working remained. Although mostly single women

*Ideology is the set of ideas presented by a ruling class, or dominant group, about the nature of reality in their social system. They are the dominant ideas, presented and accepted by the majority of people, as eternal truths. Honour, loyalty, christianity, free enterprise, slavery, male superiority—all are concepts presented by different dominant groups as God-given, and inherently good. Eternal truths are often nothing more than elaborate rationalizations for the status quo. In order to understand them in a historical context, one must analyze how the ideas serve the interests of the ruling class of the day.

In the case of women, the attitude to women's work has changed depending upon the economic and social conditions. The following model is useful: a) the ruling class is represented by the government, b) ideas are created by people of the ruling class from the context of their economic and social relationships, c) the government and the ruling class have the means at their disposal to popularize these ideas, d) the ideas generated by the ruling class are accepted by the majority of people of their time as truth, e) these ideas change as economic conditions change. (This model is developed in an unpublished paper by Patricia Deline.)

worked, there was a hard core of destitute women, frequently with dependent children, who worked throughout the period before World War II, at which point large numbers of married women joined the labour force. These destitute women were always referred to in the publications of the day as "unfortunates".

Legislation of working conditions had been demanded by working women for a long time, but the ideology that categorized the home as women's true place made it difficult for middle-class women to sympathize with the plight of their working sisters. The employment of women during the war made many people more sensitive to the problems of women in industry. This increased sensitivity, combined with the demands made by organized labour, and the changing labour needs of a quickly developing economy, led to the enactment of protective legislation.

The first section of this paper sketches the background of the war years including those aspects of Canadian economic development which affected women's productive role, the division of labour along sexual lines, and the wage differentials between men and women. The next section deals with the labour shortage during the war years, the recruitment of women to solve the problem and the types of work they performed. The last section will examine post-war attitudes towards working women and protective legislation.

I. Women's Entrance into the Labour Force

The last decade of the nineteenth century in Canada had seen recurring cycles of prosperity followed by depression and severe unemployment as industrial activity increased. By the first decade of the twentieth century the economy was undergoing rapid changes. The primary sector was still dominant but manufacturing and trade were rising in importance.[1] Between 1901 and 1911 there was a sudden increase in the proportion of women entering the work force, which can be partly accounted for by two factors: first, the 52.8 percent jump in the labour force due to a huge wave of immigration, and secondly, the development of new jobs.[2] The huge surplus of cheap labour from both immigration and the migration from rural to urban centres halted the industrial trend towards capital intensity. For this reason, as skilled craft production was being eliminated, it was substituted by large-scale exploitation of menial labour rather than by large-scale mechanization.[3] Women (particularly single girls and deserted wives), children and immi-

grants were exploited as sources of cheap labour in the burgeoning factories.

The shift from craft to industrial production meant that many of the items made by women in the home were now made in factories, and in many cases women continued their familiar household production outside the home. The garment and textile industries, for example, were largely maintained by female labour. The economy's expansion necessitated the development of service industries; by 1900 the banks and the large Eastern chain stores were established, and British money was used to develop transportation, public utilities, and the financing sector.[4] Thus opportunities were opened up to women during this period not only in manufacturing, but also as white-collar, clerical and sales workers, in banks, railways, public utilities, and the growing retail sector.*

The 1916 Report of the Ontario Commission on Unemployment notes society's lack of comprehension of the work done by women. "The fact that we have this number of women workers has not been realized, and the meaning of this fact...has been imperfectly appreciated."[5] The Commission found that in Ontario there were 175,000 women engaged in paid work, with an estimated 8,000 to 10,000 officially unemployed women between 1914 and 1915.

The refusal to recognize the existence of women in the paid work force mainly stemmed from the ideology that women's place was in the home. However, it should be noted that it was not until the first decade in Canada that there were significant numbers of women workers in the paid work force. Before this time almost all the paid work of women was in areas closely associated with household tasks, which were not considered productive labour. The 1891 census lists the ten leading occupations of women as being the following: servants, dressmakers, teachers, seamstresses, tailoresses, housekeepers, launderesses, milliners, and saleswomen.[6]

Even the figures showing the number of women in paid work fail to take into account the actual role of female labour in the economy. The 1911 census showed that Canada was still largely a

*White collar occupations include all categories of work in clerical, commercial and financial, professional, proprietary and managerial positions.

Table A

Growth of urban population in Canada (excluding Newfoundland), 1851-1961, expressed as percentages of total population.

This figure is taken from J. Wolforth and R. Leigh, *Urban Prospects,* McClelland and Stewart, Toronto: 1971. The information in the graph is based on Leroy O. Stone, *Urban Development in Canada* (Queen's Printer, Ottawa: 1968).

From 1851 to 1911 the urban population figures refer to incorporated cities, towns and villages of 1,000 and over only; from 1921 the percentages are estimates of the percentages which would have been reported in the respective censuses had the 1961 Census definition and procedures been used; for 1961 the figures are those published according to the 1961 Census definition of "urban."

rural nation at the outbreak of the First World War, with just over half that population living in rural areas. Most of the necessary work in 1911 was agricultural, and the census lists 16,000 female agricultural workers. The same census lists 917,848 males in the same occupation, and of that number 152,000 are reported to be paid workers. Therefore we can assume that the remaining 750,000 male workers were heads of family farms or male members of farm families. If we assume that these men carried out their business in partnership with their wives, in practice if not in theory, and that the number of daughters was roughly equal to the number of sons that they had, it is probable that 750,000 unpaid women workers who were engaged in agricultural production have been left out of the labour force statistics. If these women had been included in the calculation of the statistics, they would have been recognized as forming at least one-third of the labour force. According to government statisticians, the percentage of women in the paid work force did not reach this level until the 1970s.[7]

Of course, this whole question of unrecognized workers does not even touch upon the *unpaid* urban homemaker, cook, childcare worker, nurse, seamstress, charwoman, etc., who is classified as housewife and seen to be outside the labour force.

The Sexual Division of Labour and Wages

By the outbreak of the war, women were still largely employed in areas clearly delineated as "female", although new categories had appeared. Employment for women as domestics, waitresses, practical nurses, cooks, teachers, nurses, secretaries and within the garment and textile industries accounted for over 85 percent of female jobs.

The 12.5 percent of the female work force engaged in professional work appears high, particularly when compared to the percentage of the male work force (13.5 percent) engaged in the same. However, the male professions (medicine, law, etc.) are high-paying independent status positions, while female "professions" provide women with low pay and uncertain status.

Comparison of wages for men and women in similar types of work are difficult to find before 1931, not only because of the lack of information, but also because men and women did dissimilar kinds of work. The annual *Wages and Hours of Labour*, a report from the Federal Department of Labour, seldom distinguishes the sex of employees receiving reported wages. However, this publi-

Table B

Leading Occupations of Paid Women Workers

	1891	1901	1911	1921	1961
Farmers	11,638	8,421	15,094	16,315	66,081
Servants	79,473	81,493	98,128	78,118	—
Housekeepers	4,035	7,572	6,762	23,167	—
Other domestic service (Maids and other related service workers)	1,609	8,844	19,170	—	120,161
Charworkers and cleaners	—	—	—	6,251	—
Hotel and restaurant and boarding house keepers	2,344	594	4,311	6,028	—
Waitresses	—	—	—	6,372	61,081
Boot and Shoe makers	—	—	—	3,276	—
Dressmakers and Seamstresses	32,975	22,063	20,357	16,612	—
Milliners	3,777	—	—	3,029	—
Clothing Factories	1,740	1,017	5,269	14,470	50,592
Textile factory operatives	—	—	—	15,193	—
Municipal Public administration, officials and clerks	767	892	—	12,000	—
Clerical operations	—	—	—	78,342	165,613
Stenos and typists	—	—	—	—	209,410
Book-keepers and cashiers	—	—	—	—	98,663
Telephone operators	—	—	—	12,827	—
Saleswomen in stores	—	—	—	35,474	133,234
Teachers	—	—	—	49,795	118,594
Nurses	—	—	—	21,162	81,868

1891, 1901 and 1911, 1921 are from *Census of Canada, 1921.* Tables 1, 2, XXVIII.
1961 From *Women at Work in Canada,* Department of Labour. Table II.

cation does give some idea of the usual rates of pay in factories and for manual work. In Toronto in 1914, a building labourer working a 44-hour week could earn $13.20 per week. An electrical worker made $17.60 per week and a bricklayer as much as $24.20 per week. These relatively high paying construction trades were for the most part closed to women, as they are today.

Table C

The Canadian Population and Labour Force

	1881	1891	1901	1911	1921
Total Population	4,306,118	4,801,071	5,318,606	7,179,650	8,775,853
Labour Force	1,377,585	1,606,369	1,782,832	2,723,634	3,164,348
Female Labour Force		195,990	237,949	364,821	489,058
Women as Percentage of Labour Force		11.07	13.3	13.4	15.5

	1931	1941	1951	1961	1971
Total Population	10,363,240	11,489,713	13,984,329	18,200,621	21,568,310
Labour Force	3,917,612	4,195,591	5,214,913	6,342,289	8,631,000
Female Labour Force	665,302	832,840	1,163,893	1,760,450	2,831,000
Women as Percentage of Labour Force	17.0	18.5	22.0	27.3	33.3

Sources: Census of Canada, 1921.
Census of Canada, 1961.
Women at Work in Canada. Department of Labour, 1964.
Women in the Labour Force 1971: Facts and Figures. Women's Bureau, Labour Canada.

Wages in the factory were lower, and this is where many women worked. If we look at cotton textile plants as a typical example of factory wages at the time, a man could earn as little as $11.80 per week as a mule spinner in New Brunswick, or he could earn as much as $15.00 as a loom fixer in Ontario. Women in the same plants, on the other hand, earned only $6.90 per week as ringspinners and warpers in New Brunswick. The princely sum of $9.95 per week as a warper in Quebec, was about the maximum possible wage for a female textile worker.[8]

The Bell Telephone Company in Toronto paid operators from $6.60 to a maximum of $9.00 for six days work. In laundries the average wage was $9.00 per week. The wages of female store clerks varied greatly from $4.00 to two or three times that amount, and a senior buyer could earn even more.[9] Senior retail employees, along with stenographers, could earn as much as $14.50 per week. They seem to have made up the labour aristocracy of working women; even teachers and nurses were not better paid.

And what of the lower class of women, the domestic servants who comprised 40 percent of the female work force? The Woman Correspondent to the *Labour Gazette* from Vancouver in June 1915 (during a period of unemployment) reported that the average wages for domestics were $12.00 per month, plus room and board. While in Calgary during 1913, domestics had earned as much as $25 to $30 per month. Domestics' wages varied greatly according to the supply and demand for their labour. Their harsh working conditions, complete lack of privacy and set hours made domestic service an occupation that was avoided whenever possible by women who needed to work.[10]

Generally, women in the paid work force were unsupported. The majority were single girls who were working before marriage and whose wages were such that they had to live at home or take part-time jobs as domestics (or prostitutes). The remaining working women were "unfortunates"—widows, divorcées, deserted, separated women or wives of unemployed men. The Ontario Commission on Unemployment of 1916 seemed surprised to find that "generally speaking women wage earners are not convinced that the principle of higher pay to men as bread-winners works out justly."

(Women in the Production of Munitions in Canada, *Imperial Munitions Board*)

II. The War Period
Effects of the War on Women's Employment

The First World War did not require a major recruitment of new sources of labour until 1916, partially because conscription did not begin until June 1917. In fact, at the beginning of the war, there was much unemployment due to an economic recession from 1914 through the winter of 1915. Thomas White, who was the Federal Minister of Finance in 1914, commented that the first effects of the war were the disruption of business and employment, and industrial slackness.[11] This situation had a serious effect on women's employment that continued through most of 1916. The Labour Gazette Woman Correspondents in Toronto, Montreal, Winnipeg and Vancouver reported female employment as being very low. They particularly emphasized the surplus of domestic help. In Vancouver it was reported that the demand for female help had fallen 50 percent in the three years prior to 1915, and that 30 percent of the city's domestic workers had been employed formerly in other fields.[12]

In an attempt to cope with the surplus of domestic help the Protestant Directorate of Female Immigration in Montreal set up a training school, a free placement service, and a social centre for women who had come to Canada, mostly from Britain, to take up domestic employment. Thousands of these women had been employed as mill or factory workers in Britain and knew little about the conditions of domestic service; consequently, many were dismissed from their jobs within a short period. The Directorate was also engaged in placing war widows on farms in the Prairies as domestic servants; many of the families would accept widows with one or two children.[13]

As the recession continued, the marginal groups began to feel the pinch of their exploitation as a cheap reserve labour pool. In the fall of 1915, the Social Service Council of Vancouver protested the employment of "orientals" in hotels as domestics while "white" men and women were unemployed. They "urged employers to think first of the many white men and women seeking employment without which they were dependent on relief."[14] In effect women were also marginal labour as well. In Toronto, garment shops had received no war orders since the spring, and many employees, mostly women were laid off. One correspondent wrote, "One large firm has dismissed a number of tailoresses and

taken on in their stead men, who will now work for the same wage as women and are said to be better workers."[15] This is a typical example of women being laid off and men being hired in times of high unemployment. When there is extreme competition for jobs, the more skilled and highly paid workers will lower the price of their labour in order to be given preferential consideration.

The increase in industrial activity due to war-time demands and the recruitment of the armed forces did not have an effect on the labour surplus until March 1915. At that time, an increase in Government monies spent on public works projects such as railway, canal and other construction reduced the unemployment. As the war progressed the need for business to sustain production in the face of war-time obstacles, and especially to maintain a supply of labour became serious.

Industry's Ideological Campaign

The *Financial Post*, which acted as a mentor and a guide to the business community, was a good indicator of business attitudes towards the working class and the employment of women.[16] Throughout the war, the Post was preoccupied by the shortage of labour and its implications for business. Editorials in the paper questioned the extent to which financial institutions should be required to supply recruits for active service. The implications of their editorials were obvious, that money-making was more important, and that only useless bums should be made to go into active service. This position was not always defensible. In August 1915, when banks were discouraging tellers from volunteering for the army, the Post covered for the banks by carrying a front page story denying that banks were discouraging tellers, and saying that 15 percent of bank staffs had enlisted.

Because of the short supply of labour, wages were increasing, much to the dismay of the Post. In a column entitled "*Business Outlook*: Wages Higher—Greatest Difficulty Facing Business," it was noted that "high wages was (sic) becoming very embarrassing to the larger concerns, especially railways."[17]

During 1916, war production began to increase. The Labour Gazette's correspondents reported an increase in the employment of women in many cities as many women began to replace the men who had joined the armed forces or who had gone into war industries. During May 1916, discussion appeared in the *Financial Post* about moving industries to sources of labour. The Post begrudg-

Close View of the Two First Operations of Stamping Cartridge Cases for 18 Pounders

In the upper picture the third woman has just delivered the truck of blanks; after passing through the press the work is delivered at the back of the machine, collected on a truck and conveyed to the next machine for the next operator; trucking all done by women.

(Women in the Production of Munitions in Canada, *Imperial Munitions Board*)

ingly began to approve of the use of female labour, even though the employment of women was already a significant trend. However, they remained skeptical of the value of employing women and continually discussed its disadvantages. In June 1916, reporters for the Post lamented that female labour would not relocate for the

273

sake of employment and also that ladies did not want overtime because they had the men's cheques from the front.[18]

The necessity of mobilizing large numbers of women to work in munitions plants prompted the Imperial Munitions Board to respond to the skepticism of employers. A photographic report entitled *Women in the Production of Munitions in Canada* was issued "with a view to emphasizing the practicability of woman labour in the production of munitions of war in this country."[19] The *Financial Post's* prejudice against female labour is clear in the following commentary on the Munitions Board booklet:

> Much has been heard of the remarkable results achieved by women workers...on the other hand close investigation reveals that these accounts are frequently highly coloured for patriotic or some other special purpose, and large employers are not backward in deploring the lack of concentration evinced by female workers.[20]

Photographs taken in numerous pioneering plants showed smiling women in long dresses engaged in the production of shell fuses, shrapnel shells, cartridge cases and primers. Men in suits stood about observing the operation of drills, lathes, heavy power presses and tool grinders. The captions emphasize the competence and spirit of the employees. Beneath the picture of a woman standing at a press, one such caption noted, "The independence of this woman is strikingly illustrated by the contempt she has for the stool." It is also strikingly illustrated that the stool is clearly much too high to be used without producing severe back strain in the operator!

The Imperial Munitions Board Report explored the possibility of introducing women into production at all levels. Although it termed the entrance of women into the labour force the "dilution" of labour, it emphasized that women did not weaken the labour force.

> When the Dilution of Labour became imperative, the manufacturer naturally thought that the heavier the shell the less adapted they were to female labour. The direct opposite has proved the case. The repetition in handling the smaller shell produced a physical strain that was not present in the slower and more deliberate moving about of the big projectile. In the smaller shell men can conveniently, without mechanical assistance, handle them, whereas in the larger shell, men were obliged to use assistance of machinery, and consequently men and women here became equal.[21]

The report goes on to say the following:

> There are many operations in the Machine Shop which can safely be assigned to women... The tool room represents every advantage for female labour, in spite of the fact that engineering history tells us that it is the department for highly trained mechanics, but it has been clearly demonstrated that women under the guidance of trained toolmakers, are efficient and useful. The grinding of milling caps, cutters, general cutting tools and other repetition work is particularly suited for them. The making of jigs and dies is, and probably always will be, a highly skilled mechanic's task, but we look forward to the time when many more women will be admitted to this branch of engineering work. Especially have the women astonished engineers in their aptitude for the handling of milling machines.[22]

The presence of women in heavy industry appears in some cases to have been the cause of some improvements in working conditions. A section of the report talked about services provided by plants for the comfort of female employees, such as lunch rooms and medical emergency areas, and it extolled the virtues of these extras.

> We cannot too highly recommend the welfare feature of woman labour on the side of pure commercialism. It produces greater efficiency, greater output, and greater contentment where it is present than where it has not been introduced... Matrons, where the number exceeds 100 are almost indispensable as a means of adjusting the many small irritations that are magnified in a woman's mind by neglect or inability to make them known to one of her own sex.[23]

Industrial Occupations for Women—World War I

One of the few comprehensive studies on the changes in the industrial occupations of women during the war (1914-1918) was done by Enid Price in Montreal.[24] She surveyed munitions plants, railway shops, wholesale houses, department stores, civil and municipal services, office buildings, banks and various factories. Price found that within industry women generally moved from light industrial work into a wide range of heavier work. For example, before the war, in the railway and machine shops, only men were employed to do the heavy manual work of constructing and repairing locomotives, machinery and cars.[25] Later on, women were employed by the railways, but primarily as clerical workers. By 1918, in Montreal there were 2,315 women employed by railway, steel and cement companies in jobs that formerly had been done by men only.[26] This was an especially marked trend in the transportation sector, where firemen, freight handlers and trackmen were particularly scarce.

The munitions industry employed great numbers of women during the war. The United States' and Canada's late entrance into the war in March 1917 had the effect of stimulating war production. At the height of munitions production in 1917, which was also the year of conscription, there were at least 35,000 women employed in munitions plants located in Ontario and Montreal.[27] In the eight munitions plants surveyed by Price in Montreal in 1917, when all the plants were in full operation, a total of 9,931 men and 5,460 women were employed.

The following chart gives some data on the women who worked in munitions:

Table D

Women Manual Workers in Munitions Plants[28]

Plant No.	Total No. of Women Employed	% Married	% from Domestic Service	% employed for the first time
1	300	5	—	—
2	4,464	26.5	10	25.5
3	0	—	—	—
4	85	44.1	21.1	21.1
5	100	23	18	22
6	2,500	15	—	—
7	2	0	—	—
8	75	40	25	0
All Plants	7,526	22%	6.2%	15%

Although the percentage of women from domestic work was high in some plants, it never exceeded 25 percent, which was considerably less than Price expected.[29] It is reasonable to assume that most domestics, if given the chance, would switch to a factory job, where they would at least have set hours and some time to call their own.[30]

To inspect the work of about 8,000 workers, approximately 650 government inspectors were placed in the munitions factories.[31] At first all the inspectors were male, but later on female inspectors comprised 33 percent and then 83 percent of the total. This increase occurred because female labour was cheaper and because the men were needed elsewhere, usually for military service.

Table E

By the end of the war, women had replaced men in several areas of work.

Workplace	Number of Women (Men)		Average Range of Wages for Women	Percentage of Male Wages
Munitions—8 plants				
Manual workers	1917:	5,460 (9,746)	$.20 to $.35/hr.	50 to 83%
	1918:	2,715 (10,050)	$.25 to $.45/hr.	60.8 to 81.8%
Clerical Workers	1918:	193 (527)	$12 to $20.50/wk.	46 to 93%
Government Inspectors of Munitions plants —6 plants	1918:	333 (901)	$1.89 to $2.75/day	25 to 70%
Railway Shops—2 plants				
Manual Workers	1914:	5 (7,428)	$.16 to $.17/hr.	61 to 68%
	1918:	280 (7,677)	$.34 to $.45/hr.	59 to 83%
Clerical Workers	1914:	2 (78)	$12.50/week	104%
	1918:	26 (59)	$20.26 to $20.50/week	77 to 93%
Clerical Staff one large office building	1914:	300 (1,420)	$42.50/mth.	60.7%
	1918:	457 (960)	$89.50/mth.	86%
Banks—19 branches Clerks	1914:	195 (1,344)	$400 to $900/year	41 to 128%
	1918:	913 (1,281)	$408 to $802/year	41.8 to 82.3%

Source: Enid M. Price, *Changes in the Industrial Occupations of Women in the Environment of Montreal during the Period of the War, 1914-1918*. This chart is based on figures presented in the book.

Within the factories that were not involved in war production there seemed to be little change in the composition of the work force.[32] In textile, clothing, leather, rubber, electrical appliances, confectionary and tobacco factories, one-half or more of the employees were women. No women were employed in flour mills, cement plants, iron and steel works, machinery, tool and carriage shops, except in those plants involved in war production.

Price also found that at least one-half of the industries that she investigated had been employing women to a greater or lesser degree for years, and that employers used women in every capacity that was suitable to their skill and physique. Moreover, employers were of the opinion that in the tasks that women were able to do, they performed more satisfactorily than men; they also noted that women's labour was cheaper.[33]

Non-Industrial Occupations for Women

Despite the wartime flow of women from domestic service into preferred industrial opportunities, and the consequent shortage of domestic help experienced at the peak of war production in 1917, domestic service employed the largest number of women. Composing at least one third of the paid female force in 1916 in Ontario, the 54,000 domestic workers received an average wage of $18 to $20 per month, including room and board; however, they were subject to large market fluctuations and periodic unemployment.[34] There is little data on marital status, and the Ontario Commission on Unemployment assumes that "except for the unfortunates they were unmarried."

New employment opportunities for women had developed before the war in response to the changing economic structure. In 1916, the Ontario Commission on Unemployment found that there were about twelve thousand saleswomen in Canada, about five to six thousand of whom were located in Toronto. Many of these women had come from the United Kingdom. Women who were employed as sales help found that they were employed on a temporary basis. At one firm 70 percent of the women were employed for less than a year. The hours of work ranged from 8:00 a.m. to 8:30 p.m. or from 5 a.m. to 5:30 p.m. Most of these women were between the ages of eighteen and twenty-two and had perhaps one year of high school and some haphazard training.[35] This occupation was known as a "young woman's occupation" and the majority of the women in it did leave their jobs to marry.

The availability of clerical and banking jobs was steadily increasing. In Vancouver's local banks, women were consistently used to replace men who had enlisted. The Royal Bank of Canada employed 700 women in their various offices by September 1916, as compared to 250 before the war. Women stenographers were beginning to be in demand. In 1916 there were twenty-eight schools and business colleges that enrolled over 2,000 women per year. However, only 6 percent remained long enough to get a certificate.

Other women's professions that were being developed, besides teaching and nursing, were library work, banking, dental nursing, photography, physiotherapy, etc. At this point women comprised 50 percent of the secondary school teachers and accounted for nearly all the elementary school positions. Women were not barred from civil service, although in practice they were not promoted to higher administrative positions.

Women's Wages

The general pattern during the war years was for women's wages to increase, narrowing but never eliminating the gross inequalities between men's and women's wages. Prior to the war, in shops which later produced munitions, women received 65 percent of the wages paid to men, but by 1918 they received 83 percent. Generally, the wages of women in munitions ranged from 50 percent to 80 percent of the wages paid to men. In other factories, wholesale houses and department stores the wages of female clerical and manual workers increased somewhat. The lowest wages received by women in this sector were paid in wholesale houses where they received 20 percent of men's wages, and the highest wages were paid in clothing factories where women received 60 percent of men's wages. Between 1914 and 1918 the salaries paid to office clerks increased from 10 percent to 60 percent of men's wages.[36] An Order-In-Council passed in 1918 calling for equal pay for women was an unsuccessful effort to stop the exploitation of women's labour. This measure did not survive the war.

During this period the bargaining power of men and women workers generally decreased since employers used the war as an excuse to increase the length of the working day. One munitions plant in Toronto increased the working day from thirteen to fourteen hours. Seven women refused to work the extra hour saying that "they are killing us off as fast as they are killing the men in the trenches."[37] At the Verdun Munitions Board plant, women

Table F

Percentage Distribution of Working Women by Leading Occupational Groups, Canada,[1] 1901-1971.

Occupational Group	1901[4]	1911	1921	1931	1941[5]	1951	1961	1971
	%	%	%	%	%	%	%	%
Clerical	5.3	9.4	18.7	17.7	18.3	27.5	28.6	32.7
Personal Service	42.0	37.1	25.8	33.8	34.2	21.0	22.1	22.3
Professional	14.7	12.7	19.1	17.8	15.7	14.4	15.5	17.5
Commercial and Financial[6]	2.4	6.8	8.5	8.3	8.8	10.5	10.2	8.3
Manufacturing and Mechanical[2]	29.6	26.3	17.8	12.7	15.4	14.6	9.9	11.2
Other[3]	6.0	7.8	10.1	9.6	7.7	11.9	13.6	7.7
Total[3]	100.0	100.1	100.0	99.9	100.1	99.9	99.9	99.7

[1]Includes Newfoundland (1951 on), but not Yukon and Northwest Territories.
[2]Includes stationary enginemen and occupations associated with electric power production.
[3]Includes armed forces.
[4]10 years of age and over in 1901; 15 years of age and over 1911-1971.
[5]Not including active service, 1941.
[6]Includes saleswomen.

Sources: *Census of Canada, 1961.*
Women at Work in Canada. Department of Labour, 1964, Table 12.
Women in the Labour Force 1971: Facts and Figures, Labour Canada—Women's Bureau, Table 14.

Table G

Women as Percentage of All Workers in Major Occupational Groups Canada,[1] 1901-1971.

Occupational Group	1901[2] %	1911 %	1921 %	1931 %	1941[3] %	1951 %	1961 %	1971 %
Personal Service	71.7	66.8	68.7	69.5	72.8	64.1	66.4	60.1
Clerical	22.1	32.6	41.8	45.2	50.1	56.7	61.5	72.1
Professional[5]	42.5	44.6	54.1	49.5	46.1	43.5	43.2	41.1
Commercial and Financial	10.4	19.1	23.0	23.1	29.4	35.2	36.7	38.9
Manufacturing and Mechanical	24.8	25.5	24.0	18.7	19.0	18.7	16.8	23.1
Agricultural	1.2	1.7	1.7	2.1	1.7	3.9	11.7	12.9
Proprietary and Managerial	3.6	4.5	4.3	4.8	7.2	8.9	10.3	13.4
Transportation and Communication	1.4	3.5	8.4	6.5	5.3	8.2	7.9	15.2
All Occupations[4]	13.3	13.2	15.4	17.0	19.9	22.0	27.3	33.3

[1] Includes Newfoundland (1951 on), but not Yukon and Northwest Territories.
[2] 10 years of age and over, 1901; 15 years of age and over, 1911-1971.
[3] Not including active service, 1941. [4] Includes armed forces. [5] Includes teaching and nursing.

Sources: *Census of Canada, 1961.*
Occupation and Industry Trends in Canada—SP8, (1951 census publication)
Women at Work in Canada. Department of Labour, 1964. Table 13.
Women in the Labour Force 1971: Facts and Figures. Labour Canada—Women's Bureau, Table 14.

worked 72 hours per week and upwards. Women and men were similarly exploited in many areas of production during the war, working long hours for poor wages. Many of the gains that had been won by the labour movement were lost, a retrogression that sparked off a number of strikes and demonstrations. The labouring classes recognized that their worsened conditions were more a function of continued profiteering than of patriotic necessity.

Not only were the previous gains of workers eroded, but the Federal Government moved to increase its control over manpower utilization. At the beginning of 1918, when it appeared that the war

"They are killing us off as fast as they are killing the men in the trenches", declared the spokeswoman of a deputation of women munition workers who came into The Star Office yesterday morning. *"We are working six days a week from seven till seven and on Sundays from seven till four, and now they want us to work fourteen hours a day by coming back three nights a week to work two extra hours. We just have half an hour for lunch and half an hour for supper."*

There were seven of them and they had just been dismissed from a munition factory in which they had most of them been working for over a year, because they refused to work on the fourteen-hour shift. Two wore the six months' munition workers' badge, and one wore the munition workers' good service medal as well. Two had husbands at the front and one had lost a brother in the trenches, while three other brothers were on active service.

Skin Off Hands

"Look at our hands" cried one black-eyed maiden, thrusting out hands blackened with oil and machinery and from which the skin had peeled in big patches. They were all saturated with oil, and told of removing oil-soaked garments at night to replace them in the morning because they had no time for laundry work.

might go on much longer than had been expected, an Order-In-Council was issued that required the registration of all women and men. The National Registration Programme was designed to locate "those eligible men who have evaded their responsibility and duty." This was couched in patriotic terms and effectively placed the burden of the war on the backs of the working class. The programme was well supported by many women's organizations, but was actively opposed by the working class.

> "One of the girls was too sick to come with us", they said, "She has been working five nights night work and is just dying on her feet. The oil has got into her system."
>
> "We refused to work the fourteen hours yesterday, and when we went in this morning we were told we could go. We are going to see the Mayor about it."
>
> The deputation then went up to the Mayor's office, but he was not in and they were referred to the Imperial Munitions Board. Sir Joseph Flavelle was in Ottawa, and Mrs. Fenton, Supervisor of Female Labour in munitions factories, was out of town. Mr. Mark Irish, to whom the deputation was then referred, had not time to-day to make public the result of the interview.
>
> ### One Dropped Dead
>
> "There was one of us dropped dead on the street car the other day", said one of the deputation, "Though they put it down to heart trouble. And I know another who was so tired and dizzy that when she was going home from work she fell off the car and died later. And another the same way that walked right in front of a car and was so badly hurt that she is disfigured for life. I tell you we can't stand it."
>
> *Report of an article which appeared in the Toronto Daily Star of July 27th, 1917. Canada.* Debates, *House of Commons. August 2, 1917, p. 4063.*

Drilling and Tapping Wrench Holes in Adaptor 8-inch Shell Work

Operator Feeding 8-Inch Shell Into Milling Machine for Milling Thread in Base. The small jib carries the centering breech of machine, and it is easily replaced after shell is entered.

(Women in the Production of Munitions in Canada, *Imperial Munitions Board*)

National Registration was only one of the many plans suggested by the ruling class to solve the labour shortage problem. Some of the other suggestions included the importation of Chinese

284

"coolies" into Canada, and that conscription of all people of foreign birth, who would be required to work for military pay, which was $1.10 per day at the time.

Women's Organizations and the War Effort

Patriotic women's organizations supported the war effort in whatever way they could. Along with the collection of tons (literally) of linen and socks to be sent overseas, they also concerned themselves with the effect of the labour shortage on the war effort. Their approach to this problem was indicative of the class origins of these organizations. In 1916, the Women's Canadian Club in Toronto met to organize a Women's Emergency Corps in Toronto, and sent a delegation to the Canadian Manufacturer's Association convention. The Corps represented 3,000 Toronto women who were willing to work in war production industries to free men to enter the armed forces. Women from the Women's Canadian Club were well established financially, were often the wives, daughters and friends of the Canadian Manufacturer's Association members, and they did not hesitate to make such offers to the business community.[38] Of course the Canadian Manufacturers Association graciously accepted the offer and went on to make a few suggestions of its own. The President declared in his address to the convention:

> "One of the most obvious ways to overcome the difficulty would be to take full advantage of the Women's Emergency Corps, which has secured applications from thousands of women who are ready to take the place of men who have enlisted, both in industrial and clerical occupations. The magnificent spirit that prompts women to make the sacrifice herein involved should be given every encouragement by employers."

The President used the example of the "armies of women now engaged in factory work in England", to suggest that "to some extent the situation might, of course, be relieved by working seven days a week instead of six."[39]

The Toronto Women's strategy was also appreciated in government circles. When the Federal Government was faced with the difficult task of making their repressive legislation palatable to the Canadian public in 1918, they sent out a call for a Women's War Conference. The conference, held in Ottawa in February 1918, purported to seek the advice of Canadian women on the proposed tightening of labour surveillance, but actually sought to recruit the

influential support of these wives and mothers, as well as their labour power.

It is noteworthy that the representatives invited to the conference came from conservative organizations such as the National Council of Women of Canada, the Imperial Order of the Daughters of the Empire, the Young Women's Christian Association, the Women's Christian Temperance Union and the Canadian Suffrage Association. There is no record of any involvement of working-class women or their organizations in these meetings.

All those invited were asked to give advice on such diverse subjects as the relationship of women to agricultural production, commercial and industrial occupations, the compilation of the national register, conservation of food, and the further development of a spirit of service amongst the Canadian people.[40] The women, including Nellie McClung, supported registration and were willing to work with the government. The proceedings of the Conference were reported to Parliament in the following manner:

> The Women have said to the Government, "Give us a chance to serve." The Women's Conference held some weeks ago with the War Committee of the Cabinet submitted a list of occupations upon which the Women of Canada would be glad to enter if the nation wished them to serve. I say that we can reinforce our men at the front; we can send all the men that are needed; we can send more than we can get by calling up the class mentioned, and yet have sufficient labour at home for all the essential industries of Canada.[41]

Thus working class men could be forced into service if women were prepared to take their jobs. Although working-class women had no choice but to accept these jobs, it was much more convenient for industry to exploit the labour of women from the Emergency Corps, whose "patriotism" allowed them to be moved in and out of the labour force.

Issues regarding the moral and social welfare of the country were focal concerns of the organizations participating in the conference. Women used this opportunity to raise criticisms of a broad range of social issues: women's suffrage, the use of child labour, the sale of intoxicants, food conservation, the conditions of jails and asylums, female unemployment and the ending of the war.[42]

The issue of the exploitation of child labour arose out of concern for a government plan, which had already begun, to enlist the services of 25,000 school boys on farms in order to meet the

shortage of agricultural labour. (In 1917 in Ontario, over 30,000 people, mostly farm labourers left the country for the city.) The women at the War Conference opposed this plan, using the following argument:

> Examination for military service had revealed the fact that young men from farms were not as physically fit as they should be, and that this was attributed to the early age at which they should begin work... and that the effect of heavy work on boys from the city might be even more harmful.[43]

By the time of the Conference in 1918, the 35,000 women who had been working in munitions plants in Montreal and Ontario had been reduced by 5,000 due to cutbacks in the plants. Several women at the Conference were concerned about what appeared to be the gradual elimination of women from the work force. One delegate stated, "It is certainly true in Toronto, London and Montreal, that there is considerable unemployment among working women. The women in Toronto are out of work in such numbers and that wages on the whole are being reduced below a living wage."[44] The recognition of the right of women to work seems to have been cemented during the war period, and with that recognition came concern for the unemployment of women workers. The Women's War Conference asked that women's increasing role in the labour market be maintained through protective measures, thus indicating the growing concern of middle class women's organizations with female unemployment.

The government, apparently satisfied that an important source of support had been mobilized, nodded sympathetically to the women's requests for reform in all these different areas and then proceeded to ignore all but the least objectionable—suffrage. At this time, the Parliament was in the process of extending suffrage to those very persons who were being exhorted to forward every effort in the expansion of war production. Despite the contention of most Canadian history textbooks, that women were granted the Dominion vote in appreciation of the magnitude of their wartime contribution, it seems possible that the concession was more in the nature of a bribe.

> *To Women Workers—*
>
> > *Are you working for love*
> > *Or for Money?*
>
> *Are you holding a job you do not need?*
> *Perhaps you have a husband well able to support you and a comfortable home?*
> *You took a job during the war to help meet the shortage of labour.*
> *You have "made good" and you want to go on working. But the war is over and conditions have changed.*
> *There is no longer a shortage of labour. On the contrary Ontario is faced by a serious situation due to the number of men unemployed.*
> *This number is being increased daily by returning soldiers.*
> *They must have work. The pains and dangers they have endured in our defence give them the right to expect it.*
> *Do you feel justified in holding a job which could be filled by a man who has not only himself to support, but a wife and family as well?*
>
> *Think it over.*
>
> * * *
>
> *This is one of the many propaganda bulletins that were issued. Some were directed to employees, others to their employers. This and others were located in the Department of Labour Archives of the Ontario Government.*

Attitudes Towards Working Women

The war definitely changed attitudes towards paid employment of single women outside the home. However, this was a slow qualified change, for women's role of maintenance and reproduction of labour power within the family remained crucial. The need for universal domestic education for all women was expressed by the Ontario Commission on Unemployment, because "home occupations are the *ultimate* employment of all but a comparatively

small percentage of women."[45] In fact, the Commission felt that many women's occupations would be injurious to the physical and mental health of the female worker if her occupation were allowed to dominate her life, for the only truly natural place for women was within the household. The "positive hope" was that most women would not stay in paid employment for too long.[46] The concern expressed for the health and well-being of the working woman reflected Victorian ideals of the fragile home-bound nature of women. This ideology ensured that women would only remain in the work force until marriage, whereupon they would take up their designated maintenance tasks within the family.

The need for workers to fill new occupations forced the government to actively promote a change in attitudes towards *single* women working. In 1919, the Ministry of Education in Ontario published a book on vocational guidance written by Marjorie MacMurchy, whose husband chaired the 1916 Ontario Commission on Unemployment. The book, *The Canadian Girl at Work*, has the following objective:

> ...to assist girls in finding satisfactory employment. The further aim of showing them what constitutes a right attitude towards work underlies the account of each occupation. The life of the average woman is divided generally into periods of work, that of paid employment and that of homemaking. No adequate scheme of training for girls can fail to take account of this fact. They should be equipped with knowledge and skill for homemaking and assisted in making the best use of their years in paid work. Happily it appears from an investigation of the conditions affecting girls as wage earners that the knowledge which helps them to be good homemakers is necessary to their well being in paid employment. Technical training and skill are not more helpful to a girl at work than specialized knowledge in matters of food, clothing, health and failing regimen. Lack of training in homemaking is probably the greatest drawback which a girl in paid employment can have.[47]

She goes on to say that women workers do not know how to spend money, and that the girls should welcome every opportunity to learn skill and judgement in stretching their meager wages, an important skill for the household management that lay ahead of them. This smacks of the same kind of missionary attitude that certain reform organizations held towards working-class women, whose poverty was seen as a product of the mismanagement of the household.

Most female occupations were not thought of as ends in themselves, but as preparation for later married life. For example, the following recommendation came from the Ontario Commission: "It is desirable that girls and women should be taught, so that they may realize that if a girl is an unsatisfactory, indifferent saleswoman, factory worker, teacher, nurse or other worker, the probability is that she will be an unsatisfactory wife and mother."[48] MacMurchy imparted a similar message to stenographers. She told the women to be tranquil, well poised, to put themselves into the background and to work harmoniously with their associates.[49] That is, good obedient workers would be good, obedient wives and no doubt would make good, obedient workers of their children.

It is obvious that MacMurchy understands the role of women in the economy. She says, in another book published in 1916, that "it is important that paid occupation should not interfere with the efficiency of homemaking and the care of children, occupations in which contributions made by women to the state is out of all comparison more valuable than any other."[50] Although she poses the work in the home as the primary goal for a woman, she nonetheless encourages women to pursue other goals.

> As the employment of women is at present understood, a woman who is in charge of a house, whose children are not in need of constant attention, has time for other employment. She also has sufficient initiative and energy to make other occupations necessary. She must have social intercourse. Few things are more unhealthy mentally than for a woman to remain indoors alone. All day, every day.[51]

While the attitudes opposing the employment of single women declined with the rising need for clerical workers, shop girls and light manufacturing workers, social attitudes continued to exclude married women from the work force. There seem to have been no government nurseries established during the First World War as there were during the Second War; apparently the labour shortage was not serious enough to warrant the large-scale employment of married women. Destitute married women, those who were separated, divorced, deserted, widowed or married to unemployed men, had to take whatever work they could, most often as domestic servants, housekeepers and charwomen. The charitable nurseries, which were founded at the turn of the century and which were operated exclusively for the benefit of these "unfortunates", offer some information about the situation of these working mothers and

of societal attitudes towards them. When MacMurchy argues that it was healthy for married women to have other interests than the home, she encouraged volunteer and charity work on the part of the well-to-do women. It was women from the middle and upper classes who ran these nurseries for "unfortunates".

The May 1913 issue of the *Labour Gazette* contains references for the following centres in Toronto, and the number of child days that were serviced.[52]

Table H

Nurseries (in order of establishment)	Child Days					
	1892	1893	1902	1909	1912	1922
The Creche 374 Victoria St.	2,800	—	5,420	—	25,350	—
East End Day Nursery	—	1,258	8,058	—	22,743	23,436
West End Creche 521 Adelaide St.W.	—	—	5,539	10,870	—	
Danforth Day Nursery	—	—	—	—	2,826 (approx.)	—

Two other charitable agencies for children were established in Toronto around this time—the Central Neighbourhood House in 1911, and the Settlement House in 1913.

It is difficult to extrapolate the number of working women with children due to the nature of the statistics in the nursery records (which count child days rather than numbers of children and which cover irregular years from 1892 onwards), and due to the involvement of relatives and friends of the working mother in child care arrangements. However, rough as the statistics are, they do indicate that the women who operated these nurseries steadily expanded their operations to meet what must have been a significant need. The nursery organizers were adamant that the services applied only to those mothers who urgently needed child care, and thus were not to be regarded as an opportunity for other mothers to seek paid employment. However, they did actively assist their "unfortunates" in obtaining work—such as it was.

> ### President's Report of the East End Day Nursery, 1910
>
> *Looking at it from an economic standpoint we can see the wisdom of giving these boys and girls good strong bodies, since every individual is said to be worth $1,000 to the state.*
>
> *We were delighted to hear of the increase in the number of nurseries throughout the city and of their successful work. None-the-less we had a slight decrease in our attendance during the past year. The four nurseries cared for about 62,670 children (child days) this year, while the earnings of the women helped by them amounted to $45,700. These charities cost the city $3,200 but had no pauperizing effect on the people assisted.*
>
> *It is hard for a mother to leave her children all day with strangers while she does very menial work, but it is harder still to hear them cry for bread. We are trying to make her burden as light as possible and many a mother goes from our nursery to her day's washing or cleaning with a blessing for such an institution on her lips, for she knows that her babes will be well fed and well looked after.*

By 1925 there was no major change in the activities and attitudes of the people involved in the East End Day Nursery, as can be seen from the following comment in their annual report: "While theoretically the best place for the child is at home, yet there are so many things that are essential to the proper rearing of a child, that we think (they) are much better off in the nursery under the present conditions."[53] The class composition of the women who used the facilities remained basically the same. A survey of 164 parents who used the East End Day Nursery found that women workers who were mothers worked because of desperate circumstances.

1927 Survey of the East End Day Nursery			
Marital Status		*Reasons for use of nursery*	
Married	125	Insufficient income	47
Widowed	4	Unemployment or partial	56
Single	6	unemployment of husband	
Separated	17	Desertion	11
Divorced	0	Separation	13
Deserted	12	Single Parent	12
		Debt	13
		Illness	11

III. The Post War Period
Political and Social Involvement

By the 1920s women were sustaining and in some fields improving upon their pattern of involvement which had been established during the war. The increase in the size of the female work force corresponded to an increasing emphasis on education. This is demonstrated by the increase in the percentage of women under twenty-five who entered the work force and the accompanying decline among those aged ten to nineteen years. Thus the largest rate of increase for women entering the work force during the 1920s occurred among the women who were between twenty and twenty-four, followed by those between twenty-five and thirty-four. The increasing involvement of young women in continuing education and gainful employment during this period corresponds to a decrease in marriages among women under twenty-five and a substantial decrease among those between twenty-five and thirty-four. Women comprised about 25 percent of the enrollment in both graduate and undergraduate studies by the end of the twenties. The proportion of women in graduate study was greater than it is today.

Women also became more active in politics. The first woman member of the Dominion Parliament, Agnes MacPhail, was elected in 1921 and re-elected four times thereafter. Judge Emily Murphy led the 1929 court case which resulted in women's eligibility for appointment to the Senate. In British Columbia, in 1921, Mary Ellen Smith became the first woman Cabinet minister.

Some women's organizations concerned with social reform collapsed after winning female suffrage in 1917. Others, for exam-

ple the Women's Auxiliary of the United Farmer's Association of Alberta, remained politically organized after winning the vote and were instrumental in the adoption of social legislation of a growing quantity and quality. In Quebec, where women did not get the vote until 1940, the bilingual provincial franchise committee was formed in 1922; along with L'Alliance Canadienne pour la vote des Femmes du Québec, a predominantly working class group, they achieved the appointment of the Dorion Commission to recommend reforms in the civil code pertaining to women.

Table I

Marital Status of Women in the Labour Force

	1931	1941	1951	1961	1966	1971
Single	80.7	79.9	62.1	42.5	38.8	34.4
Married	10.0	12.7	30.0	47.3	52.1	56.7
Other	9.2	7.4	7.9	10.2	9.2	9.0

Sources: Women's Bureau 1970, Tables 8, 11.
Women's Bureau, Facts and Figures, 1971., Table 10.

Table J

Married Female Population by Age Group

	Married percentage of female population.	15-24	25-34	35-44
1891	52.6	18.2	68.3	80.0
1911	56.9	23.2	71.5	80.7
1921	59.2	23.6	74.5	82.5
1931	57.3	19.7	72.7	82.7
1941	58.0	21.7	71.4	81.4
1951	64.5	30.0	81.2	84.0
1956	66.3	31.7	84.0	86.1

Source: D.B.S. 1956 Analytical Report: Marital Status. Table XV.

By the end of the twenties, women had broken much ground. More women married later, worked, and went to school in both university and professional programmes. Women now had the vote. The war had favoured economic expansion in Canada and

thus had made possible an opening of opportunities for women in the 1920s. However, these gains remained within the framework that combined what was economically useful and non-threatening to family maintenance work. The Depression of the 1930s was a major obstacle in women's struggle to broaden these openings. Many women were forced back into domestic service, and the increases in the proportion of women in higher education stopped after 1931.

Table K

Enrolment of Women at Undergraduate and Post-Graduate Levels As A Percentage of Total Enrolment (Full-Time Regular Session)

Sources:
Urquhart, M.C. and K.A.H. Buckley, ed. *Historical Statistics of Canada,* Toronto, Macmillan, 1965, pp. 601-602.
Dominion Bureau of Statistics, *Survey of Higher Education,* Cat. no. 81-204, 1961-62, 1962-63, 1963-64, 1965-66, 1966-67, 1967-68.

From the Report of the Royal Commission on Status of Women, 1970, pg. 168.

Post War Employment

Since census reports only provide a glimpse of the situation every ten years, it is difficult to assess the immediate effects of the ending of the war on the female work force. From 1891 to 1921 the number of gainfully employed females in Canada increased from 195,990 to 490,150 which is a gain of about 150 percent in thirty years. From 1891 to 1901 female workers increased by 21.4 percent, from 1901 to 1911 the increase was 53.3 percent, and from 1911 to 1921 the increase was 34.4 percent.[54] The huge increase from 1901 to 1911 is accounted for by high immigration and the creation of new jobs.[55]

Aside from the increase in numbers, the most significant change in the female work force was the occupational shift. The work force as a whole shifted towards the white-collar sector. The increase in white-collar jobs from 1911 to 1921 was about 7 percent over the previous decade while absolute numbers declined in manufacturing, mechanical, personal service, and all primary non-agricultural occupations. However, this increase in the white-collar sector, was largely accounted for by the increase in the number of women working, and can be considered a predominantly female phenomenon. The two occupations most affected by this shift were personal service, where there were 30 percent less women working in 1921, and in clerical work which doubled its proportion in the female labour force.* These changes were due to the tremendous growth of paper work to service the war-boosted economy, and to the preference of women for clerical work over domestic work. By comparison, no substantive changes took place in the distribution of the male labour force. The 6 percent increase in the general classification of male white-collar occupations was largely accounted for by a rise in the numbers of men in proprietary and managerial positions.

By 1921, the 489,058 paid women workers made up about 15 percent of the work force, but the distribution of workers into occupations according to strict sex role stereotypes continued. Approximately 65 percent of all women workers were located in the following three categories: clerical, domestic service and professional. Within the professional category, three-quarters of the

*Service occupations should not be confused with service industry which might include professional, manual, clerical and service occupations.

Table L

Summary of Trends in the Percentage Distribution of Working Women for Clerical and Personal Occupations.[56]

	1901	1911	1921	1931	1961
Clerical	5.3	9.4	18.7	17.7	28.6
Personal	42.0	37.1	25.8	33.8	22.1

workers were teachers and nurses. By contrast men filled over 80 percent of the jobs in the following categories: transportation, communications, proprietary and managerial, and all primary occupations.[57] Agriculture accounted for a very low percentage of the male labour force.

Protective Legislation

Another result of the war was the enactment of protective legislation, as well as the re-enactment of pre-war legislation governing the length of the working day. The war had brought women's participation in the work force into the open. This raised considerable public concern about the treatment of working women.

There was strong reluctance to legislate working conditions due to the acceptance of the free-enterprise system, that is, a free wage and labour market. Some labour organizations saw the imposition of minimum wages for men as damaging to the individual worker's competitive position vis-a-vis other workers. It seemed that legislation for women workers was acceptable to the government only because women were seen as a weak, defenceless minority, who like child workers, would soon disappear or at least always be a negligible group. Actually, the legislation that finally passed was mere tokenism. It was full of loopholes and could be easily violated. In fact, the legislated protections became a basis for discrimination against women.

The protective legislation passed during the 1920s included laws prohibiting night work, the cleaning of certain machinery, and eating in the same room in which the manufacturing process was taking place. British Columbia was the only province that implemented a maternity protection law in 1921, which granted women six weeks maternity leave before and after having a baby.

Table M

Female Labour Force, 1911: Distribution by Occupation

	As % of Total Female Labour Force	% Concentration of Women in Female Workplaces	As % of Total Labour Force in Occupational Group
All occupations	100%		13.4
White Collar	*29.9%*		*23.8*
Proprietary and managerial	1.6		4.5
Professional	12.5	Teaching and Nursing, etc. ... 12.5	44.6
Clerical	9.1	Clerical ... 9.1	32.6
Commercial and Financial	6.7		19.2
Manual	*28.0*		*10.4*
Manufacturing and mechanical	26.4	Garments and Textiles, etc ... 26.4	25.9
Labourers	0.1		0.1
Transport and communication	1.5		3.5
Service	*37.6*		*65.3*
Personal	37.5	Domestics, Waitresses, etc. ... 37.5	67.2
Protective and Other	0.1		6.8
Primary	*4.5*		*1.5*
Agricultural	4.4		1.7
Fishing and Trapping	0.1		0.8
		Total ... 85.5	

Source:
Department of Manpower and Immigration, *Historical Statistics of the Canadian Labour Force, 1969.*

Women were protected from working between midnight and 6 a.m., and from employment in mines. Legislation also tried to prohibit "Orientals" from hiring women, and to protect women from seduction by their employers.[58]

The enactment of minimum wage laws for women in the 1920s provides a particularly good example of how protective legislation was not able to seriously obstruct the harsh exploitation of working women. In every province a board was set up to examine the existing rates of wages and to recommend minimum rates for women working full time. Direct intervention of these laws for women in the free-enterprise system was justified on the grounds that female workers were in too weak a bargaining position to protect themselves against exploitation. The minimum wage was supposed to be "the least sum upon which a working woman can be expected to support herself."[59]

Manitoba and British Columbia enacted Women's Minimum Wage Acts in 1918. By 1920 Quebec, Saskatchewan, Nova Scotia and Ontario had followed suit. These acts established boards that were authorized to issue minimum wage orders and eventually to regulate hours of employment in various establishments. In Ontario the minimum wage for women in 1924 was $12.50 per week in most factories, stores and other women's workplaces. This only applied to experienced women over eighteen years of age and was easily violated. The *Labour Gazette* noted the case of a Regina firm which employed women as canvassers. The firm made the women pay for rather expensive equipment as well as used them as free advertising agents, at a rate of pay of $40 per month or less.[60]

By 1935 even though there had been protective legislation in the form of minimum wage laws for women for over a decade in most provinces, the Royal Commission on Price Spreads gave evidence of the gross inefficiency of the Laws.

> In (Ontario and Quebec) indeed by permission in special circumstances (the legislation grants that) workers may be given the privilege of working 72 hours per week. Although these laws are relics of the dark ages of industrialism and permit longer hours than any modern standard would sanction, they are often violated with impunity or at the cost of a small fine. The laws do not apply to homeworkers (piece workers) whose wage rates encourage even longer hours than those above.[61]

The Report cited many examples of the exploitative wage rates of the unprotected home work, which made up a large part of women's paid work during the Depression.

> A woman with her daughter making boys' short pants for L'Amoureux at 30 cents/dozen less 5 cents/day for thread. Output one dozen per day. These garments made under the union scale would cost at least $1.50/dozen in labour.
> Subcontractor for Blumental receiving 80 cents to $1.05/dozen for men's pants. His wife and daughter were working at those garments and they stated that the work was let out to adjacent farmhouses at 40 cents to 60 cents/dozen.
> Women making riding breeches at $1.15/dozen. Output 5 garments per day or 48 cents per day income.

The Commissioners observed in some industries that some women's groups opposing protective legislation had feared "a tendency for male workers to be paid less than female workers and perhaps to displace them." They found cases of boys earning 2 1/2 to 6 cents per hour. The Report also stated that "for most factory jobs a 'learning period' of two years is unnecessarily long..."[62] This is an understatement of the flagrant use of apprenticeship programmes in order to pay employees starvation wages.

Where violation did not exist evasion often did. The law allowed so many loopholes that enforcement (had it been seriously attempted) would have been meaningless.

> When, as in one order, provision is made for different rates in six classes of workers; when the hours for which these rates are payable vary according to both the size of the community and also the regular hours normally worked by the firm; when the major instrument of invesigation and enforcement consists of the employers own reports of wage payments for sample weeks, then the law and its administration begin to develop technicalities which defeat its purpose. Whether the ABC firm violated the law by paying Miss Smith 15 cents/hour during a particular week is not now an easily answerable question. It has now become a question of law, custom, history, geography, accounting and arithmetic. Probably the ABC firm does not itself know. Only the most expert and hurried inspector could ever find out.[63]

The areas in which protective legislation did succeed in introducing reform were often offset by its tendency to worsen the existing disadvantage of the woman worker in a competitive labour market. Another fundamental weakness was that the legislation did not apply to farm workers, domestic servants and garment piece workers, that is, to a third of the paid female working population. Legislation designed to protect the female worker happened to exclude the very areas where there was a high concentration of female labour.

The demand of equal pay for equal work ran into similar problems. As early as 1882 the Toronto Trades and Labour Council included equal pay for women in its first platform of principles. Even though it continued to hold to this principle throughout its existence, it did very little to ensure that the laws were enforced. The truth is that equal pay could not be enforced. Not only was legislation so narrowly worded and interpreted as to exclude the possibility of its enforcement, but it was (and is) largely ignored that for the most part women did not work in the same areas as men. Unless the sexual division of labour within and without the paid work force is broken down, any legislation attempting to eradicate inequalities will reflect this fundamental division.

The whole issue of protective legislation was hotly debated by women in their labour and suffrage organizations. The middle-class suffrage groups saw special legislation for women as segregating female labour and thus withholding from them opportunities in certain types of work. However, female labour was already set apart from male labour, and in its isolation was more vulnerable to exploitation. Trade union women rejected the approach of the suffrage-type groups and viewed any protection against sweated conditions, no matter how it was won, as a desperately needed reform.

The Federation of Women's Labour Leagues (formed in 1924) expressed its opinion by publishing in its journal the statement of the Joint Committee of Industrial Women's Organizations of the United Kingdom. The Committee distinguished three types of protective legislation:

1. Provisions that would be good for men as well as for women, but which can be obtained for women and not for men at the present time.

2. Regulations that are more needed for women than for men because women are less fitted than men for dangerous and specially heavy work.

3. Forms of protection necessary for women because of their function as mothers.

The Committee stated the following, "Our position is that we take whatever we can get under all three heads, and if we cannot get it for men, or it is not necessary for them, we endeavour to secure it for women alone."[64]

The debate was carried to the International Labour Organization in 1927. On one hand, the International Women's Suffrage Alliance held that "any preferential system of international legisla-

tion as regards women might, despite its temporary advantages, become a real instrument of tyranny and might result in limiting the numbers of working women in certain undertakings and diminishing their chances of obtaining higher wages."[65]

On the other hand, the International Congress of Working Women, which represented the women who had to suffer under the oppressive working conditions spoke in favour of protective legislation. The trade union organizations won their point. Many women's suffrage groups had little organizational strength once the vote had been won, and these organizations collapsed during the twenties, isolated from the struggles of other women.

Summary and Conclusion

After the war, the women who entered the labour force to replace men during the war, stepped into new peacetime industrial jobs if they could find them. If they did not, they returned home. They did not compete with men for the same jobs, or at any rate not successfully. For example, the proportion of the female labour force in the "professions" has remained stable since 1901, although the total number of women in the paid labour force has increased more than ten fold. New jobs for women have not been created in this area. By comparison, the proportion of the male labour force in professional jobs has doubled since 1901.

The movement of women into the labour force has been marked by their entrance into the same poorly paid, low-status jobs. In 1901, 95 percent of women in the paid labour force were located in the five major occupational groups, and by 1961 that percentage had decreased slightly to 85 percent. The major historic trend in the occupational distribution for women has been a movement out of service into clerical occupations. This trend demonstrates a pattern of women's employment developing in those areas of the economy that grew; at any given moment the employment of women and the ideology governing the role of women corresponds to the labour needs of capital. As the need for cheap labour increased, the attitudes that previously opposed women working for money became more favourable.

These attitudes relaxed only within the framework of the dominant ideology that a woman's place was in the home. Thus attitudes changed only towards single women and remained intact with respect to married women. The differing attitudes towards single women workers and married women workers operated to

maintain a sexual division of labour within the workplace, as the time that women spent in the workplace was seen as a preparation for the home economy. It was not until the late 1950s that the needs of the economy changed to permanently require the labour of married women outside the home, in addition to their domestic labour. This development has now caused many women to challenge sex role stereotyping in workplaces inside and outside the home.

Footnotes

1. Primary manufacturing involves operations in which relatively minor processing of domestic natural resources is required for preparation for sale, mainly in export markets. Primary manufacturing industries can be regarded as absorbing the outputs of staple industries (fish, lumber, fur, etc.) or simply as the final step in staple production. Secondary manufacturing industries are characterized by a higher degree of processing, greater dependence upon domestic markets, and reliance on both foreign and domestic inputs. Examples of secondary manufacturing are textiles, clothing, transportation equipment, electrical apparatus etc. (See *Approaches to Canada Economic History*, W.T. Easterbrook and M.H. Watkins, 1967.)

2. Leo A. Johnson, "The Development of Class in Canada in the Twentieth Century," in *Capitalism and the National Question in Canada*, ed. Gary Teeple, p. 169.

3. Employers seized the opportunity presented by the abundance of cheap labour to reduce wages, with the result that numerous bitter strikes were fought, bringing frequent repression by the army, and the creation of the Federal Department of Labour as a means of social control.

 During the 1910-1920 period and primarily as a result of the First World War, the economy was greatly diversified, particularly into the refining of non-ferrous metals. During this period steel production almost doubled. Shortage of capital, however, as well as the continued abundance of low-cost labour, reduced capital intensity to almost 1900 levels and resulted in a further decline in the manufacturing and mechanical sub-sector and created a further increase in the use of menial labour...In other words while capitalist social labour relations had been established, capitalist industrial modes of production in many regions and occupations had not. On the other hand, the expansion of capitalist production and particularly the creation of manufacturing units, necessitated the creation of a large white-collar apparatus to manage it. It should be noted again, however, that the

size of the white-collar sector is proportional to the manufacturing and mechanical sector. See Leo Johnson, *Capitalism and the National Question*, ed. Teeple, p. 170.

4. The upper-middle classes in the urban areas were, by and large, branch managers of eastern banks or eastern mercantile chain stores Eaton's, Simpson's and the Bay. The land companies were mercantile, concerned with speculative land sales rather than agricultural production. The grain elevator companies were eastern based and tightly cartelized; by 1900 three-quarters of the elevators in Western Canada were owned by five companies.

 An important source of capital at this time was British Portfolio investment, which was encouraged to a large extent by the centralization of monetary control in Canada, with the resulting high credit ratings in international finance capital markets...Prior to the First World War, Canada was the most favoured colony of the British empire in terms of the amount of portfolio investment and this can be credited to the readiness of the Tory merchant-capitalists...to use the state structure to guarantee loans to other private and public undertakings. By 1912, government bond guarantees for private railways totalled a quarter of a billion dollars. British portfolio investment built up other transportation projects as well, and the public utilities, the banking and financial sector.

 ...by the late nineteenth and early twentieth centuries, the international division of labour that has continued to prevail until the present was well established. The branch plant secondary sector, prompted by the tariff with free entry of many parts was strongly biased towards assembly operations. The close control exercised by the American parent over its Canadian subsidiary assured the perpetuation of this division of function. In the primary sector not covered by the tariff, the typical pattern was the extraction of resources and export of raw materials for processing in the United States. (See R.T. Naylor, "The Rise and Fall of the Third Commercial Empire of the St. Lawrence," in *Capitalism and the National Question in Canada*, ed. Gary Teeple, p. 22.)

5. Ontario Legislative Assembly, *Report of the Ontario Commission on Unemployment*, p. 60.

6. *Women at Work in Canada*, Department of Labour, 1964, p. 1.

7. This analysis was developed by Patricia Alexander and is outlined at length in an unpublished paper by her.

8. *Wages and Hours of Labour*, Department of Labour, 1914, p. 27.

9. *Labour Gazette*, 1913, p. 684.

10. See the chapter on Domestic Servants by Genevieve Leslie in this volume.

11. Thomas White, *The Story of Canada's War Finance*, p. 11.
12. *Labour Gazette*, 1915, pp. 569-570.
13. *Labour Gazette*, 1916, p. 1216.
14. *Labour Gazette*, 1915, p. 174.
15. *Labour Gazette*, 1915, p. 172.
16. I shall use information gathered by Gail Dzis about the *Financial Post* in this part of the paper.
17. *Financial Post*, (May 20), 1916.
18. *Financial Post*, (June 17), 1916.
19. *Women in the Production of Munitions in Canada*, Imperial Munitions Board, 1916, p. 7.
20. *Financial Post*, (August 5), 1916.
21. *Women in the Production of Munitions in Canada*, 1916, p. 43.
22. *Ibid.*, p. 21.
23. *Ibid.*, p. 57.
24. Enid M. Price, *Changes in the Industrial Occupations of Women in the Environment of Montreal during the Period of the War, 1914-1918*. McGill University, Faculty of Arts, Department of Economics and Political Science.
 This study was submitted as a Master of Arts thesis. While Price was working on it, she received a scholarship from the Canadian Reconstruction Association, and it is interesting to note that when the study was published in May 1919, Marjory MacMurchy was head of the Women's Department of the Canadian Reconstruction Association.
25. Enid Price, *Changes*, p. 31.
26. From an unpublished paper by Toby Vigod.
27. *Report of the Women's War Conference*, 1918, p. 35.
28. Enid Price, *Changes*, p. 25.
29. *Ibid.*, p. 25.
30. In a study done by Jean Thompson Scott in 1892, *The Conditions of Female Labour in Ontario*, she found that many of the girls preferred to work where a number of other girls were employed.
31. Enid Price, *Changes*. Price did not receive figures from all the munitions factories that she surveyed, but she estimated that there would have been 650 inspectors.
32. Enid Price, *Changes*, p. 52.

33. *Ibid.*, p. 52.
34. *Report of the Ontario Commission on Unemployment*, p. 52.
35. *Ibid.*, p. 59.
36. Enid Price, *Changes*, p. 82.
37. *House of Commons Debate*, (August 2), 1917.
38. It seems from the grateful tone of the business men that the women worked for free or for a nominal wage.
39. *Labour Gazette*, 1916, pp. 1347, 1351, 1397. The references that are made to England occur because large numbers of women had joined the labour force during the war, and these women were continually used as examples.
40. *Report of the Women's War Conference*, p. 3.
41. *House of Commons Debates*, (April 19), 1918. Statement by Newton Wesley Powell, President of the Council.
42. These concerns were similar to those of women in the United States and the United Kingdom. For further information, see: J.S. Lemons, *Social Feminism in the 1920s*. (U. of Illinois Press, 1973) and Helena Swanwick, *The War and Its Effect Upon Women and Women and War*. (New York: Garland Publishing, 1971). The second was first issued in pamphlet form in 1915.
43. *Report of the Women's War Conference*, p. 27.
44. *Ibid.*, p. 35.
45. *Report of the Ontario Commission on Unemployment*, p. 63.
46. *Ibid.*, pp. 167-190.
47. Marjory MacMurchy, *The Canadian Girl at Work*, (Toronto: 1919) From the Introduction.
48. *Report of the Ontario Commission on Unemployment*, p. 59.
49. Marjory MacMurchy, p. 47.
50. Marjory MacMurchy, *The Woman Bless Her*, p. 55.
51. *Ibid.*, p. 16.
52. *Labour Gazette*, (May 1913).
53. *Report of the Toronto East End Day Nursery and Settlement, 1925*.
54. *Census of Canada*, 1921, p. xiv.
55. This is described earlier in the paper. Also see Leo Johnson in *Capitalism and the National Question in Canada*, ed. Teeple.
56. This chart is excerpted from *Women at Work in Canada*. It is presented in its entirety elsewhere in this article.

57. Woods and Ostry, *Labour Policy and Labour Economics in Canada*.
58. *Legal Status of Women in Canada, 1924,* Department of Labour, pp. 73-74.
59. *Orders of the Minimum Wage Board*, Ontario Legislative Assembly, 1924, p. 6.
60. *Labour Gazette*, 1925, p. 1039.
61. *Report of the Royal Commission on Price Spreads*, 1935, p. 112.
62. *Ibid.*, p. 131.
63. *Ibid.*
64. *The Woman Worker*, vol. 2, no. 7, pp. 14-15.
65. *Labour Gazette*, 1926, pp. 308, 531; 1927, pp. 926, 1277.

Women in Production: The Toronto Dressmakers' Strike of 1931

On February 24, 1931, Toronto Local 72 of the International Ladies Garment Workers Union went out on strike. The dressmakers' local was forced to fight a long and bitter battle for its demands which included the institution of the forty-four hour week, a wage increase of 15 percent, recognition of the union and the establishment of impartial mechanisms to arbitrate disputes.

The 500 women who took up placards and remained on strike for two and a half months made their mark on Canadian labour history for the simple reason that they were women, striking in order to force management to answer their demands. The strike continued throughout the spring, but because of economic hardship, inadequate leadership and support on the part of the ILGWU, intimidation by "detectives" hired by the employers, and threats and warnings sent to the homes of some of the strikers, it was abandoned at a mass meeting on May 5, 1931, attended by some 1,000 strikers.

The women who had gone on strike were left with the same options they had faced before the strike: unemployment, part-time work, piece work, home-work or unskilled jobs in the labour-intensive Garment Industry. The strike's legacy of scattered information helps to illustrate the struggles of working women at the time of the Depression. The oppression of the garment workers from Local 72 reflects the second-class nature of the role of female workers in industry and their relationship to unions in the socio-economic context of the Depression years.

By the middle and late 1920s, a number of ladies' garment factories had been established, creating an important industry in

Toronto. The garment industry thrived on the cheap labour of unskilled female workers, and until 1930 was practically devoid of union organization. At that time the Industrial Needle Trades Workers' Union, under the auspices of the Communist Workers Unity League, began to organize the previously unorganized dressmakers. In the struggle that developed between this left-wing union and the conservative International Ladies Garment Workers Union, the women workers were called out on strike twice in the first two months of 1931 and were twice defeated. The first defeat, in fact, was partially due to the open opposition of the ILGWU; the fragmentation and confusion that resulted was, ironically, to some extent responsible for the failure of the ILGWU's strike attempt one month later.

In response to the organizing attempts of the INTWU, the cloakmakers of the ILGWU began to encourage the organization of the sixty to eighty dressmaking shops which, in total, employed between 1500 and 2000 workers in the city. The workers in these shops were organized gradually into Local 72 of the ILGWU, which was specifically set up as a dressmakers' local. The organizing campaign continued throughout the winter of 1930 until the local reached a membership of 500—a very high figure for a previously unorganized group of workers. By early February 1931, after the strike of the dressmakers in the INTWU was defeated, the General Executive Board of the ILGWU began to talk in terms of a general strike.

The ILGWU dressmakers' strike was called on February 25, after two-week-long negotiations between employers and union representatives had failed. Three hundred men and women who had been following the course of the talks took out union cards the day before the strike when it became apparent that the two sides were deadlocked.[1] The strike proclamation read:

> Every operator, finisher, cutter, presser and draper must stop work at exactly ten o'clock on Wednesday, February 25, and march to the Labour Lyceum, 346 Spadina Avenue. Walk in couples together, directly to the Labour Lyceum. There the hall committee will show you the room where your shop will be located. Leave your shop orderly and do not create any disturbances.[2]

At the given time, hundreds of dressmakers filed out of the many dressmaking establishments along Spadina Avenue. The *Toronto Star* reported that "laughing crowds of girls and men streamed out of the buildings and for the most part there was no disorder."[3]

(February 24, 1931, The Toronto Star)

Public reaction to the strike was varied. The local trade unions offered much sympathy and aid to the strikers; of these unions, the Cloakmakers' Local was the most actively supportive, contributing financially to the strike fund. By much of the general public, however, strike and wage demands such as the garment workers' were interpreted as ill-timed greed and insubordination. Stoicism and tightening of the belt were seen as the only answers to the crisis caused by the Depression. This point of view, as always, found adherents among the local journalists.

The response of the employers was mixed; some of the employers united to form a bloc in opposition to the strike, while others

turned to Montreal suppliers. One of the employers was quoted as saying:

> We get the benefit of the strike. We handle Montreal stocks and you couldn't have a unionized shop in Montreal if you turned the town upside down. If anything we [his company] will derive benefit from it.[4]

However, those employers who did not handle Montreal stocks and were thus in direct competition with Montreal suppliers were forced to oppose the strike:

> We have met Shane [of the ILGWU] on two occasions but we could not agree to his conditions...Among their demands is one that a price committee be placed in each shop with a shop chairman. We cannot agree to this, but are willing to give a 44 hour week arrangement. At the present time we are competing with Quebec dress manufacturers who, due to low wages can produce garments 40 percent cheaper than we can in Toronto. We are willing to come to terms if they will organize Montreal at the same time.[5]

STRIKE IS CALLED OF GARMENT WORKERS

(*February 25, 1931,* The Evening Telegram, *Toronto*)

The manufacturers were obviously not operating as a solid bloc against workers. The industry was in an unhealthy economic condition and the competition between manufacturers was intensified. The Canadian Manufacturers Association which had served as a unifying body for the individual manufacturers had not survived the Depression, leaving individual shop owners to battle other manufacturers and workers' demands on their own.

During the course of the strike, dozens of workers were arrested and many more were harassed by a private detective agency, hired by employers and run by an ex-police officer who had been asked to leave the Toronto police force. Bernard Shane, Manager of the Dressmakers' Union, mentioned that the plainclothesmen were pushing, kicking, and stepping on the feet of the women on the picket line. The police, instead of protecting the strikers, or at least adopting a neutral attitude, were guarding the strikebreakers who remained in the shops.

From the very outset of the strike, it was obvious that many employers violently opposed union demands. Several incidents of violence occurred as the employees attempted to leave their workplace in an orderly fashion. One woman, for example, was assaulted by some men when she called out, "It's ten o'clock; let's quit." She was struck on the head with an iron bar and had to be taken to the hospital. Another young woman was drenched with a bucket of water when she attempted to leave her place of work. One man claimed that he was on the eighth floor of the Balfour Building, getting the workers ready to go out on strike when an angry employer from the Crown Dress Company hit him three times on the face with a bar. When a friend went to his aid, he too, was attacked by the person wielding the bar.[6]

Other employers regarded the situation more rationally. "All that the workers request," stated the manager of the Ontario Dress Company, "is that manufacturers recognize the Garment Manufacturers Union. That will probably be granted if the workers themselves prove strong enough."[7] Within two weeks, contracts had been signed in some twenty-two shops, but most of the employers refused to recognize their employees' right to organize and refused to accede to strike demands. According to the ILGWU Convention Report, these employers took their anti-union stand despite strong pressure to do otherwise from the Toronto Mayor's Office and the Department of Labour.[8]

The organizers of the strike presented employers with de-

mands for fair wages and a decent work situation for the dressmakers. Sadie Reich, an organizer from the Trade Union Educational League, pointed out at a meeting of the District Trades and Labour Council that "girls, who were expected to be respectable" were earning only $5, $6 and $7 a week, hardly enough to exist on.[9] The fact that many employers refused to sign the union agreement meant that these girls were being denied the right to a decent living standard. Bernard Shane stated at the same meeting:

> Surely we are entitled to ride in a second hand automobile and to go to a picture show now and then. We are producing the finest clothing in the world and yet we are paid starvation wages and are working thirteen hours a day. This is an intolerable position... ours is a rich industry. Many of us cannot be replaced.[10]

Shane's arguments, however, failed to take into account the particular role that women workers played in the Garment Industry. It is true that it was a fairly prosperous industry; what he failed to understand and incorporate into his strategy was that women were inarticulate in publicly expressing workplace grievances, inexperienced in the trade union movement, and, as unskilled workers, *were* extremely "replaceable."

The strike failed. To understand this failure, the economic context of the strike must be outlined, because in the 1930s Canada was in the throes of its worst economic crisis in history—the Great Depression. As a relative newcomer to modern industrial capitalism, Canada was drastically affected by the Depression. Because the country's economy pivoted around the export of raw materials, it was unable to compete on a world market which featured increasingly protected markets and trade. Canada's wheat-oriented economy, suffering from drought and decline in export value, could not provide sufficient capital to support the country's infant manufacturing industry. The post-war boom had led to a crisis of overproduction with no possible markets, either internal or external, for manufactured goods. The capitalist (shop or factory owner) faced with overstocked warehouses, tried to rationalize his production by laying off workers, cutting wages, and decreasing the gross value of goods produced.

Wages and jobs, particularly in a labour-intensive industry like the Garment Industry, are the only elements in the economic equation of profit that can be manipulated. The capitalist cannot change the amount of capital that he has already invested in property or machines (capital equipment) and he does not want to

change his rate of profit. His only alternative is to fire some workers—usually the unskilled—or to replace skilled workers with unskilled workers at cheaper wages. In the Garment Industry during the thirties, the value of the goods produced was cut to almost half of its pre-Depression level. Seventeen precent of the workers engaged in the industry lost their jobs and those who managed to keep their jobs lost about one-third of their wages. Women's jobs were the first to go since their unskilled labour was the most expendable. Noting from statistics available from that period that the total amount paid out in wages and salaries in the Garment Industry fell by 44.4 percent, it becomes evident that the price of labour was forced down in order to stabilize the rate of profit for the industry.[11]

The expansion of the economy into the service industries after the First World War and throughout the 1920s, as well as the increased mechanization and decreased specialization of factory work, facilitated women's movement into the labour force. From 1921 to 1931, the total number of women gainfully employed in Ontario rose from 193,506 to 249,096 (29 percent), as compared to a rise in the female population of 19 percent,[12] thus increasing the number of women in the work force by 10 percent. With the Depression, more women *had* to work, and since they worked for such low wages they often found it easier to secure jobs.

Unemployment reached its peak in 1935. However, women who stayed at home were not considered to be unemployed or actually looking for work. Many, to be sure, were deterred from seeking employment because of the public outcry against women, particularly married women, taking jobs outside the home. The public argued that married women were taking jobs away from men who had wives and family to support, as well as robbing single girls of the opportunity to earn a wage. A letter from a male factory worker to the Ontario Minister of Public Works and Labour, J.D. Montieth, is an example of this wide-spread fear. It asked the government to set up strict regulations to prevent married women from working unless they were able to show ample need. Further, it stated that married women didn't need to work because their husbands and their families could provide for them.[13] Another letter to the Minister emphasized that the economic plight of the single girl was ignored by employed married women who took jobs that otherwise would have been held by single girls.[14] Some married women began to use their maiden names when applying for

work because of the public censure against their working.[15]

The hostility to married working women was supported by the whole ideological fabric of the society at the time. A woman's place was in the home and those women who had to join the workforce in the '20s and '30s did so against great odds. Out of economic necessity, they were forced to oppose everything they were socialized to believe. Given this situation, it is not surprising that 88 percent of the home-based garment workers were women. A report on the tailoring trade in Toronto exemplifies the prevalent attitude towards garment work done in the home:

> The work suits women because they can carry on household work at the same time; several women are mothers of families who eke out their husbands' wages in this way; others are obliged to be at home to care for aged or sick relatives.[16]

Thus, womens' work in the labour force, the homework that they were likely to accept, and the work that they were likely to be offered, was contingent upon their role as housewives and mothers. A government report on the Garment Industry, written anonymously in 1919, shows the conditions under which homework was done:

> The living conditions of the family are apt to be upset by the pressure of the mother and the older children to work; the price of work for shop workers is cut through this illegitimate competition; the long and irregular hours kept by homeworkers are ruinous to the health; workers suffering from disease often work where they would not be permitted to do so in a shop.[17]

During the Depression the conditions were probably just as bad, if not worse; in fact, in 1931 the Ontario Executive Committee of the Trades and Labour Congress of Canada presented a programme of desired legislation to the provincial government which included the "prohibition of the manufacture of clothing in the homes of wage earners."[18]

It is reasonable to assume that during the Depression women preferred factory work to the more sporadic and lower paying work done in the home. The needs of the Garment Industry were such that it demanded cheap flexible labour. The Industry's solution was the use of female workers as a reserve labour pool; that is, it paid them lower wages, worked them longer hours during the high season and laid them off during the low season. As a result, women garment workers in the Depression were the first to be laid off and the first to be rehired. Although at first glance this seems to be a

contradiction, it is actually a very logical extension of the patterns of exploitation of women workers. The societal taboo against women working outside the home restricted women's abilities to such an extent that they usually entered the labour force as unskilled, vulnerable workers. As the unskilled labourers of the trade, they were easily expendable in times of economic cutback, and easily replaced when business picked up. Since their situation in the workforce was so precarious, subject to societal hostility, family responsibilities and job insecurity, they were in a weak bargaining position; they were unable to effectively utilize the trade union systems that already existed for male workers in the Garment Industry.

Skilled workers, on the other hand, were more difficult to fire during slack periods because their specialized knowledge was essential to the ongoing production of goods. They were therefore in a stronger position to fight cutbacks and lay-offs, and were able to organize into unions. The Depression, of course, did undercut the bargaining power of skilled workers protected by unions because of the unemployment and job competition it created; but even in those years, women workers were penalized to a greater extent.

The hostility of male workers to female workers can be further understood in light of the fact that the low wages that women were offered and were forced to accept had an adverse effect on the wages of other workers. It is clear that women did not consciously try to undercut male workers' wages, but economic forces beyond their control were at the root of the problem. In fact, legislation to fix a minimum wage for women, which was intended to increase their job security and discourage their exploitation, seems to have had the opposite effect, especially in the Garment Industry. A memorandum from the Deputy Minister of Public Works and Labour in 1933 clarifies the picture:

> Where a factory usually works on a 48 hour a week basis, employees working only 24 hours may receive as little as one half of the weekly minimum wage. It should also be borne in mind that where girls are employed on a piece-work basis, the law requires that 60 percent of such workers shall be paid at a rate which enables them to earn the minimum weekly wage for a full week's employment. Thus, 20 percent of the girls may be paid at a lesser rate than the minimum fixed for the industry without violating the requirements of the act.[19]

The case of a woman worker in a garment factory in Toronto during the Depression demonstrates the relative flexibility of women as part of the labour force. Men were not laid off as easily as women were because they were skilled and generally organized into unions. When they were laid off, however, they usually had a more difficult time finding a new job than did their female counter-parts in the industry because hiring them implied a more permanent commitment. This woman's husband, a skilled cutter in the needles trade, had been laid off in Winnipeg and couldn't find another job. They moved from Winnipeg to Toronto in 1932 in order to find work. He didn't find a job and received $2.50 per week in food vouchers. She found employment in a children's wear factory, where she worked until she was laid off two months later. She was unemployed for six months in the winter of 1933 and then found employment as a chambermaid at the Royal York Hotel, working sixty hours a week. The stress of this job combined with her domestic duties overcame her and she decided to quit. She later found work in a skirt factory where she worked on and off, depending on the season. Throughout this period the family was paying $19 a month for two furnished rooms and a kitchenette with linen, light, and gas included. The $8 a week she earned at the skirt factory, plus the $2.50 in food vouchers, left them with $13 a month for emergencies and for those times when neither of them was working. This case history illustrates how essential the work of women often was for families during the Depression. Although women's employment was always sporadic, they tended to find employment more easily than their husbands.

The report went on to state that everything possible was being done by the Labour Department to maintain minimum wage rates for women, but at the same time it listed the reasons why the Minimum Wage Act was not being completely enforced:

> It would appear to be folly to attempt complete enforcement of the law under existing conditions as it would require a staff of inspectors many times greater than we now possess and would inflict undue hardship on a number of small employers who are doing the best they can under conditions over which they have no control. The general scarcity of employment and reduction in wages during the period has made it increasingly difficult to discover violations of the Act, especially where women and girls voluntarily accept lower than the minimum.[20]

The Department was confronted with some instances of women reporting their employers' violations of the Act only after they had been discharged or laid off. Those women who did have the courage to report violations often did so on condition that no action would be taken against the offending employer; they were afraid that they would lose their positions and be unable to find employment elsewhere. The Department of Labour noted that there appeared to be

> a general disposition on the part of workers, both male and female, to accept whatever wages are offered and leave it to the government officials concerned to discover violations of the existing legislation or regulations.[21]

In spite of this, the report assumes that irregularities in the execution of the Minimum Wage Act could be attributed "in most cases" to part-time employment. Employers commonly avoided paying the intended minimum wage of $10 a week to women by labelling the work they did as "part-time." The seasonal nature of the employment in the Garment Industry made it especially easy for employers to do this. A statement by the Cloakmakers in 1931 concerning the effects of seasonal work on the workers documents this particular form of exploitation:

> During the peak periods the workers are obliged to work intensively from early in the morning to late hours of the night, successively for six days in the week. The off seasons produce little, if anything, in wage returns, *but the worker is none the less constantly in attendance at the factory waiting for work to be prepared for his particular branch or division.* [author's emphasis][22]

The statement also claims that the active periods of the year amounted to six months at the most, and that "during the balance

of the working year the employee earns at the most from one to one and a half days of pay per week."

A significant feature of the Garment Industry is the segregation of the production of men's and women's apparel. These two areas of production differ according to employment patterns, the ratio of male to female workers, the skill required and the wages.

The statistics indicate that the women's garment sector was significantly more labour-intensive than the men's sector, which tended to be capital-intensive. The male sector was highly mechanized, and thus required fewer workers, but these had to be more skilled than in the female sector.

In the four year period between 1924 and 1928, the capital outlay in the women's garment sector increased by 3.4 percent, while the number of employees increased by 7.7 percent. For the same period in the men's sector, the capital outlay increased by 28 percent while there was only an 8 percent rise in the number of employees.[23] This indicates that the women's garment sector relied more on the cheap labour of women than did the men's factories.

Federal unemployment figures for workers in the men's garment factories show that women were being laid off at a higher rate than men during the Depression. From 1925 to 1930 the percentage of women to men in the men's garment sector was approximately equal, ranging from 49 to 51 percent. With the Depression, however, the numbers of women employed in that sector dropped to a low of 43 percent in 1935. In the women's garment sector, women comprised a consistently higher percentage of workers than men, ranging from a high of 70.7 percent in 1924 to a low of 66.6 percent in 1935.[24]

The two most skilled occupations in the Garment Industry in 1931, cutting and tailoring, were male-dominated. Since skilled labour is more valuable in the capitalist labour market, and since women were generally excluded from skilled jobs, they were left with the lowest paying jobs on the market. A wage scale, presented by the ILGWU in 1931 supports this thesis, given that the finishers and underpressers in the business were mostly women. At the height of the season, the wages varied for the different occupations as follows:[25]

Cutters	$25 to $35 per week
Operators and Pressers	$20 to $30 per week
Underpressers	$12 to $18 per week
Finishers	$12 to $18 per week

The real differences between the situation of unskilled female labour and skilled male labour becomes evident when it is realized that in both the men's and women's garment sector, women comprised by far the highest percentage of workers who did piece work, and consistently received lower pay than the waged employees who received a weekly income. Waged employees were skilled and received a steadier, higher income than the piece workers. In the men's garment sector in 1925, piece workers made 49.3 percent ($923) less per year than the waged workers, but with the expansion of the economy by 1929, their position had improved to the point where they made 41 percent ($750) less than the waged workers. The Depression interrupted this trend, however, and by 1933 the average piece work rate was 52.7 percent less than wages.[26]

A similar situation existed in the women's garment sectors, but the discrepancy between fixed wages and piece work rates was much greater. In 1925, piece workers made $1,102 less than the wage workers, who comprised only a small section (11 percent) of the workers in that sector. In 1933, the worst year of the Depression, the discrepancy between wages and piece work rates remained approximately the same. Thus, women, as unskilled piece workers, were harder hit by the Depression than male wage workers.[27]

It is significant that such a wide discrepancy between wages and piece work rates existed in an industry which had a high percentage of women working, who were easier to exploit and harder to organize into unions than their male counterparts. The men in the Garment Industry were usually organized into unions, held the skilled positions, and did not tolerate the general lowering of wages, the sweatshop conditions and the blatant discrepancy between piece work and wage rates that women in the industry did. As noted before, women were being laid off at a higher rate than men, and were thus in a much weaker bargaining position.

To understand women's powerless and disadvantaged position within the Garment Industry, it is important to examine the particular response to and participation of women workers in union activity. In general, female participation in unions reflected their more general socio-economic role as second-class workers and their strike activity usually resulted from extreme oppression in the work place. Women workers responded to conditions of superexploitation, like the lowering of wages and speed-up in

production demands, but their ongoing union activity tended to be limited. This was partially because the long-term goals of unionization were more attuned to the needs of the male skilled workers, since they were coming from a better bargaining position and thus were usually the ones to initiate union organization within the factory. Women's perceived and actual role as a reserve labour pool, as unskilled and transient workers, resulted in their intensive exploitation in the Garment Industry. It was very difficult for them to use the trade unions as a defense against their sweatshop working conditions. Moreover, the trade unions rarely came to their defense; the intense competition for jobs existing during the Depression, the prevailing societal opposition to women's work outside the home and the inability of the women to defend their needs, combined to make solidarity with women workers a low priority for the craft-based unions. The trade union movement rallied with women occasionally around their short-term demands, but in general, unionization was not able to meet the long-term needs of working women.

The failure of the dressmakers' strike of 1931 presents an excellent historical example of this thesis.

Why did the employers fight so intensely against the organization of the dressmakers? Why did the International Ladies Garment Workers Union fail to provide the necessary leadership during the strike? The answers to both of these questions reflect the attitude held by both employers and trade unionists toward women as second-class workers. To the employers, the maintenance of women in that category was crucial to the continuing exploitation of them as cheap labour power. Because women were replaceable, accepting lower wages, working longer hours in intolerable conditions, and were not as likely to complain as men, it was essential that they be prevented from unionization. In addition, the economic ravages of the Depression, and the competition from Montreal suppliers, meant that the employers were less able and willing to comply with their demands.

The lack of adequate support on the part of the ILGWU is partially explained by its struggle with the Communist-run Industrial Union of Needle Trades Workers Union. On January 13, 1931, the IUNTW launched its first strike of the Toronto Dressmakers. In an industry where women worked under the sweatshop conditions already outlined, the demands of the IUNTW for higher wages and shorter hours spoke directly to the real needs of the

women employed in the trade. While approximately 400 workers*
went out on strike, the action lasted only five days and was lost to
the employers. The IUNTW claimed after the defeat that the
ILGWU had not only approved of scabbery, but had openly conducted scabs to and from work.[28] They maintained that this behaviour on the part of the ILGWU was responsible for the failure
of the strike.

The ILGWU opposed the IUNTW strike because the
IUNTW represented the revolutionary politics of the Communist
Workers Unity League. The Communist Party of Canada's trade
union policies threatened the traditional craft-based and more
conservative structures of the ILGWU; in fact, the IUNTW held
that

> the main tasks of the Canadian Party (The Communist Party of
> Canada) are the organization and leadership of the economic struggles, the building and consolidation of the revolutionary industrial
> consciousness and the consolidation of the Workers Unity League
> into a mass revolutionary union and the revolutionary opposition in
> the reactionary unions.[29]

The Party, it further maintained, must support the Workers
Unity League to develop and lead struggles against wage-cuts,
hours worked, working conditions, lack of security, etc. The
Workers Unity League covered all industries and Communist
Party members had to be members of the League.

The conservative reaction of the ILGWU to the strike of
January 13 is best illustrated by the words of Bernard Shane of the
ILGWU who reported to the *Toronto Globe* that when the Communists called their strike, the ILGWU went around to the shops
cautioning their people that there was a *proper* way to handle a
trade union dispute.[30]

In an attempt to pursue "proper" or "correct" trade union
techniques, the ILGWU, on February 25th, called out the Toronto
dressmakers once again. The demands put forward by the ILGWU
for higher wages, shorter hours and better working conditions
were not unlike those demands put forward by the IUNTW in
January, but the second strike was not based on the same objectives

*The Industrial Union of Needle Trades Workers of Canada's *Report of
the National Convention, Toronto, May 23-25, 1931* reports that 400 went
out on strike. *The Labour Gazette*, February, 1931, however, reports that
200 workers went out. The real figure is probably somewhere in the
middle.

as the IUNTW. On the contrary, the ILGWU strike call appears to be more a reaction to the Communist gains made among the unskilled, non-unionized needleworkers than an attempt to defend these workers against the oppressive work conditions of the time. The fact that the Communist demands were adopted by the ILGWU in its strike programme and that it hurriedly organized the previously neglected dressmakers point to this conclusion. While the action of the IUNTW in January failed as a first attempt to mobilize unorganized garment workers against their intolerable working conditions, in the long term it was successful in forcing the ILGWU to take an uncharacteristically progressive position on the organization of unskilled workers.

Although these two strikes were not initiated by the dressmakers themselves, the demands put forward by the two unions did speak to the real need of the workers for higher wages and better working conditions. It is important to emphasize that in spite of the fact that these strikes did not grow out of an increasing consciousness on the part of the dressmakers of the need to unionize, they were a long overdue challenge to the intolerable conditions under which the workers sweated in the garment trade.

In times of crisis the union movement's interests have sometimes coincided with the immediate needs of women workers, but in general, the movement has not evolved a programme of long-term benefits for women. Until recently, these workers were not even able to articulate such long-term demands; this is because they never perceived themselves as *real* workers. Women were thought of and thought of themselves as transient workers. In 1931 the number of women who worked was only 20 percent of the female population; the other 80 percent of women in Canada were still in the home.[31] Since the majority of women did not work, and those who did usually did so only until they were married, there was little contradiction between the prevalent ideology of the female role in society and the actual condition of women at that time. However, the germ of the contradiction was there, since 20 percent of the female population *was* working and, during the Depression, was working out of economic necessity.

The problem of women's consciousness at the time was that although the exploitation of women workers was explicit, to say the least, the ideology under which they laboured made it unlikely that they would rebel. Of course their place was in the home! Of course they would only work until they married! Certainly they

were transient, and their position in the workforce was dominated by their marital possibilities. They were socialized to be passive and once in the workforce, they were either paternalized or terrorized into being productive and uncomplaining. The objective base was there to provide a consciousness of themselves as workers, but the ideology of the time hindered the development of such awareness.

The dressmakers' strike of 1931 is typical of the strike experience of women, even to the present day. It resulted from extreme exploitation and was fought over short-term goals. Women's perceived and actual status as second-class workers meant that they were not able to use the union movement effectively. In the thirties, however, women made up only a small percentage of the labour force. Many of them were single, young, and easily exploited. They were concentrated in the industrial and unskilled jobs. Today they are in a stronger position because they constitute a larger and more permanent part of the labour force; they tend to be better educated and the expectations of women's role in society have changed so that it is now acceptable for women to work. Women are now recognizing their position as valuable and essential workers. These new conditions provide the basis for women not only to effectively organize and defend themselves as workers, but also to challenge the whole conception of their place in society and ultimately, one hopes, the society itself which has relegated them to an inferior position.

Footnotes

1. *Globe and Mail*, February 25, 1931.
2. *Toronto Star*, February 25, 1931.
3. *Ibid.*
4. *Globe*, March 6, 1931.
5. *Ibid.*
6. *Ibid.*
7. *Ibid.*
8. *ILGWU Convention Report*, 1932.
9. *Globe*, March 6, 1931.
10. *Ibid.*
11. Between 1928 and 1933 the highest value of goods produced in the Ontario Garment Industry was $49,932,060 in 1929, just before the crash. The amount of capital invested in the industry in that year was also a high of $24,433,632. The number of employees decreased by 3,007 with an accompanying decrease in the amount of salaries and wages paid out of $7,575,297, in the years between 1928 and 1933. (See Tables 1, 2, 3 and 4).
12. *Census of Canada for 1931: Occupations and Industries vol. 7*, (Ottawa: King's Printer, 1936), Table 26, p. 37.
13. Deputy Minister of Labour Files for 1934-45. Letters to the Minister of Public Workers and Labour, Archives of Ontario.
14. *Ibid.* It is difficult to determine from this source how widespread this public response was at the time, but the idea of "women's place is in the home" probably did arise as a response to similar work situations as that created by the Depression. These letters were taken from one of the few files which the Deputy Minister of Labour kept on women and was in a box specifically marked "married women."
15. From an interview conducted in Toronto on Dec. 10, 1972. The woman interviewed was a retired machine operator of Ukranian heritage. She was one of many women who used her maiden name when applying for work during the Depression.
16. Anonymous Report entitled "Information Regarding the Tailoring Trade in a Small District of Toronto," from Deputy Minister of Labour files, 1916-1920 in Archives of Ontario.
17. *Ibid.*
18. *Labour Gazette*, February 1931, p. 188.

19. Deputy Minister of Labour Files, Archives of Ontario.
20. *Ibid.*
21. *Ibid.*
22. "Statement of Cloakmakers' Union of Toronto Regarding the Condition of Workers' General Strike," 1931. Deputy Minister of Labour Files, Archives of Ontario.
23. Figures in this section calculated from *Canada Year Book* from 1924-1935. They are derived from the tables on "Statistics of the Number, Capital, Employees, Salaries and Wages, Power, Fuel and Materials, and Values of Products of Canadian Manufacturing Industries."
24. *Ibid.*
25. "Statement of Cloakmakers' Union," Deputy Minister of Labour Files, Archives of Ontario, 1931.
26. and 27. Figures in these sections calculated from *Canada Year Book*, from 1924-1935.
28. Industrial Needle Trades Workers of Canada, *Report of the National Convention May 23-25*, Toronto, 1931.
29. *Ibid.*
30. *Globe and Mail*, January, 1931.
31. Calculated from Tables in Canada, Bureau of Statistics, *Canada Year Book 1934-35*, (Ottawa: King's Printer, 1935).

Table 1

Number of workers in the Garment Industry in Ontario between 1928 and 1933.

Year	Total	Women's clothing factories	Men's clothing factories
1928	13,626	9,387	4,239
1929	12,963	8,783	4,180
1930	12,458	8,272	4,186
1933	9,854	6,387	3,467

Table 2

Salaries and Wages Paid Out in the Garment Industry in Ontario between 1928 and 1933.

Year	Total	Women's clothing factories	Men's clothing factories
1928	$15,648,738	$10,422,830	$5,225,908
1929	14,698,759	9,232,035	5,466,724
1930	13,452,920	8,544,045	4,908,875
1933	8,073,438	5,032,366	3,041,072

Table 3

Gross Value of Production in the Garment Industry in Ontario between 1928 and 1933.

Year	Total	Women's clothing factories	Men's clothing factories
1928	$49,320,307	$32,457,143	$16,863,164
1929	49,932,060	32,499,648	17,432,412
1930	42,522,592	28,876,839	13,645,653
1933	26,280,694	17,116,389	9,164,305

Table 4

Capital Investment in the Garment Industry in Ontario between 1928 and 1933.

Year	Total	Women's clothing factories	Men's clothing factories
1928	$23,822,230	$13,825,601	$ 9,996,629
1929	24,433,632	13,091,553	11,342,079
1930	22,246,435	11,644,209	10,602,236
1933	14,736,198	8,434,892	6,301,306

Table 5

Average annual wages paid in the Garment Industry in Canada between 1928 and 1933

	Men's clothing industry		Women's clothing industry	
	Wages pd. on a weekly basis	*Piece work*	*Wages Pd. on a weekly basis*	*Piece work*
1928	$1905	$ 994	$1981	$899
1929	1828	1078	1945	884
1930	1851	955	1910	864
1933	1420	725	1488	660

Women's Organization: Learning from Yesterday

In some important ways, this article has as much to do with today, as with the period that it covers, the late 1920s, because the research was prompted indirectly by several months discussion about the future of an "autonomous" women's movement. Discussions have been sifting through many women's groups about such apparently diverse topics as separation or autonomy vis-à-vis the left with regards to organizational structure and strategy; the "productivity" of housework; and organizing women in the workplace and the community. Yet there is one unifying question underlying all of these debates: what is the basis of women's political power? This question is only now beginning to be posed in a Marxist-Feminist understanding of women's historical role in capitalist production, and in the anti-capitalist struggles of the working class. This article comes as a contribution to this developing perspective.

The original outline of the article has changed several times as these discussions developed. In the beginning it was to be a social history of women in the trade union movement. Not only was it difficult to find materials by and about women's participation in the trade union movement, but it became clear that this was an arbitrary category, adopted from the struggle of another section of the working class, which aided very little in elucidating particular lessons for women. What was needed instead was an analysis of woman's particular conditions of oppression and exploitation, and her resultant attempts to organize. From this analysis of her own activity, we could also put her role in the trade unions in a much clearer context.

The article is now framed by two women's struggles at the turn of the twenties, one a meat boycott in the Jewish community of Toronto, the other a textile strike in Hamilton, Ontario. In looking at these two events in some detail: how they came about, who and what they organized, and the reasons for their success and failure, I hope to raise some questions about how the conditions for organizing have changed, and what we can learn from this.

The general theoretical methodology for analyzing these changes has also developed during the course of writing and discussion. In the beginning the article was too much of the "liberal social history" genre; part of the vague and often classless search for a tradition of Canadian feminism to accompany the modern movement, much like the parallel attempts to recreate an authentic Canadian culture. Where the article moves away from this style, is not in the emphasis given to documenting the everyday lives and struggles of working-class people. The difference is a greater interest in documenting accounts of struggles in a clearly Marxist context, in an attempt to draw out patterns relevant for today. For in analyzing history generally, and the developments in the mode of capitalist production in particular, as a dynamic of the class struggle, many recurring tendencies become clearer.

Capitalism has drastically altered most of every part of people's lives. Changes in the family, in the role of the state, and in the development of the mass consumer society, to name just a few, have considerably altered women's role in this society since 1930. Yet there is an essential unity between the pre-capitalist and the capitalist periods. If we analyze how the above occurrences have altered the structure of woman's work, and therefore the possibilities available to her for struggle, we can see the more general overall development of her political power as a section of the working class. For women this means analyzing the organization of her work in the home, and then outside of it. How did these two organizations provide a common basis for her understanding of her oppression, and a common base for her struggle against it? What was her relation to other powerful sectors of the working class?

This article is really only a beginning exercise in developing such an analysis. It covers just two high points of women's political involvement. Much important background is not covered because of space, time and lack of theoretical work yet done in this area. The paper also leaves out a whole discussion of the role of

political organizations, most importantly, the Communist Party. Hopefully some of the other articles in the book can provide some of the missing historical background. The developed analysis of women's struggle can be started with the empirical articles in this book as a beginning.

Introduction

> The modern system of machine production has resulted in an entire change in the life and occupations of women.
> Through the machine process the bulk of the home operations have been transferred to the factory, thus the labour of women has been reduced, either to household drudgery, or it has been converted to wage-labour.
> The machine process has done more. It has brought about a division of labour so great, that the entire labour of the working class is necessary for the smooth operation of any one branch of industry. In this great wage-labour process, the labour of the women is just as much an essential factor as the labour of the men...
> No working-class struggle is effective, no movement complete, without the sympathy and active support of the women. The wage system, its effect on home and workers, men and women alike, forces action of some kind. The kind of action that will benefit the whole working class must be the joint action of the working men and women on the road of struggle, the end of which must be victory for the workers and a New Social Order.[1]

As this document from the Federation of Women's Labour Leagues indicates, by the 1920s in southern Ontario the wage labour system was the over-riding determinant in most people's lives. It had brought massive changes in everyone's working and-living situations. Ironically, in its reckless, rapid development which had totally restructured the world, it was possible for many to see a totally new system. Capitalism, historically unique in its introduction of socialized production, had produced the conditions for its own overthrow. In other words, as it organized production, centralizing the labour of the working class in ever-increasing social units, it also provided the material basis for the working class to overthrow it. Industrialization had made it possible to foresee a society without want, where the workers would run production for the greatest social benefit.

Recent developments in Europe had also strengthened the revolutionary perspective of Canadian militants like the Women's Labour Leagues. The 1917 Russian Revolution, and the factory

The working women of Canada are almost entirely unorganized on the fields of economic and political class interests. Here and there small groups of working women have banded themselves together to take up the struggle against great injustices to working women and girls. With the limited means at their disposal they have attempted to organize the women and girls working in shops and factories into unions, while they have also endeavoured to interest working women in labour politics.

Throughout Canada, there are some fifteen Women's Labour Leagues and Clubs doing work of this description. But each is working in its own way, each is self-centered, knowing little of the work and the struggles elsewhere, yet each has now reached the point where it recognizes the need of centralized effort. In view of this the present conference has been called. The unanimous opinion of this conference is 1) that the local Leagues must be strengthened in order to be able to act as a stimulating force capable of bringing the women of the working class into the Labour Movement for united class action...

With this beginning the Federation of Women's Labour Leagues was formed in Canada in London, September, 1924. Many of the women originally involved had worked in the Scottish Labour Movement, or in the British Labour Party. Some of the key speakers at this conference, like Annie Buller representing a Nova Scotia League, and Florence Custance, the Toronto secretary, were later to take up influential positions in the Communist Party.

The London convention brought together some working women, but mainly housewives. There was also a resolution passed at the convention to bring together farm women, who the convention recognized were part of the same profit-oriented system of production as they were.

The local groups were of an agitational or educational nature. The Hamilton group, for example, had sponsored a letter writing campaign to the Federal Government, protesting the meagre subsidy given to immigrant women, as well as supporting a strike of theatre workers. The Drumheller and Sydney delegates told of the support work they were doing in these mining communities during the long strikes.

There was a general resolution to do more educational work, including the establishment of a working women's newspaper. The newly established Central Executive Committee was delegated the responsibility of preparing special bulletins relating to the lives of working women, to be discussed by members of each local league. Each local was to arrange a course of lectures open to the public, as a furthering of their educational work.

The general aims of the Federation at this time were related to women working in industrial jobs. They saw the importance of organizing women workers into the union of their industry and the wives of trade unionists into auxiliaries. They also saw the importance of campaigns around equal pay for equal work, higher wages, injury compensation and shorter hours for nonindustrial workers not covered under the law.

If there was any doubt about the link to the Communist movement of the Federation in 1924, this was dissipated when the second document was written in 1931. The Federation was involved in many of the same campaigns as the Worker's Unity League in their trade union and parliamentary work. These legislative campaigns included the above mentioned general aims of the Federation in 1924, as well as old age pensions, mothers' allowance, free maternity care and free day care, food, and clothing for the children of unemployed workers. They also protested against child labour and night work, and were involved in some community struggles against the high cost of living.

One document, by a leading member of the Communist Party, Becky Buhay, indicates the potential it saw for the Women's Labour Leagues. She saw them as a mass-based group that could be turned into a revolutionary body, under the direction of the Workers' Unity League. She also elaborated on how the Leagues could be useful for recruitment to the Party, or to its many front groups.

occupations of the German workers' councils had demonstrated how workers were taking over production from their respective backward bourgeoisies. But in Canada, capital was able to adapt itself and there was to be no revolution—not yet.

The Canadian ruling class, like all others, had mastered well many techniques of divide and rule. For although it was necessary for most labour to be brought into the orbit of capitalist production, it was not all of equal weight or equal bargaining power.[2] Capital had instead organized it into a series of hierarchies, each with a corresponding limited function, scale of wages, and bargaining power. The strongest of these divisions of labour within the working class continued to be the oldest, the sexual divison between men and women.

We can see how this hierarchy of labour power operated for the women of the Toronto Labour Leagues who produced the previously quoted document. Seeing the importance of women's contribution to the general class struggle, they had applied for membership to the strongest section of the class at that time, the national Trades and Labour Council (TLC). They had already been accepted by the Toronto chapter, but the national body turned them down by ten votes. The principal objection was that they were not "producers."

> One can answer this objection by referring to the firefighters, the letter carriers, the street railwaymen, and the street cleaners, yet these are allowed to enter the Congress. The members of the Labour Leagues are mostly housewives and wage-earning houseworkers, women who cook, sew, wash, scrub, and who perform duties necessary to the whole process of production. One day those objectors, who, in mentality, belong to the Middle Ages, will wake up and find themselves living in an age of social production... [3]

Today there is also a lot of discussion about the "productivity" of the housewife. As in the days of the Labour Leagues, this question is most important in how it defines her social power in relation to capital, and in this case relation to the other stronger sections of the class.[4]

In pre-capitalist society, the family was the basic unit of production and reproduction of goods and labour power. Woman's labour—farming, garment-making, cleaning, nursing, looking after the kids, and her husband's sexual needs—was part of the labour necessary to the total family product. With the advent of the

modern family under capitalism, labour was split into two separate spheres: commodity production done mainly by men in industry, and the unwaged domestic labour of the woman at home. Socialized production has gradually removed the traditional household tasks from the family unit and its primary responsibility has become the production and reproduction of labour power. To the extent that the housewife goes out of the home to do many of the same tasks earlier done in pre-capitalist days in the family unit, she is waged. Her labour in the home is unwaged and appears totally separate from the sphere of economic production.[5]

We have only to look at the letters to the editor column of the *B.C. Labour News* to see how one woman expressed this separation.

> I can understand in a measure why men, our husbands, fathers and brothers, are interested, and accordingly devote much spare time to their respective union duties. But for the life of me I don't see why apparently sane women, housewives and mothers of growing children, the dictators of tomorrows citizenship, can conscientiously waste a whole afternoon each week diagnosing and attempting to treat the ills of industry. Personally I find that the proper care of my house and two children require an average of fourteen hours each day. If I have any spare time I have always found that it would and could be quite profitably spent in devising ways and means for stretching my husband's meagre wages to comply with the ever-increasing cost of living.[6]

The separation was very severe when a working-class woman could work fourteen hours a day, since the pay cheque was so meagre, to bring up two future workers and maintain the life of one present one. The unwaged labour of the housewife appeared as the independent sphere of the working class reproducing itself. In many ways, because of this, the mode of production of the housewife has been described as pre-capitalist. For she produced goods and services for use within the family, and not for exchange. Her work was in small atomic units, separated from the other family members who also received a wage for their work. She worked with others only to the extent that she shared her workspace with her neighbours, children or relatives.

Her work was also private to the extent that she produced goods and services not yet socialized by private capital or the government. These two major forces were beginning to influence the role and work of the housewife. There was not a large mass

337

consumer market as "store bought" goods: clothes, furnishings and prepared foods were still being made at home. While the last vestiges of small commodity production were being removed from the home, the family was still totally responsible for the reproduction of labour power. There were public schools, but they were only beginning to produce the modern industrial workers. Welfare, the Unemployment Insurance Commission, pensions and medicare did not exist at all. Much of this social legislation was only implemented during the depression, after long campaigns led by the communist and social democratic movements.[7]

The much-touted protestant work ethic of the family, in the 1920s had a material base in the real need for self-reliance and thrift in working-class families. Much of this charity-proud, anti-welfare attitude of course continues to the present day, and as another letter from the *B.C. Labour News* (1922) indicates, has much to do with masking the real causes of poverty.

> ...While the major portion of the followers of the greatest and yet most common profession, home-making for the producers of the nation, spend their entire time in a fruitless attempt to adopt the environment of themselves and their families to comply with the effects of an irresponsible social system, so long will we have labour troubles, social evils and the increasing demand for charities of all descriptions...
> While mothers of the working class (are)...too busy with duties of the home...to offer resistance to the forces which drag 70% of their boys and girls into...industry, when they are yet mere children, so long will we lack the educational facilities to which these children are entitled. When the workers and especially the mothers of the workers realize that there is no just cause for any lack of commodity necessary to our best interests, when they understand that the cause and cure of our industrial and social evils lie in their hands, then will we mothers be in a position to conscientiously spend all of our time in our homes if we so desire...

Looking back at the social power of the housewife, she was beset with difficulties. She was isolated, worked long hours, with very little time for any outside activities. In working for the "love" of her family, in a period unaided by any welfare state social services, many were dependent on her, and also saw her job as one of the most fulfilling available. In many ways she did have more control of her day-to-day work process than any other workers.[8] Yet, she was seldom seen and seldom saw herself as a worker. The

workers precluded her involvement in specific struggles, and if she did initiate action, support from other sections of the working class was often lacking, as we've seen from the TLC's rejection of the Women's Labour Leagues' application for membership.

Yet like most developments in capitalism, this separation and estrangement of women from the political process was uneven. Both the suffrage and temperance movements have demonstrated the campaigns of some women for more power for themselves, and against the sexual division of labour. One way that women have tried to gain this power is through community struggles. We will now look in detail at the Jewish meat boycott of 1932 as an example of this tactic.

The Meat Boycott

This boycott was exceptional in many ways, for its time. Some of the background causes seem more familiar today, than in 1932. In looking at them we can see part of the potential base for women's power at the present time.

In 1932, the Jewish community, newly arrived from eastern Europe, had settled in the downtown Toronto area of Spadina, bounded by McCaul, Crawford, Bloor to the Lakeshore. This area was used frequently as a reception centre for incoming immigrants from abroad, as well as from other parts of Canada and the United States. The community, much like the Chinese in the same area today, was largely self-sufficient. It included Jewish homes and shops, and the factories of the garment industry where many were employed.

The garment trade, made up of hundreds of little shops employing anywhere from 25-200 workers, was the largest employer in Toronto at the time. A very high proportion of the workers were Jewish, some of whom had worked in tailor shops in eastern Europe. The makeup of the local union, the International Ladies Garment Workers Union (ILGWU) records this Jewish predominance, for the cutters' local, the only one dominated by English workers, was called the Gentile local. Sixty percent of the workers were women, many young and single, (or at least recorded as single to make it easier for them to get jobs during the Depression.)

The industry was highly labour-intensive, and one needed very little initial capital to set up a shop. But once established, it

was not easy money, for the profit margin was low, the competition high, and the bankruptcy rate astounding.

Predictably, the Depression hit the garment trades and in turn the Jewish community very hard. It brought dozens of plant closures, layoffs, and wage cuts. Any increase in the price of basic commodities would have made it very difficult for the working class. Actually, because of the way household goods were still produced by petit-bourgeois merchants, who operated under the classical market conditions and who were affected by supply and demand, the prices of many commodities dropped.

This was not true for the Jewish butchers. Meat retail was regulated by the religious congress, the Kehilah, which was responsible for sanctifying it. Since Jewish housewives had to shop at these butcher shops to obey the dietary laws, this price fixing in what amounted to a closed market, meant a virtual monopoly. The price of meat in these shops was almost twice as high as a similar cut in a Gentile shop.

Newspaper reports of the time give a partial and incomplete picture of events, but it seems that a power struggle was going on at the time within the Kehilah, between the Orthodox and Conservative sections. By the fall of 1932, the Conservative group finally won some representation in the Congress. Soon after, the price of meat went up from 5 cents to 15 and even 25 cents a pound. In response, the women organized a boycott.

Begun by women militants in the Labour League who had strong links with the Communist Party (CP), the fight soon spread throughout the community. Many small organizations of women, for example the local chapters of the synagogues, joined in the campaign. Groups from every section of the community—the left, the right, factory workers, and housewives joined in too.

The organizing began by leafleting door to door throughout the area for a mass organizational meeting at the Labour Lyseum, then on Borden Street. The meeting was packed, and the boycott began in earnest.

Every butcher was picketed each morning by small groups of women, often starting at 6:00 a.m. They tried to prevent anyone from going in, and often ripped the meat out of the hands of those who did buy, and threw it into the street. Some men joined in, although the groups were 90 percent women. Like most street demonstrations, some days it ended in court cases, but the police and the courts did not view the women as a serious threat. One

woman, Mrs. Shaska Mandel, described in an interview how she dropped the charge of assault against one butcher, only to have him assessed for all court costs, lawyers' fees and the cost of organizing the boycott.[9]

The meat boycott was not totally successful—it ended in a compromise. The price of kosher meat went up, but not to the extent originally intended.

There had been many community campaigns for which women were beginning to take social and political responsibility in the '20s and particularly during the Depression years of the '30s. Many had involved food issues, as well as housing, schooling and public health. Yet in my research, I found none that had the same impact as this meat boycott. Women in all sectors of the community came together around this issue in a way that, as already stated, was atypical of the period.

Like boycotts today, this one would not have been possible without wider organizational and political links to back it up. It is true that the monopoly of the Kehilah had crystalized the community interests of the consumer. The boycott was only effective, though, because of the other layers of organization: the homogeneity of the Jewish neighbourhood, the use of local organizations already established, and the direction of the militant women of the Labour Leagues.

At this time the housewife did not face monopoly production. Today, in contrast, supermarkets, chain and department stores are the rule, rather than the exception. This accounts in a large part for the increased use of the boycott as a political tactic of several groups, including the United Farm Workers of America, the Canadian National Farmers' Union, and the Dare cookies boycott,* and several Third World solidarity groups. There is another even more fundamental comparison that we can make with today. I hope to sketch the web of this comparison, to provoke more discussion and debate.

Since the '30s in Canada, and in most other countries, the major change could be characterized as the development of large monopoly corporations and the corresponding development of the State. If we look at the growth of these two sectors we can see how

*This was a strike in support of the women at the Dare factory in Kitchener, Ontario in 1972.

they have radically altered every component part of our lives. All aspects have become more and more integrated into capitalist commodity production. Everything that we create, even the most personal parts of our social relationships, have been reduced to commodities, to be bought and sold.

In a similar way, the production and reproduction of labour power has been taken over by the various government agencies —for example, Manpower in training people and locating them in jobs, Health and Welfare in its distribution of welfare, medicare and pensions.

These developments, like most under capitalism, have not been consistent. For even as the concentration of jobs, industry and people into cities continues, ironically so too does the isolation of the individual person and family. It is this atomization and alienation of everyday life that will probably become one of the most crucial problems in any revolutionary organizing in this country.

How have these changes affected women—their lives and their work? What new potential forms of struggle have they initiated? These are the questions that we must continue to answer in a more contemporary setting.

We have seen how women's lives have changed considerably in the last fifty years, both from an examination of the articles in this book, and probably for most of us, from conversations with our mothers, grandmothers, and other older women. The situation is certainly not radically different now—women still remain isolated in their primary role as housewife. Yet much of the work of the housewife is becoming more and more integrated directly into socialized production. Many of the jobs she used to do in the home: nursing, teaching, etc. have been removed and are now done by women working in plants, offices and shops with many other women, who are paid either by the State or by large private companies. Another important change has been the growing intervention of the State. The government, both through pressure from the working class, and also because of the needs of capital to organize a skilled available work force more efficiently, has taken over some of the responsibility for the reproduction of the labour force.

The political significance of these generalized projections is quite clear. For us it means that the private sphere of the housewife and her labour is being radically altered. It is from this understand-

ing that I think we should look at the significance of the recent wave of community struggles in Toronto, in which women have often played the principal role.*

Immigrants and their role in the Canadian economy

There is yet another aspect of the boycott which is similar to the situation in many neighbourhoods today. The homogeneity of the Jewish community provided the tight-knit social network and organization necessary for an effective struggle.[10]

Today, redevelopment in Toronto is quickly destroying many of the older working-class neighbourhoods, eroding the economic and social structures that sustain them. Many working-class families have left for homes in the suburbs, often to follow the local industries that have relocated there, or to take up Ontario Housing Corporation homes. The most solid remaining neighbourhoods in the downtown area are those of the recent immigrants—the Chinese, Italian, Portuguese, West Indian and Greek. Until recently, the traditional parliamentary politicians have been the major people to understand and use the political power of these neighbourhoods, by running "ethnic" candidates in elections. Recently, though, militants in these communities have begun to organize, using the community as the base.

Women and Organization

The boycott was also significant in the particular forms of organization developed by the women. The Jewish community was not unique in its traditional separation of labour and power by sex. The strength of the boycott was that the women were able to use the traditional women's organizations composed from this sexist division; and also to develop new forms. Much of the organizational base of the boycott, the social network, was provided by the ladies' chapters of the local synagogues. Their membership did most of the leafleting and picketing. Through their constituentcies, the boycott was able to reach large numbers of women, in direct personal contacts.

The leadership of the boycott, though does not seem to have come from these groups, but from the women of the Labour

*for example, Women Against Soaring Prices (WASP), the Mother-led Union

Leagues. It was this new group which made the boycott significant. Their politics came together from two sources. Many of them had worked in the garment trades and had been involved in the numerous general strikes that had taken place. Some had also become socialists through the influence of the Russian Revolution. Much of the Toronto Jewish community had come from Eastern Europe, some having been involved in the revolutionary years starting in the late 19th century. The Russian Revolution had also won many Jews, because of the early Soviet promises of an end to discrimination against them.

This political leadership of the Labour League women added to the day-to-day organization of the boycott. They were able to bring to the house-wives' fight a wealth of experience and the tactics developed in the garment strikes and also in the activities of the left-wing movement. In a sense they operated as a class vanguard using the tactics and organization they had developed in one arena, to increase the power of women in another area of struggle.

In a long-term way, their organization provided the crucial link, developing women's social power beyond the limits of the community and workplace alone. In bringing the power they had developed in fights with the garment bosses, they strengthened the housewives (and they themselves were of course housewives) against another set of merchants, the butchers. In developing an organizational strength for women fighting for more political power for themselves, they also threatened the traditional division of power within the working class itself. From now on, their own men would have to listen to them more as well.

Something more should be said here about the origin of the power of the Women of Labour leagues. The leftwing political composition of the Jewish communities, and the homogeneity of it, were important reasons for the beginnings and the growth of these organizations. Contrary to much traditional Marxist writing about women, the Leagues did not come into being just with women's entrance into waged work. Their power was an exception among waged workers at the time, based on women's work in the garment trade, which had the most socialized conditions of work for all industry at the time.

Most women workers at the time had much the same scope for organizing as the housewives. Their workplace power was thwarted by the small units they worked in. In fact their primary role as

housewife determined in many ways the particular limitations of their struggle.

The position of the unwaged woman in the home threatened the bargaining power of the waged woman. Coming from a dependent situation at home with no money of their own, women would accept smaller wage packets than men. This reserve of unwaged housewives reinforced job competition, and made strike action difficult, since there were always more workers available, and low wages made long strikes very difficult. There was also no job protection on the basis of skill, or seniority for the woman waged worker. Her skills were developed in the family, and there was no shortage of workers with similar training. Any seniority was undermined by her "nobility" because of her later role as wife and mother.

Thus the traditional organization developed by male workers with the socialization of industry, was jeopardized for woman by her role as housewife. The constant threat of the reserve army, the "emotional blackmail" of those in "essential services" and the small shops combined to make workplace power almost impossible.

The Strike in the Textile Industry

The Hamilton textile strike of 1929 emphasizes many of these problems, but raises some insights into new forms of struggle for women.

In 1928, there were at least 125,000 women in manufacturing. 64,000 were employed in the garment and textile industries, which were concentrated in Ontario and Quebec. These two labour-intensive industries employed the majority of women in industry.

The strike itself involved several elements. In microcosm, it shows the intensity of the class struggle at the time—primarily between the organized craft worker, and the modern industrialist—over control of the production process. This radically affected women workers, both in their relation to work in the factory, and to the craft union structure as well. It also starts an examination of the role of the government in labour disputes.

> *There were some separate organizations set up by the craft union movement to relate to women. One such group was the National Women's Trade Union League. It was started in Chicago and Philadelphia in 1915, by several social workers, and a few labour militants. They had all worked before in the Settlement House Movement, establishing community service centres for working-class people. They set up the League to aid working-class women.*
>
> *The League was designed (after an earlier British model) to assist in the unionization of women workers. It did not itself issue charters, but encouraged women to join the existing unions. After some hesitation, both the AFL in the States and the TLC in Canada agreed to endorse the League.*
>
> *Its platform included organization of women workers into trade unions, equal pay for equal work, the eight hour day, and the forty hour week. The League called also for an American standard of living, full citizenship for women, the outlawry of war, and closer affiliation of women of all countries.*
>
> *The League apparently had little success in organizing. Its most notable successes were in the 1919-1920 garment strikes in the States. Little of its activity is known in Canada.*

Development of the Textile Industry in Canada

The textile industry played a prominent role in Canada's early development. As in many other countries the textile industry was one of the first to be capitalized with the introduction of the factory and the changeover from small commodity production. This took place for the most part in the 1870s, although several small mills had been in existence since 1840 in Ontario and Quebec.

The textiles in many ways seem to be a transitional industry in the industrial process. They developed in rural areas and remained there for the cheap labour needed for such a labour-intensive industry long after most industries had left for the city.

> The craft union movement also had several women's auxiliaries. In the late twenties there were about fifteen of these throughout Canada, with a membership of about 800. The majority were attached to the Machinists, Railroad Unions and Building Trades. Some were also affiliates of the National Council of Women, a large federation of women's service clubs, and patriotic organizations, including the I.O.D.E. and the Girl Scouts.
>
> These auxiliaries were not by and large active in the working-class movement. They were mainly made up of trade union officials' wives, with a few rank and file members. Their main functions were sewing circles and card parties, with an occasional lecture that seldom talked about politics.

Unlike the garment trade, corporate ownership of the textile industry was consolidated to a large extent around the turn of the century. Many of these early merged companies maintained their competitive lead, at least until the Depression. Several more companies were formed with the development of the mass consumer market at the time of the first world war. The importance of this integration becomes clearer later on.[11]

The World Market

Many other countries, as well as Canada had a rapid period of growth after the war. This growth was curtailed soon after by a deflationary period in 1922-23, accompanied by a depression and crisis in overproduction. The international cotton market, so long dominated by Britain, became highly competitive for the first time. This was due to the rapid expansion of exports in other countries—the U.S., Japan, China and India. The new low labour and production costs threatened British control. This international view helps to explain many of the background causes for the strike, particularly as we look at the lessons that the Canadian manufacturers learned from their British and American counterparts.

Britain's long imperial dominance was not to come to an end: not just yet. While the industrialists of those countries that Britain

had exploited for so long now threatened its dominance, it still had the upper hand to again outmanoeuvre them with the accumulated capital from centuries of colonial expansion which could be reinvested in the industry itself. The major British firms set out on a massive campaign of consolidation. They amalgamated many companies, closed down several more in the Lancashire cotton districts and formed huge export combines. They also invested money in new machinery, directly laying off some workers, replacing others with cheaper, less skilled labour. This combination and recapitalization made it possible for Britain to maintain her primacy for a few more years.

Manufacturers in the States secured themselves in many of the same ways. With the traditional "Yankee knowhow" they were also able to expand their markets with new uses for cotton, in the rubber and auto industries, and also in the making of footwear and linoleum.

The market in Canada could only reflect world patterns. Canadian manufacturers could not compete with the low production costs of imported goods, and had trouble even supplying the domestic market. Most non-staple items were not even made in Canada. Producers seldom could hold their own in cotton goods, and American manufacturers controlled much of that market. The Canadian textile industry was clearly on the edge of a crisis.

It responded in the same predictable fashion as its British and American counterparts. Manufacturers had few other choices. They could try for more tariff protection; or they could consolidate internally, reducing competition through mergers and the forcing out of inefficient companies; or they could try to lower production costs. The first two alternatives were not very realistic. They had real difficulty in getting adequate tariff protection, as they couldn't supply the market even if it was closed for them. They had already consolidated the industry about as much as possible. Most of this had occurred before the war, so that by 1928, the thirty plants operating were controlled by seven or eight companies.

The last possibility was to rationalize the production process itself. If companies could find the necessary capital to break the small amount of control that the workers had over the work and wage process, they could increase the value exploited from every worker. Industrialists throughout North America bought themselves the techniques of "scientific management" for the job. The resulting layoffs and speed-ups could not be instituted without a

series of militant strikes throughout North America. One of these occurred at the Canadian Cottons Ltd. plant in Hamilton, Ontario.

Canadian Cotton Ltd.

Financial Post, the major business newspaper, records Canadian Cotton Ltd. as "one of the strong well-established cotton textile companies".[12] Its development seems typical of the larger concerns. It was started in 1891, as the Canadian Coloured Mills Ltd. The company rapidly took over several other mills in southern Ontario and New Brunswick. For a period of ten years, they also controlled the production of Hamilton Cotton Co. and the Gibson Cotton Co. in Marysville, New Brunswick. Although there had been no new mergers at the time of the strike, the directors were strengthening their power in other ways. Several of the directors had holdings in other textile companies. The president and managing director was also a director of the Bank of Montreal. At a lower level, the Hamilton plant manager was chairman of the Ontario Manufacturers' Safety Association, in the textile section.

Canadian Cotton was one of the largest companies in Canada. It employed over 3,000 workers in eight plants in New Brunswick and Ontario. Dominion Textiles was the largest with 7,500 workers.

Fly Frame, Verdun Mill, Dominion Textile Co. Ltd., 1929 (Public Archives of Canada)

Yet even they were experiencing economic difficulties. This letter from the President of the company to the workers at the time of the strike illustrates some of the problems.

> Dear Fellow Workers: Although I happen to be president for the time being of Canadian Cotton Ltd., I am addressing you as a fellow worker because we are all making our living by working for the same company and our interests are therefore mutual. As a chain is only as strong as its weakest link, we must all suffer together when there is a breakdown in any part of the organization.
> *Some Facts*
> 1. Mills in other countries are trying to take Canadian trade away from Canadian cotton mills.
> 2. A majority of these mills pay lower wages than Canadian mills pay. In some cases wages are down to about 50% of our standard.
> 3. Ontario mills run 50 hours per week. Some of our foreign competitors run from 110 to 120 hours per week.
> 4. Ontario very justly prohibits women working at night in cotton mills. Many of our competitors are located where this is allowed.
> 5. Canadian mills, because of the size of the population of Canada, are obliged to diversify their products in order to meet all of the needs. Our competitors can specialize.
> 6. In view of the above facts our Canadian mills must reduce their costs by modern methods or go out of business. A good example of this is found in New England, where a large number of mills that have stuck to the old methods either have gone or will soon go into bankruptcy.
> 7. The newer methods to which some of you have objected will, if carried out, do the following: a) actually make your work easier than it was a year ago (all jobs are laid out with a reasonable rest time); b) reduce manufacturing costs so that the mill will survive; c) pay higher wages to all those whose jobs are altered.
> 8. As evidence that the company has always done its best for its employees, I would remind you that it has spent many thousands of dollars to improve machines and running conditions even though the Ontario mill lost $90,000 last year.[13]

Internal reorganization was not just the last choice left. It was also the most obvious. There had been no changes in the spinning methods for sixty years. If we look at the orthodox economic theories of the time we can also see the source of the choice. For it was a popular conception that in a period of recession, capitalist profits had to be defended by decreasing the workers' wages and creating unemployment. Scientific management techniques

clearly were a negation of the power of the working class and resulted in both wage cuts and unemployment.

Workers' Power and Taylorism

In 1928, Canada Cotton Ltd. hired the Textile Development Co. Ltd. of Boston to do an overall reorganization plan of their Hamilton plant. This use of professional consultant teams was not unique to the textile industry. Production analyses were being used in all major industries, after the pioneering of Henry Ford. They represent the epitome of a remark once made by Karl Marx: "It would be possible to write quite a long history of the inventions made since 1830 for the sole purpose of supplying capital with weapons against the revolts of the working classes."

Scientific management was developed first by an American, Frederick Taylor, at a time when the craft unions were very strong. The craft worker was a very essential and powerful element who virtually ran the shop floor day to day. In the larger industries this meant hiring the unskilled helpers, assigning tasks, and controlling the methods used in each work process. Any industrialists trying to expand their production and profit had to work through the organization of the craft workers.[14] Taylorism was a series of techniques designed to alter this control. The "science" consisted of analyzing the way the workers had organized production on the shop floor, and inventing methods to destroy it. This included destroying both the organization that allocated the jobs, and the actual work processes making up each skill. For the industries in which craft-control predominated, particularly the auto and steel industries, the techniques introduced were the assembly line and measured day work. These techniques broke the skills into several monotonous unskilled jobs, regulating their timing to demand the maximum output, and effectively tied the worker to the machine. No longer did the workers as a group organize the process; control and knowledge were removed from them and handed over to a new hierarchy of foremen and technicians.

Scientific management began to be used in the textile industry during the depression of 1922-23. The actual purpose for its use and techniques used were somewhat different than in the larger more capital-intensive industries. For the textiles already used a majority of unskilled labour. Its implementation for them meant a

further rationalization of the job and an establishment of a new hierarchy based on "skill."

Time studies were used to analyze the most efficient method for a task, and to tie the workers to a production quota based on this faster speed. The former jobs of the spinner and weaver were divided into two, one for a "skilled" worker to join the broken ends, the other for an "unskilled" worker to clean the machines and keep them supplied. This not only increased the number of machines each girl had to attend, but set up a new arbitrary division between the "skilled" and "unskilled." It also increased the monotony and the amount of walking involved. This introduction of lay-offs, speed-ups, and job division produced a production increase of 300 percent.

The strike at Canadian Cottons was in direct response to the introduction of production changes in the Hamilton factory. The Textile Development Company had arrived in January. Immediately after they arrived, they conducted time studies, particularly in the spinning department. In a couple of weeks they presented their general recommendations. Numerous changes were to be made in production, to simplify the jobs and increase the speed. They also recommended new high-speed machines.

On Tuesday, January 20, two girls walked out of the spinning department followed by several others. By the next Monday, 600 women and 150 men were out. Their press release recorded their perception of the events.

> On January 1, Canadian Cottons Ltd., decided to install a new system of working conditions under the direction of an imported efficiency expert. After the employees had been under surveillance for several days, the experts put into operation a new programme in the spinning room, which dispensed with the services of four of nine girls and holding the remaining four girls repsonsible for the entire equipment. As has been stated by the management, a wage increase of 11% was offered to the four girls to do more work. Realizing that if this system was put into effect throughout the entire mill many would be jobless, and after one girl had reached a state of collapse, the mill hands decided to withdraw their services until conditions were remedied. Many large mills in the New England States now employ the old methods which prevailed at the St. James Street north mill, prior to the system being introduced.[15]

They also objected to the machines being cleaned while they were operating them. This was confirmed and criticized by a provincial factory inspector.[16]

Alex Adams, the local manager, and president of the Ontario Manufacturers' Safety Association, denied the cleaning objection. Yet otherwise, his statement to the federal investigator concurs with that of the strikers.

...a few weeks ago they recommended that we should start rearranging our workers so that skilled help will not be required to spend time doing labouring or cleaning work. We first started on this work in the spinning room a few weeks ago, but before making any changes we put a man in to make time studies, and he explained fully to the spinners who agreed to make the first trial, that it would take a little time to determine just the proper number of frames a spinner could attend to without unduly taxing her...the spinner was given ten frames to look after...Her wages were advanced...under this new arrangement. Beginners were put on the work of cleaning the frames. Also a spare spinner was appointed to help the regular spinners...The change in that department was put into effect, and apparently the workers were well satisfied. We attempted to proceed with this extension of labour into our 22 spinning room, and found that the workers were lined up solidly against making any change. They said that they preferred to continue as they had been doing, and would not even give the new system a trial. When we attempted to force the issue, two of the spinners left their frames and started around the room interviewing all the other spinners. As they refused to obey, the overseer was obliged to discharge them. This occurred on the afternoon of Tuesday, January 20th. The other workers in that room continued at their work until the usual hour for stopping, but they did not turn up for work on Wednesday morning, January 30th. The card room ran as usual on Monday morning, but they did not come to work in the afternoon.

...On Wednesday night, January 30th, we found it necessary to close down the rest of the mill...

...the strikers took the opportunity to form a Union. We attempted to start up the mill on the following Monday morning, and again this Monday morning, but not enough came to work...We will not now attempt before February 18th...

...We have met the Workers' Committee* three times and have given them the full facts and figures as to our position but evidently they are not willing to see our side of the case...[17]

*The Workers' Committee was formed the first day, by three women and six men. They declared that they would not return to work until things had been restored to the system prior to the efficiency expert.[18]

As far as I know, this was the first strike at the plant. The majority of the workers were young, single women, who had not been in a union before. For some of them this would have been their first waged job. The majority must still have lived at home, for their wages were too low to allow them money for separate accommodation, and living away from home was not an accepted practice at that time.

The strike originated among the more skilled workers in the spinning department. Yet all the other departments came out, realizing the potential threat to their jobs. For the conditions were already bad, with poor lighting and ventilation, and cramped conditions. The introduction of rationalization meant the threat of layoff for every worker. If not that, it implied an increased speed up and increased monotony for each job.

Strategy of the Strike Committee

The strategy of the young strike committee was three-fold: to maintain the work stoppage in the plant; to extend the strike to other plants; and to gather support from the labour movement. They were only partially successful in each area.

For the month duration of the strike, they maintained a militant picket. Every morning at 6:30 a.m. the police arrived to watch the 100-220 pickets. Each morning there was usually some squabble on the line, and the police were accused of strikebreaking.[19] By the end of the month, with no strike pay, and little savings on such low wages, some of the women had gone back to work.

On the same·day that the strike started, workers down the road at Hamilton Cottons came out in support for an hour. Their situation was much the same. Working conditions were very poor. The management there had just completed the financing for the "scientific" reorganization of the mill. There had been attempts to organize there before, but the workers had been outmanoeuvered by a pay raise offer from management. The same thing happened this time. The workers returned after an hour, with the offer of an 8% raise. On neither occasion was the money forthcoming from management.

The strikers were no more fortunate in their attempts for support from the labour movement. It's not clear how they arrived, but soon after the start of the strike, the Trades and Labour Congress (TLC) became prominent. (From this point on there is no record of the strike committee.) Many of the meetings were held in

the Labour Temple, and the local TLC secretary, H.J. Hampson, was often listed as spokesman in all newspaper accounts.

Two other sections of the labour movement had a small part to play in the strike. The activity of both the Workers' Unity League (WUL), and the All-Canadian Congress of Labour was similar. Both intervened mainly through leaflets, critical of the TLC leadership. Both asserted the need for an industrial union, as opposed to a craft one, yet neither opposed the unionizing campaign, saying that they did not want to split the ranks. Both posed their respective organizations as the only alternative to militants critical of the TLC leadership.

In contrast was the TLC strategy: get rid of your opposition through red-baiting; unionize the workers into a craft union; and settle the strike with the aid of federal intervention. Each time that the opposition groups attempted to leaflet, they were dismissed as "Commies", and the strikers were instructed to rip up the leaflets.*

The TLC sent early for the United Textile Workers Union of America (UTWUA) to organize the strikers. This craft union had been involved in many similar disputes in New England, with little success. They had received a lot of criticism from left wing industrial union supporters for their strike work. The most common criticisms were of the bureaucratic nature of their organizations and their craft sectionalism, throwing one section of the industry against another. This was the union the TLC invited to Hamilton. Once there, they signed up 850 of the workers into Local 16531. Five officers were appointed, only one a woman. After the card-signing, their work was limited. Yet, they still had the gall to intone at the end of the strike that the loss was inevitable since there had been no union there before!

After refusing support of other sections of the trade union movement, and bringing in a tame union, the TLC chose the government to help them out. Early in the strike, they asked them to set up a negotiation conference, but the company, within its rights, refused. Later, a letter drafted by the TLC chairman was sent, asking the government to intervene. When the Department of Labour representative did arrive, he was turned down by Canadian Cottons, and given a brusque reception from the strikers. In

*In fact only one of the groups was Communist, the WUL.

response, the TLC wrote a letter to the government apologizing for the strikers, for after all they were 90 percent women and girls, and the strike had been spontaneous.[21]

The TLC strategy failed miserably. Although the government officials might have been easier to work with than the strikers (from their point of view), these officials had no power to aid the situation, even if they had wanted to. The UTWUA had helped little, only commenting "as expected" at the end. And any larger solidarity action within the labour movement had been ruled out by sectional interests.

Toronto Carpet Manufacturing Co., 1928 (Public Archives of Canada)

Conclusion on the Textile Strike

I have as yet found no accounts of the workers' perspective of the strike. Indeed there is no further mention of the strike committee, or of any political direction from the strikers after the intervention of the TLC. From that point the workers' participation seems limited to the picket line, and the various mass meetings.

For a time the strike had threatened the company's profit margin and had ended some of its orders from suppliers. Yet after

a month the strike was over, with the company the victor. The new high-speed machines were installed over the next couple of years. The company quickly recouped its losses, and by 1931, two years later, was described as "one of the most efficient cotton manufacturing units in North America."

The workers' balance sheet showed several weeks without pay, and for many no jobs to return to. 350 had already gone back, before the end, while 300 returned afterward. Some of the others were able to find work elsewhere, although 200 were still jobless a month after the plant resumed operations.

The strikers from the beginning had had little chance of winning, tied as they were to the fortunes of such a precarious industry. The flimsy economic stability of Canadian Cottons could only have been maintained through the vicious layoffs and wage cuts, introduced under the "scientific management" programme. Nevertheless, several companies never did make it through the thirties. We must also remember that most of the textile plants were located in semi-rural towns with few other industries and job opportunities.

The strike and the power conflicts it reveals between the company, the union, and the women workers, can be seen against a more general backdrop. The women were not caught out simply under the forces of rationalization, in the creaking textile industry. The strike is also illustrative of the inability of the craft unions to develop a wider class offensive, beyond their sectional and very defensive traditional form of struggle.

We can see the roots of their strategy in their particular role in production. For a long time the essential nature of their skills for the smooth running of industry had given them the power to stop production at will. We have only to look at the accounts of the miners and railway workers to see the extent to which they used this lever in pursuit of better wages and working conditions, and in opposition to any technological change.

Their power had two sides, though. Ultimately the craft workers were tied to capitalist development. They never considered challenging the system, particularly the division of labour on which their power was based. They were in fact just negotiating the best rates of exploitation, "a fair day's work for a fair day's pay." If we understand this sectional limitation of the craft unions we can go a long way to understanding their inept handling of the strike. Their patronizing attitude to the women strikers was not

just a display of their male chauvinism, but rooted in their traditional ways of handling strikes and organizing. They knew of few alternatives. All they could offer was an International Union already proven bankrupt in similar disputes in New England; and the aid of a government agency, the Department of Labour.

We have seen how the conditions were created in the textile industry for women to wage a strike to maintain control of their working conditions. A homogenous group of young women had been brought together with a common understanding of their exploitation, and a base to organize collectively around it. The struggle could not be extended by a union campaign. The craft union could not offer the minimal job security and control over working conditions. The only concentration of women in industry was in labour-intensive trades, whose precarious nature tied them into the needs of the capital in this particular sector. In comparison, more capital-intensive industries like auto or steel had a higher rate of profit, and this allowed more bargaining power for the male workers.

Yet most waged women were not even in the relatively strong position of the factory worker. We will have to look for new forms of organization outside of the traditional ones, which are rooted in an analysis of woman's role at home and in industry.

Conclusion

There can be no definite conclusions from this look at only two women's struggles. Yet some definite patterns have emerged. It is quite evident from the research that there is a long history of women fighting in the workplace and the community, sometimes by themselves, sometimes with men.* They creatively used different forms of organization available to them, trying to develop links in other areas, as with the solidarity strike of the Hamilton Cottons workers and the involvement of both factory and house workers in the meat boycott.

I will now sum up some of the major points that I started in the introduction. One of the primary ideas I have tried to develop is how the class struggle adapts itself to changes in the capitalist

*As capitalism developed, these were more and more working-class struggles, directed against new focuses of capitalist intervention.

system. This has created many more arenas of struggle than just the point of production in the workplace.

I have also tried to show how woman's political power does not derive solely from her entry into waged work. An analysis of her particular role in production shows that her primary role is as housewife, waged or unwaged. Her presence in the workplace has no real permanence; it is always dependent upon the changing whims of capital. (Capital still needs women working at home.) The struggle against her role as housewife, against her domestic labour, does not *just* necessitate getting an outside job. After work women still have to come home to do their family's housework. The bargaining postition of woman in waged work is affected by her weak position as a housewife. We must look at woman's waged work as an organizational point for challenging her exploitation, but we must also emphasize her particular oppression as a woman—a housewife.

However, waged women are not tied to the sectional organizations of the workplace—the trade unions. This means that it is possible to go beyond the limits of the workplace and into the community, bringing together the struggle against the wage labour system in both spheres, so long separated. The meat boycott shows the beginnings of the ways in which women used the forms of organization available as well as creating new ones. Today we have to begin to analyze how to use the women's movement in this way to spread tactics and ideas and, more importantly, organizational power from one struggle to another.

There is another point to be mentioned here as well. The struggles that women make against the dominance of the wage labour system, for more time and money and better working conditions for their jobs, is usually a struggle against the sexual division of labour, and for more power for women within the class as well. This struggle of women, that challenges the way capital has organized the divisions within the class, strengthens the general class struggle. Women's fight against their housework, waged or unwaged is a fight both against the ways capital uses their labour to continue to make profits, and against the weakness of women in the working class. It is from this class perspective that I suggest we look at the possibilities for women in the revolutionary movement.

Footnotes

1. Conference Report of the Federation of Women's Labour Leagues. London, Sept. 1924.
2. See Selma James, "Sex, Race and Working Class Power" in *Race Today*, Dec., 1973 for a further discussion.
3. Conference Report of the Federation of Women's Labour Leagues.
4. For more material on this debate: *Radical America*, double issue on women, volume 7, no. 4 & 5; Mariarosa Dalla Costa and Selma James, *The Power of Women and the Subversion of the Community*; and Wally Seccombe, "The Housewife and Her Labour under Capitalism" in *New Left Review*, (Jan./Feb., 1974).
5. Eli Zaretsky, "Capitalism and Personal Life", *Socialist Revolution*, (Fall 1973), no. 13-14.
6. *B.C. Labour News*, 1922.
7. See box material about Women's Labour Leagues in this article.
8. Lise Vogel, "The Earthly Family," in *Radical America*, vol. 7, no. 4 & 5 for further discussion.
9. Irving Abella, Interview with Mrs. Shaska Mandel at her home, tape archives at York University, Toronto.
10. It is perhaps no coincidence that the immigrant communities of the thirties—the Jewish, Ukrainian and Finnish—played such an important role in the Canadian Communist Party. They were the most radical elements, not only because of their experience of the Russian Revolution, but also because of their exploited role as immigrant labour in the Canadian economy.
11. Most of this information comes from articles published, 1925-33 in *The Manual of the Textile Industry of Canada*.
12. "Survey of Corporate Securities," *Financial Post*, 1927.
13. *Hamilton Herald*, Feb. 15, 1929.
14. For a very thorough discussion of how this operated in the American steel industry see Katherine Stone, "The Origins of Job Structures in the Steel Industry" in *Radical America*, (Nov./Dec., 1973), vol. 7, no. 6.
15. *Hamilton Labour News*, Feb. 26, 1929.
16. Report of the factory inspector, March, 1929 in *Labour Gazette*.
17. Letter from Alex E. Adams, Manager, Canadian Cottons Ltd. to Deputy Minister of Labour, Feb. 11, 1929.

18. *Niagara Falls Review*, Feb. 1, 1929.
19. There were two strikers arrested; Delia Vanslett and Mary Krakauskas, who were charged with intimidation. In court they insisted on telling their own story, without the aid of the interpreter. Eventually the case was dismissed. *Hamilton Herald*, Feb. 27, 1929. Office of police court clerk, April 18, 1929.
20. C.I. Aitchison, Department of Labour correspondent, Feb. 25, 1929 in a report to the Department of Labour.
21. Letter from secretary of TLC to the Minister of Labour March 5, 1929. The secretary thanked the Minister for his help and regretted that the impression given by the strikers that the federal government not be recognized. He further said that the strike was a spontaneous outbreak, 90 percent women and girls over whom the TLC had no control. The secretary also enclosed a copy of the ACCL circular explaining "one problem." The circular was very critical of craft unionism, particularly the UTWUA handling of the New England strikes.
22. For further material, see Sergio Bologna, "Class Composition and the Theory of the Party at the Origin of the Workers-Councils Movement," trans. by Bruno Ramirez. *Telos*, 1973.

How to do Research

One purpose of this book is to encourage the writing of women's history, particularly concerning their economic role in society. The way women's history is written and disseminated into the community will be determined in part by who writes it. Traditionally, history has been written by male, middle-class academics, whose work reaches most Canadians in the form of a highly generalized high school text with a heavy emphasis on political, constitutional and military matters. Such history excludes women, for while they have been affected by those events, they did not shape them. Women were not politicians, statesmen, judges, or military leaders.

Economic and social history should deal with the development of the productive forces of a country, the role of the working class in that development, and the effect of that development on the lives of ordinary people. It should take history out of the textbooks and make it personal and relevant. It should be the history of your family, your town, the local industry (its technology, working conditions and effect on the town), your union, the local social and political groups, etc. This kind of history affects people's understanding of their present society. It is also a history that includes women.

It is no accident that this history has been neglected by academics, and that they concentrate on the role of the ruling class in society. While most of them may labour under the illusion that they are objective and neutral, they have been trained in the concepts, attitudes and ideology of the dominant class and sex, and, with some exceptions, will perpetuate these ideas in their

teaching and research. To do otherwise would brand them as radical and quite possibly endanger their salaries and research grants, coming to them through the universities, which in turn are funded by the state apparatus and by business firms. In addition, male academics have neglected writing women's history because of their male chauvinist prejudices. We cannot expect, therefore, that the history of women and their productive role in society will receive adequate treatment from this source; in fact, women are almost totally excluded from history texts.

Much of the writing of the history of women will have to be done by non-academics—by women who are excited about their own history—who remember stories told by their mothers and grandmothers, and who know that this history must be recorded. The purpose of this chapter is to share our experiences in researching women's history in the hope that it will help other women to continue our work.

Manuals on research usually advise a look at general surveys of a chosen subject. This advice is seldom helpful in researching women's history because our history is as yet unwritten. Almost all material will come from primary sources; at best secondary sources will enable you to put your primary material in an historic context. Your dependence on primary sources will limit your topic, particularly from a geographic standpoint. In our case, we intended to write a book on women in the work force in Canada, and were forced by limitations of time, energy, and available data to restrict our investigation to Ontario. While the scope of your topic will be shaped largely by the material you turn up, a good deal of unnecessary work can be avoided by starting with a topic of feasible size.

While most of your data sources will be written, some material will come through personal contact with participants in events or their descendants. They may provide interviews which you can tape, or have records and papers. Sometimes finding these people can be difficult. One of our writers tried sending questionnaires to old people's homes and received very little response. You may find that names of participants in a specific event will appear in newspaper accounts and you can trace them from there through telephone books and city directories. Whenever friends mentioned grandmothers while we were working on these papers we would enquire as to their occupation prior to marriage, in the hope that we would get an interview we could use.

When you do interview people, don't limit your questions to the material you think they may have. Involve them in your whole project. You may approach them for their personal recollections of an event and learn instead of some previously unknown newspaper material. Check out leads with subsequent sources; I was once told a participant in an event was dead, but when I casually mentioned this to another source, she retorted, "I can see his kitchen light from my window right now." It can become as exciting as a detective story!

Probably you'll begin research at the local library, often the archives for local primary material; there, you can also look at books on local history in order to establish the setting for your topic. You will probably find the reminiscences written by the Women's Institutes. Frequently libraries keep vertical clipping files under various subject categories that can save you months of going through newspapers. One suburban Toronto library, for example, has scrapbooks of all references to that community in Toronto daily papers from the mid-1920s to the mid-1950s.[1] The local librarian may also be able to suggest other papers and people who should be contacted.

Small libraries will probably pose no problems; finding material in large libraries can be quite difficult, because the system varies from one library to the next and because different types of material require different cataloguing systems. Be prepared to ask for help and don't be put off by a librarian who assumes that you are or should be familiar with the system.

Once you've checked out the library, you might look next at the relevant newspapers. In Ontario many go back to the 1820s. Checking them is tedious, time-consuming work, but they are probably our best source of data for details of everyday life, and accounts of events and attitudes. Keep in mind that one hundred years ago, newspapers were at least as biased as they are now; however, there is no substitute for the data they provide.

Government documents are somewhat useful because they often contain the only available statistics. Apart from federal records like censuses, you may obtain some occupational and sociological data from assessment rolls. Town council minutes, court records, police reports, and school board records may also be useful. The provincial government in Ontario, for example, did not keep verbatim records of the debates in the provincial House until 1948, but the journals of the House do provide a chronological

account of the legislation passed, and scrapbooks of newspaper accounts of the debates are quite comprehensive.

Institutional records can also be examined, such as those from hospitals, mental institutions, churches, jails, poorhouses, orphanages, and homes for destitute women. These organizations may have kept minutes of their meetings or put out annual reports. The Orange Order, Women's Institutes, farmers' associations, trade unions, the YMCA or YWCA—any such group may have records which reflect local problems and conditions.

Another useful source of information is company records. Old store accounts provide information on diet, cost of living, clothing styles, etc. The paper on domestics in this book based the household technology section on store catalogues. Businesses, however, are notoriously reluctant to grant access to researchers. With regard to personnel records, this attitude may be a legitimate desire to protect confidential information, although surely this is no longer necessary when sufficient time has elapsed. Other company records probably are not divulged because they do not present the company in a particularly attractive light.

Two rare sources of data are personal correspondence and diaries. These are frequently available from the upper class but seldom from the working class. This lack of personal data on the working class can be filled, for recent periods, by taped interviews with older people. Taped material has some limitations—people's memories as to dates and numbers are not reliable. But for general impressions of a period and for descriptions of living conditions and attitudes of the time, nothing can replace this technique. Making the most of interviews is an acquired skill, though a sympathetic personality helps. Give the people you are interviewing lots of leeway; let them discuss the subject in their own way. This minimizes the effect your preconceptions will have on their remembrances. It also gives you the story in their words rather than an interview consisting of your questions and their "yes" and "no" answers. However, *do* come to the interview with a check list of questions. They keep the interview going when it bogs down and you can make sure before you leave that all the necessary points were covered. The interview will be more useful in clearing up contradictions and filling in gaps if you have done a substantial portion of your research prior to it.

Don't contradict or argue in the interview. Proving that some recollections are inaccurate on some point will dry up the inter-

view. Scoring debating points is not the purpose of the exercise; collecting data is. You have an obligation to quote the material you obtain honestly and in context. You should consider sending the persons you interview a copy of the completed paper, particularly if their contribution was significant.[2]

Occasionally, however, you may require access to data or an interview with someone who disagrees with the purposes for which you are writing the paper. A paper on a strike written from the point of view of the strikers (for once!) will obviously not satisfy the company involved, but data from both sides is necessary. In order to extract information from management, it is important to present your questions in a way that doesn't alienate them. To serve the interests of management, sociologists have been misrepresenting their purposes in interviews with the working class for years. Researchers who wish to serve the interests of the working class should be realistic about the fact that the research they are doing will not necessarily agree with management's point of view.[3]

For information on assembling material and writing the paper, consult a standard reference guide.[4] One problem in assembling data, particularly primary and local data, is that you can easily be overwhelmed by the details and present them as an undigested mass. History, if it is to be at all relevant to the reader, must not only outline events but must also provide some analysis of the relationship between events and the reasons for their occurrence. For example, the paper on World War I explains the steady influx of women into the work force by outlining the technological changes that caused this phenomenon. The article on domestics explains why women preferred factory work to domestic work, even though the latter provided more financial rewards. The paper on prostitution uses data on the incomes and expenses of working women to clarify the economic factors that drove women to prostitution. A paper is unsatisfactory if it provides the reader with information about events but gives no idea of their causes. Often there may be insufficient material to know why an event occurred. It is still worthwhile to speculate on causes as long as you point out to the reader that your generalizations are tenuous.

You may also be forced to provide speculative explanations for contradictions in data. Contradictory data can and should be used if it is significant, providing you let the reader know that you are aware of the disparities.

How can the assembled data be utilized? The most obvious method, publishing in a book or historical periodical, is not often possible with research of this type. The Canadian Women's Educational Press, who published this book, is interested in similar material. There are other radical publishers who handle this type of research.[5] In smaller communities, local newspapers may publish such material, probably in a condensed and popularized form. But presentation doesn't have to be in written form. Talks before community groups and schoolchildren may be the easiest and most valuable way of presenting the information. Consider photo displays and slide shows if you have been fortunate enough to locate photos. Even the local drama group is a possibility. Material buried in your head, your files, or your professor's files is useless.

Let us know how you make out, and good luck!

Footnotes

1. S. Walter Stewart Library in East York.
2. For a more rounded treatment of this subject see *Aural History Institute of B.C.: Manual 1974*, Vancouver. On aural history research and methods.
3. For more detailed suggestions for obtaining information from reluctant sources see "How to Interview the Ruling Class and Its Agents" in *Bibliography on Latin America* published by the North American Congress on Latin America.
4. One such guide is *The Modern Researcher* by Jacques Barzun and Henry Graff.
5. Two that spring to mind are New Hogtown Press, University of Toronto, and New Canada Press, Toronto.

Bibliography

This bibliography is divided into five sections: books; government publications; newspapers and periodicals; material in archives including pamphlets, unpublished material, reports of conferences, etc.; and taped interviews. Material has been included in the bibliography that might be useful for research in the area, whether or not it was used in the preparation of the articles in the book.

Where there is any possibility that a book may be difficult to obtain, the name of one library which has the book has been included. The abbreviations used are explained below. Government publications are listed by the government that published them commencing with Canada, followed by the provinces from east to west, then city governments, and finally the U.S. Within these categories, listings are by government department in alphabetical order. Newspapers and periodicals are in alphabetical order, and with the exception of a few specific articles, only papers used in preparation of the book were included. For an excellent listing of Canadian labour newspapers see the bibliography by Hann, R.; Kealey, G.S.; Kealey, L.; and Warrian, P.; *Primary Sources in Canadian Working-Class History, 1860-1930*. In addition to labour newspapers it lists manuscripts, pamphlets and government documents from across the country. The book is invaluable for research into working-class history and much of the material in this bibliography has been taken from it. Labour newspapers are shown here with publication dates and locations where these are known. Where magazines are not generally valuable, specific articles and dates are shown.

Archival material is listed by location beginning with the Public Archives of Canada, and the Department of Labour Library, both in Ottawa, by province from east to west, then by city in alphabetical order and then by specific libraries. Taped interviews are listed by location of the tape.

Abbreviations for locations of materials (shown in parenthesis).

CNAA—Canadian Nurses Association Archives
FWTAO—Federation of Women Teachers Associations of Ontario
MTCL—Metropolitan Toronto Central Library
ODE—Ontario Department of Education
ODLL—Ontario Department of Labour Library
OISE—Ontario Institute for Studies in Education
OOA—Public Archives, Ottawa
OOL—Department of Labour Library, Ottawa
OTAR—Ontario Archives
OTU—University of Toronto

Books

Aaron, B., ed. *Dispute Settlement Procedures in Five Western Countries*. Los Angeles: Institute of Industrial Relations, University of California, 1969. (ODLL)

Abbott, Edith. *Women in Industry*. New York & London: D. Appleton & Co., 1913.

Abella, Irving. *Nationalism, Communism and Canadian Labour*. Toronto: University of Toronto Press, 1973.

Agnew, G. Harvey. *Canadian Hospitals, 1920-1970*. Toronto: University of Toronto Press, 1974.

Althouse, J.G. *The Ontario Teacher: An Historical Account of Progress 1800-1910*. Toronto: Ontario Teachers' Federation, 1969.

Ames, H.B. *The City below the Hill*. Toronto: University of Toronto Press, 1972.

Armstrong, Audrey. *Harness in the Parlour, A Book of Early Canadian Fact and Folklore*. Toronto: Musson Book Co. Ltd., 1974. Pre-1867.

Atwood, Margaret. *The Journals of Susanna Moodie*. Toronto: Oxford University Press, 1970.

Aural History Institute of B.C.: Manual 1974. Vancouver.

Baker, E.F. *Technology and Women's Work*. New York: Columbia University Press, 1966. (OTU Business Library)

Barzun, Jacques, and Graff, Henry. *The Modern Researcher*. New York: Harcourt Brace and World, 1970.

Beard, Mary. *Women as a Force in History: A Study in traditions and reality*. New York: MacMillan, 1946. (OTU)

Bell, Ernest A. (ed.) *Fighting the Traffic in Young Girls*. Chicago: 1910.

Berton, Laura Beatrice. *I Married the Klondike*. Toronto: McClelland and Stewart, 1961.

Bibliography on Latin America. New York: North American Congress on Latin America, 1973.

Binnie-Clark, Georgina. *A Summer on the Canadian Prairie*. Toronto: Musson Book Co. Ltd., 1910. (MTCL)

Binnie-Clark, Georgina. *Wheat and Women*. London: William Heinemann, 1914. (MTCL)

Bliss, M. and Grayson, Linda. *The Wretched of Canada*. Toronto: University of Toronto Press, 1972.

Bone, Enid (Price). *Changes in the Industrial Occupations of Women in the Environment of Montreal during the Period of the War, 1914-1918*. Montreal: McGill University, 1919. (MTCL)

Boone, Gladys. *Women's Trade Union Leagues in Great Britain and the United States*. New York: Columbia University Press, 1942.

Boserup, Ester. *Woman's Role in Economic Development*. London: Allen & Unwin, 1970. (OTU)

Broadfoot, Barry. *Six War Years: 1939-45*. Toronto: Doubleday, 1974.

Broadfoot, Barry. *Ten Lost Years, 1929-1939*. Toronto: Doubleday, 1973.

Bruce, Herbert Alexander. *Varied Operations: An Autobiography*. Toronto: Longman's, Green & Co., 1958.

Buck, Tim. *Steps to Power: A Program of Action for the Trade Union Minority of Canada*. Toronto: Trade Union Educational League, 1925.

Bullough, Bonnie and Vern. *The Emergence of Modern Nursing*. New York: MacMillan Co., 1964.

Butler, Elizabeth. *Women and Trades*. Reprint. New York: Arno Press, 1969. (OTU)

Callwood, J. and Zuker, M.A. *Canadian Women and the Law*. Toronto: Copp Clark Publishing Co., 1971.

Campbell, Marjorie Freeman. *Hamilton School of Nursing*. Toronto: Ryerson Press, 1956.

Canadian Nurses' Association. *The Leaf and the Lamp*. Ottawa: 1968.

Canadian Nurses' Association. *Selected References*. Ottawa: 1965-66. (CNAA and OTU)

Canadian War Contingent Association—Ladies Committee. *Women's Work in War*. London: 1915.

The Canadian Women's Annual and Social Service Directory. Toronto: McClelland, Goodchild & Stewart, 1915. (MTCL)

Canadian Women's Educational Press. *Women Unite.* Toronto: 1972.

Canadian Youth Commission. *Youth & Jobs in Canada.* Toronto: Ryerson Press, 1945.

Careless, J.M.S., Brown, R.C. *The Canadians 1867-1967.* Toronto: MacMillan, 1967.

Carnegie, David. *The History of Munitions Supply in Canada, 1914-1918.* Toronto and London: Longman's, Green & Co., 1925. (MTCL)

Carr, Emily. *The Book of Small.* Toronto: Oxford University Press, 1942. (MTCL)

Casgrain, Therese. *A Woman in a Man's World.* Toronto: McClelland & Stewart, 1971.

Cass, Peter H. *History of Trade Unions in Canada.* Toronto: Toronto & District Labour Council, 1963. (OTU—Wallace)

Cassidy, H.M. *Unemployment and Relief in Ontario 1929-1932.* Toronto: J.M. Dent & Sons Ltd., 1932.

Caswell, Maryanne. *Pioneer Girl.* Toronto: McGraw-Hill Co. of Canada, 1964. (OTU)

Clark, Alice. *Working Life of Women in the 17th Century.* London: George Routledge & Sons Ltd., 1919. (MTCL)

Clark, C.S. *Of Toronto the Good.* Montreal: The Toronto Publishing Co., 1898. Reprint—Toronto: Coles Publishing Co., 1970.

Cleverdon, Catherine. *The Woman's Suffrage Movement in Canada.* Toronto: University of Toronto Press, 1950.

Coburn, Kathleen. *The Grandmothers.* Toronto: Oxford University Press, 1949.

Cochrane, Honora M. (ed.) *Centennial Story: The Board of Education for the City of Toronto 1850-1950.* Toronto: Thomas Nelson & Sons, 1950.

Corrective Collective. *Never Done—Three Centuries of Women's Work in Canada.* Toronto: Canadian Women's Educational Press, 1974.

Corrective Collective. *She Named it Canada Because that's What it Was Called*. 3rd rev. ed. Toronto: James Lorimer & Co., 1972.

Cotes, Sara Jeanette (Duncan). *The Imperialist*. Introduction by Claude Bissell. Toronto: Presbyterian Print & Publishing Co., 1899. (OTU)

Courçy, Henri Potier de. *Les Servants de Dieu en Canada*. Montreal: Des Presses a vapeur de John Lovell, 1855. (MTCL)

Cran, Mrs. George. *A Woman in Canada*. London: J. Milne, 1910. (MTCL)

Dalla Costa, Mariarosa and James, Selma. *Women and the Subversion of the Community* and *A Woman's Place*. Bristol: Falling Wall Press, 1972.

Davidoff, Leonore. "Mastered for Life: Servant, Wife and Mother in Victorian and Edwardian Britain." Paper presented at the Anglo-American Conference in Comparative Labour History, Rutgers University, April 26-28, 1973. Mimeographed.

Davidson, John. "Statistics of Expenditure and Consumption in Canada." In *Transactions of the Nova Scotian Institute of Science, Halifax*. Vol. X. Session 1898-99 in *Economic Conditions: Canada*. (MTCL)

Dawson, J.W. *Fifty Years of Work in Canada*. Edited by Rankine Dawson. London: Ballantyne, Hanson, 1901. (MTCL)

Dent, Melville, Mitchell and Ross. *The Story of the Women Teachers' Association of Toronto*. Volume I. Toronto: Thomas Nelson & Sons Ltd. (FWTAO Library)
Volume II 1931-1963, by Eva K. Walker. Toronto: Copp Clark, 1963.

Di Ferrucio, Gambino. *Format of the Working Class at Ford in Britain*. Mimeo. E. London: Big Flame, no date. Available from New Tendency Industrial Group, Toronto.

Douville, Raymond and Casanova, Jacques-Donat. *Daily Life in Early Canada: from Champlain to Montcalm*. New York: MacMillan, 1968.

Duncan, Sara Jeanette. See Cotes, Sara Jeanette.

Dunlop, Eleanor S. (ed.) *Our Forest Home: Correspondence of the Late Frances Stewart*. Toronto: Presbyterian Print & Publishing Co., 1889. (OTU)

Durden, Vivienne Geraldine Surtesse. "Some Human Rights in Restaurant Employment of Women." MSW thesis, University of Toronto, 1963.

Dymond, Allan M. *The Laws of Ontario Relating to Women and Children*. Toronto: Clarkson James, 1923. (OTU—Sigmund Samuel Library)

Easterbrook, W.T. and Aitken, H.G. *Canadian Economic History*. Toronto: MacMillan Co., 1956.

Eaton's Catalogues. 1885 to date. (Eaton's Archives Toronto)

Ehrenreich, Barbara and English, Deirdre. *Complaints and Disorders, The Sexual Politics of Sickness*. New York: The Feminist Press, 1973.

Ehrenreich, Barbara and English, Deirdre. *Witches, Midwives and Nurses*. New York: Glass Mountain Pamphlets, 1973.

Engels, Frederick. *The Origin of the Family, Private Property and the State*. Moscow: Foreign Languages Publishing House.

Epstein, Cynthia F. *Woman's Place; Options and Limits in Professional Careers*. Berkeley: University of California Press, 1970.

Etzione, Amitai. (ed.) *The Semi-Professions and their Organization; Teachers, Nurses, Social Workers*. New York: Free Press, 1969. (MTCL)

The Family in the Evolution of Agriculture. Ottawa: Vanier Institute of the Family, 1968. Fortin, Gerald. "Woman's Role in the Evolution of Agriculture in Quebec." (MTCL)

Fleming, W.G. *Ontario's Educative Society. Vol. III, Schools, Pupils and Teachers*. 1971. *Volume VII, Educational Contributions of Associations*. 1972. Toronto: U. of T. Press. (OTU—Sigmund Samuel Library)

Fraser's Canadian Textile, Apparel and Variety Goods Directory. Annual. Toronto: Maclean Hunter.

French, Doris. *High Button Bootstraps: Federation of Women Teachers' Associations of Ontario, 1918-1968*. Toronto: Ryerson Press, 1968. (OISE)

French, Doris. *Faith, Sweat and Politics: The Early Trade Union Years in Canada*. Toronto: McClelland & Stewart, 1962. (OTU—Rare Books)

Garner, John. *The Franchise and Politics in British North America 1755-1867*. Toronto: University of Toronto Press, 1969.

Gibbon, John Murray. *Three Centuries of Canadian Nursing*. In collaboration with Mary S. Mathewson. Toronto: MacMillan, 1947.

Gillespie, Jack. *A Guide to Educational Records in the Possession of County Boards of Education—Eastern Ontario*. Toronto: Department of History and Philosophy, OISE, 1972.

Gilman, J.P. and Sinclair, H.M. *Unemployment—Canada's Problem*. Ottawa: The Army and Navy Veterans, 1935.

Glazebrook, G.P. de T. *Life in Ontario: A Social History*. Toronto: University of Toronto Press, 1968.

Goldman, Emma. *The Traffic in Women and Other Essays on Feminism*. Washington: Times Change Press, 1970.

Goulson, Carolyn. "A Historical Survey of Royal Commission and Other Governmental Inquiries into Canadian Education." Education Dept., University of Toronto, 1966.

Gray, James H. *Red Lights on the Prairies*. Toronto: MacMillan Co. of Canada, 1971.

Greenough, William. *Canadian Folk-life and Folk-lore*. New York: G.H. Richmond, 1897. Reprint Toronto: Coles Publishing Co., 1971. (MTCL)

Guillet, Edwin. *In the Cause of Education*. Toronto: University of Toronto Press, 1960. (OTU—Sigmund Samuel Library)

Haig, Kenneth M. *The Brave Harvest: The Life Story of E. Cora Hind*. Toronto: T. Allen, 1945. (MTCL)

Hall, Oswald. "Social Change, Specialization and Science: Where Does Nursing Stand?" In *Nursing Education in a Changing Society*, edited by Mary Q. Innis. Toronto: University of Toronto Press, 1970.

Hann, Russell G.; Kealey, Gregory S.; Kealey, Linda; Warrian, Peter. *Primary Sources in Canadian Working Class History, 1860-1930*. Kitchener: Dumont Press, 1973.

Hardy, J.H. "Teachers' Organizations in Ontario." Doctoral thesis, University of Toronto, 1939.

Harris, Robin S. *Quiet Evolution: A Study of the Education System of Ontario*. Toronto: University of Toronto Press, 1967. (OTU—Sigmund Samuel Library)

Harrison, Marjorie. *Go West Go Wise*. London: Edward Arnold & Co., 1930.

Hartman, Grace. "Address to the Brantford and District Labour Council, Canadian Union of Public Employees, January, 1970." (Available from the Union in Ottawa.)

Hartman, Grace. "Women in the Canadian Labour Force." Canadian Union of Public Employees, Toronto, 1968. (Available from the Union in Ottawa.)

Healy, William Joseph. *Women of Red River*. Winnipeg: Russell Lang & Co. Ltd., 1923. (MTCL)

Henry, Alice. *The Trade Union Woman*. New York & London: D. Appleton & Co., 1915. (OTU—Sigmund Samuel Library) Bibliography.

Henry, Alice. *Women and the Labor Movement*. 1923 edition. Reprint New York: Arno, 1971. (MTCL)

Hershaw, Josephine. *When Women Work Together. The Story of the YWCA*. Toronto: Ryerson Press, 1966.
Sequel to *Unfold the Years*, by M.Q. Innis.

A History of the Ontario Medical Association. Toronto: Ferguson, Murray Printing Co., 1930. Minutes of meetings of the Ontario Medical Association from 1890s-1920s.

Hochberg, Helen Altman. "Motivation and Expectations of the Female Restaurant Employee." MSW thesis, University of Toronto, 1963.

Hodgins, J.G. *Documentary History of Education in Upper Canada 1792-1876*. Toronto: Ontario Department of Education and Warwick Bros. and Rutter, 1894.

Hodgins, J.G. *The Establishment of Schools and Colleges in Ontario, 1792-1910*. Three vols. Toronto: King's Printer, 1910.

Hodgins, J.G., (ed.). *Historical and Other Papers and Documents Illustrative of the Education System of Ontario, 1842-1861*. Toronto: L.K. Cameron, 1912.

Hynes, M. *A History of the Rise of Women's Consciousness in Canada and Quebec from 1850-1920*. Toronto: New Hogtown Press, 1970. (OTU—Sigmund Samuel Library)

Innis, Mary Quayle. *The Clear Spirit: Twenty Canadian Women and their Times*. Published for the Canadian Federation of University Women. Toronto: University of Toronto Press, 1966. (OTU)

Innis, Mary Q. *Unfold the Years; the Story of the YWCA 1870-1949*. Toronto: McClelland & Stewart, 1949.

Jamieson, Stuart Marshall. *Industrial Relations in Canada*. Toronto: MacMillan Co., 1957.

Jamieson, Stuart Marshall. *Times of Trouble: Labour Unrest and Industrial Conflict in Canada, 1900-1966*. Study no. 22 in Series, Task Force on Labour Relations. Ottawa: Task Force on Labour Relations, 1968.

Jarvis, Charlotte. *Leaves from Rosedale*. Toronto: William Briggs, 1905.

Kalbach, Warren E. and McVey, Wayne W. *The Demographic Bases of Canadian Society*. Toronto: McGraw Hill Co., 1971.

Karr, W.J. *The Training of Teachers in Ontario*. Ottawa: R.J. Taylor, 1916. (MTCL—Microfilm)

Katz, Michael. *The Irony of Early School Reform: Educational Innovation in Mid-Nineteenth Century Massachusetts*. Cambridge, Mass.: Harvard University Press, 1968.

Kealey, Greg. *Canada Investigates Industrialism: The Royal Commission on the Relations of Labour and Capital, 1889*. Toronto and Buffalo: University of Toronto Press, 1973.

Kealey, Greg. *Working Class Toronto at the Turn of the Century*. Toronto: New Hogtown Press, 1973.
This short work contains a high proportion of material on working conditions and wages for women as well as housing conditions.

Kergin, Dorothy. "Is Social Work a Profession?" *Proceedings of the National Conference of Charities and Correction*. Chicago: 1915.

Knox, Ellen M. *The Girl of the New Day*. Toronto: McClelland & Stewart, 1919. (MTCL)

Kovacs, Aranka E., ed. *Readings in Canadian Labour Economics*. Toronto: McGraw Hill of Canada Ltd., 1961.

Langton, H.H., ed. *A Gentlewoman in Upper Canada: The Journals of Anne Langton*. Toronto: Clarke, Irwin, 1950.

Larkin, Jackie. *Toronto Trades Assembly—Labour Council of Metropolitan Toronto, 1871-1971*. Toronto: Labour Council of Metropolitan Toronto, 1971.

Lawr, D. and Gidney, R. (eds.) *Educating Canadians: A Documentary History of Public Education*. Toronto: Van Nostrand Reinhold, 1973.

Lawrence, Margaret. *History of the School for Nurses, Toronto General Hospital*. Toronto: Alumnae Association, 1931.

Lieberman, Myron. *Education as a Profession*. Englewood Cliffs, New Jersey: Prentice-Hall Inc., 1956. (OISE)

Lingwood, F. "The State Control of Education". D. Paed. thesis, Queen's University, Kingston, Ont., 1911.

Lipton, Charles. *The Trade Union Movement in Canada 1827-1959*. Montreal: Canadian Social Publications Ltd., 1966.

Liptzin, Sam. *Tales of a Tailor*. New York: Prompt Press, 1965.

Logan, Harold A. *History of Trade Union Organization in Canada*. Chicago: University of Chicago Press, 1928.

McCabe, James Dabney. *The Household Encyclopaedia of Business and Social Forms*. Paris, Ont.: John S. Brown, 1883.

McClung, Nellie. *Clearing in the West: My Own Story*. Toronto: Thomas Allen, 1964.

McClung, Nellie. *In Times Like These*. Toronto: University of Toronto Press, 1972.

McClung, Nellie. *The Stream Runs Fast: My Own Story*. Toronto: Thomas Allen, 1965.

McCutcheon, J.M. *Public Education in Ontario*. Toronto: T.H. Best, 1941.

MacDermot, H.E. *History of the School of Nursing of the Montreal General Hospital*. Montreal: Alumnae Association, 1940.

MacGregor, Donald Chalmers. *The Canadian Wage Earner in the Machine Age*. Toronto: Social Service Council of Canada, 1933. (OTU)

McInnis, Edgar. *Canada: A Political and Social History*. Toronto: Rinehart & Co. Inc., 1947.

MacMurchy, Marjorie. See Willison, Marjorie.

Mactaggart, John. *Three Years in Canada*. London: H. Colbourn, 1829. (MTCL)

Magrath, Thomas. *Authentic Letters from Upper Canada*. Reprint of 1833 edition. Toronto: MacMillan Co. of Canada, 1967. (MTCL)

Manual of the Textile Industry of Canada. Montreal: Textile Journal Publishing Company Ltd., 1925. (MTCL)

Marglin, Stephen. "What do Bosses Do? The Origins and Functions of Hierarchy in Capitalist Production." Unpublished article. Cambridge: Harvard University, 1971.

Marty, Aletta Elise. *An Educational Creed*. Toronto: Ryerson Press, 1921. (MTCL)

Massey, Alice Vincent. *Occupations for Trained Women in Canada*. London: Dent, 1920. (OTU—Victoria College Ed.)

Masters, D.C. *The Rise of Toronto 1850-90*. Toronto: University of Toronto Press, 1947. (OTU—Sigmund Samuel Library)

Matthews, W.D.E. "The History of the Relative Factors in Ontario Elementary Education." Unpublished doctoral thesis, University of Toronto, 1950.

Middleton, J.E. *The Municipality of Toronto: A History*. Toronto and New York: The Dominion Publishing Co., 1923.

Middleton, J.E. *The Province of Ontario*. Toronto: Dominion Publishing Co., 1927. (MTCL)

Miller, Audrey S. (ed.) *The Journals of Mary O'Brien, 1829-1839*. Toronto: MacMillan Co. of Canada, 1968.

Miller, John Ormsley. *The New Era in Canada*. London: Dent and Sons Ltd., 1917. (OTU)

Millett, Kate. *The Prostitution Papers*. New York: Avon Books, 1973.

Moodie, Susanna. *Life in the Clearings*. Toronto: MacMillan Co. of Canada (Pioneer Books), 1959.

Moodie, Susanna. *Roughing it in the Bush*. Toronto: McClelland & Stewart (New Canadian Library), 1962.

Morgan. *Men and Women of the Time*. Thirteenth edition revised by G. Washington Moon. London and New York: G. Rutledge and Sons, 1891.

Morrison, T.R. "The Child and Urban Social Reform in late 19th Century Ontario." Thesis, University of Toronto, 1972.

Nason, Gerald. "Canadian Teachers Federation; a study of its historical development, interests and activities from 1919-1960." Thesis, Education Dept., University of Toronto, 1964. (OISE)

National Council of Women. *Women of Canada: Their Life and Work*. 1900 (MTCL)

National Council of Women of Canada Year Book. *Women Workers of Canada*. (OTU)

Newnham, W.T. and Nease, A.S. *The Professional Teacher in Ontario*. Toronto: Ryerson Press, 1965.

Nielsen, Dorise Winnifred (Webber). *New Worlds for Women*. Toronto: Progress Books, 1944.

Nutting, Adelaide and Dock, Lavina. (ed.) *A History of Nursing*. Four volumes. New York: G.P. Putnam's Sons, 1912.

Oddson, A. *Employment of Women in Manitoba*. Economic Survey Board, 1939. (MTCL)

Oppenheimer, Valerie K. *The Female Labour Force in the United States*. Berkeley: Institute of International Studies, University of California, 1970.

Pattison, Mary. *Principles of Domestic Engineering*. New York: The Trow Press, 1915. (MTCL)

Peitchinis, Stephen G. *Canadian Labour Economics*. Toronto: McGraw Hill, 1970.

Pentland, H.C. "Labour and the Development of Industrial Capitalism in Canada." Thesis, University of Toronto, 1960.

Phillips, C.E. *The Development of Education in Canada*. Toronto: W.J. Gage & Co. Ltd., 1957. (OTU—Fac. of Ed.)

Pinchbeck, Ivy. *Women Workers and the Industrial Revolution, 1750-1850*. Reprint of 1930 edition. London: F. Cass, 1969.

Platt, Harriet L. *The Story of the Years: A History of the Women's Missionary Society of the Methodist Church in Canada, 1881-1906*. Toronto: Wm. Briggs, 1908. (MTCL)

Prentice, Alison. "The School Promoters: Education and Social Class in Mid-nineteenth Century Upper Canada." PhD thesis, University of Toronto, 1974.

Price, Enid. See Bone, Enid.

Purdy, Judson. "John Strachan and Education in Canada 1800-1851." Toronto: Thesis—University of Toronto, 1962. (MTCL, OOA)

Putman, J.H. *Egerton Ryerson and Education in Upper Canada*. Toronto: Wm. Briggs, 1912.

Queen's University. *Economic Welfare of Canadian Employees. 1913-37*. Kingston: Department of Industrial Relations, Queen's University, 1940.

Quinn, George. "The impact of European immigration on the elementary schools of central Toronto, 1815-1915." Master's thesis. Toronto: University of Toronto, 1968. (MTCL, OTU)

Reed, Evelyn. *Problems of Women's Liberation—A Marxist Approach*. New York: Pathfinder Press, 1971.

Reid, Helen R.Y. *The Problem of the Unemployed*. National Council of Women. 189?.

Reynolds, Lloyd and Killingsworth, Charles. *Trade Union Publications*. Baltimore: King Bros. Inc., 1944.

Reynolds, Roy. OISE has published this series of important guides cataloguing primary source material on education in Ontario. The original material can be found in the Ontario Archives.

Analysis of Record Group 2, Ontario Archives Series C-G-C 1865. Dept. of History and Philosophy, OISE, 1972?

A Guide to Items Relating to Education in Newspapers in the Ontario Archives; Dept. of Hist. and Philosophy, OISE, 1972?

A Guide to Pamphlets in the Ontario Archives Relating to Educational History, 1803-1967. Dept. of History and Philosophy, OISE, 1971?

A Guide to Published Government Documents Relating to Education in Ontario. Dept. of History and Philosophy, OISE, 1971?

Items Relating to Education in Private Papers in the Ontario Archives: A Guide to Sources in Educational History from the Private Manuscripts Section of the Archives of Ontario. Dept. of History & Philosophy of Education, OISE, 1973.

Roberts, Sarah Ellen. *Of Us and the Oxen.* Saskatoon: Modern Press, 1968.

Robertson, Heather. *Salt of the Earth.* Toronto: James Lorimer & Co., 1974.

Ross, George William. *The School System of Ontario: Its Historic and Distinctive Characteristics.* New York: D. Appleton & Co., 1896. (MTCL)

Rowsell, H. *By-Laws of the City of Toronto.* Toronto: 1870.

Roy, Gabrielle. *The Tin Flute.* Toronto: McClelland & Stewart (New Canadian Library), 1967.

Ryerson, Stanley B. *The Founding of Canada: Beginnings to 1815.* Toronto: Progress Books, 1963.

Ryerson, Stanley B. *Unequal Union: Confederation and the Roots of Conflict in the Canadas 1815-1873.* Toronto: Progress Books, 1968.

Salmon, Lucy Maynard. *Domestic Service.* New York: The MacMillan Company, 1897. (OTU)

Salverson, Laura (Goodman). *Confessions of an Immigrant's Daughter.* London: Faber & Faber Ltd. 1939; Reprint Society, 1949. (MTCL)

Sanders, Byrne Hope. *Emily Murphy, Crusader ("Janey Canuck").* Toronto: The MacMillan Co. of Canada Ltd., 1945.

Sanger, William W. *The History of Prostitution.* New York: The Medical Publishing Co., 1910; Harper & Bros., 1859. (MTCL)

Sayles, Fern A. *Welland Workers Make History.* Welland, Ontario: Winnifred Sayles, 1963. (MTCL)

Schreiner, Olive. *Women and Labour.* Toronto: S.B. Gundy, 1914. (OTU—Victoria College, rare books and special collection)

Scott, F.R. and Cassidy, H.M. *Labour Conditions in the Men's Clothing Industry*. Institute of Pacific Relations. Toronto: Thomas Nelson & Sons, 1935.

Scott, Jean Thomson. *The Conditions of Female Labour in Ontario*. Toronto University Studies in Political Science; W.J. Ashley, ed. First Series No. 111. Toronto: Warwick & Sons, 1892. (OTAR)

Seath, John. *Education for Industrial Purposes*. Toronto: Ontario Provincial Dept. of Education, 1911. (MTCL)

Shack, Sybil. *Armed With a Primer*. Montreal: McClelland and Stewart Ltd., 1965.

Shaw, Rosa. *Proud Heritage*. Toronto: Ryerson Press, 1957.

Shryock, Richard. *The History of Nursing*. London: W.B. Saunders, 1959.

Sissons, C.B. *Church and State in Canadian Education: An Historical Study*. Toronto: Ryerson Press, 1959.

Sissons, C.B. *Egerton Ryerson: His Life and Letters*. Vols. I and II. Toronto: Oxford University Press, 1937.

Smiley, Donald (ed.) *The Rowell Sirois Report*. Book I. Toronto: McClelland & Stewart, 1963. (Carleton Library)

Smith, A.H. et al. *A Bibliography of Canadian Education*. Bulletin No. 10. Department of Educational Research. Toronto: University of Toronto, 1938.

Sofri, A. *Towards Workers' Power*. Intro. by P. Taylor and J. Huot, 1973. Available from New Tendency Industrial Group, Toronto.

Sparks, R.P. "The Garment and Clothing Industries, History and Organization" in *Manual of the Textile Industry in Canada*. Montreal: Canadian Textile Journal Publishing Company Ltd., 1930. (MTCL)

Splane, Richard. *Social Welfare in Ontario 1791-1893*. Toronto: University of Toronto Press, 1965.

Stephenson, Marylee (ed.) *Women in Canada*. Toronto: New Press, 1973.

Stewart, Isobel Maitland. *A History of Nursing from Ancient to Modern Times*. New York: Putnam, 1972.

Stewart, Margaret and French, Doris. *Ask No Quarter: The Story of Agnes Macphail.* Toronto: Longmans, 1959.

Street, Margaret M. *Watch Fires on the Mountain: The Life and Writings of Ethel Johns.* Toronto: University of Toronto Press, 1973.

Sullerot, Evelyn. *Woman, Society and Change.* New York: McGraw Hill Book Co., 1971.

Survey of Corporate Securities. Published annually by the Financial Post from 1927 to date. Title varies. Now known as *Survey of Industrials.*

Swainton, Donald. (ed.) *Oliver Mowat's Ontario.* Toronto: MacMillan, 1972.

Sykes, Ella. *A Home Help in Canada.* London: Smith, Elder & Co., 1912. (MTCL)

Talman, J.J. (ed.) *Loyalist Narratives from Upper Canada.* Westport, Conn.: Greenwood Press, 1969. (MTCL)

Tivy, Louis. (ed.) *Your Loving Anna: Letters from the Ontario Frontier.* Toronto: University of Toronto Press, 1972.

The Toronto Normal School Jubilee Report 1847-1897. Toronto: Warwick Bros. & Rutter, 1898. (Toronto Board of Education Library).

Traill, Catherine Parr. *The Backwoods of Canada.* Toronto: McClelland & Stewart (New Canadian Library), 1966.

Traill, Catherine Parr. *The Canadian Settlers' Guide.* Toronto: Printed at the Old Countryman Office, 1855. (MTCL)

Tunis, Barbara Logan. *In Caps and Gowns.* Montreal: McGill University Press, 1966. (MTCL)

Turner, E.S. *What the Butler Saw: Two-hundred and fifty years of the servant problem.* London: Michael Joseph Ltd., 1962.

Vance, Catherine. *Not by Gods but by People: The Story of Bella Hall Gauld.* Toronto: Progress Books, 1968.

Vaughan, Victor. *Healthy Homes and Foods for the Working Class.* Concord, New York: Republican Press Association, 1886. (MTCL)

"Wages for Housework and The Struggle of the Nurses". Power of Women Collective, 1974. Mimeographed.

Wagner, Edith. "Education as Revealed in Family Papers, Ontario 1800-1900." Unpublished Master's thesis, University of Toronto, 1954.

Walker, Eva K. *The Story of the Women Teachers' Association of Toronto*. Toronto: Thomas Nelson & Sons Ltd., 1930. (MTCL;FWTAO)

Weir, R.M. *Survey of Nursing Education in Canada*. Toronto: University of Toronto Press, 1932.

Willison, Marjorie (MacMurchy). *The Canadian Girl at Work*. Toronto: A.T. Wilgress, 1919. (MTCL)

Willison, Marjorie (MacMurchy). *The Woman, Bless Her*. Toronto: S.B. Gundy, 1916. (OTU—Victoria Library)

Wilson, J. Donald, Stamp, Robert M., and Audet, Louis Philip. *Canadian Education: a History*. Toronto: Prentice Hall, 1970.

Wismer, Leslie E. (ed.) *Proceedings of the Canadian Labour Union Congresses*. Ottawa: Trades and Labour Congress, 1951.

Woodham-Smith, Cecil B. *Florence Nightingale 1820-1910*. London: Constable, 1950.

Woods, H.D. and Ostry, Sylvia. *Labour Policy and Labour Economics in Canada*. Toronto: MacMillan of Canada, 1962. (MTCL)

Woods, H.D. (ed.) *Patterns of Industrial Dispute Settlements in Five Canadian Industries*. Montreal: Industrial Relations Centre, McGill University, 1958. (OTU or OOL)

Woodson, Harry M. *The Whirlpool—Scenes from Toronto Police Court*. Toronto: 1917. (MTCL)

Government Publications

Canada

1. Bureau of Statistics

The Canada Year Book. Ottawa: Queen's Printer, Most years from 1910.

Canadian Conference on Children. Ottawa: Queen's Printer, 1965.

Census of Canada. A census of the Canadas was produced in 1851-2 and at 10 year intervals since that time. First edition published in Quebec by John Lovell, recent editions published in Ottawa, by Queen's Printer.

Changes in the Occupational Composition of the Canadian Labour Force. Ottawa: Queen's Printer, 1968.

The Demographic Background to Change in the Number and Composition of Female Wage Earners in Canada 1951-1961. Ottawa: Queen's Printer, 1967.

The Female Worker in Canada. by Ostry, Sylvia. Ottawa: Queen's Printer, 1968.

The Growth of Manpower in Canada. by Denton, Frank T. Ottawa: Queen's Printer, 1970.

Historical Estimates of the Canadian Labour Force. by Denton, F.T. and Ostry, Sylvia. Ottawa: Queen's Printer, 1967.

Married Female Labour Force Participation: A Micro Study. Ottawa: Queen's Printer, 1970.

Women Who Work, Parts I and II. by Allingham, John D. Ottawa: Queen's Printer, 1967. Part I subtitled The Relative Importance of Age, Education and Marital Status for Participation in the Labour Force. Part II subtitled Married Women in the Labour Force: The Influence of Age, Education, Child Bearing status and residence. Ottawa: Queen's Printer, 1968.

2. Department of Labour

Annual Report on Wage Rates and Hours of Labour in Canada. Ottawa: 1921. 1901-1920.

Canadian Laws Governing the Employment of Women. Ottawa: 1923 and 1929.

Changing Patterns in Women's Employment. Ottawa: 1966. Based on papers by Ostry, Sylvia, and Meltz, Noah.

Fifty Years of Labour Legislation in Canada. (Lorentsen, E., and Woolner, E.) Ottawa: 1950.

Labour Organization in Canada. Ottawa: King's Printer, Annually from 1911.

Legal Status of Women in Canada. Ottawa: 1924. Subtitled "As shown by extracts from Dominion and Provincial Laws Relating to Naturalization, Franchise, Crimes, Marriage, Divorce..." Published at the request of the National Council of Women in Canada.

Maternity Leave Policies: A Survey. Ottawa: Queen's Printer, 1969.

Maternity Protection for Women Workers in Canada. (Woodsworth, S.) Ottawa: 1967. Women's Bureau.

Occupational Trends in Canada 1931-1961. Ottawa: 1963.

Part Time Employment in Retail Trade. Ottawa: 1969. Published by the Economics and Research Branch and the Women's Bureau.

Report of the Round Table Conference on the Implications of the Traditional Divisions Between Men's Work and Women's Work in Our Society. Ottawa: Queen's Printer, 1964. Published by the Women's Bureau.

Report on a Consultation on the Employment of Women with Family Responsibilities. Ottawa: Queen's Printer, 1965. Published by the Women's Bureau and Information Canada.

Report on Strikes and Lockouts in Canada from 1901-1912. Ottawa: 1913.

Report on Strikes and Lockouts in Canada, 1901-16. Ottawa: 1918.

What Do Women Want? Ottawa: Queen's Printer, 1970. Three papers presented during 1970 dealing with: discriminatory practices in the universities; the labour force, the GNP and unpaid housekeeping services; laws and practices in Canada which discriminate against women.

Women and Part-Time Work in Canada. Ottawa: Queen's Printer, 1966.

Women at Work in Canada. Ottawa: Queen's Printer, 1957 and 1964.

Women in the Labour Force, Facts and Figures. Ottawa: Queen's Printer, 1970, 1971. An annual publication of the Women's Bureau of the Department of Labour.

Women in the Public Service. (Judek, Stanislaw). Ottawa: Queen's Printer, 1968.

3. Department of Immigration and Colonization

The Houseworker in Canada. Opportunities for Success, Work and Wages; Where to Go and What to Take. Ottawa: 1928.

Women's Work in Canada. Duties, Wages, Conditions and Opportunities for Household Workers in the Dominion. Ottawa: 1921.

4. Department of Manpower and Immigration

Historical Statistics of the Canadian Labour Force. (Meltz, N.M.) Ottawa: 1969.

5. Imperial Munitions Board

Women in the Production of Munitions in Canada. Ottawa: 1916.

6. Information Canada

Attitudes of Union Workers to Women in the Industry. Ottawa: 1971.

A Comparison of Men's and Women's Salaries and Employment Fringe Benefits in the Academic Profession. Ottawa: 1970.

Cultural Tradition and Political History of Women in Canada. Ottawa: 1971.

Manpower Utilization in Canadian Chartered Banks. Ottawa: 1971.

Patterns of Manpower Utilization in Canadian Department Stores. Ottawa: 1971. by The Royal Commission on the Status of Women in Canada.

Status of Women in Canada—1972 Report. Ottawa: 1972. By the Co-ordinator, Status of Women.

Women at Home: The Cost to the Canadian Economy. Ottawa: 1970.

Women in the Labour Force; Facts and Figures. Ottawa: 1970.

7. Public Service Commission of Canada.

Sex and the Public Service. (Archibald, Kathleen). Ottawa: Queen's Printer, 1970.

Royal Commission on a Dispute Between the Bell Telephone Co....and Operators at Toronto. Report. Ottawa: 1907.

Royal Commission on Price Spreads. Report. Ottawa: 1935.

Royal Commission on the Relations of Labour and Capital. Report. Ottawa: 1889.

Royal Commission on the Status of Women in Canada. Report. Ottawa: 1970.

8. Sessional Papers 1882.

Report of a Commission Investigating Mills and Factories. ix no. 42.

9. Sessional Papers 1896.

Report Upon the Sweating System in Canada. v 29, no. 61.

Nova Scotia

Commission on the Hours of Labour, Wages and Working Conditions of Women Employed in Industrial Occupations. 1920.

Quebec

Civil Code Revision Office.

Report on the Legal Position of the Married Woman. Quebec: Quebec Official Publisher, 1964.

Ontario

Board of Health Annual Reports. Toronto: 1884, 1887, 1891.

Bureau of Industries Annual Reports. Toronto: 1884-1914.

Bureau of Labour Reports. Toronto: 1897-1915.

Commission on Unemployment Report. Toronto: 1916.

Committee on Child Labour Report. Toronto: 1907.

Department of Health.

Health Confessions of Businesswomen, by Businesswomen. Toronto: 1923.

Department of Education.

Normal, Model and Common Schools of Upper Canada annual reports for the years 1846-1871, prepared by the Chief Superintendent of Education.

Factory Inspectors Report. Toronto: 1888.

Houses of Refuge and Orphan and Magdalen Asylums in Ontario Annual Report. Toronto: 1890-1915.

Inspector of Prisons and Public Charities Upon the Common Gaols, Prisons and Reformatories of the Province of Ontario Annual Report. Toronto: 1890-1915.

Laborer Laws of Province of Ontario. Provincial Statutes, Ontario Law Reports. 1913.

A Legal History of Health Professions in Ontario. (McNab, Elizabeth). Toronto: Queen's Printer, 1970. A Study for the Committee on the Healing Arts.

Ministry of Labour

Fourteen Ways to Train for a Better Job. Toronto: 1972.

Mothers' Allowances; An Investigation. Toronto: 1920.

Occupational Trends in Ontario, 1931-1961. (Green, Shirley P.) Toronto: 1967.

Women Returning to the Labour Force. (Bell, Linda). Toronto: 1969.

Women's Division Report. Toronto: 1930.

Working Women In Ontario. (Eastham, Katherine). Toronto: 1971.

Orders of the Minimum Wage Board Regarding Employment of Women in the Province of Ontario. 1924.

Saskatchewan

Some Saskatchewan Legislation Affecting Women and Children. Regina: 1920.

City of Toronto

Medical Health Officer to Toronto Board of Health, Report. Toronto: 1911.

Police Department Annual Reports. City of Toronto Minutes, Appendix C, 1890-1920.

Social Survey Commission Report. Toronto: Carswell Co., 1915.

Treatment of Neglected Children Report. Toronto: Arcade Printing, 1907. Prepared by Toronto Police Force.

<u>United States</u>

Foght, H.W. "The School System of Ontario with Special Reference to the Rural Schools". Washington: D.C. Government Printing Office, 1915. U.S. Office of Education Bulletin No. 32.

Urquhart, M.C. (ed.), Buckley, K.A.H. (ass. ed.) *Immigration to Canada by Occupational Groups.* Cambridge: Univ. Press, 1965. Because this is a condensation of important census data libraries may file it under government documents.

Newspapers and Periodicals

The Beaver. Van Kirk, Sylvia, "Women and the Fur Trade". Winter 1972.

Border Cities Labour News. Walkerville; 1932. Published by the Essex County Trades and Labour Council.

B.C. Federationist. Vancouver: 1911-1925.

B.C. Labour News. Vancouver: 1921-22.

Canada Forward. Toronto: 1926-1927. Connected with the central Toronto Labour Party.

Canadian Educational Monthly. Toronto: 1879-1903.

Canadian Forum. McCready, S.B., "Rural Education in Ontario". XIII July, 1933.

Canadian Historical Review. Houston, Susan E., "Politics, Schools and Social Change in Upper Canada". LIII No. 3, Sept. 1972.

Canadian Home Journal. Farquharson, Rica, "The Post War Woman". July 1945. Garner, Grace, "The Girl Behind the Gun" February 1941. Lawrence, Margaret, "The Presence of Women" October, 1942. Tribute to Women War Workers. Oct. 1942. Entire issue.

Canadian Journal of Corrections. "Brief on the Woman Offender". January 1969.

Canadian Labour Advocate. Vancouver: 1919-1926.

Canadian Labour Defender. Toronto: 1930-1935. Published by Canadian Labour Defence League.

Canadian Labour Herald. Vancouver. Published by Vancouver Branch of the Canadian Federation of Labour.

Canadian Labour World. Hamilton: 1923-1931.

Canadian Magazine. Oakeley, Hilda, "Progress of Higher Education for Women". June 23, 1904.

Canadian Medical Association Journal. MacDonald, E.M., and Webb, Elizabeth, "A Survey of Women Physicians in Canada, 1883-1964". June 4, 1966.

Canadian Nurse. Montreal: Canadian Nurses' Association, 1907-1974. An excellent source of information on the early history of the profession, the organization, and on the attitudes of the early nurses towards their work.

Canadian Public Health Journal. Millar, W.C., "Rural School Sanitation". XXIV, Dec. 1933.

Chatelaine. Frum, Barbara, "Why There Are So Few Women in Ottawa". Oct. 1971. Gillen, Mollie, "Women at Work". February, 1969. Landsberg, Michele, "How Trade Unions Let Women Down". March, 1971.

Cotton's Weekly. Toronto.

Educational Courier.

Educational Monthly of Canada. Toronto: 1903-1905.

Educational Weekly. Toronto: 1885-1887.

Federation of Women Teachers of Ontario Bulletin. 1924-1930.

Financial Post. "Many More Wives are Working in Canadian Industry". May 4, 1957. McArthur, Jack, "The Case Against Legislating Equal Pay for Women". February 26, 1955. Schreiner, Jack, "Sweet, Lovely, and so Plentiful—Women Rushing into the Labour Force Bringing Some Special Problems". December 12, 1964. "Working Women Increase—Spell Permanent Problem?" May 31, 1958.

Grain Growers Guide. Periodical of western farm women and men.

Hamilton Herald.

Hamilton Labour News. 1912-1955.

Journal of Education for Upper Canada. Toronto: 1848-1877. Sponsored by Egerton Ryerson. Ryerson, E., "Teachers' Associations and the Profession in Upper Canada." XVII No. 10, Oct. 1865.

Labour Gazette. Ottawa: 1900 to date. Journal of the Department of Labour. Particularly valuable from 1913 to 1918 when it contained a column from women correspondents composed of letters written from Montreal, Toronto, Winnipeg and Vancouver.

Labour History. Davis, A.F., "Womens Trade Union League: Origins and Organizations". No. 5, 1964.

Lance. Toronto: 1909-1915. Published by Hambley Brothers.

Maclean's Magazine. Collins, Robert, "When Mother was a War Worker". December 19, 1959. "Little Woman—What Now?" November 1, 1944.

Manitoba Law Journal. Cameron, Harvey, "Women in Law in Canada". Volume 4, No. 1, 1970.

Manitoba Teacher. Garland, Aileen, "Of Old Unhappy Far-off Things and Battles Long Ago". Nov. Dec., 1968.

Monthly Review. Ehrenreich, I. and B., "Hospital Workers: A Case Study in the New Working Class". Feb. 1973.

New Left Review. Seccombe, Wally, "The Housewife and Her Labour Under Capitalism". Jan. Feb., 1974.

The New Yorker. Kramer, J., "Profiles: Founding Cadre". Nov. 28, 1970.

One Big Union Bulletin. Edmonton: 1919-1934.

Ontario History. Gidney, R.D., "Elementary Education in Upper Canada: a Reassessment". Vol. LXV No. 3, Sept. 1973. Spragge, G.W., "Elementary Education in Upper Canada, 1820-1840." Vol. XLIII No. 3, July 1951. Tennyson, B.D., "Premier Hearst, The War and Votes for Women". LVII 1965.

Ontario Teacher. Strathroy, Ont.: 1837-1875.

Race Today. James, Selma, "Sex, Race and Working Class Power". January, 1974.

Radical America. Ewen, Stuart B., "Advertising as Social Production". Vol. 3, No. 3, May June, 1969. Stone, Katherine, "The Origins of Job Structures in the Steel Industry". Vol. 7, No. 6, Nov. Dec., 1973. Double Issue on Women. Vol. 7, Nos. 4 & 5, July and Oct. 1973.

Rolling Stone. Brecher, Jeremy, "Strike". 1973.

Saturday Night. Higginbothom, C.H., "Women Must Choose Privileges or Rights". November 22, 1947. Lee, Tannis, "Is it Home Sweet Home, for the Women Who Want and Need a Job?", Feb. 15, 1947. Morgan, Isabel, "Position Wanted—How to Nurse the Lowly 'Job' into a Career". April 12, 1947. Pewtress, Marjory, "Equal Pay". March 6, 1954. "Six Authors Sketch the Ideal Woman". March 14, 1953.

Socialist Revolution. Zaretsky, Eli, "Capitalism and Personal Life". Nos. 13 and 14, 1973.

Telos. Bologna, Sergio, translated by Ramirez, Bruno, "Class Composition and the Theory of the Party at the Origin of the Workers-Councils Movement". No. 13, Fall, 1972.

Toiler. Toronto: 1902-1904. Toronto and District Labour Council.

Toronto Education Quarterly. Published by the Toronto Board of Education.

Toronto Evening Telegram. "Good Maids are Unique, Welfare Worker Says Not All Girls Capable of Doing Housework". July 29, 1935.

Toronto News. "The Night Hawks of a Great City as seen by the reporters of the *Toronto News*". 1885, 3rd edition.

Trades and Labour Congress Journal. Ottawa: 1922-1956.

Tribune. Toronto: 1905-1906. Toronto and District Labour Council.

Western Clarion. Vancouver: 1905-1925. Particularly Lester, Ruth, "Women and the Socialist Party of Canada". July, 1911. "Sex Equality". Aug. 1911.

Western Labour News. Winnipeg: 1918-1923.

Woman Worker. Toronto: 1926-1929. Federation of Women's Labour Leagues. Workers Party.

Worker. Toronto: 1922-1936. Clarion Publishing Association.

Worker/Le Travailleur. Vancouver: 1919. Published by the One Big Union Lumber and Camp Workers Industrial Union.

Young Worker. Toronto: 1924-1936. Young Communist League of Canada.

Material in Archives

Canada

1. Public Archives of Canada, Ottawa.

Alexander, Charlotte; charity worker concerned with the emigration of young girls; originals; 1885-1893; letters received and a register summarizing cases.

Bronson Company Papers; Ottawa Valley; originals; 1857-1950; including correspondence and clippings on the Ottawa Maternity Hospital.

Canadian Labour Congress; 1956—includes earlier papers of: Trades and Labour Congress, 1921-1958, Vol. 1-18; All Canadian Congress of Labour and Canadian Congress of Labour, 1927-1958; Vol. 19-226; Canadian Labour Congress, 1940-1970, Vol. 226-255. microfilm 1956-68 23 reels. Vol. 247-55 contains Dr. Eugene Forsey's notes on a history of the Canadian labour movement; MG 281.

Counter, Charles A., *Woman's Rights*, Kingston: 1882, pamphlet.

Department of Immigration; 1873-1959; Department records include passenger lists, information on children, deportations, servants, self-help societies, etc. The following categories in Record Group 76 have been examined and found to be particularly relevant to women.
R.G. 76: 2209, Part 1, 1873-1906; 1378, Vols. I & II, 1890-1906; 1381, Parts I, II, and III, up to 1912; 22787, Vols. I to VIII, 1891-1919.

Department of Labour. Newspaper Clipping service. Collection of all references in Canadian periodicals to a strike or lockout. Also a report from both management and the employees listing; total number of employees, total number on strike, wages, conditions before and after strike and both positions as to the cause of the strike. Comes with general finding guide for cross-reference, listing: industry, number of workers involved by sex, duration of the strike and cause.

Kemp, Edward; cabinet minister; originals 1915-1919; military hospital commission papers, contain material on military

training; also files on postal employees and customs employees in Toronto; labour conditions, stenographers and office help. MG 27 11 D9

Massiah, Kate; journalist; originals; 1901-1936; correspondence relating to establishment of a Dept. of Public Health, letters from C.E.F. members in rehabilitation centres, role of women in WWI. MG 27 111 F7

Montreal Society for the Protection of Women and Children; originals; 1882-1970; board minutes, treasurer's reports, printed reports, staff notes and research material. MG 28 1 129

Murray, Norman, *The Experience of an Old Country Pedlar Among the Montreal Servant Girls and Their Mistresses*. Montreal: 1887, Pamphlet

National Council of Women, Minutes Volume 56.

Woman's Work in Canada. Ottawa: 1924. Pamphlet. Duties, wages, conditions and opportunities for household workers in the Dominion.

Young Women's Christian Association. 1870-

2. Department of Labour Library, Ottawa.

Department of Labour; typescript; 1920; Women—employment file; memorandum on Canadian legislation concerning the employment of women.

International Congress of Women; 4th, Toronto: 1909. Report of congress held in Toronto under the auspices of the National Council of Women.

International Federation of Working Women; Congress held in Vienna in 1923.

International Ladies Garment Workers Union; Convention Reports for 1919, 1928, 1932, 1934, and 1937.

MacArthur, Marion R., Secretary of Women's Trade Union League; origs; Women file; Why women should join trade unions.

National Womens Trade Union League of America; proceedings of 12th convention; 2nd deferred triennial 1929-1936.

United Womens Educational Federation; 3rd annual report, 1924 convention of Trades and Labour Congress. Official Annual Labour Review.

Women's Labour Leagues, report of conference in London, 1924.

British Columbia

1. Rossland Historical Museum

Soldiers Comfort Fund Association; Kamloops; originals; 1915-1919; minutes.

Manitoba

1. Manitoba Provincial Archives, Winnipeg.

Brief History and Constitution of the Local Council of Women of Winnipeg. Pamphlet.

Independent Labour Party, Minute Books, 1920-1923.

National Council of Women, Winnipeg branch; correspondence, roll call, minute books, 1916-1934, miscellaneous items and articles.

Women Workers of the World. National Council of Women Yearbooks, 1894-1935. Title varies, some issues available at this location.

Ontario

1. Hamilton Public Library, Ontario.

Associated Field Comforts; Hamilton 1914-1918. War Work in Hamilton, correspondence, forms, clippings and notebooks.

Gould, Mrs. Sophe (Vallance) Hamilton; typescript; 1914-1918; account of organizations engaged in war work compiled at the request of C.W. Gordon.

Hamilton Aged Women's Home; 1846-1946; minutes of Board of Management's meetings Oct. 20, 1858-Oct. 26, 1868. Minutes of relief given to families in the various wards, 1854-1909.

Hamilton Girls Home; 1907; Annual Report for 1906.

Hamilton Orphan Asylum; origs, 1848-1914; register of names, 1848-1914; record of apprenticeship, 1881-1905.

Lyle, Elizabeth, *Hamilton Local Council of Women, 1893-1919, A Record of 26 Years of Activity*. Hamilton: 1920. Pamphlet.

YWCA scrapbook. 1891-

2. Niagara Historical Society Museum, Niagara-On-The-Lake

War Scrapbook; Niagara-On-The-Lake; 1914-1918; local women's war work.

3. Queens University, Kingston.

Brockville First Presbyterian Church; Originals; 1919-1921, 1925; minute books of Women's Missionary Society.

Canada, Department of Agriculture, *Reception and Protection of Female Immigrants in Canada*. Ottawa: 1879.

Orphans' Home and Widows' Friend Society; Kingston; origs; 1857-1966; minutes, annual reports, record books.

Private Instructions for Teachers. Montreal: Protestant Board of School Commissioners, 1874. Pamphlet.

Stowe, Dr. Emily Howard; doctor and suffragist, origs; 1873-1885; two scrapbooks.

Women's Christian Association; Hospital and home for the friendless in the city of Belleville; 11th annual report, 1889-1890; Belleville: 1890.

4. Simcoe County Archives, Minesing.

Women's Institutes; Simcoe County; 1907- ; minute books, cash books, membership lists, historical sketches.

5. University of Western Ontario Regional Library, London.

Victorian Order of Nurses; London; originals; 1923-1930; minute book.

6. Toronto

a) Ontario Archives, Toronto

Aiken, Catherine; Simcoe county; servant; origs; 1855; apprentice indenture to W. Stoddart to learn "art of household work and industry".

Buhay, Beckie, Report on Women's Labour Leagues for Communist Party of Canada; Internal women's department document, 1931. Part of Attorney General's Material seized under the War Measures Act.

Department of Education, Ontario, Records; Series RG 2.
E2 Local School Histories and Teaching Experiences, c. 1800-1876.
F3D Miscellaneous Inspectors Reports and Correspondence. Box 1: c. 1873-1879. Box 4: c. 1870-1905.

Department of Labour of Ontario; originals; 1916- ; records including subject files 1916-1920; employment offices, 1918- ; legislation, 1918- ; boiler inspection branch, 1918-1920, 1925-1933; operating engineers branch, 1908; file of the Senior Investigator, 1923-1946; files on the International Labour Organization 1919-1935; case files, subject files and correspondence of director of apprenticeship, 1928- ; scrapbooks, 1921-1945; pamphlets and leaflets, 1915-1945.

Miss Rye's Emigration Home for Destitute Little Girls; London: Jas. Wade, 1880. Report for 1879, pamphlet.

Public Health Nurses in rural Ontario, Contains interesting if horrific reports by nurses of conditions among farming families.

Sproule, Dr. Robert, *Health and Healthy Homes in Canada*. 1882. Pamphlet on domestic and public hygiene.

Stowe-Gullen, Augusta, *A Brief History of the Ontario Medical College for Women*. Toronto: 1906. Pamphlet.

Traill, Mrs. C.P., *The Canadian Emigrant Housekeepers Guide*. 1861. Pamphlet.

What Every Canadian Should Know About the Woollen and Knitting Mills of Canada. 1925. Pamphlet.

Willison, Marjory (MacMurchy), *Women of Today and Tomorrow*. 1919. Pamphlet.

Women Workers in Economic Struggles. Mimeographed article from the Communist Party documents file. Part of Attorney Generals Collection seized during the War Measures Act.

Women's War Conference, Report. Held at the invitation of the war committee of the cabinet. 1918. Pamphlet.

Women's Work in Western Canada. C.P.R., 1906.

The Work of Women and Girls in the Department Stores of Winnipeg. Report of a study by the Winnipeg University Womens Club, Civic Committee. Winnipeg; 1914. Pamphlet.

b) Toronto Public Library

The Influence of Women in the Labor Movement; Labour Day Souvenir. Toronto: 1907. Toronto Labour Council.

Toronto City Mission, Annual Report for 1897.

Toronto East End Day Nursery Annual Reports; 1900-1901—1936. Also known as the East End Creche.

Toronto Industrial Refuge, Annual Reports for 1886-1905.

Toronto Industrial Room Society; 1893 Report. Society established in 1891 to secure employment for women and girls—usually needlework.

Toronto West End Creche Annual Reports; 1909-1910—1954.

c) United Church Archives, Toronto

Methodist Church; Department of Temperance and Moral Reform, 1913-1914; Department of Social Services and Evangelism, 1914-1920; correspondence of Miss Beatrice Brigden, special worker with women and girls, contains correspondence and reports of speaking tours.

Methodist Church; Women's Missionary Society; origs; 1881- ; correspondence, minutes, scrapbooks continue under United Church after 1926; also annual reports for 1881-1882, 1883.

Presbyterian Church of Canada; Women's Missionary Society; origs; 1888-1926; correspondence, minute books, pamphlets, annual reports.

d) University of Toronto.

All Canadian Congress of Labour, Minutes of 1927 convention.

Blewett, Jean, *Canadian Woman and Her Work*. Toronto, Canadian Suffrage Association. Pamphlet.

Denison, Flora McDonald, journalist and woman's suffrage supporter, Toronto; 1898-1911; scrapbooks, clippings from her columns in Sunday World.

New Brunswick

1. Mount Allison University, Sackville.

National Council of Women, Sackville Branch, originals; 1919-1966, minutes of local branch.

Women's Christian Temperance Union, Sackville Branch, originals; 1883-1905; minute books.

2. University of New Brunswick, Fredericton.

MacDonald, Janet; Parish of Cambridge, Queens County, N.B.; housewife; typescript; 1857-1868; diary of a farm housewife.

Nova Scotia

1. Acadia University, Wolfeville.

Cramp, Mary. *Retrospects: A History of the Formation and Progress of Women's Missionary Aid Societies of the Maritime Provinces*. Halifax: 1891. Pamphlet.

Women and Reconstruction. Canadian Reconstruction Association, 1918. Pamphlet.

2. Dalhousie University, Halifax.

Massey, Mrs. A.S.V., *Occupations for Trained Women in Canada*. London: 1920. Pamphlet.

Munro, John. *The Place and Work of Women in the Church*. Halifax: 1877. Pamphlet.

Halifax Charities; 12 pamphlets, chiefly reports dealing with various philanthropical and educational institutions, Halifax, 1870-1878.

National Council of Women; report of eighth annual meeting in London, Ont., 1901.

3. Nova Scotia Public Archives, Halifax.

Temporary Home for Young Women Seeking Employment; 1870-1872. Annual reports Vol. 1-3.

Taped Interviews

York University Tape Archives; supervised by Irving Abella and available through him. A series of recorded interviews with militants who were active in the '30s and '40s mainly in the garment trades. Most of the still living CP and CCF leaders are here. Very few women interviewed. List of names of those interviewed can be found in *Primary Sources in Canadian Working Class History*. David Chud who did most of the interviews is extremely helpful in supplying background history, as well as contacts and ideas for information not yet gathered, ie. women.

Manitoba Human Rights Commission. Tapes on Winnipeg General Strike including interviews with Bertha Guberman, June, 1972; Mrs. Hunka, July 5, 1972; and Mary Kardash, July, 1972.

Manitoba Provincial Archives. Tapes including an interview between Robert B. Russell and Lionel Orlikov. Tape no. 4, 1961.